100 Painters of Tomorrow

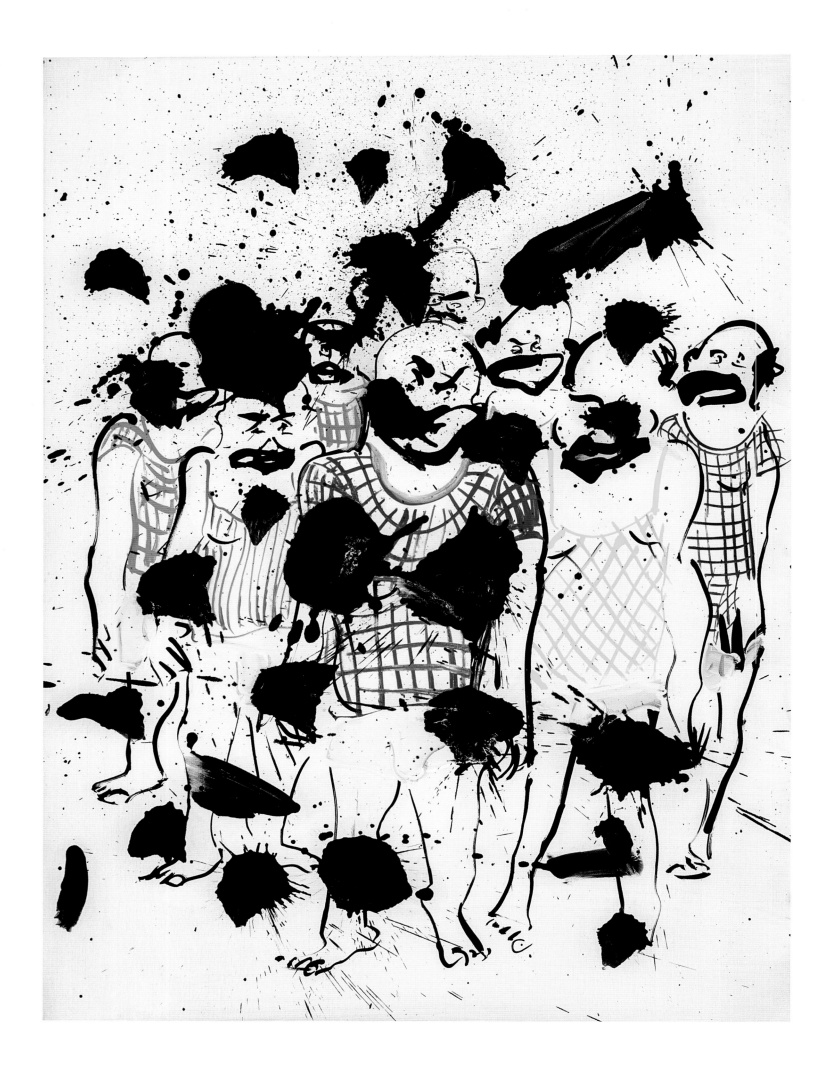

100 PAINTERS OF TOMORROW

Kurt Beers

Thames & Hudson

330 illustrations, 320 in color

This book is dedicated to young and creative minds
everywhere, but especially to my nieces and nephews:
Spencer, Jaynie, Roman and Charlotte

p.2 Tala Madani, *Blackout*, 2012, oil on linen (see p.154).

100 Painters of Tomorrow © 2014 Thames & Hudson Ltd

Introduction © 2014 Gregor Muir

All artworks © 2014 the individual artists
Measurements of artworks are as supplied by the artists or their galleries

Designed by Matilda Saxow
Display typeface: *Parlour* by Matilda Saxow

First published in 2014 in hardcover in the United States of America by
Thames & Hudson Inc., 500 Fifth Avenue, New York, New York 10110

thamesandhudsonusa.com

Reprinted 2014

Library of Congress Catalog Card Number
2014930111

ISBN 978-0-500-23923-0

Printed in Latvia by Livonia Print

TABLE OF CONTENTS

PREFACE

by Kurt Beers

The art of painting represents one of our earliest and most momentous human achievements. From the prehistoric cave imagery at Lascaux, through Byzantine icons and Romanesque frescoes, the political and religious upheavals mirrored in the Italian Renaissance and French Revolution, the daring developments of Impressionism, Cubism and Surrealism and the minimalist colour field paintings of the 20th century, through to the reinterpretations of pop culture, ideas of low-brow masquerading as high-brow (and vice versa) and 'postmodern' ideals of the early 21st century, in which everything has been viewed through a lens of inclusivity, painting has long served as a catalyst for both communication and creative expression.

Painting thus carries a greater sense of tradition than almost any other discipline. To paint is to engage in a rich lineage of social history and artistic evolution, one which exists both imbued by its past but also autonomous and exhilarating unto itself. However, such an understanding of the role of paint and the painter leads to significant questions. *What is, and how can we articulate*, the current status of painting? *What does it mean* to be a painter today? *How are today's artists* working in paint indebted to, but also liberated from, its complex history?

It was with the implications of this powerful lineage in mind that I set out to compile a unique assemblage of emerging artists: a collection of promising new voices working primarily with paint. This would eventually take the form of *100 Painters of Tomorrow*, a project to identify and recognize some of the future luminaries in the field. While countless tomes have been released on the history of painting, and there are plenty of noteworthy publications that acknowledge established artists, and even a number of great texts that look at emerging artists working in all disciplines, I could find no recent, concise, intelligent publication that looked specifically at emerging artists working principally with paint. This seemed like a missed opportunity, since I firmly believe that painting today – not unlike literature, theatre, fashion, music or any other form of cultural communication – is, at a grassroots level, perhaps at its most raw, exciting and inspired.

All sorts of baggage and complications (for better or worse) come into play once artists become more established. Some go on to succeed; many fail. But at an 'underground' level, beyond the confines of the 'higher', often institutionalized levels of the 'white cube', brilliance can frequently be found at work. It is no surprise that anecdotes about successful musicians often begin with

accounts of representatives from the music industry lurking about New York's Lower East Side, catching momentous gigs at 'insider' watering holes. Put even more colloquially, it is the 'kids' (though 'emerging' should not be confused with 'young') who are doing the moving and shaking, instigating change at a base level; and it is their tremors that are felt all the way through the institution.

It seems even more perplexing, then, to continue to hear about the 'death of painting', the hyperbolic pronouncement that has loomed ominously over painters for the last couple of centuries. This book attempts to prove that painting is more alive and well than ever before. One only needs to hear about the selection process for the project, which was conducted with careful consideration and meticulous research by a whole host of individuals working at various levels of the art world.

Through an open call for submissions and a panel of internationally esteemed judges, the 100 artists were selected from a pool of over 4,300 applicants, hailing from 105 countries. Entrants submitted works online and from these the jurors first derived a longlist, and then a shortlist, and eventually, via a process of blind jurying and tabulating scores using a 'first past the post' system, the final 100 was reached. At each and every stage, we found ourselves exhilarated by the quality, breadth, vision and uniqueness of the work submitted. How could artists working in such a 'plagued' and 'weighted' discipline, with such an encompassing history, still manage to excite and surprise us? The overriding reality is that, even in an age of social media, technological advancements and a ubiquitous removal of the 'human hand' from all aspects of creation, painting is doing more than simply surviving; it is thriving.

The integrity of the jurors' panel in selecting the artists was critical to the credibility and relevance of the project. The panel was made up of a diverse range of artists, curators, critics, art historians and collectors, each lending their distinctive experience, enthusiasm and knowledge to the process of selecting the final 100 painters. Cecily Brown, Tony Godfrey, Yuko Hasegawa, Suzanne Hudson, Jacky Klein, Gregor Muir, Valeria Napoleone, Barry Schwabsky and Philip Tinari comprised the panel. Gratitude is also owed to Sir Norman Rosenthal for his contributions and consultation throughout the process. Another important element was the participation of over 40 of the top international painting schools, who lent their support by referring current and former students they deemed worthy of consideration.

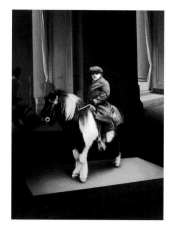

Left: Andrew Sendor, *Installation view: Alton Ambrose Booker, Artist Unknown, 2027, human being, horse and mixed media, dimensions variable; This is not a room, Giles Godfrey, 2026,* 2 channel video projection, 2011, oil on linen mounted to panel, 50.8 × 35.5 cm (20 × 14 in.)

The final 100 artists indicate a diversity wholly representative of the project. The 53 men and 47 women hail from 37 different countries, and their works showcase an extraordinary range of styles and approaches. Each of these emerging artists offers a unique perspective on the role and significance of painting as a medium. For some, the act of painting is an extension of their own physical presence and being, while for others it is a profound means through which to illustrate and communicate a broader conceptual standpoint. In each and every case, the artists exhibit a dedication to their craft, a belief in the history and future of the medium, and a desire to paint in new and exciting ways.

This book aims to encompass an entire global community of artists from all backgrounds, working within many different areas of interest. Some of the artists make unconventional uses of media (see the introduction, pp.14–15); others work in what might be considered more conventional ways, but operating through knowledgeable, subversive approaches that exhibit a profound understanding of painting and a desire to refute historical ideals from inside the system. I consider these artists the 'unconventional conventional'.

Andrew Salgado (see p.210), whom I have represented as Director of London's Beers Contemporary gallery since 2008, works within a method that exhibits a deep understanding of the ideals of Classical masculinity and beauty, but combined with a leaning toward abstraction and a political perspective that elevates the work beyond 'the figure' into a territory of very real, and often intense, social commentary. Through a similar critique of identity, Peter Linde Busk's work (see p.64) seems immensely personal (if not autobiographical), his technical approach resembling painting's answer to automatic writing: free-form, aggressive and arising from the subconscious.

Paweł Śliwiński's paintings (p.222) verge so acutely on satire that they risk being almost comedic, but their addressing of, and anchoring from, social ills and a feeling of responsibility toward the painter's native Poland, mean the works bear a macabre gravitas. Other artists in the book – Akira Ikezoe (p.136), Evren Sungur (p.236), Shahryar Hatami (p.128), Stelios Faitakis (p.102), Jirapat Tatsanasomboon (p.244) and Aleksandar Todorovic (p.248), to name but a few – work in a similar context, paying homage to their heritage, each of their respective styles borrowing from the visual history of their culture, but remaining critically self-aware of any implications carried therein.

Madeline von Foerster (p.106) seems perhaps the most technically conventional of the selected 100, but her tableaux exhibit such mastery and use such wryly self-aware tropes of the conventions of Dutch still life that, as viewers, we feel complicit with the satirical critiques operating within them. Andrew Sendor (above and p.214) furthers an analysis of contemporary society by amalgamating traditionally inspired, almost hyperreal scenarios, painted exclusively in black and white, and referencing the dawn of photographic media, though often infiltrated by planes of pixelated 'censorship'. Alexander Gutsche (p.126) plays with concepts of the subconscious so astutely that he aligns himself as a contender alongside his recent Leipzig School predecessors and the Surrealist movement, with even a modest reference to the starkly contrasted works of Giorgio di Chirico.

Any analysis of artists in this publication must of course remain cursory, but the aim is to exemplify the many facets at work today and to show that any one movement occurs within an almost infinitely larger, highly exciting context. These painters have not only an astounding history of source material to reference, but also a high level of awareness, with the ability to offer a sense of time, place and significance on a global scale.

I once challenged one of the artists I represent for 'dumbing down' the importance of what he does. 'I'm not saving lives,' he mused self-deprecatorily before a small group at an artist talk. Afterwards I corrected him: many thousands of people train to be doctors, teachers, solicitors and scientists, but it takes real courage, conviction, sense of purpose and that ever-elusive creative impulse to make artists who and what they are. Their achievement is no small feat, for these 'painters of tomorrow' are the individuals who dictate how we perceive the world around us. They help us understand our place in time and space, and how we, as individuals and as a society, situate ourselves within our culture, history and existence at large. Art – and specifically painting – continue to be vital as a visual cue for society.

Although the future is, by definition, just beyond our reach, it is not entirely out of sight, and I believe that by offering a glimpse into the future of painting, *100 Painters of Tomorrow* also provides a means by which the aesthetics and communicative patterns of our time are digested and represented. I am confident that the 100 artists compiled here all bring something remarkable and distinctive to the ever-vibrant and developing realm of painting.

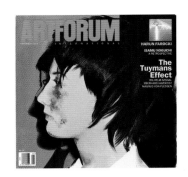

iNTRODUCTiON
'BEWARE WET PAINT'

by Gregor Muir

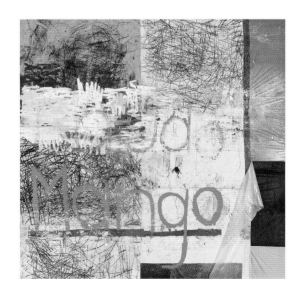

Above: *Artforum International*, November 2004, front cover displaying Wilhelm Sasnal, *Anka, Ewa*, 2004, oil on canvas, 35 × 35 cm (13¾ × 13¾ in.)

Left: Oscar Murillo, *Untitled (Mango)*, 2012, oil paint, plastic and dirt on canvas, 470 × 467.4 cm (185 × 184 in.)

It's not the most unusual explanation I've been given by a young gallerist in the process of describing a work by one of their artists, but I was nevertheless surprised when encountering a painting by young London-based Colombian artist Oscar Murillo (see opposite below) to be told, 'He's not really a painter.' I was stood before a towering painting twice my height, with brightly coloured impasto reading 'Fish Taco'. I was left wondering, how could this artwork be produced by anyone other than a painter? By definition, Murillo applied paint to a raw, scruffy-looking canvas. As the author of this work, surely he could be described as a painter? But the gallerist was right. While the end product walked and talked like a painting, the process from which it derived was more akin to a form of performance, a distinction that I shall return to in due course. Since this encounter, I have discovered numerous glitches in the received notion of what it is to be a painter. For instance, in an interview with London-based Jock McFadyen, a man in his sixties who has been painting his entire life, he asks not to be called an artist, preferring instead to be referred to only as a painter – a provocative statement that points to the difficulties not only of distinguishing between the terms 'artist' and 'painter', but also of attempting to define painting as a medium.

There are innumerable variants on how an artist arrives at a finished painting, including the processes by which he or she gets there. Aside from the physical technicalities, there is the context in which a painting is received, whether it be exhibited inside a 'white cube' gallery or an uptown restaurant, unveiled as a public or private commission, or hidden from view, as was once the case with Gustave Courbet's *L'Origine du Monde* (1866). In the present day, paintings are made through so many differing approaches that to discuss the act of painting as a nebulous catch-all is no longer viable. To understand the art form in the present, and to understand the absolute value of painting within the broader context of contemporary art, we need to address how artists wish their work to be interpreted and how they choose to position themselves across a broad spectrum of possibilities within an ever expanding art world; a course set long before paint is applied to any surface. Having accepted that interdisciplinary practice is intrinsic to our understanding of contemporary art, artists today will undoubtedly view painting as one of many mediums at their disposal. This option to resort to painting, in a far more relaxed manner than traditionally thought possible, represents a fundamental shift in the relationship between artists and painting – one that does away with the received orthodoxies surrounding how they might function together. This sea change, regarding how an artist arrives at painting, has played a significant role in breaking up established genres. In short, painting – as with most forms of creative practice in an age in which art is discussed in terms of theories such as Relational Aesthetics, Post-Net Aesthetics or Object-Orientated Ontology – is now fractured.

As with other creative endeavours in the present, painting has become many things, with numerous sub-headings and permutations. Like music, it is mutable, interchangeable and continues to sample itself through a collaging of past and present, something proposed by painting long before the arrival of Post-Modernism. It continues to explore the history of the image – photographic, mass-produced or digitally transmitted. It even attempts to interpret the widespread distribution of images as relayed via computers or smart phones, be they celebrity-orientated or newsworthy, scientific or sexual, sensational or banal.

All the while painting reports back to us about the impact of new technologies on the way we are. Over the centuries, painting has become increasingly sentient, aware of its own durability, not only in the auction houses as a market commodity, but also as a perpetual modelling device for our thoughts and desires. Moreover, it is cheap to paint and widely accessible – more so than many other forms of artistic media. If we trace the tradition back to the Lascaux cave paintings, it is as though mankind were genetically programmed to receive art through painting. Indeed, contemporary painting continues to thrive in a culture in which it was assumed artists would defect to the internet. Conversely, the arrival of the internet seems to have bolstered our interest in the medium. The advent of photography never posed a real threat to painting and the form continues, begging the question: whatever happened to the death of painting? Clearly such reports were greatly exaggerated.

If we consider painting as a living entity across time, a self-conscious thing, then might it be possible to discuss painting as possessing a memory of itself? Put simply, painting, like other forms of artistic media, is inextricably linked to its past and it would be surprising not to find trace elements of other paintings in recent works. The notion that paintings 'inherit' the appearance of other paintings may not sit happily with those artists who desperately seek originality and claim that mere coincidence has brought them into comparison with others. However, this has never deterred scores of critics, curators and art historians from identifying precedents on their behalf. Painting evokes other paintings and the tradition has been going on for far too long for it not to be self-referential to its own canon. Many of the painters in this book support this notion of lineage and heritage. Sascha Braunig (see p.54) notes: 'To work in painting is to be involved, whether you like it or not, in a trajectory of other painters, and I've come to adore the thought of artists throughout history all working simultaneously in a parallel dimension; some massive Borgesian studio hive.' Indeed, painting depends upon its history and the connections we make across many centuries of artistic production to make sense of it.

Like a call and answer, an artist's response to the meme-like influence of painting can occur over centuries, decades, or, as has been argued in recent exhibitions of the work of Braque and Picasso, at one and the same time. In order to visualize these connections, we need look no further than the writings of Marcel Proust, who described the stirring of a distant memory as though from 'a great depth' as being 'embedded like an anchor' before 'mounting slowly', providing us with an image of a taut chain in the abyss of the subconscious mind. To appreciate painting in the present, one has to acknowledge its anchors and the precedents to which it is connected.

That contemporary painting dredges up memories of other paintings offers a seemingly limitless range of anchors to its past. Some of these connections are clear, some less so, but only a few propose a new way forward for painting. Mapping these networks is complex. In an article published in *Artforum* in 2004 entitled 'The Tuymans Effect', Jordan Kantor argued that the influence of Belgian painter Luc Tuymans could be traced through the work of younger European painters, including Eberhard Havekost, Magnus Plessen and the Polish painter Wilhelm Sasnal, whose work featured prominently on the cover (opposite above). The article was contentious, particularly to some of the artists named, who

were understandably uncomfortable with having their influences decided for them; especially where seismic differences might equally be argued between Tuymans and Sasnal, whose fascination with the Holocaust may unite them, but whose approach widely differs. Take, for instance, how Sasnal wraps up his take on history within a broader system of images to include those of family and friends, as well as Pop cultural references. That Sasnal is influenced by Tuymans remains a point for discussion, but the real anchor for these artists – linking Tuymans through Sasnal and beyond – is Gerhard Richter (above), whose photo-realist works, in particular his Baader-Meinhof series 'October 18, 1977' (1988), have served as a touchstone for painters using lens-based imagery in recent decades.

As the list of artists featured in *100 Painters of Tomorrow* took shape, it became clear how Richter's influence continued to be felt. Lithuanian artist Kristina Ališauskaitė (p.30), like Sasnal, addresses a mediated reality that acknowledges how we receive imagery in the present day through multiple formats, specifically referencing random domestic snapshots. Similarly, Łukasz Stokłosa's homoerotic imagery and paintings of decadent interiors (p.234) are transformed through their isolation as though plucked from the narrative of a lost film. In her depictions of everyday life, South African artist Kate Gottgens (p.116) undoes the pomp of historical painting and its associations with high art, showing us

instead someone by a camper van turning to a camera, possibly in the moment of being hailed by a friend. The subject matter and composition of these images speak a familiar language, that of the ordinary. They invite us to become absorbed by someone else's domesticity. British artist Sikelela Owen (p.184) achieves this by creating a world of friendly faces and huddled groups, intimate moments caught on camera, only her subjects remain remote and withheld, frozen in time before being turned into paintings. Operating on the outer limits of objective realism, Chechu Álava (p.26) blurs fact and fiction to the point where her misty, figurative images lose themselves to contemporary romanticism. It is possible that Álava's work finds its footing in the psychosexual work of Balthasar Klossowski de Rola, otherwise known as Balthus, whose controversial paintings of adolescent girls remain challenging to this day. Emerging artists such as Benjamin Senior (p.218) and Ivana de Vivanco (p.252) also produce paintings with figures in highly stylized poses; their palette and questionable meaning may ultimately chime with the lasting legacy of Balthus's older brother Pierre Klossowski (below), whose writings and somewhat perverse drawings appear to be re-entering our contemporary lexicon.

There has also been a tendency in recent years for artists to employ painting as a form of escapism. In an age of mounting social, economic and environmental nihilism, those attempting

Above: Gerhard Richter, *Confrontation 3*, 1988, oil on canvas, 112 × 102 cm (44⅛ × 40⅛ in.)

Left: Pierre Klossowski, *Les Barres Parallèles IV*, 1976, colour pencils on paper, 202 × 130 cm (79½ × 51⅛ in.)

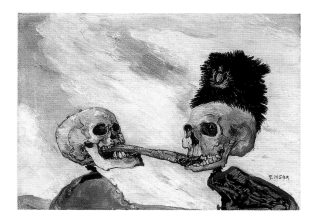

to immunise themselves against the trauma of modern-day living are often inclined to retreat inside the imagination. The surrealist paintings of younger generation Polish artist Jakub Julian Ziolkowski (p.266) are crammed with figures, intestines, eyes, insects and so on, unfolding over time like a psychedelic comic book. While his paintings say a lot about him, they also reflect back on our desire to sidestep mankind's woes in the real world, which is perhaps unsurprising coming from an artist whose hometown of Zamość near the Ukraine border still bears the scars of German brutality during the Second World War. Behind Ziolkowski's work is that most perplexing of painters, the late Belgian artist James Ensor, whose dense canvases reveal carnival mobs in grotesque masks and images with titles such as 'Skeletons Fighting over a Pickled Herring' (above).

Djordje Ozbolt also plunges headfirst into a swarm of surrealistic visions where exotic and perverse relationships form between the simultaneously meaningful and absurd. Ozbolt often refers to heraldic symbols such as the red, yellow and green of the Ethiopian flag and the Lion of Judah. Associated with Jamaican reggae music, these colours are sported by the Rastafarians who occasionally populate his paintings, such as those seen manning a stall outside a derelict Guggenheim museum (p.187). However, in the context of Ozbolt's work, this symbolism – typically associated with a reverent multiculturalism – finds itself open

to the artist's mischievous intervention. Dale Adcock (p.22) presents us with depictions of primitive masks and totems whose significance remains deeply ambiguous, while the work of Ryan Mosley (p.168) offers a world of imaginary ancestral portraits tinged with sentiment from bygone days. Then comes the business of subverting language through the collaging of figures with animal or bird parts, or the inclusion of mysterious interventions in a classical landscape, be it a blur of paint or an out-of-place personage, all of which can be interpreted as a form of latter-day Magic Realism. In the wake of Minimalism and Conceptualism, references to traditional Old Master painting are mixed with contemporary kitsch in the work of many young artists, including Henny Acloque (p.20), Mark Nader (p.172), Anj Smith (p.226) and Mathew Weir (p.256). The lineage for this particular strand returns us to the depths of art history, recalling Pieter Bruegel the Elder (1525–1569), Lucas Cranach the Elder (1472–1553), and that most revered of artists, Hieronymus Bosch (c. 1450–1516; below).

Another talented young artist featured in these pages is Iranian-born, now American-based, Tala Madani (p.154), who presents us with depictions of, among other things, fat, bald, middle-aged men in stained underwear. Looking at Madani's surreal and often provocative imagery, we instinctively feel she wants to direct us toward the early works of American artist Sue Williams or contemporary artists such as Nicole Eisenman.

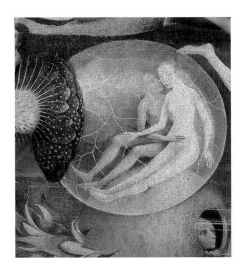

Above: James Ensor, *Skeletons Fighting* over *a Pickled Herring*, 1891, oil on panel, 16 × 21.5 cm (6¼ × 8½ in.)

Left: Hieronymus Bosch, *The Garden of Earthly Delights*, c. 1500–5, triptych, detail from the central panel, oil on panel, 220 × 390 cm (86⅝ × 153½ in.)

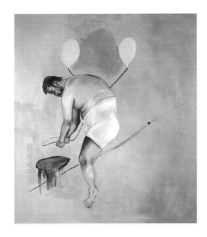

However, Madani's works go further than their surface images of swiftly painted ungainly men. Having decided upon her subject matter, she lets rip, setting out to show us what paint can do. Whole worlds open up in the flash of a brush as her quickfire technique defines a space for painterly experimentation. At this point, it becomes apparent that anchoring Madani's work is less a post-feminist repositioning of Robert Crumb than the German painter Martin Kippenberger (above), who appeared in his late paintings as a dishevelled figure wearing hiked-up Picasso underpants. Meanwhile, Emma Talbot (p.242) adopts a cartoonish approach to female sexuality, depicting moments of isolation and loneliness, such as waiting by the phone, the anxiety of dating, electrifying sexual encounters, then shifting to expressions of love and betrayal – 'Do not feel burdened by the indignity of being misunderstood', or 'I love you as certain dark things are to be loved in secret between the shadow and the soul'.

Reviewing the selected painters, some are clearly inspired by reference points that exist outside painting, such as computer or graphic design, as well as advertising and illustration. These are examples of artists who look beyond the remit of painterly language and expression, being concerned by the plight of the image in our age of mass consumerism. Toronto-born Shaan Syed (p.240) plays with absurdist arrangements of text and

colour, while fellow Canadian Dan Brault (notably in his recent work; p.50), American artist Andrew Brischler (p.62), the Australian Marc Freeman (p.108) and British artist Hannah Hewetson (p.134) continue to extend the legacy of abstraction into the present, playing with form and colour in the context of the digital age. We also find two artists whose work reminds us of images of abstract paintings from the 1960s. Glowing lines appear etched over coloured grounds in the work of Jenny Kemp (p.148), recalling the more lyrical works of Paul Klee or Eva Hesse's cord paintings, while Tonje Moe's non-figurative paintings (p.160) present us with formal, cabinet-like structures used to frame expressionistic brushstrokes. Along with other contemporary abstract painters, including those concerned with geometric abstraction, both Kemp and Moe seem to find great pleasure in playing into Modernism's extra time.

A significant number of artists are working in the area of expanded painting, by which I refer to paintings that have abandoned their own frame and entered the world of sculpture and multi-media installation. Cornelia Baltes (p.36) produces paintings that are evidently conversant with architecture and design. Canvases are rejigged to reveal brightly coloured stretchers, while other paintings grow legs to become freestanding objects. Enhancing the overall sense of a controlled environment,

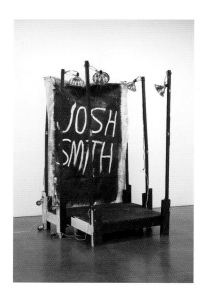

Above: Martin Kippenberger, *Ohne Titel/Untitled*, 1988, oil on canvas, 240 × 200 cm (94½ × 78¾ in.)

Left: Josh Smith, *Stage Painting 2*, 2011, wood, paint, fabric, lights and hardware, 243.8 × 172.7 × 137.2 cm (96 × 68 × 54 in.)

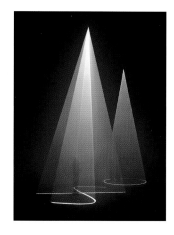

the surrounding walls are often painted in bold block colours. This is painting viewed as a three-dimensional experience, not just an obsession with two-dimensional representation. Meanwhile, Spanish artist Guillermo Mora (p.166) also challenges the identity of painting. Some of his works appear as tightly wrapped bundles of juicy colour placed on the floor, while others are constructed from the detritus and remnants of other paintings. Having reworked the basic elements of a painting – paint, canvas and wood – Mora arrives at a form that can no longer be considered purist.

Aside from producing an endless stream of paintings in a variety of styles based on his own name, American artist Josh Smith has been known to produce small wooden stage-like structures with canvas sheets hanging between poles (opposite below). In an interview given in 2011 for the Opening Ceremony website, Smith illustrated the conundrum surrounding exactly where expanded works such as these end up. Smith starts off by pointing us in the direction of one of his stages. 'This is something I made when I was a little kid, and I've remade it. It's an artwork in retrospect, but it's not a painting. It has the same elements of a painting – the paint, the canvas, the wood. It functions the same way as a painting, but it's just been re-arranged. I mean, I'm a painter, but I think all artists in [New York] are here because they're exhibitionists.'

Australian-born artist Caitlin Yardley (p.262) incorporates materials that fall outside the remit of what we readily associate with traditional forms of painting. Her deeply sculptural works include stained timber, broken concrete paving and steel frames from which goat skins or Amish quilts are draped. Yardley unashamedly works across forms, exiting the orbit of straight painting with considerable relish. New York-based German artist Tamara K.E. (p.142) makes paintings whose subject matter is at times absurd, cartoonish and surreal (recalling the exuberant paintings of British painter Rose Wylie). She exhibits her paintings on walls with gridded lines, partly reminiscent of musical notation, or steps outside of her individual practice to work with fellow Georgian artist Thea Gvetadze to produce complex multi-media installations. Swedish-born Anna Ring (p.200) produces site-specific architectural interventions, confronting us with large wall-painted dots or a line running from a wall over the skirting board and onto the floor using not paint, but melted chocolate. All these forms take their cue from the expanded practices of the 1960s and '70s, be they sculptural, take for example Gordon Matta-Clark who dissected entire buildings, removing floors, ceilings and walls, or Expanded Cinema, a term that includes artists experimenting with the materiality of film and its projection, such as Anthony McCall whose projected light cones (above) once inspired Matta-Clark to 'cut' into two townhouses opposite the Centre Georges Pompidou (below).

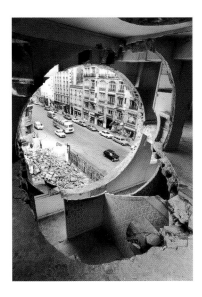

Above: Anthony McCall, *Between You and I*, 2006, installation view at Peer / The Round Chapel, London, 2006

Left: Gordon Matta-Clark, *Conical Intersect*, 1975, architectural intervention, documentary photographs, photoworks and Super 8 film: colour, silent, 18:40 minutes

Returning to Oscar Murillo, whose paintings are grounded in performance, when asked whether he views himself as a painter, he instead prefers to discuss painting as a place to draw lines, referring not just to the predominantly blue squiggles that engulf his canvases, but to painting as a setting that transcends social barriers, engaging a class of people who might otherwise be unattainable to him, be they gallerists, curators, critics, collectors, and so on. Another reference to class mobility is contained in Murillo's use of a broomstick to draw lines on canvases that he places upon the floor, recalling how he once made a living in the City of London cleaning office buildings. His canvases also serve as a record of what he refers to as 'studio pollution'; they are pushed about his workplace before being emblazoned with words such as 'yoga', which he cites as having been culturally displaced in much the same way he felt displaced having left a small town in South America to live in London.

No longer viewed as a hermetic practice, painting presently has the potential to position itself as an interdisciplinary art form, one that can accommodate sculpture and performance, so much so that a recent Tate Modern exhibition examined the influence of theatrics on painting. 'A Bigger Splash, Painting After Performance' included work by Jackson Pollock, whose paintings serve as records of the artist's movements; Yves Klein, who once used life models as living brushes; Niki de Saint Phalle, who shot bags of

paint attached to canvases; and Bruce Nauman, who turned to painting his own body on film. One of the more vivid examples of this crossover between painting and performance is Viennese Actionist Hermann Nitsch (above), whose ritualistic happenings – Orgien Mysterien Theater – used animal entrails and blood in the production of paintings. If we were to bring additional works to the fore such as Paul McCarthy's video 'Painter' (1995; below), which shows the artist struggling with an enormous tube of paint and a pantomime brush, it becomes clear just how far we've strayed from easel painting.

That said, one last port of call remains that may well define a new path for painting. The term 'conceptual painting' continues to gain ground, which is not to suggest that all other forms of painting exist without thought or intent. The term primarily refers to paintings with direct links to Pop and Minimalism; think Richard Prince's joke paintings, Rudolf Stingel's silver gauze paintings or Wade Guyton's canvases fed through wide-format ink-jet printers. Conceptual painting is increasingly being discussed in relation to post-Warholian abstraction, which connects the work of several young artists such as Tauba Auerbach who spans a broad range of media to include artist books, sculpture and design. In recent years, Auerbach has become known for producing paintings by spray-painting canvas at varying angles to the floor to enhance the creases and folds inherent in the material itself. The result

Above: Hermann Nitsch, *Untitled*, 1989, oil on canvas and smoke, 200 × 300 cm (78¾ × 118⅛ in.)

Left: Paul McCarthy, *Painter* (video still), 1995, video, 50:01 minutes

is a subtle chromatic fade, a *trompe l'œil* effect that displays a certain lightness of touch that may yet prove to be the hallmark of this generation. The same might be said of young West Coast artist Nathan Hylden, who silkscreens images of his studio on to aluminium sheets which he then stacks up and sprays with white paint so that they mask one another, contributing to their own creation while also becoming a record of his daily activity.

Another young artist, David Ostrowski (above), produces large-scale works that are predominantly white and appear not so much effortless as lazy. They look like they've been vandalized with blue spray paint and the canvas removed before being re-stretched, suggesting they were badly put together in the first place. They seem to recall the more neglected areas of the urban environment, empty and uncared-for public spaces where random stuff just happens. Over time, it becomes possible to appreciate Ostrowski's attempts to perfect his work using a limited palette of oil, lacquer and dirt. Beneath the surface it also becomes possible to detect another artist, one who hails from Boston, grew up in Chicago and moved to New York in 1973. Having dropped out of art school, he immersed himself in the world of underground film and music before staging numerous shows of his own work. He is known for producing paintings using bold block stencilled text, as well as cheap, patterned commercial paint rollers. In his recent 'gray paintings' he creates large

abstracts as a result of repeatedly adding and rubbing away black enamel spray paint. Using a digital process, he alters the scale, colour and resolution of the marks from previous paintings before reinserting them into new paintings using silkscreens. That artist is Christopher Wool (below).

The full extent of Wool's influence is only just beginning to be felt and his presence marks a diversion from the path set by Gerhard Richter that has remained dominant for so many years. That there appears to be a swing in favour of Wool has become increasingly noticeable in the work of younger artists who appear to embrace his self-reflective abstraction. Wool's work might be easily contained by comparisons to Robert Rauschenberg's use of random imagery and smeared paint or Robert Ryman's acutely literal white monochromes, but he goes beyond such comparisons by capturing the near invisible marks left by mankind when no one is looking. In Wool's work, the world occurs at street level, in its haulage trucks and beaten-up phone boxes. It is this language, one that references the contemporary wasteland, which seems to capture the imagination of so many young artists. In relative terms, Wool's brand of conceptual painting is a fairly recent phenomenon, joining a host of other genres in the present. Performance painting, expanded painting, post-Warholian abstraction, magic realism, photo-realism and neo-feminism: all conspire to create a new reality for painting.

Above: David Ostrowski,
F (Between Two Ferns), 2013,
acrylic, lacquer, paper and
cotton on canvas, wood,
241 × 191 cm (94⅞ × 75¼ in.)

Left: Christopher Wool,
Untitled, 2007, enamel
on linen, 320 × 243.8 cm
(126 × 96 in.)

100
PAINTERS OF
TOMORROW

HENNY ACLOQUE

b. 1979, London, England
Lives and works in London

Henny Acloque is drawn to painting because of its ability to transport the viewer to a version of reality that deviates, even if only slightly, from actual reality. Her small-scale paintings typically feature scenes of natural idylls, with allusions to Classical art history alongside references culled from a personal collection of books, postcards and catalogues. Her works – with their glossy surface texture, often lacquered in resin – retain a firm nod to the paintings of the Dutch masters or the traditions of Renaissance landscape painting, but they notably depart from their influences. One of Acloque's primary sources of inspiration is the tradition of Victorian fairy painting, a genre rooted in Romanticism and depicting meticulously detailed scenes, in which fairies – presented with an assumption of veracity – generally perform benevolent acts. However, in Acloque's re-telling, these mystical, mythical creatures are replaced by central figures who have been obscured and re-interpreted by amorphous painted abstractions. In subverting her viewers' expectations of 'the subject', Acloque heightens our excitement. Perhaps in a perverse act of retention, we feel compelled to address the mystery made present through Acloque's processes. By focusing on the restraint embodied in each painting, we are forced to ask ourselves to reconsider norms of representation. This notion of obscurity is also of critical significance in that it provides a gateway for considering the Self in relation to the Other.

'My paintings are "evidence of evidence of evidence". In combining the old and the new, I hope to transport the mind to different places through different portals. I want to create unexpected experiences and to allow the viewer to travel.'

Right: *Bendable Poseable*, 2013, oil on panel, 50 × 40 cm (19⅝ × 15¾ in.)

Opposite above: *Tarantella*, 2013, oil on board, 30 × 40 cm (11⅞ × 15¾ in.)

Opposite below: *287*, 2011, mixed media on canvas, 20 × 25 cm (7⅞ × 9⅞ in.)

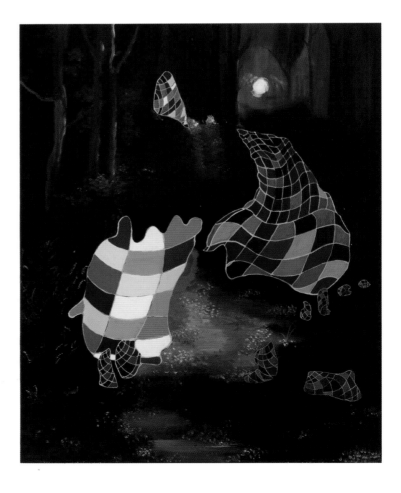

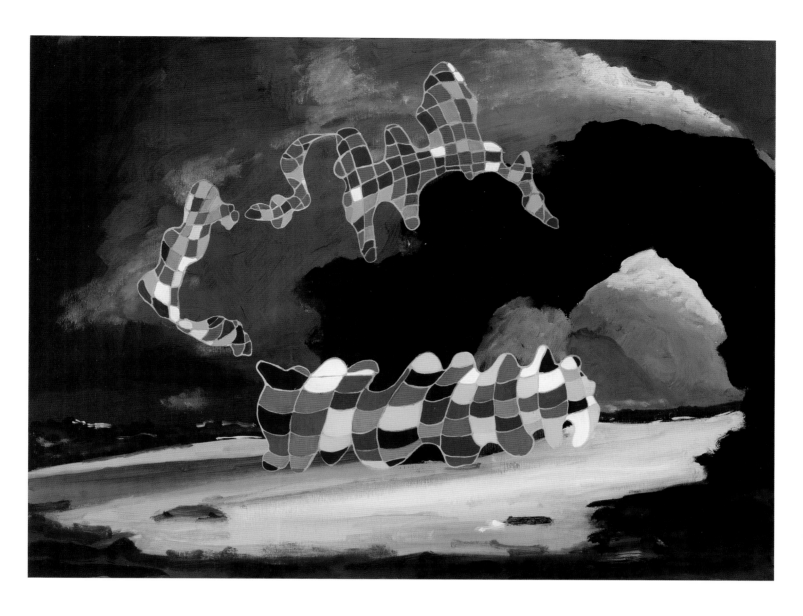

Henny Acloque

DALE ADCOCK

b. 1980, Osgathorpe, Leicestershire, England
Lives and works in London, England

As a 9-year-old schoolboy, Dale Adcock was awarded a gold star for a painting of Tutankhamun's death mask. It was this precise moment that led to his decision to become an artist. Today, his paintings are oddly subversive reinterpretations of the relics depicted. Based on the artist's own sketches, these imaginary structures reference actual iconic monuments from historical antiquity, and the subject matter includes elements such as upside-down sphinxes, skew-eyed tribal masks and portraits based on origami maquettes. The works are massive in scale, with an astonishing level of detail, executed in a *trompe l'œil* style. Of particular interest is Adcock's relationship to paint. While so many of his peers celebrate the fluidity and materiality of their chosen medium, Adcock chooses

to hide the nature of his brushwork, the surface of each painting appearing so refined, flattened and textureless that the mark-making is almost indecipherable. *Tomb* (opposite) features a repeated engraving motif, executed entirely in paint, that is historically based in death ritual but ultimately the artist's own creation. *Stack of Heads* (below) portrays six geometric, humanoid blocks in an inverted pyramid with a perspectival distortion, which, while scarcely noticeable to the naked eye, creates a marked sense of uncanniness, or even unease. All the works are the products of an obsessive interest in painterly practice: this graduate of London's Chelsea College of Art and Design notes that a single work can take up to 12 months to complete.

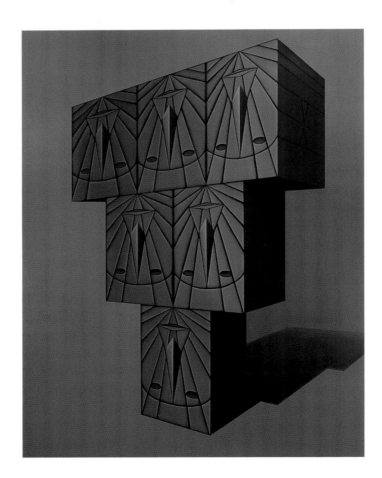

Right: *Stack of Heads*, 2010,
oil on linen, 260 × 199 cm
(102⅜ × 78⅜ in.)

Opposite: *Tomb*, 2012,
oil on linen, 260 × 199 cm
(102⅜ × 78⅜ in.)

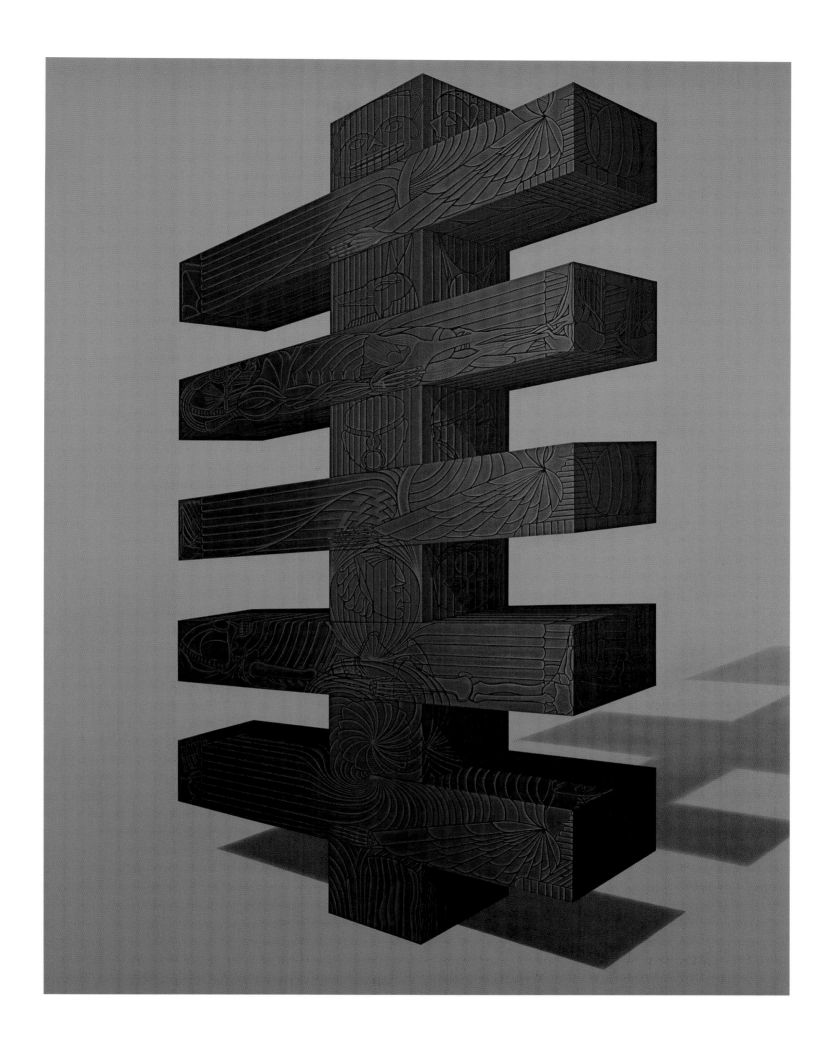

Dale Adcock

JULIETA AGUINACO

b. 1983, Mexico City, Mexico
Lives and works in Mexico City

Julieta Aguinaco is interested in time. 'To think about it, to try to understand it, and to try to represent it' are her goals. She draws particular inspiration from the theoretical writings of French historian and sociologist Fernand Braudel, who classifies time into three categories: biological, corresponding to the duration of a human life (decades); historical, in which one generation or more makes history (centuries); and geological, in which mountains move, climates change and evolution causes species to appear, transform or disappear (millennia). Aguinaco explores each type of time through paint. Her works appear like stratospheric/geological cross-sections, but often contain images of contemporary society – industrial smoke stacks and power plants, traces of architecture

or infrastructure, even elements that resemble primitive cave drawings. Aguinaco states: 'The Earth is now a threatened world, from the problems of global warming to the numerous political conflicts raging throughout the globe. The situation is chaotic, and even frightening. I don't mean to suggest a merely fatalistic view, but these are complex times, and my paintings intend to portray this spirit of the moment, whether the micro-universe of a local or personal history, or the macro-universe of Earth and its Periods; the idea of the death of progress and the birth of fragility and catastrophe.' While acknowledging that paint is an expressive medium with inherent boundaries, Aguinaco notes that these 'boundaries can be changed, broken or trespassed'.

'My work explores the poetics of
time through geography, history,
geology, architecture.... I seek to
evoke the ephemeral condition of
the human being – as individual,
as community, as species.'

Opposite: *Future is present,
present is past and past is
past (#1, 2, 3, 4 & 5)*, 2011,
acrylic and pigmented ink on
canvas, each 160 × 160 cm
(63 × 63 in.)

Above: *Future is present,
present is past and past is
past #1*, 2011, acrylic and
pigmented ink on canvas,
160 × 160 cm (63 × 63 in.)

Julieta Aguinaco

CHECHU ÁLAVA

b. 1973, Piedras Blancas, Asturias, Spain
Lives and works in Paris, France

Chechu Álava's subtle and stirring works offer a quiet reflection on the nature of femininity and identity. Having obtained a degree in painting from the University of Salamanca, Álava draws on her practice as a means of attaining an understanding of the value of beauty. Her portraits – with their softened lines, blurred appearance and muted palette – take on the timeless feel of old photographs lifted from literary, artistic and even political histories. Her subjects are presented in traditional poses, reflecting an appreciation for art historical precedent. Indeed, Álava finds inspiration in the works of Tintoretto, Velázquez and Goya, but her variations on these predecessors are noticeable, even taking on a feminist perspective. Perhaps the reflection on femininity

recalls the work of Mary Cassatt, another major influence on Álava: both painters seem to focus on domesticity and on the private, unremarkable moments of the female subjects they depict. However, Álava does not defer to art history alone: her portrait subjects include Ingrid Bergman, Simone de Beauvoir, Sylvia Plath, and even Frida Kahlo at the age of 5. 'My subjects can be dead or alive, renowned or anonymous.... It's as if I were looking for an older sister, or a story that completes mine.' Even as we appreciate the mysterious, austere beauty of Álava's subjects, we are led to view the meaning and function of this aesthetic precept with a sense of caution, as so many of her subjects confront our gaze with what appears to be a knowing, quiet defiance.

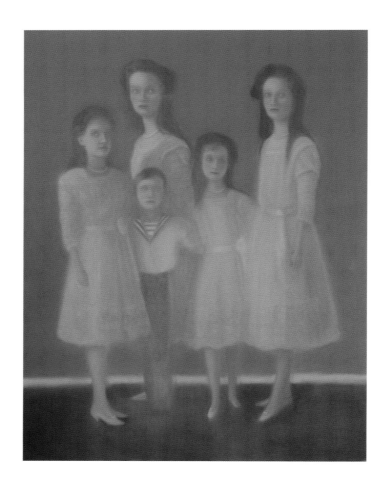

Left: *Familia Rusa*, 2010, oil on canvas, 162 × 130 cm (63¾ × 51¼ in.)

Opposite: *Femme Animal*, 2012, oil on canvas, 35 × 27 cm (13¾ × 10⅝ in.)

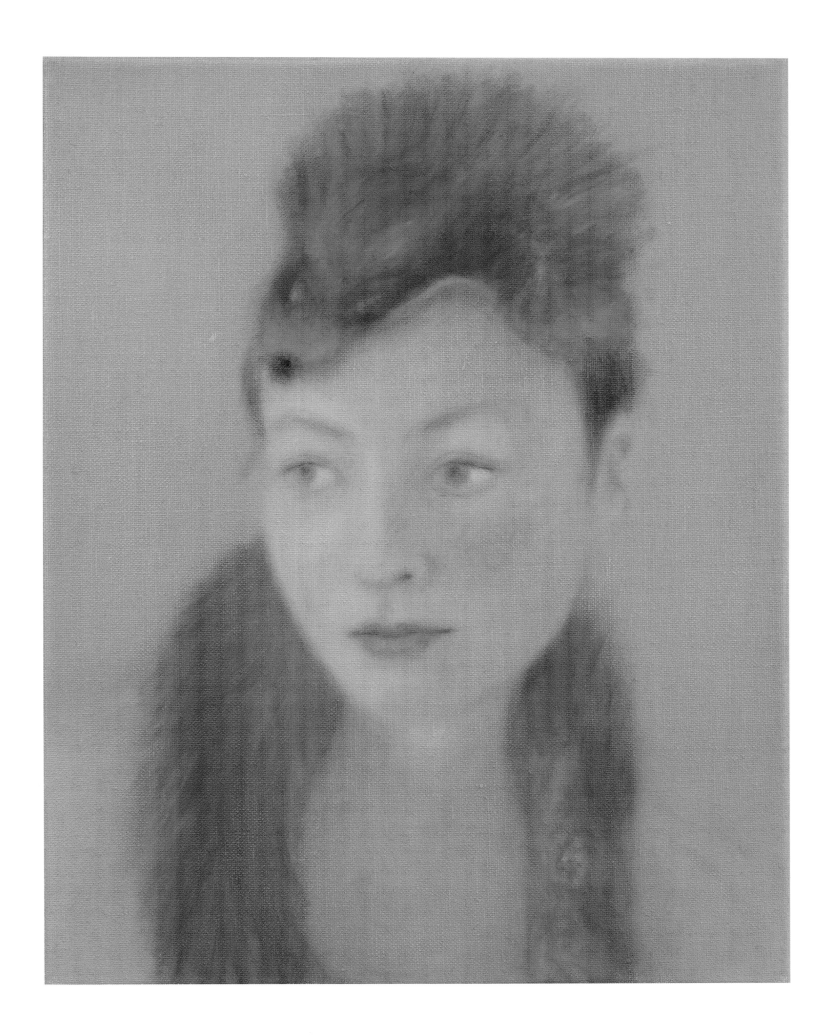

Chechu Álava

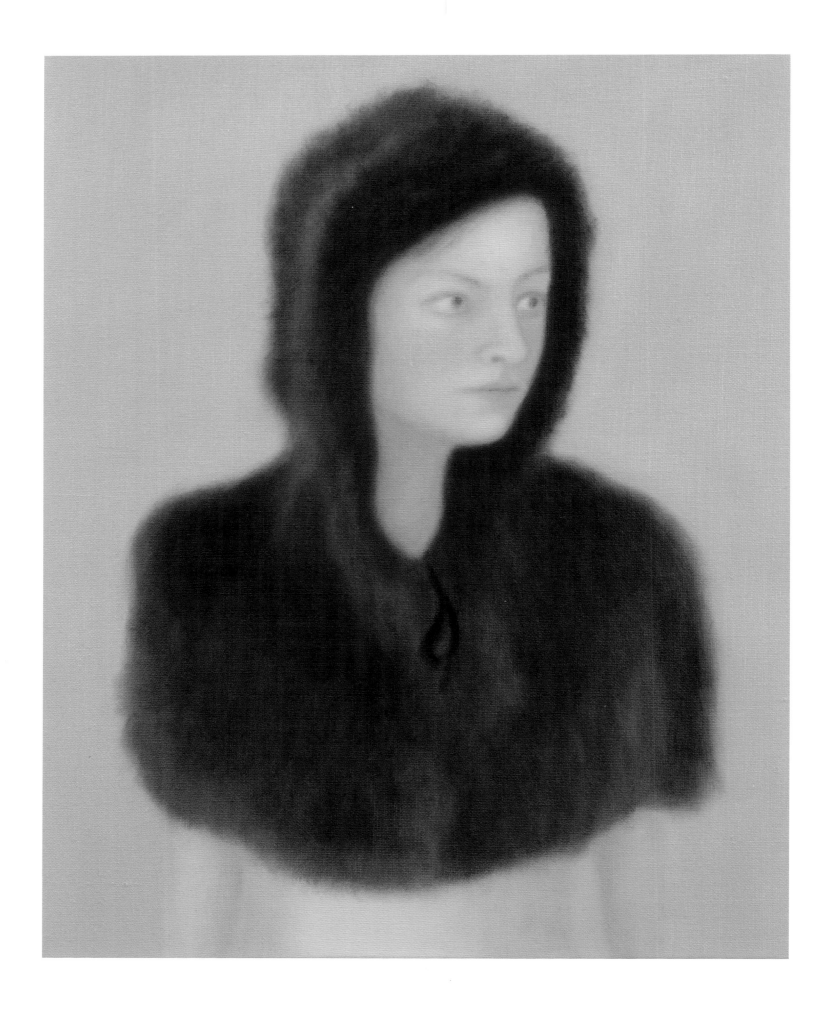

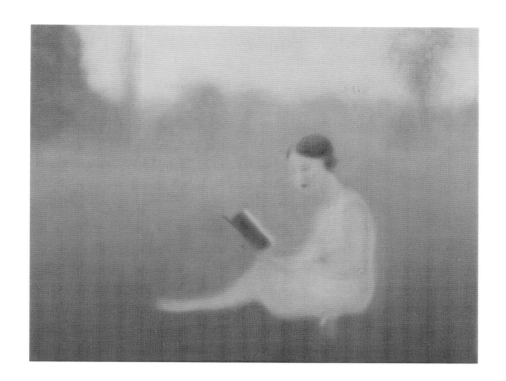

'A strong feeling of empathy makes me choose an image and paint it. In many cases it is an emotion that appears all of a sudden and has a connection with the mystery of beauty.'

Opposite: *Black Riding Hood*, 2013, oil on canvas, 41 × 33 cm (16⅛ × 13 in.)

Top: *Simone de Beauvoir*, 2012, oil on canvas, 27 × 35 cm (10⅝ × 13¾ in.)

Above: *Hannah Arendt*, 2012, oil on canvas, 41 × 33 cm (16⅛ × 13 in.)

Right: *Niña niño*, 2012, oil on canvas, 35 × 27 cm (13¾ × 10⅝ in.)

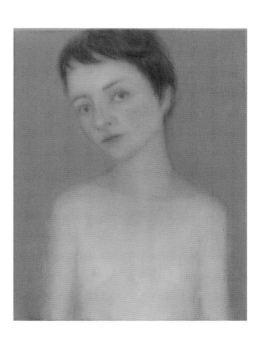

Chechu Álava

KRISTINA ALIŠAUSKAITĖ

b. 1984, Klaipeda, Lithuania
Lives and works in Vilnius, Lithuania

The imagery of dreams is often understood as an uncontrolled cognitive re-processing of the same images we have encountered, even subconsciously, in real life. However, through her artistic practice, Kristina Ališauskaitė attempts to question this notion of dreams and reality being considered for the most part as mutually exclusive entities. Her unsettling scenes, usually executed in a palette restricted to shades of black, white and blue, typically remove telling details and instead leave ghost-like traces and mere suggestions of the images that are depicted. For Ališauskaitė, such a presentation mirrors the atmospheric quality of dreams, and this, for her, allows unrestricted access to the psyche. 'My recurring subjects and themes seem to suggest something traumatic in the situations I portray,' she notes. 'Conversely, their ceaseless repetition is potentially therapeutic – an unburdening of the mind.' A hint of autobiography is also at play. As such, viewers may reach the conclusion that the paintings tell Ališauskaitė what to explore, rather than the artist directing this herself. While she acknowledges Freud and Jung in their theories of the subconscious, Ališauskaitė maintains that her perspective is detached from psychoanalysis, aiming rather to speak to the viewer through familiar, even banal scenes. Apparently coded with symbols and metaphors, her works evoke an intimacy that seems uncertain. In opening out and provoking reflection on our own subconscious, they invite the viewer to participate quietly.

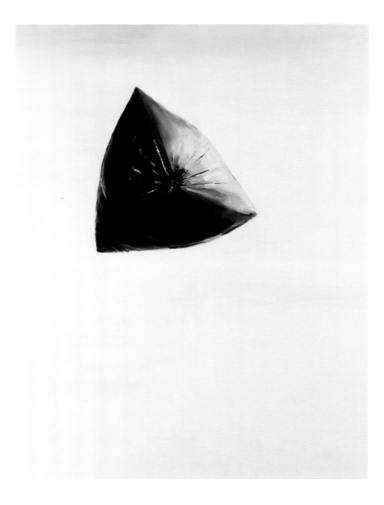

Right: *Balloon*, 2012, oil
on canvas, 100 × 90 cm
(39 × 35 in.)

Opposite: *Don't ask II*, 2011,
oil on canvas, 30 × 25 cm
(12 × 10 in.)

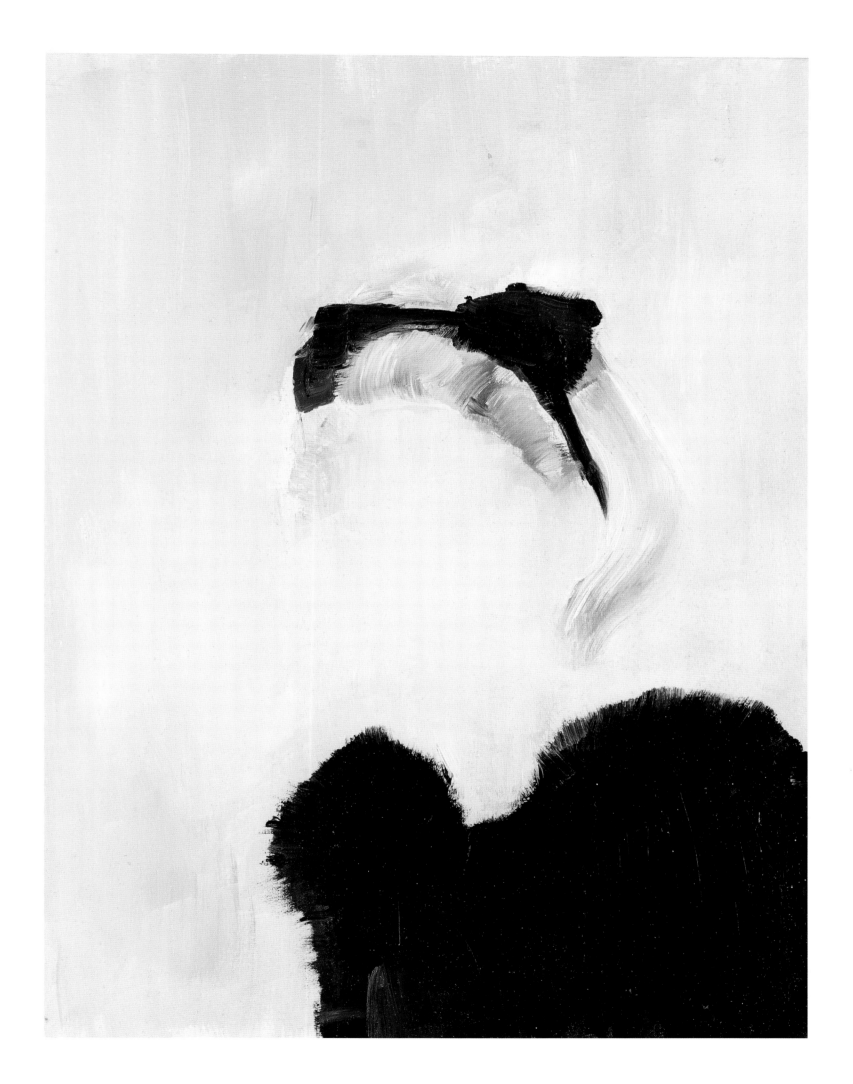

Kristina Ališauskaitė

MICHAEL ARMITAGE

b. 1984, Nairobi, Kenya
Lives and works in London, England

A graduate of the Slade School of Art and the Royal Academy of Arts in London, Kenyan-born Michael Armitage uses his practice to explore East African development and its inevitable knock-on effects. His work notably makes use of Ugandan bark cloth and various other African textiles. One series of paintings relates to the tensions surrounding the Kenyan elections of March 2013, during which NGOs coined the phrase 'peace coma' – the title of a series by Armitage (see overleaf) – as a description of the public's unwillingness to criticize election results. Armitage states: 'I've been thinking about the way that development is having an effect on culture in Kenya as older forms of cultural identity are threatened. What are we left with, and how do we represent ourselves?' He cites the example of the 'parody' of a traditional Maasai hunting dance being performed as a spectacle for tourists and politicians. The ramifications of such simulacra on both culture and representation are highly significant for Armitage's practice. He also notes how 'the tropics' have been defined through the history of painting (he lists, in particular, Gauguin, Kirchner, Rousseau and Doig), and is keenly aware of his own saccharine and nostalgically familiar palette of pinks, yellows and cool greens, accentuated by bright flashes of colour. 'Perhaps the way we look at these types of painted image has the same effect on the culture as does the *Moran*, continually performing his hunting dance for the tourists.'

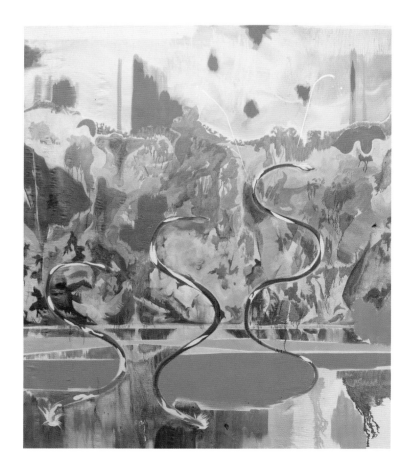

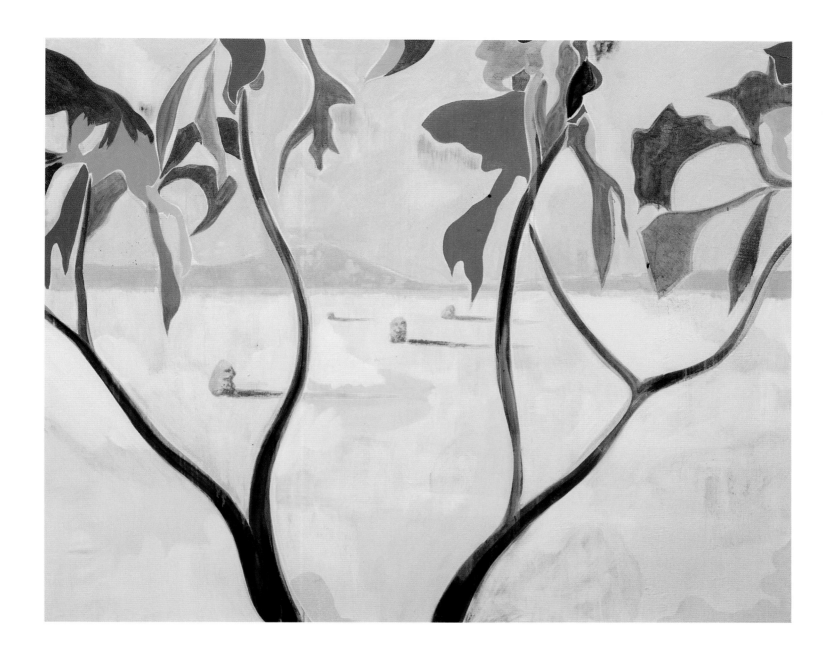

Opposite: *Balcony*, 2013,
oil on lubugo bark cloth,
210 × 160 cm (83 × 63 in.)

Above: *The uprising*, 2012,
oil on lubugo bark cloth,
150 × 180 cm (59 × 71 in.)

Right: *Vision*, 2013,
oil on lubugo bark cloth,
196 × 165 cm (77 × 65 in.)

Far right: *Door*, 2013,
oil on lubugo bark cloth,
195 × 150 cm (77 × 59 in.)

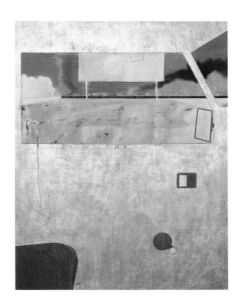

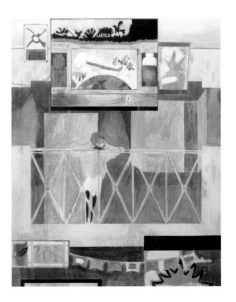

Michael Armitage

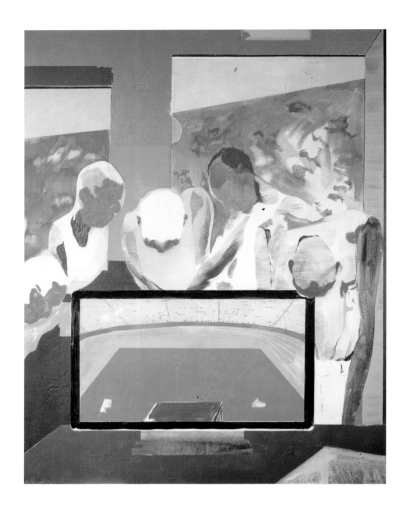

Above: *Inauguration*, 2013,
oil on lubugo bark cloth,
195 × 150 cm (77 × 59 in.)

Above right: *Peace coma*,
2012/13, oil on lubugo
bark cloth, 110 × 75 cm
(43 × 30 in.)

Right: *The search (rinse
spin dry)*, 2013, oil on lubugo
bark cloth, 150 × 195 cm
(59 × 77 in.)

Opposite: *Aspirations of
an illiterate man*, 2012/13,
oil on lubugo bark cloth,
190 × 220 cm (75 × 87 in.)

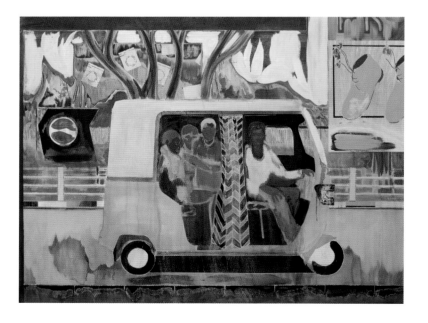

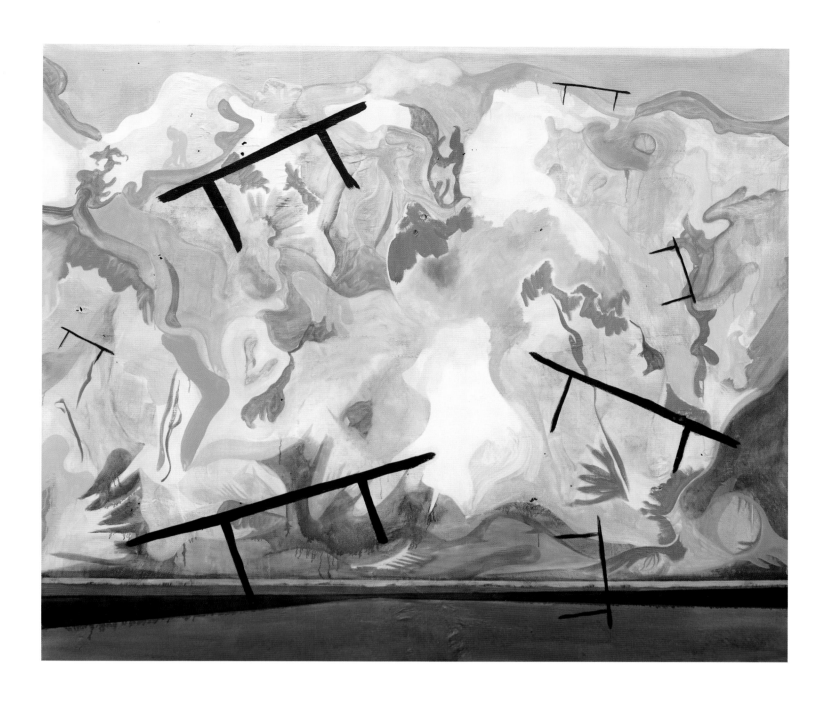

'I am interested in questioning
and reflecting the cultural and
political development of East Africa
on both a local and international
stage. Through the poetry of a still,
silent image, my work enquires
into the position of painting and
art within East African cultures.'

CORNELIA BALTES

b. 1978, Mönchengladbach, Germany
Lives and works in London, England, and Cologne, Germany

'My works are playful investigations,' says Cornelia Baltes. Viewing painting as just one element in a wider arsenal of tools, she treats each component of her compositions as significant to the understanding of the whole. Stretcher bars, for instance, might peek out from underneath a canvas, as in *Dingbats* (opposite). In *Deep Thought* (below right), the notion of material hierarchy is further negated, as Baltes cuts into the canvas to reveal the supporting wall. In so doing, she shifts the nature of the artwork and considers the painting as an object within an environment: painting as installation. Similarly, in *Girl with a Pearl Earring* (below left), she pulls the viewer into a broader art historical context to question the source and motive of

the work, as well as its current placement in time and space. Throughout Baltes's practice the idea of space is delineated to a lesser or greater degree, and a sense of both context and humour prevail. 'I try to capture the essence of an idea, a simple beauty,' Baltes explains. 'I guess there is also an ironic nod towards heroic formalism in my work.' While her practice makes use of a number of different media, she believes that it is the directness of paint that trumps all others. It is perhaps through its immediacy and historic connotations that we feel able to unearth different meanings in her works, which are sometimes thoughtful, sometimes amusing, but always alive to the sheer tangibility of the object and the messages it can carry.

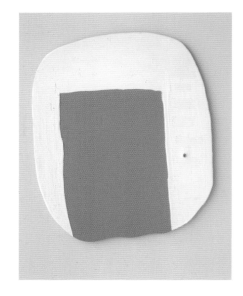

Above left: *Girl with a Pearl Earring*, 2013, oil, acrylic and eyelet on canvas and wood, 125 × 105 cm (49¼ × 41⅜ in.)

Above right: *Deep Thought*, 2013, oil and acrylic on canvas and wood, 148 × 138 cm (58¼ × 54⅜ in.)

Opposite: *Dingbats*, 2013, acrylic on canvas and wood, 120 × 130 cm (47¼ × 51⅛ in.)

'The haptic experience of making a work is key to me, as it is often the placement of a material or the quality of a drawn line that determines the outcome of my fairly simple compositions.'

Cornelia Baltes

AGLAÉ BASSENS

b. 1986, Mons, Belgium
Lives and works in London, England

In representational art, a duality exists between the object being represented and its artistic interpretation: that is to say, the way in which an object appears and the way in which the artist chooses to depict the object are not necessarily one and the same. Aglaé Bassens chooses to situate her practice somewhere within this dichotomy, creating work that explores corners of difference. She believes this duality is something inherent in the medium of painting itself, with the artist's subjectivity and physicality inevitably affecting every attempt to engage with the medium. Perhaps it is for the purpose of unearthing these minute differences that her paintings feature so much repetition: the legs of synchronized swimmers bent akimbo like folds of origami; rows

of wigs in various colours; the texture of water or hair embellishing a figure. On the other hand, perhaps Bassens's approach to painting is less informed by her subject matter and more by her sheer love for the medium and its transformative powers, as her process allows her to study difference, through repetition, in the very act of translating raw material into image. Through paint, she believes, an artist can move beyond the realm of the aesthetic to offer real insight into the conceptual, and back again. 'At the heart of my practice is a fascination with the shift between a state of immersion and a removed state of observation. I want viewers to sense this awkward tension between visual pleasure and conceptual anxiety.'

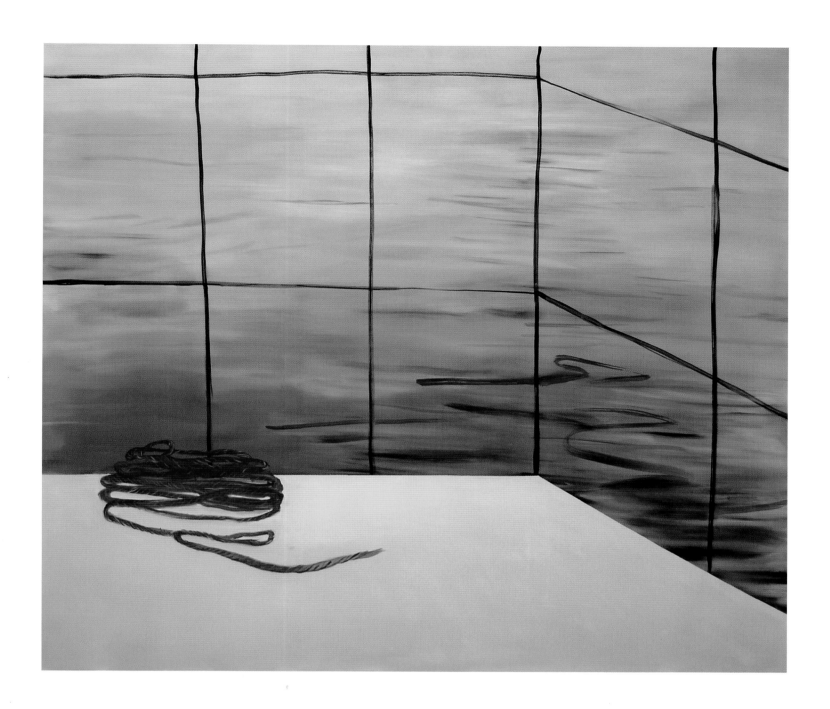

Opposite: *Beyond The Sea 2*,
2013, oil on canvas, 190 × 220
cm (75 × 87 in.)

Above: *Roped In*, 2013,
oil on canvas, 190 × 220 cm
(75 × 87 in.)

Left: *The Bathers*, 2012,
oil on canvas, 100 × 130 cm
(39 × 51 in.)

'The continuous tension between two states of mind is central to the process of painting, and out of this duality stem painterly counterparts that inspire my work: movement and stillness, the revealed and the concealed, and most of all presence and absence.'

Opposite: *Water Under the Bridge*, 2013, oil on canvas, 150 × 180 cm (59 × 71 in.)

Above: *Back at the Apartment*, 2011, oil on canvas, 150 × 180 cm (59 × 71 in.)

Left: *Yunus*, 2013, oil on canvas, 150 × 180 cm (59 × 71 in.)

Aglaé Bassens

LESLIE BAUM

b. 1971, Summit, New Jersey, USA
Lives and works in Chicago, Illinois, USA

Leslie Baum uses her artworks to form a sort of diorama, inviting viewers to navigate a series of complex yet playfully presented ideas. Her tableaux notably include irregularly shaped canvases adorned with painterly abstractions, perched upright and placed throughout the exhibition space. For Baum, these colourful pieces function like artifacts in which any multitude of variables can generate meaning, as 'bits of paintings never meant to occupy the same context bump against each other'. Through their staged presentation, the works transcend the confines of the two-dimensional support and enable the viewer to negotiate with them in unusual ways. Pieces are often placed in associative groups; Baum also likes to place smaller objects atop a table, as if for ready engagement by the viewer. She likens her ongoing series 'Particular Histories' – in which 'art historical references are transparent, but their legibility is muted by the imperfection of my hand' – to the children's game, Telephone, in which 'distortion and misquotation yield fresh imagery'. Such an analogy seems appropriate for work that urges us to engage an almost child-like sense of discovery. In fact, through her own creative process of discovery, Baum invites viewers to consider how we experience our environment in a wider context. Her works challenge the modern canon as much as they pay it homage. 'A good painting can collapse time, evoking the past, present, and future. For me, the act of painting is the act of wondering and wandering.'

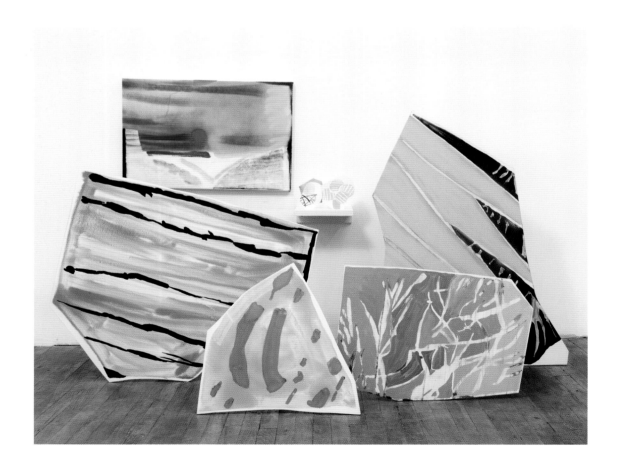

Left: *Another Way of Knowing*, 2012, oil and spray paint on canvas, 51 × 76 × 5 cm (20 × 30 × 2 in.); oil on wood panel, approx. 112 × 60 × 1.5 cm (44 × 23½ × ½ in.); oil on wood panel, approx. 53 × 53 × 1.5 cm (21 × 21 × ½ in.); oil on wood panel, approx. 47 × 67 × 1.5 cm (18½ × 26½ × ½ in.); oil and spray paint on wood panel, approx. 96 × 76 × 12.5 cm (38 × 30 × 5 in.); watercolour on Arches paper, approx. 15 × 15 cm (6 × 6 in.); watercolour on Arches paper, approx. 15 × 14 cm (6 × 5½ in.); watercolour on Arches paper, approx. 8 × 9 cm (3 × 3½ in.)

Opposite: *Duet*, 2012, oil and spray paint on canvas, 107 × 91.5 × 5 cm (42 × 36 × 2 in.); oil on wood panel, approx. 99 × 69 × 1.5 cm (39 × 27 × ½ in.)

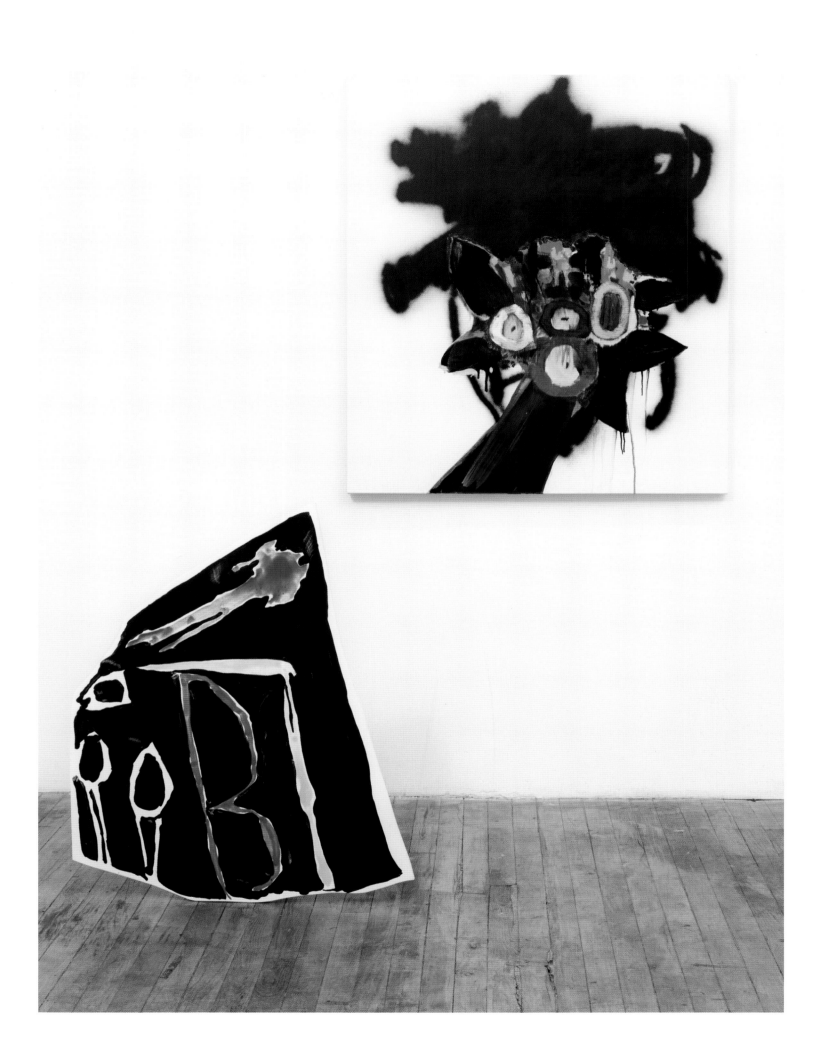

Leslie Baum

EMMA BENNETT

b. 1974, Brecon, Wales
Lives and works in London, England

For centuries artists have mused on the concept of death. Emma Bennett, educated at the Chelsea College of Art and Design and Central St Martins, explores death and the effects of time in her unique, sobering compositions: still lifes set against deep black backdrops that appear as painstaking homages to the *nature morte* tradition while conveying a sense of urgent modernity. Notably drawing inspiration from 17th-century Dutch masters, Bennett also looks to Baroque floral painters such as Rachel Ruysch, imagery from the Italian Renaissance, and – perhaps tellingly in relation to her mastery of technical skill – sources such as photography and film. With their stark, cinematic qualities and hyper-realist appearance, her works seem like off-centre details of a more grandiose Classical story. We are left to wonder what is cropped from the frame; what is suggested. Bennett's very medium and method emphasize the temporality of art-making. 'My work is about the value of life and all living things. It's about the momentum that propels individuals forward and the gravity that pulls them back.' Evoking the transience of time and fragility of life, her wilting floral arrangements, dead hares strung up by the hind legs, white cloths like funerary veils and flames that seem to flicker before our eyes, are all archetypal examples of *memento mori*. Perhaps Bennett's paintings speak to us because the fear of death continues to resonate. We can all connect with her desire to question the permanence of the image, and of life itself.

Right: *Always is Always Now*, 2010, oil on canvas, 170 × 130 cm (66⅞ × 51⅛ in.)

Opposite: *Nor Any Haunt of Mine*, 2012, oil on canvas, 140 × 110 cm (55⅛ × 43⅜ in.)

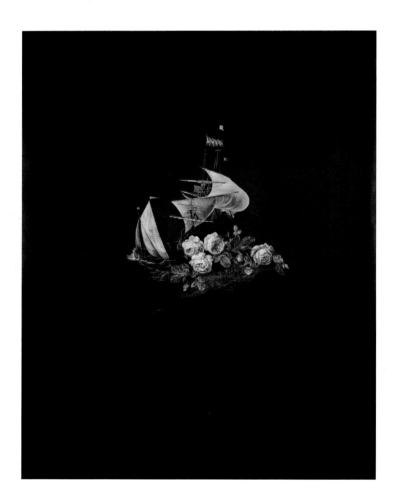

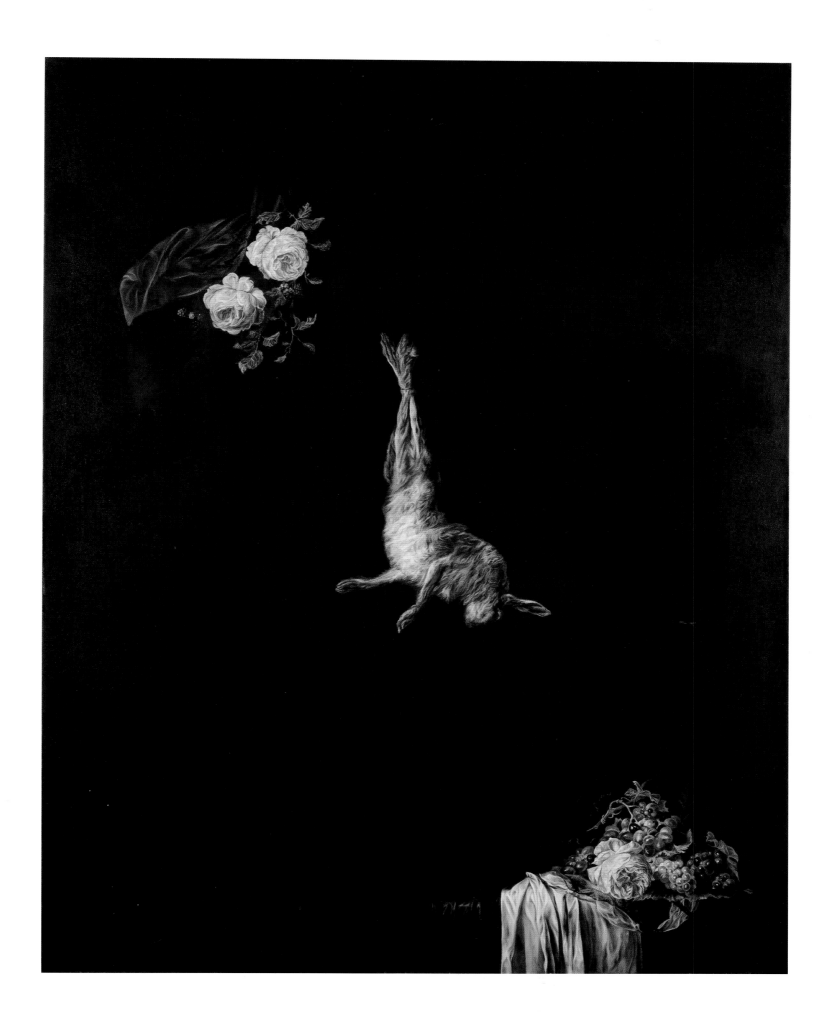

Emma Bennett

45

SZE YANG BOO

b. 1965, Singapore
Lives and works in Singapore

The abandoned shopping malls and uninhabited interiors of Sze Yang Boo's paintings are both haunting and culturally relevant. Inspired by the vast architectural structures found in his native Singapore, Boo transforms space into a symbol of contemporary life in an ongoing series of paintings that come to vivid expressionist life through his loose, gestural technique and use of a restrained palette to emphasize the materiality of paint. Boo often chooses to exaggerate architectural elements and this causes a slight warping, creating an optical play on representational accuracy and forcing the viewer to think again about familiar settings. Depicting empty church interiors and unpeopled commercial spaces with escalators that seem to stretch beyond comprehension, Boo's paintings can be read as heady critiques of modern consumerism. Since he offers such topical commentaries on contemporary society, it is interesting that Boo chooses to work in the historically weighted medium of paint. However, he states that he considers painting to constitute a break from the excessively fast pace of modern life. 'Making and looking at a painting is a slow process. This forces us to activate our imaginations and draw on our memories.' His interiors appear almost as future fossils; visions of a post-apocalyptic society on the verge of collapse. Perhaps he is offering a pessimistic metaphor for the present, or perhaps he is predicting a future in which society no longer embraces mass-consumption.

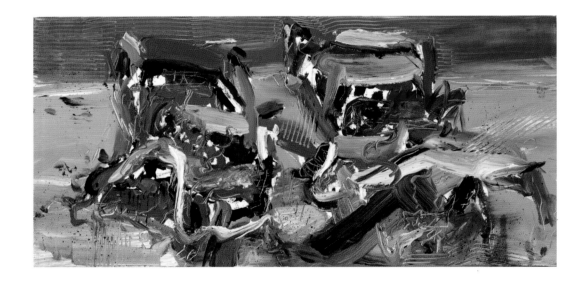

'My paintings of modern architecture and elements of contemporary living – public spaces, everyday objects, images taken from mass media – are studies of space as concept and space as symbol. They present a way to "read the city".'

Above: *Boom! #6*, 2009, oil on canvas, 30.5 × 61 cm (12 × 24 in.)

Opposite: *The Mall #6*, 2010, oil on linen, 122 × 92 cm (48 × 36¼ in.)

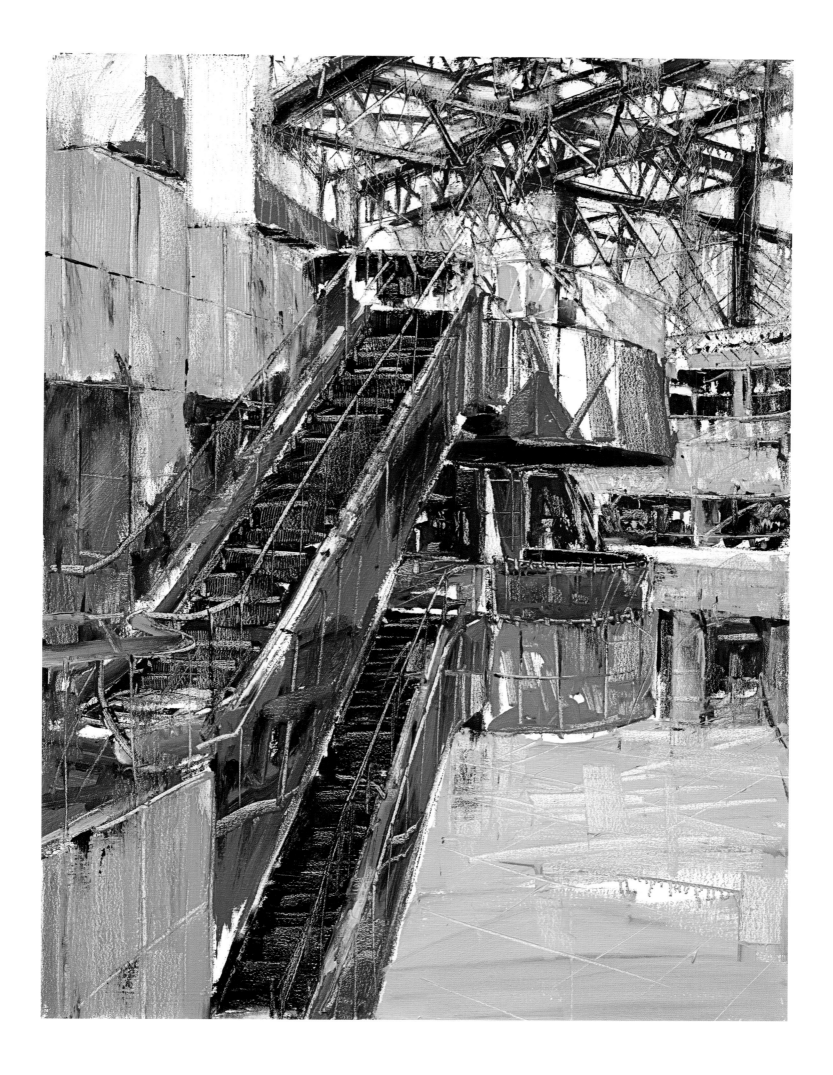

Sze Yang Boo

NINA BOVASSO

b. 1965, New York City, New York, USA
Lives and works in New York City

The utopian idealism and pop sensibility of the 1960s are major influences on the dynamic paintings of American artist Nina Bovasso. Also drawing inspiration from retro textile designs, she re-contextualizes motifs and shapes, and in lieu of hard-edged geometry or crisp patterning embraces a handcrafted aesthetic that is almost artisanal, or even child-like, in appearance. 'My practice echoes an urban cacophony, in which pattern and regiment have gone amok,' she states. 'It's a kind of anti-design.' Each shape is dependent on the last, until the paintings seem to heave with organic masses, tentacles, rays and repeated intuitive patterns. These wild and gestural marks emphasize the humanity behind the works. In some instances, pieces larger than the artist

herself seem to burst with exuberance from the canvas and invite us to make a connection with the physicality and psychology of the artist. The notion of tactility also plays a role in her choice of imagery: recent paintings see her pursuing an interest in surface materiality – perhaps as a reaction against the increasing presence of digital media in the art world. For Bovasso, even her works that feature pixelation or geometry embrace their human origins and exult in their wonky execution. Welcoming viewers to interact with her work, Bovasso asks us to re-evaluate our relationship with communicative symbols and patterns that transcend the cold distance of the computer screen and engage with their full physical presence, sense of imagination and fantasy.

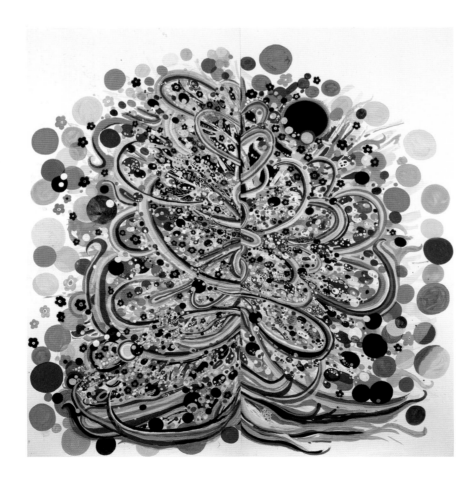

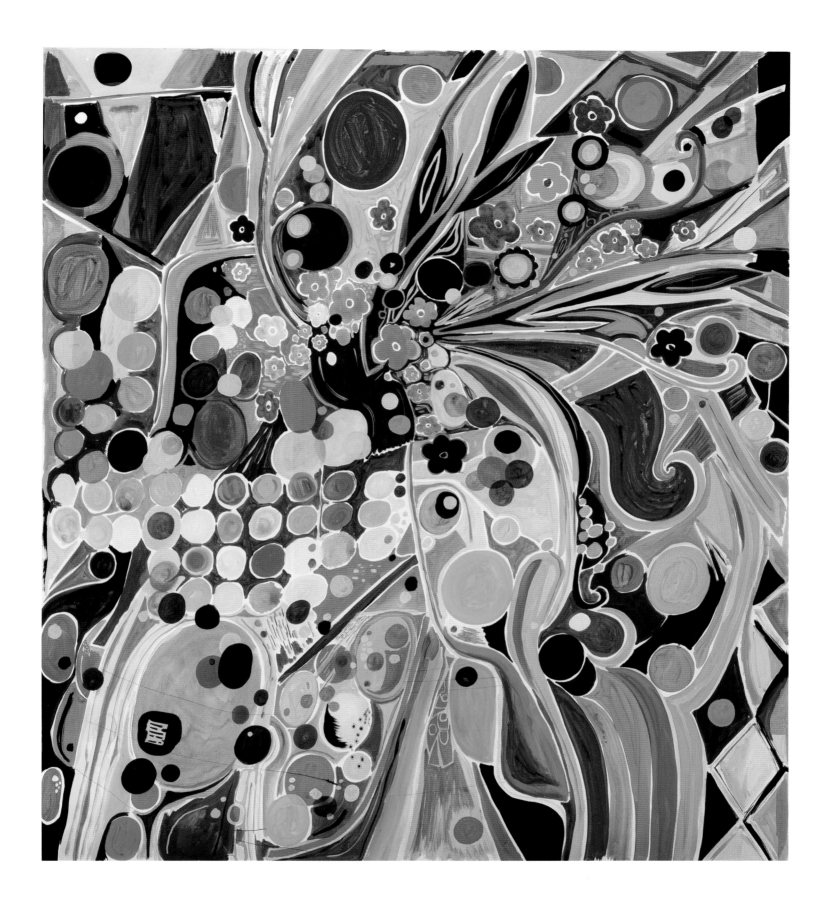

Opposite: *Lighting the Way for Hovering Dark Object*, 2012, acrylic, watercolour, gouache and ink on paper, 228 × 213 cm (90 × 84 in.)

Above: *Rabbit and Girl*, 2012, acrylic, watercolour, gouache and ink on paper, 152 × 130 cm (60 × 51 in.)

'Some of my paintings have a stream-of-consciousness narrative/non-narrative. The element of surprise and discovery is what keeps me going.'

Nina Bovasso

DAN BRAULT

b. 1979, Quebec City, Quebec, Canada
Lives and works in Quebec City

Through a playful, multilayered and intuitive approach to media, Dan Brault aims to provide his viewers with an experience of painting as discovery. This Masters graduate of Laval University considers painting the ultimate form of virtual reality. His spirited creations utilize image fragments and elements of design to entice and intrigue the viewer. Drawing inspiration from nature, personal experiences of happiness and enlightenment, and an arbitrary relationship to colour, shape and form, Brault believes that 'nature is ultimately the best computer: our minds and our hands will always be the richest tools to use when it comes to image-making'. He sees painting as a critical means of constructing new visions and realities, but he prioritizes freedom, colour and optimism over any truly conceptual approach. Not unlike Kandinsky, whose work was meant to inspire with the jubilance of music, Brault's intention is to make interaction with his works an exciting and memorable experience. He cites many artists, including Matisse, Basquiat, Hockney, Stella and Tal R, as major sources of inspiration, believing it necessary for artists to look at other artists' work: 'To look is to listen, and you can't have a dialogue if you're not listening.' Brault's own relationship to painting is one of joy, and the visceral materiality of paint informs his working method. For Brault, paint is more than just a medium; it is an extension of the self and the only adequate means of articulating urgent thoughts and feelings. 'I paint because that is my voice,' he says.

'I seem to have little or no filter when it comes to subject matter. All that matters is to paint with candour and merriment. I am interested in making art that is packed with joy and positive energy. The world desperately needs a little faith. And that is what I have to offer.'

Right: *Festivities (for BGL)*, 2013, acrylic on canvas, 137 × 122 × 5 cm (54 × 48 × 2 in.)

Opposite: *Remembering president lake*, 2013, acrylic on canvas, 137 × 122 × 5 cm (54 × 48 × 2 in.)

Dan Brault

Above: *Making noise*,
2013, acrylic and oil on
canvas, 137 × 122 × 5 cm
(54 × 48 × 2 in.)

Opposite: *Je t'aime à la folie
(for Zack)*, 2013, acrylic and
oil on canvas, 137 × 122 × 5
cm (54 × 48 × 2 in.)

Dan Brault

SASCHA BRAUNIG

b. 1983, Qualicum Beach, British Columbia, Canada
Lives and works in Portland, Maine, USA

Sascha Braunig's *Chevron* (opposite) depicts a figure, likely female, seemingly upholstered in a pattern of teal green and warm peach; alternatively it might depict a painted sculpture posed before a wallpaper pattern. Either way, this is a visually perplexing image; an assault of pictorial and mental stimuli. For Braunig, the explanation is not resolute: 'It's about how figures can act/ interact on a surface within the boundaries of a painting; about the psychology and aesthetics of surface.' Working from stage-lit models in her studio, Braunig finds herself responding to the 'concentrated play' of painting: 'I multiply, distend and otherwise encourage textures to metastasize into overabundant surfaces.' Her process often finds her moving backwards, choosing a title first and responding to this through paint. Her sources of reference include the artists Hans Bellmer, Hans Memling and Picasso; haunting, sexually dangerous 'ex-wives' from a canon including *Jane Eyre* and *Rebecca*; cinema, ranging from Alfred Hitchcock and Kenneth Anger to B films and horror films; and the idea of the muse. While Braunig's disturbing creations are a complex amalgam of pop culture, art and literary history, she nevertheless says, 'I hope that the viewer might look at my work and experience first a retinal/optical connection and, second, a recognition of a psychological state.' As she notes of other works: 'When I see good paintings, I feel I can often connect with them in a flash. Even though they're inert and quiet, they're buzzing with activity to me.'

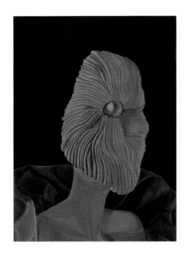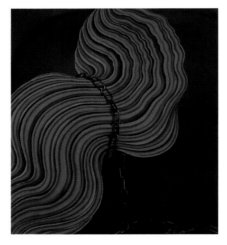

'In fashion photography the
model's body is mapped
like a wire-frame with pores,
gleams and hairs. I think of my
work as a hallucination of
this zealously lensed detail.
My humanoid subjects propose
the flaunting of blemish and
trauma as self-decoration.'

Above left: *Coverage*, 2010,
oil on canvas over panel,
57.2 × 39.4 cm (22½ × 15½ in.)

Above centre: *Bridle*, 2013,
oil on canvas over panel,
63.5 × 55.9 cm (25 × 22 in.)

Above right: *Claude*, 2012,
acryla-gouache on panel,
40.5 × 30.5 cm (16 × 12 in.)

Opposite: *Chevron*, 2012, oil
on canvas, 45.7 × 35.5 cm
(18 × 14 in.)

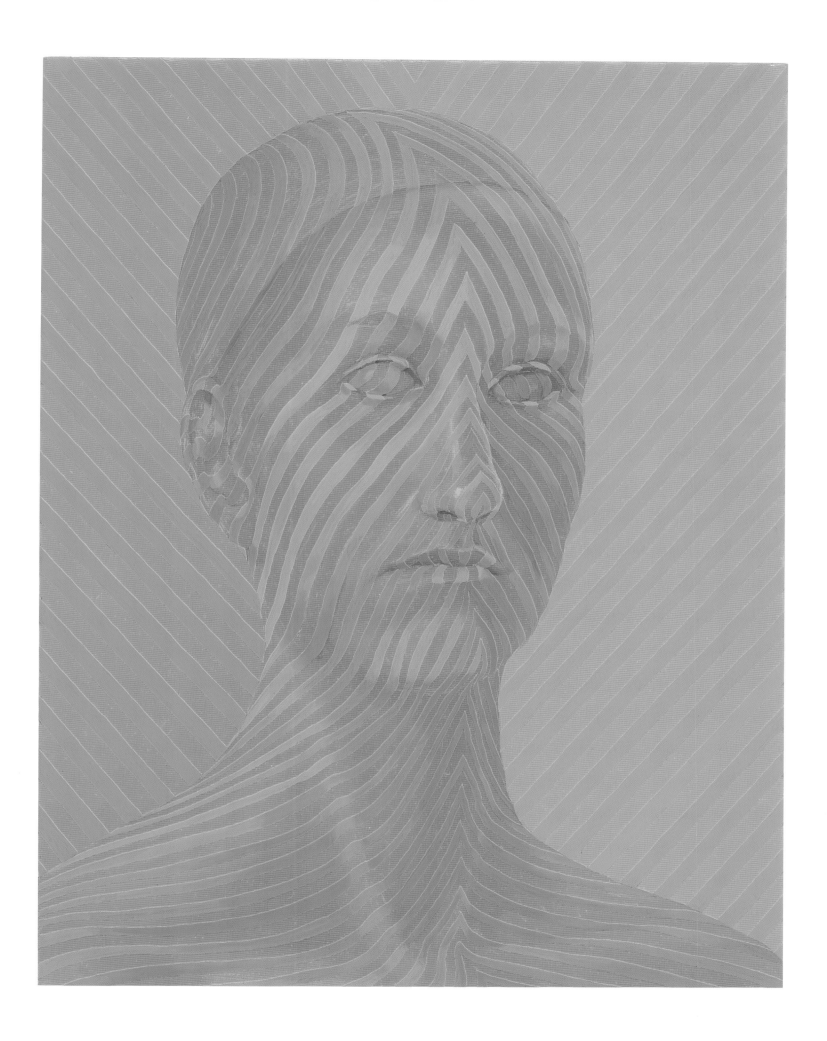

Sascha Braunig

55

BENJAMIN BRETT

b. 1982, Norwich, Norfolk, England
Lives and works in London, England

In *Floorswamp* (opposite), Benjamin Brett has liberally applied a vibrant blue wash over a pre-existing painting. One can still see the traces of a figure underneath, floating hesitantly near the surface of the canvas. Other marks – or what the artist refers to as 'stains' – exist under this 'swamp' of colour, as though Brett had turned the canvas 90 degrees and continued painting. This form of art gives precedence to suggestion, as opposed to revelation. Art theorist Clement Greenberg, in his essay 'American-Type Painting', posited that Cézanne's late apple paintings were attempts to convey the essence of a subject rather than to offer a realistic recreation. Brett explains his process: 'To transcribe something looks for a direct likeness, whereas to translate something seeks a different

perspective. In older works ... the key factor in the selection of my subjects was that their visual appearance was ambiguous or could be interpreted in numerous ways.... I would use these subjects to inform or explore conventional aspects of abstraction.' Brett's paintings inhabit a similar terrain, bearing only subtle traces of reality. But, while enunciating relatively little in terms of concrete subject matter, they hint at an underlying tendency toward a narrative. Through a kind of semiological connect-the-dots, these undercurrents of narrative can emerge. As Brett points out: 'Nothing is entirely abstract: it comes from something; its starting place is still in representation. My works are about essence, and they translate an article/object into something else.'

'Unexpected shapes on the surfaces of my paintings combine to create an ambiguity of visual communication. Paradoxes of representation playfully challenge viewers' expectations, refusing a single interpretation.'

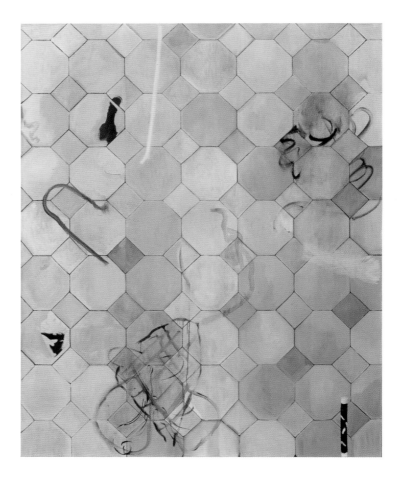

Right: *Metencle*, 2013, oil on canvas, 235 × 188 cm (92 × 74½ in.)

Opposite: *Floorswamp*, 2013, oil on canvas, 235 × 188 cm (92 × 74½ in.)

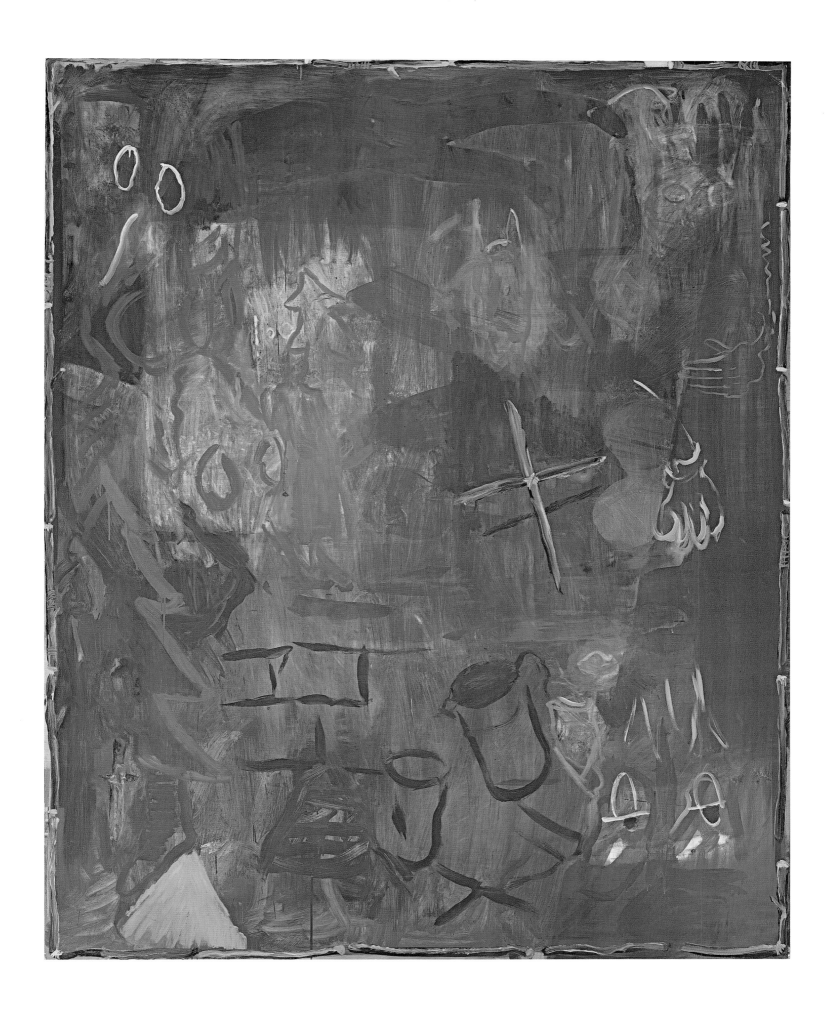

Benjamin Brett

GL BRIERLEY

b. 1962, Glossop, Derbyshire, England
Lives and works in London, England

Through an exploratory approach to painting, in which the end result is achieved via chance and accident, GL Brierley transcends classification. 'Paint material is poured,' she states, 'smeared, left to wrinkle, crack in layers, until an "object" arises from the alchemical soup.' In one piece (opposite), we see what looks like a coral reef, skins of paint pools creasing to create porous-looking marine flora, the background ebbing and flowing in and out of focus, like a murky, submerged landscape. In another piece (overleaf right), an oddly humanoid figure looms before a zigzag background. A grotesque clown face seems to appear, but in the next moment the subject gives way to the sheer textural quality of pink paint recalling melting ice cream, dotted with vibrant blue

highlights like icing from a pâtissier's piping bag. It is precisely through this uncanny combination of the delectable and the repellent that Brierley's works attain their power. Her paintings are about technique and the application of paint, but they are also about the heaving masses they depict: organic, playful, horrific, whether one perceives representations of volcanic rock, chiffon and fauna, or human eyeballs, lips and limbs. Brierley notes that our first intense relationship with objects arises when we are forced to separate from the mother figure, who we therefore need to see as 'abject; a site of conflicting desires'. As she notes: 'The things in the paintings reflect this attraction/repulsion quality in their *materiality*, a word rooted in *mater*, meaning mother.'

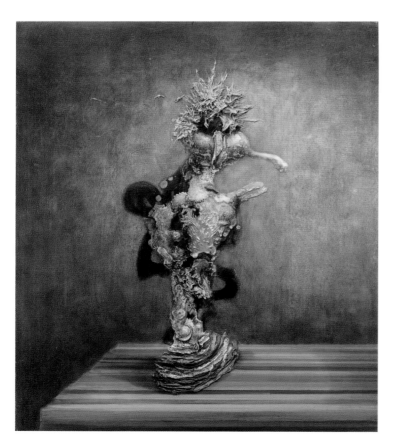

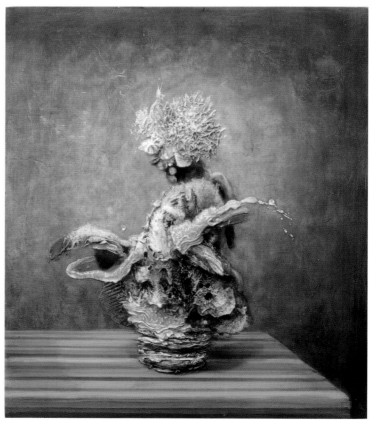

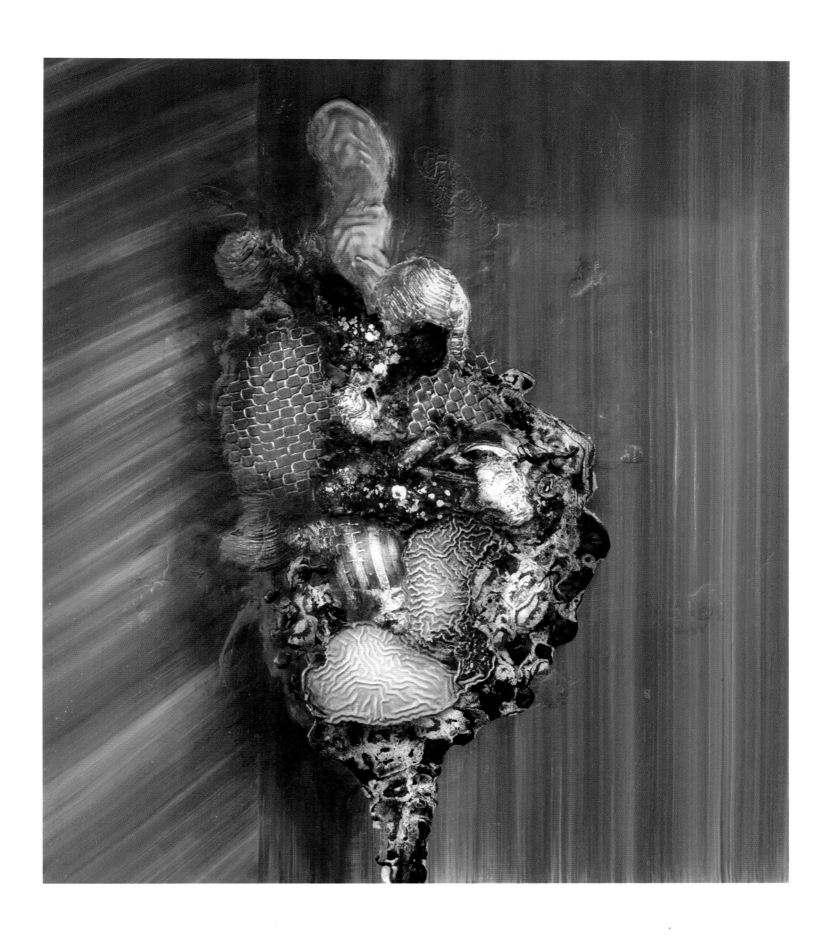

Opposite: *Helder-Melder*
(diptych), 2012, oil on wood,
each 71 × 61 cm (28 × 24 in.)

Above: *Fud*, 2012, oil on wood,
53 × 46 cm (21 × 18 in.)

GL Brierley

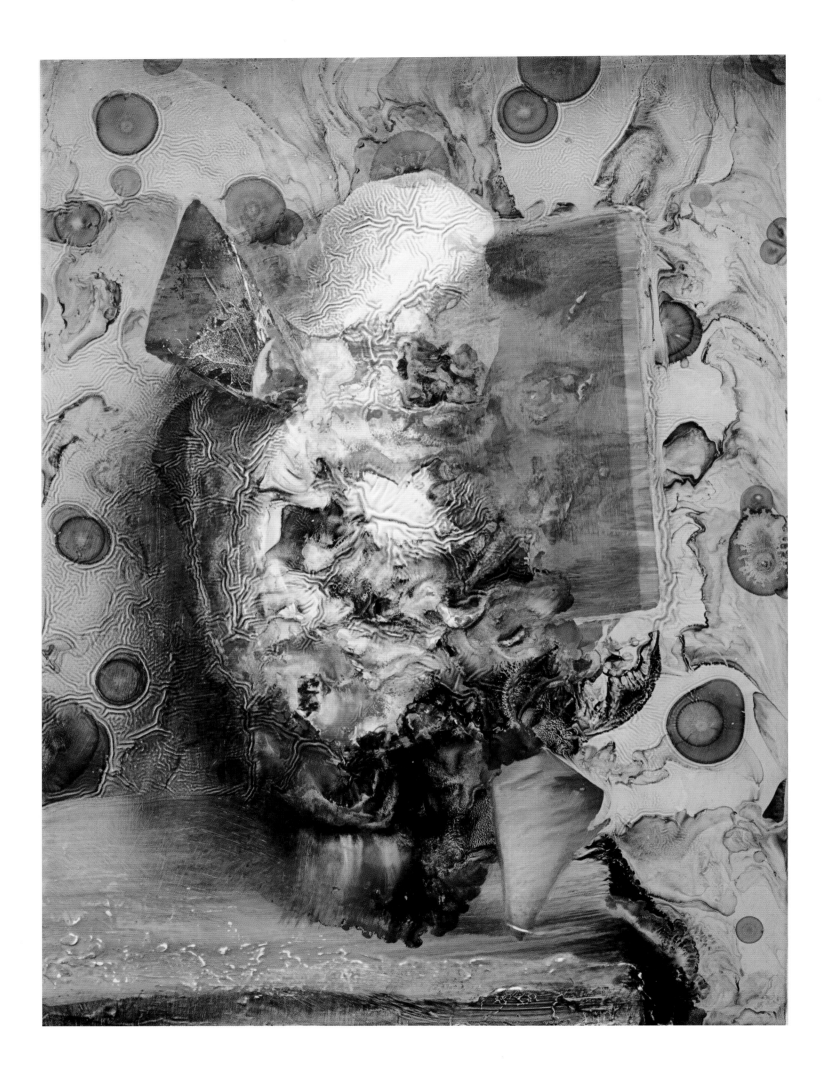

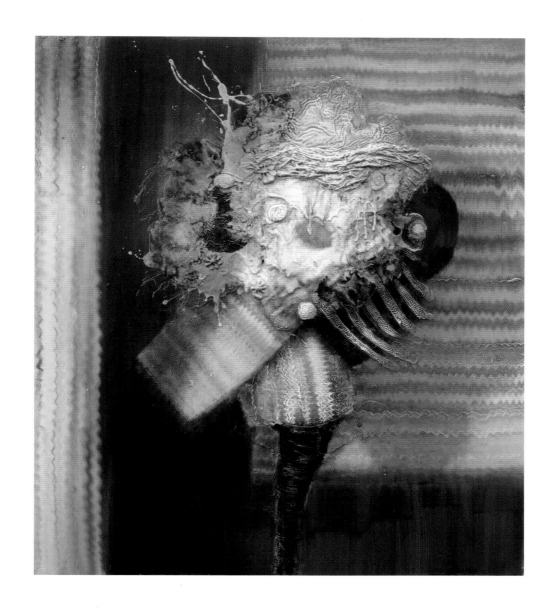

'We are human, made from the
materiality of flesh. Paint gets very
close to this. My work is about
a relationship to paint as matter
that is symbolic of the lost mother,
both venerated and abject.'

Opposite: *Winifred*, 2013,
oil on panel, 40 × 30 cm
(16 × 12 in.)

Above: *Lovestick (April)*, 2012,
oil on wood, 103 × 90 cm
(40½ × 35½ in.)

GL Brierley

ANDREW BRISCHLER

b. 1987, Long Island, New York, USA
Lives and works in Brooklyn, New York, USA

'Painting, the primal urge to record an idea visually, is an inescapably universal phenomenon,' notes Andrew Brischler. 'I've never thought of it in relation to or in opposition to our digital age.' Despite the loud, assertive tendencies of his hard-edged geometry, angular 'doodles' and brightly coloured gradients, he finds himself most interested in the moment when an expertly crafted painting begins to fall apart. These moments of revelation are, for Brischler, abundant, inevitable and canonical: 'You see it in the puckered corners of Warhol's massive diamond dust paintings, in the black stains of Al Held's colour fields and in the tremulous lines of Frank Stella's early shaped works: tiny failures that make even the most monumental and heroic paintings seem flimsy, vulnerable, even

sad.' In this context, Brischler's own works have less to do with pure geometric abstraction and more to do with locating one's place in time and space. 'I am unavoidably, shamelessly, a "millennial",' he admits, but his works both embrace and depart from conventional notions of superficiality in order to speak to personal feelings of self-consciousness and mortality; a process that weaves his own anxieties into otherwise bold paintings that seem a conceptual hybrid between the techniques of Op art and the tropes of the *memento mori*. On some level, it is possible to imagine these pieces as time capsules from the Pop art movement, their frayed edges and sandy backgrounds serving as a nostalgic reminder of some long-forgotten, much-cherished Golden Age.

Above left: *Steamheat & Opium*, 2013, coloured pencil and graphite on raw canvas over panel, 50.8 × 40.6 cm (20 × 16 in.)

Above right: *Cold War*, 2013, oil and pencil on raw canvas over panel, 35.6 × 27.9 cm (14 × 11 in.)

Opposite: *The Forbidden Zone Was Once a Paradise (Die Farbe)*, 2013, coloured pencil and graphite on paper, 27.9 × 21.6 cm (11 × 8½ in.)

'My mash-ups of intentionally flawed modes of studio production, cool minimalism and strands of popular culture take traditional Abstract Expressionist notions of vulnerability, weakness and upheaval and connect them to my own personal feelings of inadequacy.'

Andrew Brischler

PETER LINDE BUSK

b. 1973, Copenhagen, Denmark
Lives and works in Berlin, Germany

Peter Linde Busk's works employ a darkly diverse cast of characters who seem to be personifications of failure and entrapment, existing in varying states of melancholia and claustrophobia. Wildly executed in materials including acrylic, oil, crayon and pencil, the figures exemplify these emotional states through their creator's violently patterned desire to fill any empty space. As a result, the figures are decorated to the point of excess. Grotesque jesters draped in cloaks, wings and crowns, they are anthropomorphic metaphors that seem to mock the viewer from their confines with an almost aggressive psychological intensity: sometimes they even stand two, three, four in a row, as though to taunt the viewer. While Busk's loose, sketchy marks delineate his figures against stained linen backgrounds,

reverberating in an atmosphere of uncertainty, his repetitive mark-making also accentuates his tendency toward obsessive patterning. Pulling from the Art Brut movement, and often appearing as mutated, darkened variations on the works of Egon Schiele, these works exude an uncomfortable technical familiarity. Their exploratory appearance can resemble art for therapy, or even free-association drawing. Tellingly, Busk considers many to be self-portraits, and as such he finds them strangely affirmative. He notes that they offer avenues for escape: 'Having liberated themselves, these monarchs have nowhere to go but down.' For this artist, perhaps the works are an ode to the liberating potential of catastrophe.

Right: *No Pasarán*, 2011, acrylic and crayon on linen, 185 × 145 cm (72¾ × 57 in.)

Opposite: *They Hold No Quarter, They Ask No Quarter*, 2011, acrylic and crayon on linen, 185 × 145 cm (72¾ × 57 in.)

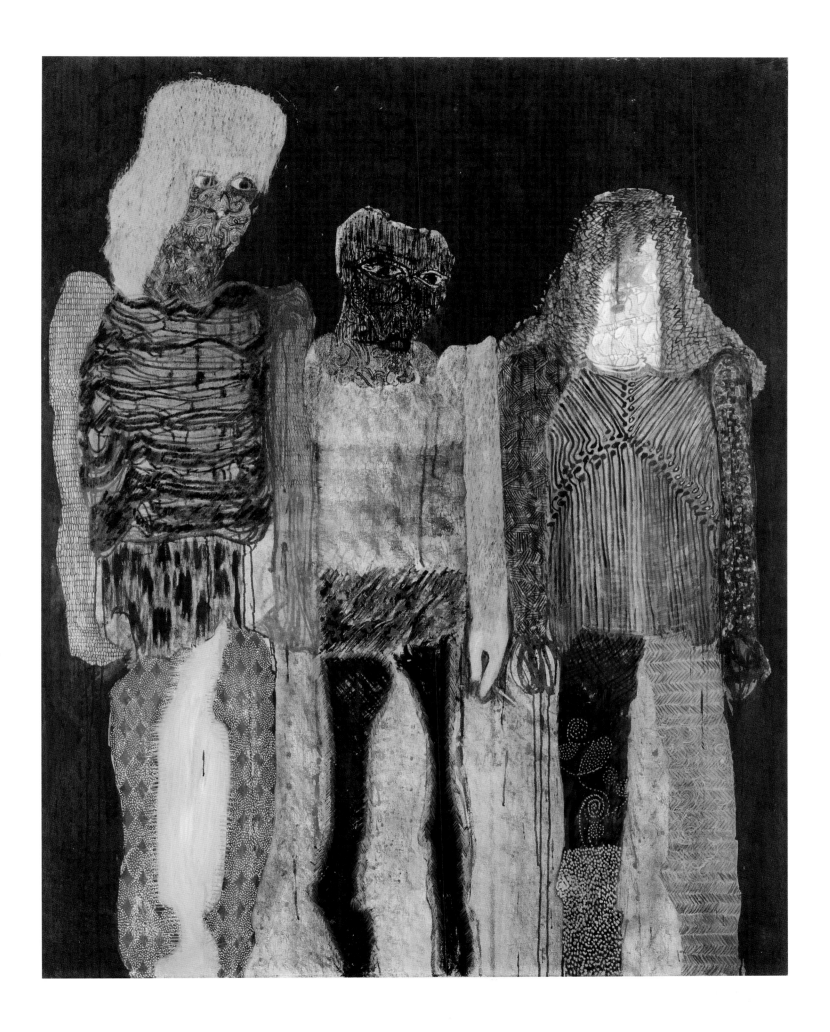

Peter Linde Busk

JANE BUSTIN

b. 1964, Borehamwood, Hertfordshire, England
Lives and works in London, England

Jane Bustin is like a storyteller, arranging readymade objects and bits of canvas, aluminium, wood, copper, latex and other materials to relate a tale. At first, the viewer may be struck by the challenge presented to comprehend the syntax. Bustin explains: 'The paintings and the space around them resemble the thoughts and pauses upon a blank page.' In one piece of work (see opposite), she references Masaccio, the 15th-century Italian 'inventor' of perspectival painting, perhaps as a critique of the way in which we learn to understand images through given notions of correctness. Bustin's own artistic process involves intense periods of research, during which she familiarizes herself with certain theoretical precepts. 'My work explores the metaphysical potential for painting to "make visual" philosophical concepts found primarily in literature, as well as in music, science and theology,' she states. 'It is an exploration into making the unsayable visual.' Many of her works are made in collaboration with writers: Tracy Chevalier, Hélène Cixous, John Hull, Sally O'Reilly and Andrew Renton, among others, have influenced her conceptual framework, and she has also composed work influenced by the 19th-century poet Stéphane Mallarmé. In Bustin's paintings one senses a desire to elaborate on the broad function of the image. Still, the artist remains satisfyingly evasive with respect as to how she reaches her conclusions through art and how she makes these manifest in the cohesive presentations received by the viewer.

'I obsessively place fabrics, shapes, colours and objects side by side and, as I do so, they begin to speak. A language develops between myself and the material. We are entwined; locked in this conversation until it starts to sing.'

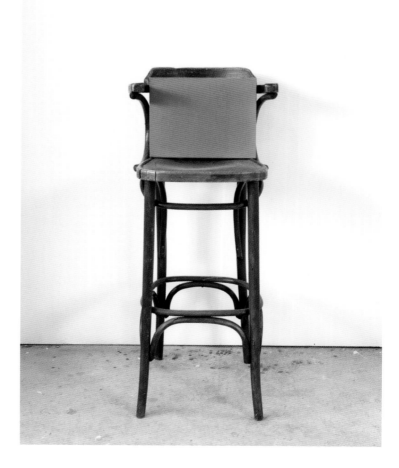

Right: *aimé – beloved*, 2011, oil on flax with chair, overall 110 × 41 × 40 cm (43 × 16 × 16 in.)

Opposite: *Masaccio*, 2013, mixed media including wood, linen, copper, gauze, porcelain, oxide and oil paint, 200 × 100 cm (79 × 39 in.)

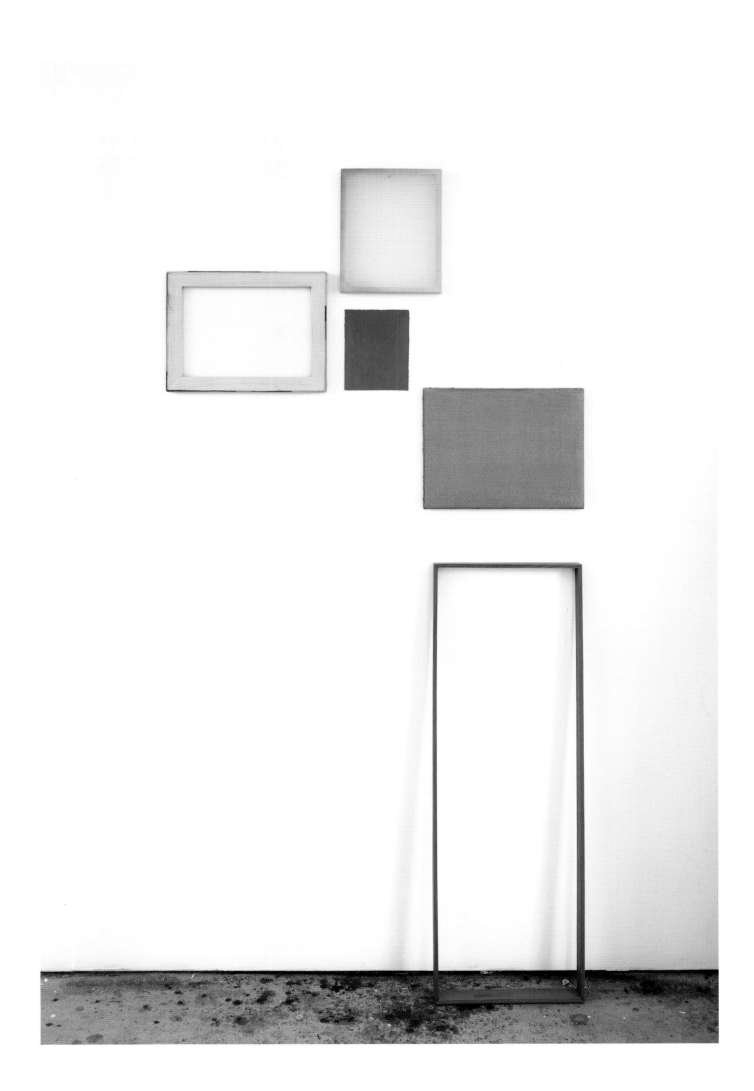

Jane Bustin

CARLA BUSUTTIL

b. 1982, Johannesburg, South Africa
Lives and works in Oxford, England

Through her paintings, South African-born artist Carla Busuttil searches for new ways to understand notions of historical authority and interpersonal and social conflict. Within the confines of the fictional worlds at war on display, the characters in her works are masked, lawless, lost and lurching towards some undefined dystopian fate. The eeriness is accentuated by stark backgrounds, often in bright colours such as lemon yellow or cadmium orange. 'The imagined future – or alternative present – is a world derived from history but extrapolated to an exaggerated end,' Busuttil has stated. Drawing from various historical contexts, and referencing found images from textbooks, newspapers, magazines and the internet, she transforms her characters so that they bear little

resemblance to the originally sourced material and inhabit a world of their own. The viewer is then presented with a highly critical response to the modern age, with its rampant consumerism and sense of entitlement. Of her masked figures, she says, 'Self-promotion is subsumed by the prize of anonymity.' On closer inspection we can see how her paintings might appear to reflect political or religious iconography, mockingly re-painted in garish hues and using a primitive technique. Citing fellow South African artists such as Robert Hodgins, Penny Siopis, Marlene Dumas and Kendell Geers as her greatest influences, Busuttil ultimately uses her constructed realms to question the illusion of exactness and truth, in both painting and the representation of history itself.

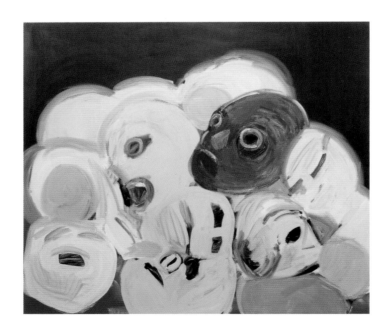

Above: *Headstack*, 2011, oil on canvas, 150 × 160 cm (59 × 63 in.)

Opposite: *No More Losing War*, 2013, oil on canvas, 190 × 160 cm (74 × 63 in.)

'In looking at and re-editing found historical images, I create something familiar but ultimately unknown. This world is flat, its inhabitants a lost generation. Their masks are objects of interest and signifiers of power.'

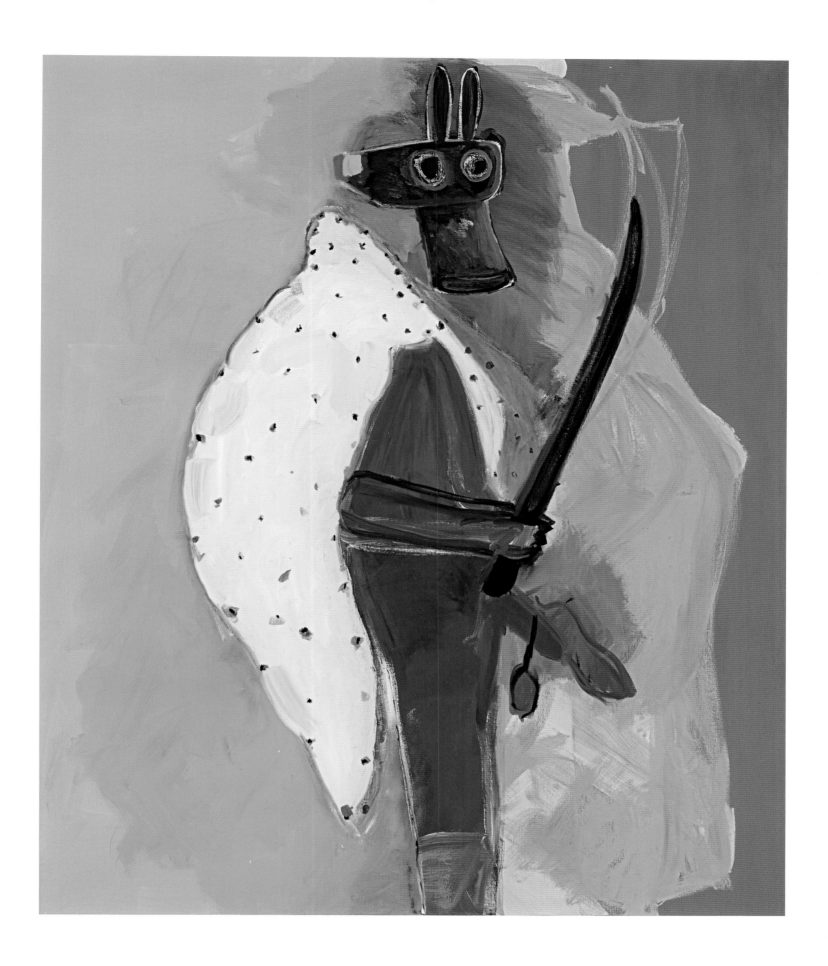

Carla Busuttil

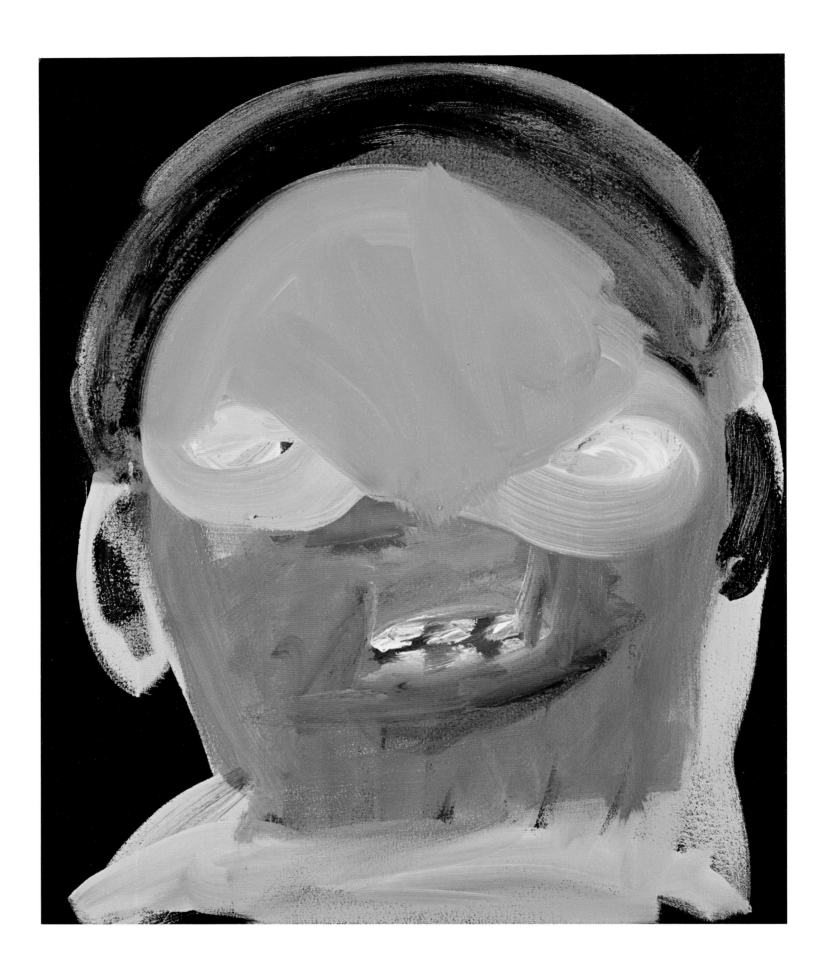

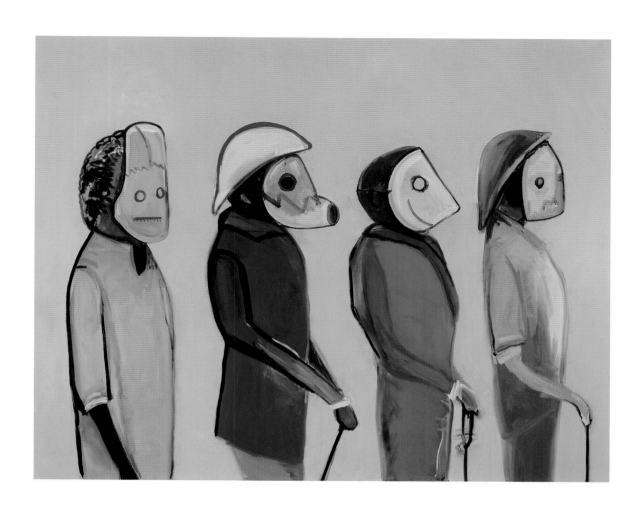

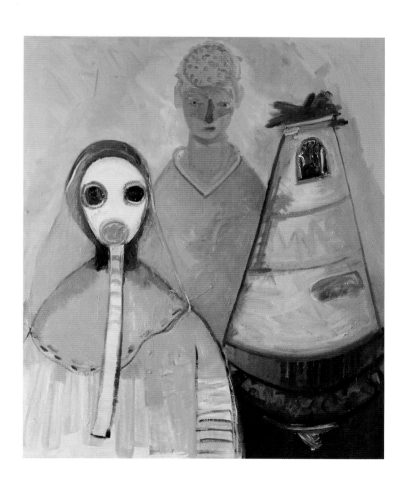

Opposite: *I Want to be a Machine*, 2012, oil on canvas, 60 × 50 cm (23⅝ × 19⅝ in.)

Above: *Manifold Men*, 2013, oil on canvas, 200 × 250 cm (78 × 98 in.)

Left: *The Secrets Holding Paint Together*, 2013, oil on canvas, 180 × 150 cm (70 × 59 in.)

Carla Busuttil

JORGE CASTELLANOS

b. 1982, Mexico City, Mexico
Lives and works in Puerto Escondido, Mexico

In Jorge Castellanos's paintings, vividly rendered flesh tones, mangled bodies and graphically disfigured forms combine to evoke the presence of death. Reminiscent of death masks, or the rituals surrounding death, his works are intensely unnerving. His vision pertains to a greater societal and cultural whole within his native Mexico, appropriating from a long history of Mexican painting that has a preoccupation with death, ranging from the religious *retrato*, which features visitations of saints to the recently deceased, to the macabre tendencies of Gabriel Orozco, Frida Kahlo and David Alfaro Siqueiros. Castellanos's work also serves as a wider commentary on the alleged 'death' of painting, exploring the function of the medium within the contemporary world.

'If modern art is dead, one must show it dead in order to vindicate it as art ... showing it as terrible and eliminating its decorative connotations. My work emerges from the vestiges of modern art in a new context, within the present reality of contemporary Mexico, [with] the violence of form: the remains of human carnage mingled with the remains of modern art.' Form may here be equated with content. In the style he has named 'Turbocubism', and with darkly evocative titles such as *Modern Dorian Gray* and *Head Trophy*, Castellanos pays tribute to his cultural and artistic traditions, but he also allows his multifaceted inquiry to act 'as an exorcism ritual', generating a new entry point and critique on the status of contemporary art.

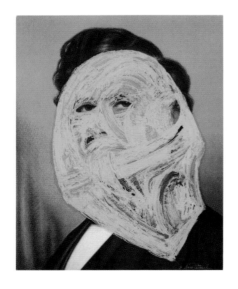 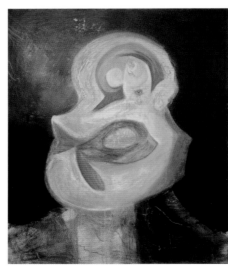

Above left: *President Z (Natural Causes II)*, 2011, oil and acrylic on US ex-presidential poster, 36 × 28 cm (14⅛ × 11 in.)

Above right: *Modern Dorian Gray*, 2011, oil and acrylic on canvas, 120 × 100 cm (47¼ × 39⅜ in.)

Opposite: *President Y (Throat Cancer)*, 2011, oil and acrylic on US ex-presidential poster, 36 × 28 cm (14⅛ × 11 in.)

'I am interested in topology, a major area of mathematics concerned with properties that are preserved under continuous deformations such as stretching. In this way I can manipulate bodies without them losing their true nature.'

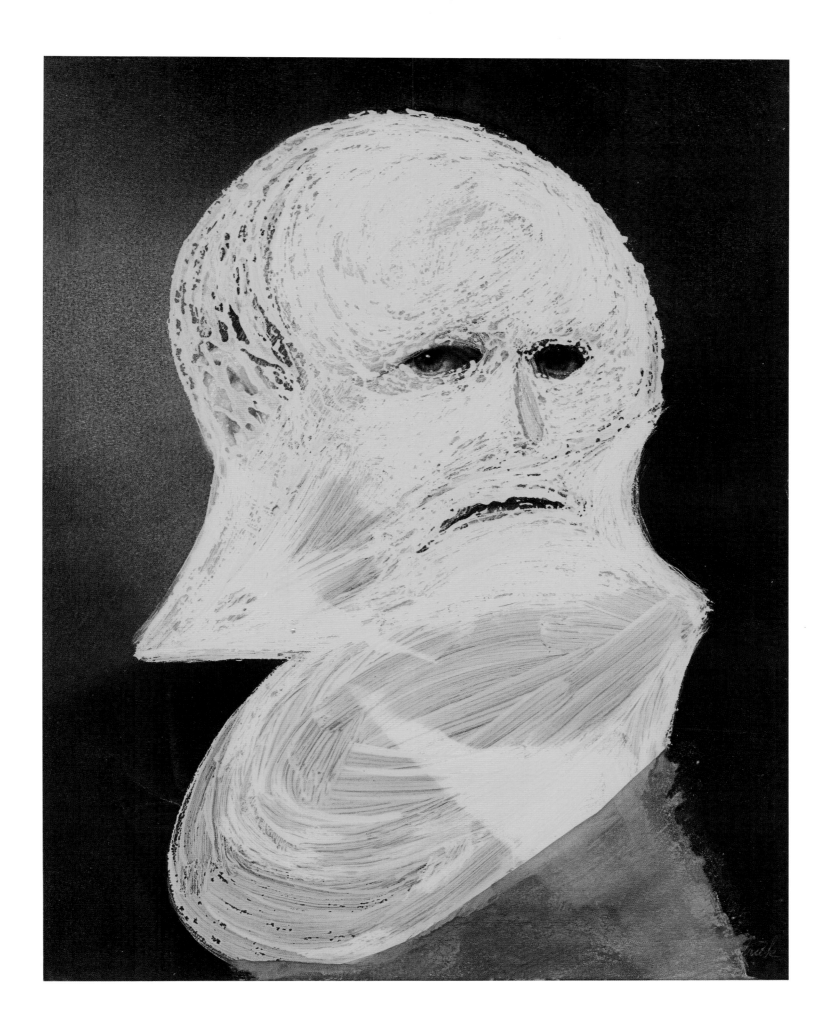

Jorge Castellanos

CHOKRA

b. 1988, United Arab Emirates
Lives and works in New York City, New York, USA

Emirian performance artist CHOKRA ('Conscious Hoarding of Kinetic Rage Associated') has found a unique interpretation for painting's function in the realm of art. He creates multifaceted performances, with which he aims to take viewers to a heightened state of awareness. Moving beyond the passive role of spectator, and immersed in a sensory journey that questions and revitalizes conventional artistic traditions, the viewer is propelled to consider art as an active experience. 'In my work the act of painting is updated with a ceremonial progression of Arabian Gulf attire and a hyper-sensory propagation of aromatic oils, surrealistic visuals, neon pyromania, flares, brilliant hues in exploding pigment, crushed gold and a participation of somatic consequence,'

says CHOKRA of his extraordinary kinetic practices. Above all, he is interested in his work serving as a catalyst for enlightenment. What remains from his performances are what he calls 'post-performance paintings': desolate landscapes that recall the activity previously witnessed, in a type of earth painting. Inspired by both spiritual and artistic rituals, he aims to break free from the hierarchical boundaries of his medium. Though he also incorporates elements such as multi-channel electric sound and rap rhymes in Arabic, Urdu and English, CHOKRA is clear that all his components are structured 'in the language of painting', and it is paint that – in highly unorthodox ways – informs the visual and conceptual framework of each of his celebratory performances.

Above: *Al-Mtsaalh Haal (Trucial Case)*, 2010, live performance, variable dimensions

Opposite above and below: *Zawaj Al Khaleej (Gulf Marriage)*, 2013, live performance, variable dimensions

'My work is situated at the intersection of electronic art and hyper-sensory performance. Algorithmic projections, multi-lingual poetic rhymes and exploding pigments intensify as live theatrical spectacles. Their aftermaths collapse painting, sculpture and installation.'

CHOKRA

b. 1977, Muar, Malaysia
Lives and works in Singapore

Heman Chong frequently paints found objects, believing that any material can be a worthy source for informing the production of art. By literally applying paint to the covers of novels, he questions the concept of conventional media and its perception by viewers. 'For me, there are no hierarchies when it comes to media,' he says. 'What is important is the processes involved in dealing with the material and the context in which the work is placed.' Ever conceptual in his approach, Chong seeks to expand on the traditional studio practice of the painter. This is a logical approach for an artist who holds an MA in Communication Art and Design from London's Royal College of Art. By locating painting within the realm of visual communication and language, Chong

concerns himself with a hybridization of forms, discussed through paint. As he has stated, he seeks 'to learn about painting while producing paintings, rather than being led by the rhetoric of art or design history'. However, he remains inspired by the structures and formalities of ways of seeing, and filters painting through similar conventions. Of his book covers, he notes: 'I have elected to use only one single typeface, with the same point size, as a binding identity. It is a way for me to encounter the lexicon found in the history of painting.' But the conceptual aspect of his work is always given precedence, and as such – while acknowledging art as a critical tool in recording human experience – Chong uses it as a means to an end in illustrating his meticulously researched ideas.

'My "Cover (Versions)" series is a platform for painting and graphic design to meet without any preconceived hierarchy of one being more important than the other. What is important is the concept behind the work.'

Right: *Time Out Of Joint/ Philip K. Dick*, 2011, acrylic on canvas, 61 × 46 × 3.5 cm (24 × 18 × 1½ in.)

Opposite (clockwise from top left): *Play It As It Lays/ Joan Didion*; *The Brief Wonderous Life of Oscar Wao/Junot Diaz* (2); *Leaving Las Vegas/John O'Brien* (2); *The Interrogation/J. M. G. Le Clézio*, all 2013, acrylic on canvas, each 61 × 46 × 3.5 cm (24 × 18 × 1½ in.)

Play It
As It Lays
Joan Didion

The
Brief
Wonderous
Life Of
Oscar Wao
Junot Diaz

The
Interrogation
J. M. G. Le Clezio

Leaving
Las Vegas
John O'Brien

Heman Chong

BLAKE DANIELS

b. 1990, Cincinnati, Ohio, USA
Lives and works in Savannah, Georgia, USA, and Johannesburg, South Africa

Blake Daniels was born in Ohio, raised in South Carolina and educated at the Art Institute of Chicago in Illinois, but it was six months spent in South Africa that enabled him to link personal experience with an interest in art history and to find his feet as an artist. After witnessing the armed attack of a mother and her children on a train in Cape Town, Daniels began to concern himself with exploring the politics of gender, race, family and society. *Capricho No. 81* (opposite), for instance, is based on Goya's *Capricho No. 65: Dónde va mamá?*, part of the famous series by the Spaniard in which almost every aspect of society comes under scrutiny. Here, Daniels strikes with the same blade: 'This turbulent atmosphere of mob violence started up [against the assailant

on the train]. The idea of Goya's *Capricho* echoes strongly when I think of the illusionary morals, beauties and social conditions in both South Africa and America.' Through vivid coloration and partially figurative imagery removed from the confines of reality, Daniels weaves together stories that are simultaneously historical, imagined and relevant. His disturbing, post-colonial, dislocated hybrids contest notions of fixed social algorithms. As Daniels has stated: 'I ground my imagined reality within representational images drawn from my own experiences. I then explore the potential poetic outcomes that emerge from the multiplicity of narrative.' New social relations demand a new space and narrative, he says; 'a re-imagined language that can craft them'.

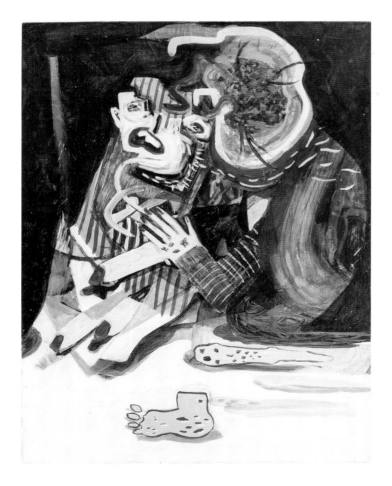

'The images that I create depict bodies and spaces that are constantly being altered and fragmented through the internalization of the socially built spaces they experience. An inherent hybridism has arisen between representation and abstraction.'

Left: *My Dear Dead Dad*, 2012, egg tempera and oil on panel, 44 × 33 cm (17 × 13 in.)

Opposite: *Capricho No. 81: ¿No le basta? (Isn't it enough?)*, 2013, oil on canvas, 110 × 152 cm (44 × 60 in.)

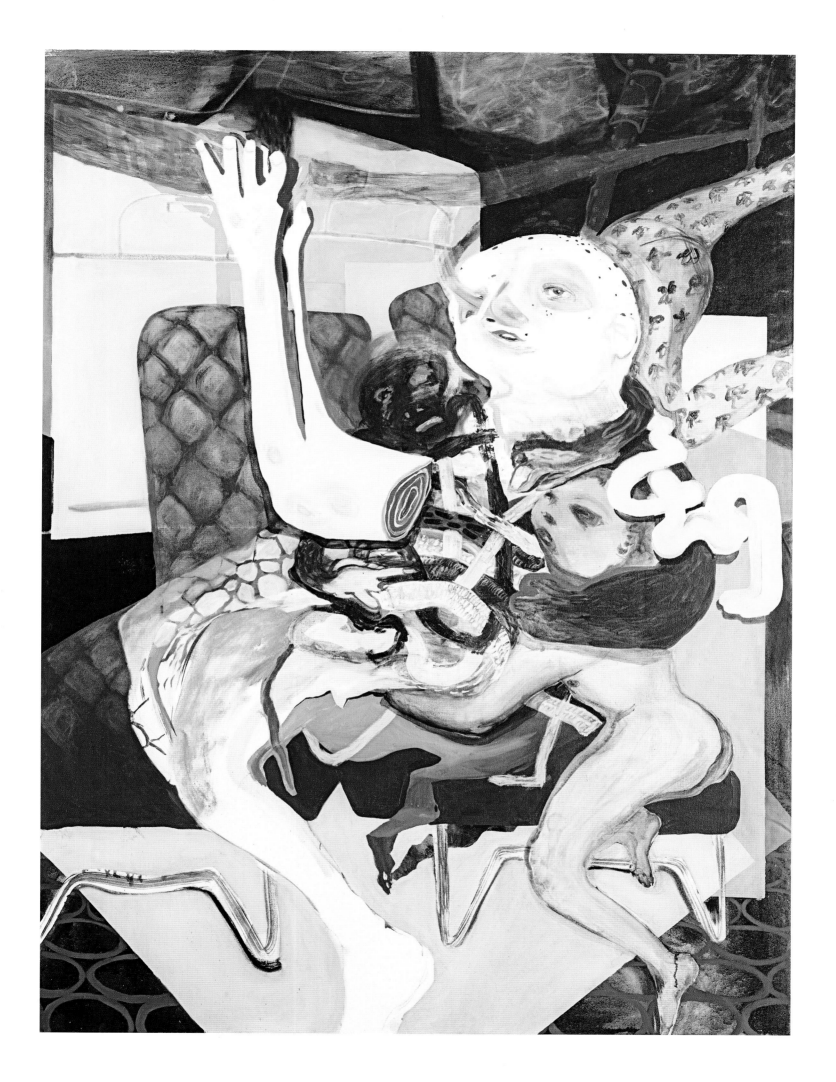

Blake Daniels

WILLIAM DANIELS

b. 1976, Brighton, East Sussex, England
Lives and works in London, England

What becomes of an image after it has been converted into new forms and media? Imagine a text that has been repeatedly translated into different languages, passed along the ages, with various words and phrases inevitably giving way to their new contexts, becoming distorted with each articulation, and gaining and losing elements as they are reinterpreted. William Daniels embraces this process of reinterpretation in his artistic practice. His working technique is methodical. Often beginning with a famous work from art history, this graduate of London's Royal College of Art crafts a sculptural model using cardboard, paper and metallic foil. He photographs his maquette, capturing vibrant reflections of light and colour. He then translates the photograph

into paint, meticulously rendering every fold, glint and shadow. As he comments: 'Tin foil is like a blank canvas, yet absorbent and reflective; a means to create a form or motif, facets uncontrollable, natural, light folded, colours reflected, photographed and then made solid in paint.' The result is a unique aesthetic interpretation, but it is moreover an enquiry into the life of an image and how that image continues to exist after it has been re-represented. Authenticity and documentation are central themes; so, too, a forceful desire to investigate the authority of the painter. For Daniels, the use of paint is of great significance to the meaning of the work, paint being a historically loaded tool for both translating and re-considering an established lexicon of images in the world.

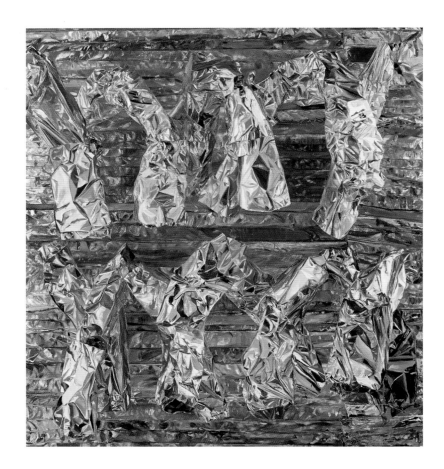

Left: *Untitled*, 2013,
oil on board, 113 × 104 cm
(44 × 41 in.)

Opposite: *Untitled*, 2013,
oil on board, 98.5 × 88 cm
(39 × 35 in.)

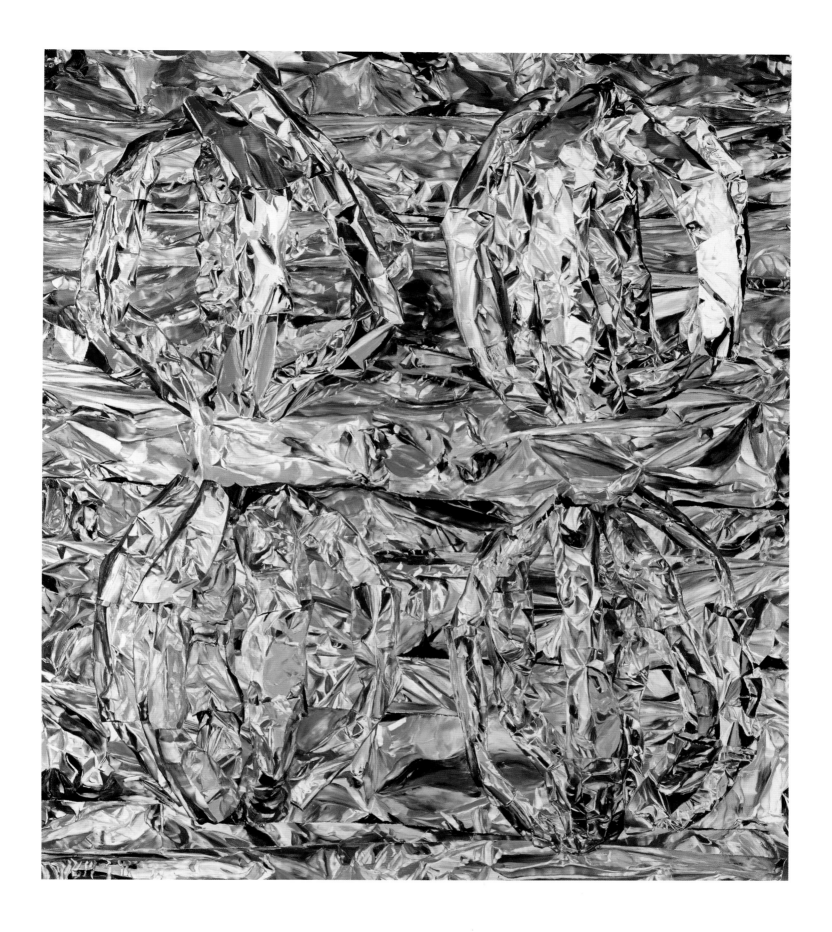

William Daniels

PETER DAVIES

b. 1970, Edinburgh, Scotland
Lives and works in London, England

For some artists, it is the physical act of painting or mark-making that lends meaning and significance to their efforts and practice. For Peter Davies, a special appreciation for process and detail is involved. A recent body of monochromatic works departs from earlier, colourful paintings, but retains the same preoccupation with 'making' that categorizes his general practice. As the artist himself puts it: 'The appearance of my works is determined by the process of making them. The paintings are by-products of that process.' From afar, the works take on the vague appearance of grey colour-field paintings, but upon closer inspection they reveal obsessive landscapes of repeated marks, shapes and line motifs transformed into oversized grids. Davies sees his compulsive mark-making as a conversation with painting and a means of dissecting the culture of contemporary art. In many ways his paintings are also highly psychological and symbolic, as much about a dedication to craft or an internalized pattern of thought now made visible. Paint thereby serves as a catalyst for a simultaneous exercise and release of tension and anxiety, though there is little relief in these works. Reformulating the simple line drawing into any complex arrangement of order, Davies is concerned with process and presence. Drawing on the same tradition as practitioners such as the minimalist Agnes Martin, or even the representational artist Vija Celmins, Davies's works speak to a notion of the psychological sublime.

'These paintings initially appear to be grey monochromes, but they are in fact made of multiple tiny repeated black marks or shapes. I am interested in systems, in setting them up and seeing them fail.'

Above: *Black Dabs*, 2012, acrylic on canvas, 183 × 366 × 3.5 cm (72 × 144 × 1⅜ in.)

Opposite: *Grid Floor*, 2013, acrylic on canvas, 198 × 152 × 3.5 cm (78 × 60 × 1⅜ in.)

Peter Davies

ADAM DiX

b. 1967, London, England
Lives and works in London

Executed in a series of glazes in a muted colour palette, the works of artist Adam Dix seem frozen in a timeless vacuum. They appear at once folkloric, like snapshots of a Nixonian era of home television and like scenes taken from the 1969 moon landing. In one work we see a sepia-toned tableau of individuals bowing down before oversized computer consoles. In another, *The Hive*, Dix presents us with a triptych of idol worship, cult-like adulation and a vision of the future as though imagined through a 1950s lens. In *Do You Receive Me* (opposite), members of a conformist society appear to exalt a simultaneously futuristic and primitive deity. 'I want my work to convey a sense of unified, heightened worship and compliance,' says Dix. His work concerns itself with the disconnect between communications technology and the communal human space of communication. In his imaginary dystopia, 'society is consumed by the device, and the phone mast or satellite dish take on the character of "totem"'. His painted visions are reminiscent of Stanley Kubrick's *2001: A Space Odyssey*, or 1970s political anxiety films, such as *Logan's Run* and *Newsroom*, as well as the found lithographic printed material of the 1950s to which the artist regularly turns for inspiration. In bringing to the fore the proliferation and mediation of communications devices that compel constant connection, Dix's works – with their multitude of strange, appropriated imagery – offer a salutary comment on today's society and what the future may hold.

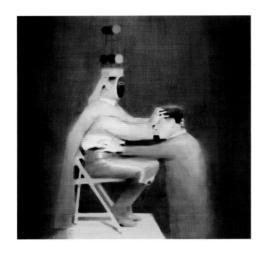

'I see a disparity between the desire to communicate and the isolation that technology can engender. By using science fiction and religion, and by exploring ritual and ceremony, I emphasize a secular celebration of communication.'

Above left: *Receive Thy Message*, 2011, ink and oil on panel, 57 × 57 cm (22½ × 22½ in.)

Above right: *Charmed Circle*, 2011, ink and oil on canvas, 87 × 87 cm (34¼ × 34¼ in.)

Opposite: *Do You Receive Me*, ink, fluorescent pigment and oil on canvas, 65 × 90 cm (25½ × 35½ in.)

Adam Dix

TOMORY DODGE

b. 1974, Denver, Colorado, USA
Lives and works in Los Angeles, California, USA

For an artist, there is often great visual potential to be found in accidents and mistakes. Tomory Dodge approaches his canvases with an open mind. 'I regularly find myself in the absurd position of trying to replicate something accidental, labouring to achieve a kind of randomness.' Dodge's work attempts to derail the traditional trajectory of representation, and indeed he considers his art to be positioned somewhere between the representational and the abstract. In one work, *Washington State*, the presence of an impasto wash in the vein of Gerhard Richter atop a forest-green underpainting seems to suggest a nature painting of pine trees under a crisp morning sky, the title further emphasizing this dichotomy between representation and abstraction. Dodge's

paintings, in addition to conceptual considerations, evoke a fascination with the materiality of paint and what Dodge calls a 'central mystery' inherent in the medium. 'A painting is an object that is a window; an object that is a space. I think this enables it to be a self-contained universe.' The experience of painting itself is a primary concern. Dodge considers it to be a basic human instinct, yet points out that painting currently has no function outside art. He prefers to see this as a sign of liberation rather than obsolescence. So he continues the pursuit of translating experience into forms of visual communication, and finds interest in the notion of a creation for its own sake – ideally, for him, with an end result that is unforeseeable and unpredictable.

'I am very interested in ideas relating to
entropy. Due to the inherent impossibility
– and perhaps absurdity – of duplicating
a painterly gesture, mistakes build up,
creating a visual tension that resonates
throughout the image.'

Opposite: *The Late Show*,
2012, oil on canvas, 183 × 229
cm (72 × 90 in.)

Above: *Horrid Torrid Times*,
2011, oil on canvas, 213 × 213
cm (84 × 84 in.)

Tomory Dodge

Above: *The Future*, 2010, oil
on canvas, 198 × 411.5 cm
(78 × 156 in.)

Tomory Dodge

FREYA DOUGLAS-MORRIS

b. 1980, London, England
Lives and works in London

Freya Douglas-Morris uses her paintings to expound on her fascination with place and experience. Using loosely conjoined, often imprecise elements to form an imagined reality, her paintings offer an ambiguity that is also loaded with a strange sense of familiarity. Although her constructed scenarios reference both landscape and narrative, they are generally not specific to a particular event. 'I use photography to document the places I visit,' she explains, 'and I gather materials from a variety of sources – books, films and newspaper clippings – but more often than not it is the memory of an environment that forms the initial ideas behind the work.' Douglas-Morris is thus driven to occupy the threshold between reality and fiction, familiarity and foreignness.

Hers are dislocated paintings that depict the experience of being 'somewhere', rather than a particular place. For Douglas-Morris, painting is the ideal medium for such an excursion, as it allows her to experiment with temporality and metamorphosis. 'A figure may occasionally appear, offering the illusion of a narrative happening off-scene,' she states. 'Other paintings remain uninhabited, the landscape becoming more of a felt space without an indication of location or time.' Sometimes Douglas-Morris even leaves the edges of her paintings frayed, 'as if the image is fleetingly caught between a boundary of what is real and unreal'. Additionally exploiting the potential of accident and intent afforded by working with paint, she absorbs us in her strange, dream-like worlds.

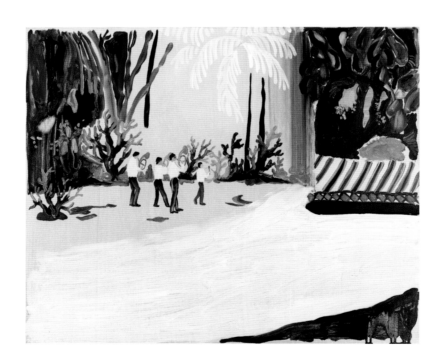

'These paintings often refer to ideas of travel, of crossing thresholds into another environment; a sensorial place that feels both familiar and foreign.'

Above: *The Trumpeters*, 2013, oil on board, 51 × 61 × 2 cm (20 × 24 × 1 in.)

Opposite: *Morning*, 2013, oil on canvas, 140 × 110 × 4 cm (55 × 43 × 2 in.)

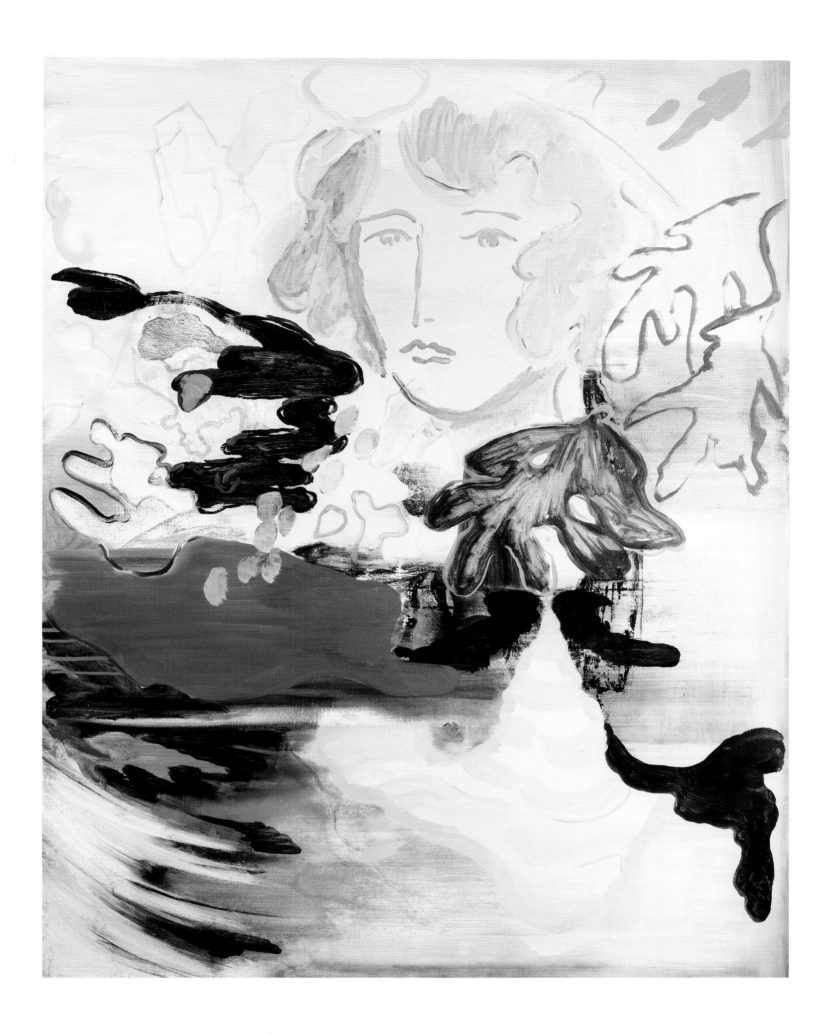

Freya Douglas-Morris

MILENA DRAGICEVIC

b. 1965, Knin, former Yugoslavia
Lives and works in London, England

Abstraction is sometimes at its most effective when it remains loosely tied to the sphere of reality; Milena Dragicevic's paintings straddle such territory. For Dragicevic, personal identity is a major informant of artistic creation. Though she currently lives and works in London, her dual identity as a Canadian Serb (and a fraternal twin) has led her to engage in a fascination with intersection and dichotomy, as well as in ideas relating to psychological communication. 'I feel that cultural and other intersecting references are a way of approaching the parameters of a painting in order to affect ways of seeing,' she states. 'I am interested in the suspension of form, and how intervention can capture the possible passage of objects.' Through vibrantly

coloured paintings that seem to reference objects and animals but never divulge more than they wish to withhold, Dragicevic's paintings seem like muzzled real world objects, or psychological sublimations in which socially unacceptable impulses are consciously disguised and transformed. The rich objects she depicts seem to occupy two worlds, dancing along the border of what is recognizable. By suspending the idea of the actuality of form, Dragicevic suggests a new way to approach the image. She considers the act of painting an intervention in the lives of fictionalized objects, and it is through this intervention, and subsequent abstraction of form, that her paintings are able to transcend the limiting perspective of reality.

Left: *Erections for Transatlantica (Ora)*, 2011, acrylic, oil and clear gesso on black fabric, 148 × 91.5 cm (58¼ × 36⅛ in.)

Opposite: *Erections for Transatlantica (Majkl)*, 2011, acrylic, oil and clear gesso on upholstery fabric, 148 × 91.5 cm (58¼ × 36⅛ in.)

Milena Dragicevic

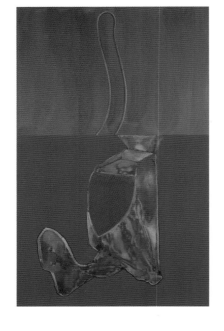

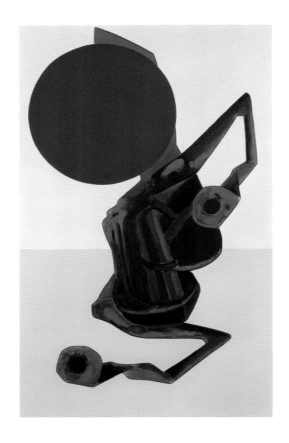

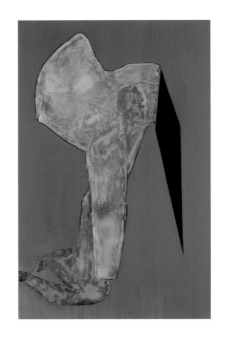

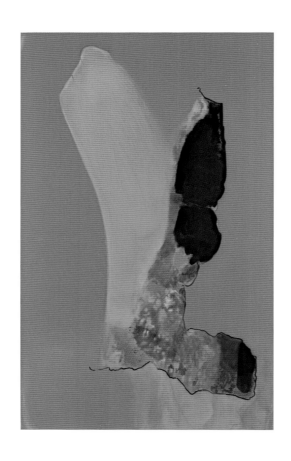

Above left: *Erections for Transatlantica (Juta)*, 2012, acrylic and oil on upholstery fabric, 148 × 91.5 cm (58¼ × 36⅛ in.)

Above centre: *Erections for Transatlantica (Vernr)*, 2011, acrylic and oil on linen, 148 × 91.5 cm (58¼ × 36⅛ in.)

Above right: *Erections for Transatlantica (Šila)*, 2011, acrylic and oil on linen, 148 × 91.5 cm (58¼ × 36⅛ in.)

Left: *Erections for Transatlantica (Ragnr)*, 2013, acrylic and oil on upholstery fabric, 148 × 91.5 cm (58¼ × 36⅛ in.)

Opposite: *Erections for Transatlantica (Tjeri)*, 2010, acrylic, oil and clear gesso on linen, 148 × 91.5 cm (58¼ × 36⅛ in.)

'My work is not about object or
story. Rather, it is about how to make
a painting that resonates within
its own structures. I am reconfiguring,
compressing, erecting.... My goal is
not to convey, but to play the game.'

Milena Dragicevic

DEJAN DUKIC

b. 1975, Vienna, Austria
Lives and works in Vienna

Perhaps one can imagine a romantic scene: a stack of unfinished paintings lined up in a row in the studio of artist Dejan Dukic so that only their canvas-covered, paint-splattered shoulders are visible. Immersed in his work, the artist suddenly has his 'eureka' moment. The remarkable series of works he ends up with, entitled 'Storage Paintings', is about the act of painting, or, more specifically, about the act of storing paintings. It is about a dissociative relationship to one's practice, in which the detritus actually becomes the focus. The artist has succeeded in opening up the traditional medium, with its two-dimensional support, to encompass practices that are sculptural and performative, and as much about time, media and suggestion as they are about the materiality that makes up the sum of these parts. 'For me,' says Dukic, 'it is important to see how far I can go with painting and how I can put it into a new perspective.' In rejecting conventional subject matter and treatment, and in switching the focus, 'a visual vocabulary emerges from the technical structure of the image carrier itself'. Dukic's work here becomes experiential: 'translated into visual material, the conceptual substance is processed into sculptural compositions.' In other series, Dukic has experimented with unusual media, including blankets and epoxy. This artist offers new ways for art to be apprehended and comprehended.

'My work is about painting. The contextual background of painting – in fact, the very limitation of the canvas itself – is central to my artistic practice. I want to see how far I can go and whether I can show a new view of the medium.'

Left: *Storage Painting Nr.21*, 2012, wood, acryl, fluid pigment and oil on canvas, 200 × 161.5 × 4.5 cm (78¾ × 63⅝ × 1½ in.)

Opposite: *Storage Painting Nr.14*, 2012, wood, acryl, fluid pigment and oil on canvas, 200 × 173 × 4.5 cm (78¾ × 68 × 1½ in.)

Dejan Dukic

TiM ELLiS

b. 1981, Chester, Cheshire, England
Lives and works in London, England

Tim Ellis's series entitled 'United in Different Guises' features a number of paintings that are reminiscent of militaristic banners or flags. They are folded, scuffed, gradually aged and hung by bulldog clips, taking on the look of textiles recovered from ancient or forgotten republics. Ellis uses a variety of source imagery for his works, ranging from advertising and design magazines to artistic movements such as Art Nouveau and elements of Zen symbolism such as the Ensō circle. 'I collect vast amounts of images and design motifs into a glossary for potential use,' the artist explains. 'I draw my own designs inspired by them. The colours are chosen in a similar manner, but are intuitively worked and changed for each painting.' Unusually, Ellis conceives of each

painting as either male or female. His works – containing nods to contemporary artists such as Gert & Uwe Tobias; one can even find (perhaps less visceral) suggestions of origins in Viennese Actionist performances by artists such as Hermann Nitsch – are loaded with cultural and historical significance. In addition to art and design history, his syntax is sourced from his daily life and surroundings in contemporary London: 'Windows and doors that I pass on the street, the world I inhabit, provide me with an index of images to abstract into my paintings.' What Ellis creates amounts to a subversion of historical referencing, or a codified language system that questions notions of symbolism and authenticity and appears to defy chronological or cultural classification.

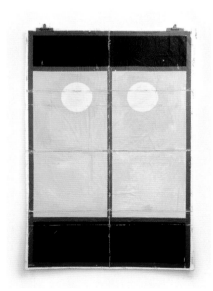 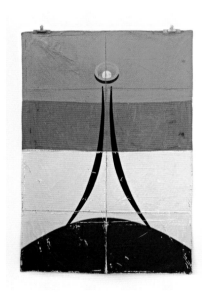

Right: *United in Different Guises XLI*, 2011, acrylic, varnish, cotton and bulldog clips, 205 × 136 cm (80¾ × 53½ in.)

Far right: *United in Different Guises – Temporal Cycle III*, 2011, acrylic, varnish, cotton and bulldog clips, 205 × 136 cm (80¾ × 53½ in.)

Opposite: *United in Different Guises CXXVIII*, 2013, acrylic, varnish, cotton and bulldog clips, 76 × 45 cm (29⅞ × 17¾ in.)

'The paintings in this series have a function that sits between the communicative and the symbolic. The source imagery is a mixture of signage and design: this is reconstructed to form gendered symbols.'

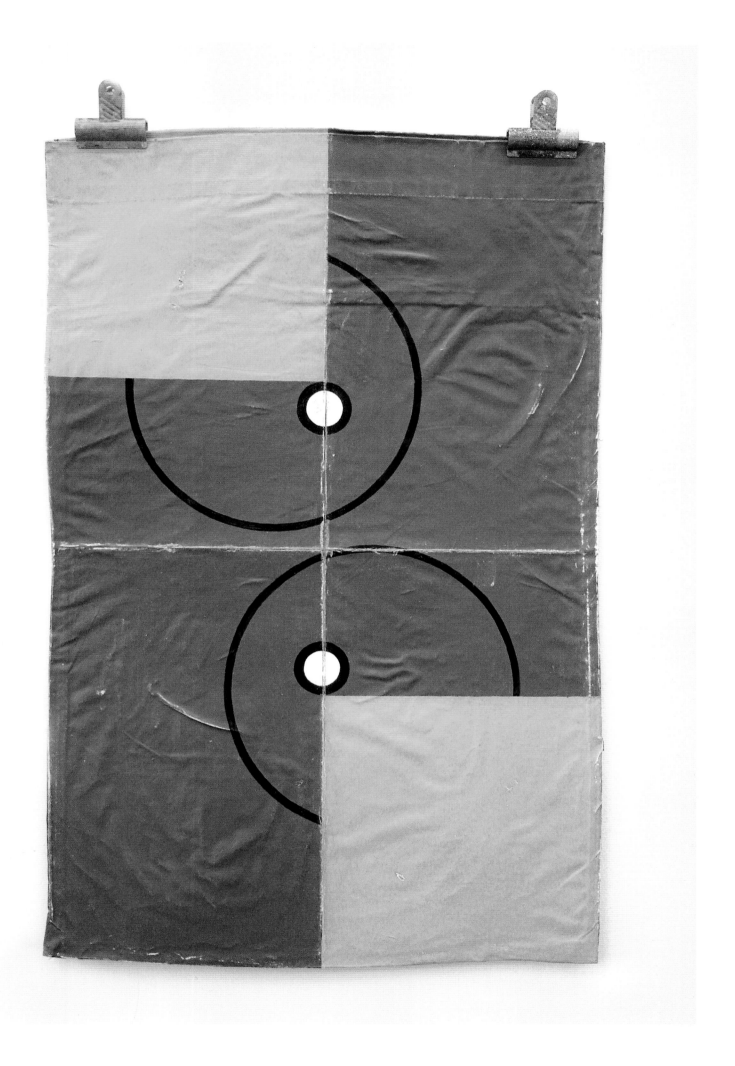

Tim Ellis

MATILDA ENEGREN

b. 1989, Vasa, Finland
Lives and works in Jakobstad, Finland

Matilda Enegren's evocative portraiture is an inquiry into the nature of human communication. Working from a photographic base, she uses painting to lend longevity to the otherwise fleeting moments encountered in everyday life. Inspired by a love of the subtleties of illumination, she carefully renders her subjects in varying nuanced lighting scenarios. The act of partially or completely obscuring the faces of her subjects is a means through which Enegren questions the complexity of human relationships. It also alludes to another critical interest of the artist: the reality of vision and perception. Through a body of work entitled 'Gaze', Enegren references Lacanian psychoanalytical theories, such as the Self's relationship to the Other, symbolism, and even desire, which, according to Lacan, 'is not a question of recognizing something…. In naming it, the subject creates, brings forth, a new presence in the world.' Enegren seems to be concerned with *scopophilia* (the procurement of pleasure from seeing), or the politics of looking: the overriding cultural implications of looking at art which, in a sense, looks right back at you. Enegren asks the viewer to consider their own role as an onlooker, with the use of paint reminding us that what we are looking at is a fallacy, a construction, that is outside of – and yet connected to – reality. Enegren elucidates: 'I believe painting can suggest other, slower and more contemplative ways of looking at and perceiving life than most other forms of imagery.'

'My work is about observing light, colour and people. People concern me. By painting I seek to grasp a sense of belonging. I try to get hold of visual and emotional experiences that strike me, and I make an attempt to clarify what exactly got my attention.'

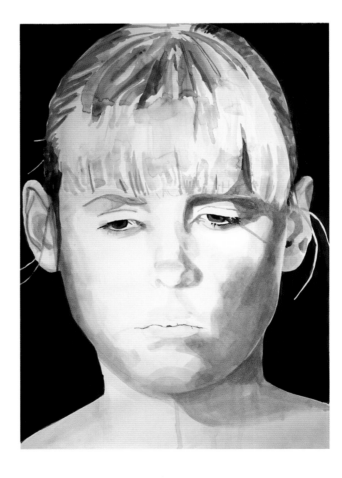

Right: *Evening*, 2013,
watercolour, 61 × 43 cm
(24 × 16⅞ in.)

Opposite: *Henry*, 2012,
oil on canvas, 90 × 75 cm
(35⅜ × 29½ in.)

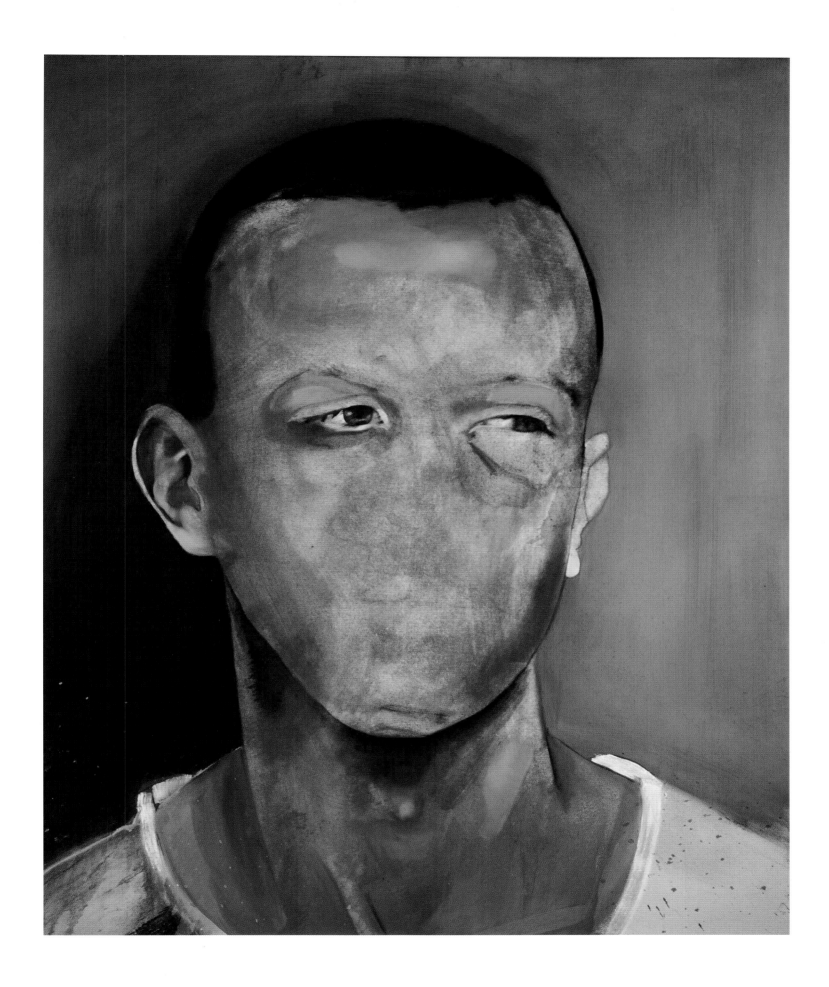

Matilda Enegren

STELIOS FAITAKIS

b. 1976, Athens, Greece
Lives and works in Athens

The tradition of mural painting is freighted with historical and political connotations. Stelios Faitakis embraces these associations as part of his artistic arsenal, believing that painting is a medium that inherently revisits its own past with each new development. Educated at the Athens School of Fine Arts, Faitakis creates large-scale works that are painted from the basis of an art historical framework that honours, most specifically, the precedents set by Diego Rivera and painters from the Mexican muralist movement of the early 20th century. Also apparent is the influence of Byzantine art, with its flattened perspectives and its religious iconography, including magnificently rapturous scenes of Hell in all its imagined glory. Devices of torture and ecstasy lifted from medieval illuminated manuscripts are also in evidence, now populated with images of subjects like Chairman Mao and given titles such as *Pincer of Germany – Revolution of Machno*, or *Socrates Drinks the Conium*. Faitakis's world involves excess, a collapsing of political correctness, a diffusion of time and Escher-like space, and a marriage of antiquated stylism and contemporary critique. Creation is a major recurring theme, in terms of the individual, the artist and the world. Ultimately, Faitakis states, 'My work engages questions of humanity; what it is to be human and how this relates to the world and its Creator.' Through his own acts of creation, Faitakis uses painting as a spiritual outlet. In this way he locates himself within the history and tradition of his chosen medium.

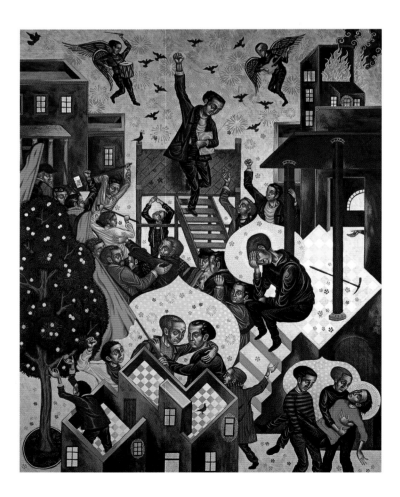

'I am interested in how the fundamental questions of religion, spirituality, philosophy, science and other frameworks of reference position humans within the universe. The arts provide me with a rich source of raw material.'

Left: *Dream*, 2008, oil, acrylic, latex, egg tempera, metallic paint and spray paint on canvas, 240 × 190 cm (94½ × 74¾ in.)

Opposite: *Babel*, 2009, oil, acrylic, latex, egg tempera, metallic paint and spray paint on canvas, 260 × 190 cm (102½ × 74¾ in.)

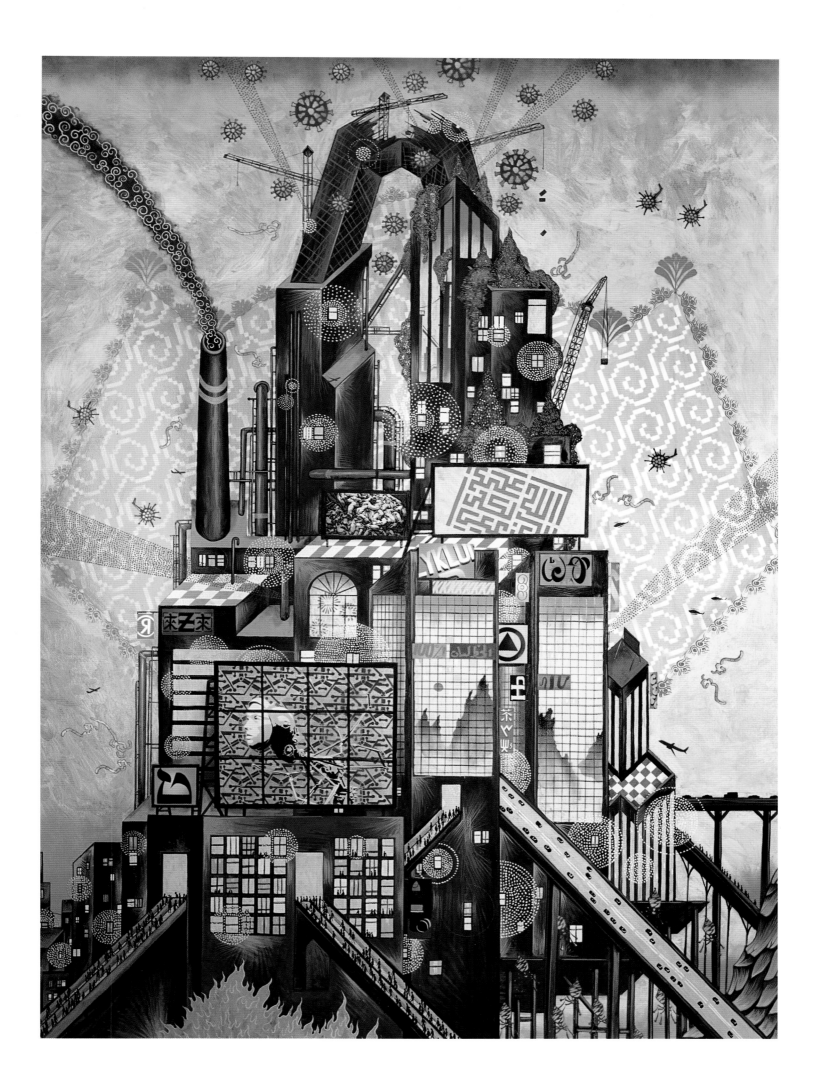

Stelios Faitakis

MICHAEL FANTA

b. 1989, Graz, Austria
Lives and works in Vienna, Austria

Reflexivity is a challenging concept to get across successfully within contemporary painting. All too often it seems like an afterthought, superficially imposed upon the art after its creation, or else it is so forcibly entwined in the fabric of its make-up that the art seems to suffer from its conceptual baggage. The paintings of Michael Fanta, however, articulate a pleasing autobiographical detachedness. 'In painting, one thing seems to be very present,' the artist has stated; 'how the actual paint and the way objects present themselves to one's personal view can meet at certain points.' One series of works, typically titled after the dates on which they were completed, features a recurrent skull that the artist has placed to look back at the viewer, perhaps as a tongue-in-cheek variation on the

memento mori. These paintings commonly utilize a *mise-en-abyme* effect, in which paintings appear within paintings, the skull moving comically, eerily, throughout the various compositions. Learning from his teacher Daniel Richter, Fanta is intuitive and causal in his work: 'I am not very analytical. If a painting is good, it should be able to explain itself.' So one is left perplexed as to whether another series of works, entitled 'The Drunk Paintings' and ostensibly featuring drunk or drinking men in various stages of inebriation, is titled as such simply due to the subject matter, or whether Fanta might be playing with semantics and performance, painting the works while he himself is drunk. He asserts that 'every object can be used as a tool to tell a story'.

Opposite: *Skelett*, 2011,
acrylic and oil on canvas,
145 × 180 cm (57¾ × 70¾ in.)

Above: *10.1.13*, 2013, oil on
canvas, 150 × 150 cm (59½
× 59½ in.)

'Even if the story being told is dark,
the telling can be funny; or the
other way round. Maybe a painting
can move along on the edge of
these two extremes. Painting is
always about some inner conflict.'

Michael Fanta

MADELINE VON FOERSTER

b. 1973, San Francisco, California, USA
Lives and works in Cologne, Germany

Madeline von Foerster is one of very few contemporary artists worldwide painting in oil and egg tempera, the technique developed by the Flemish Renaissance masters. Vividly recalling being inspired as a child by seeing Hieronymus Bosch's *Garden of Earthly Delights* in a book, and noting the fact that it took two years to create, she says, 'For me then, both the virtuosity of the artwork and the time span required to create it were simply incomprehensible. But an awareness dawned in me that with enough time, toil and creativity a painter can create entire worlds.' For her own works, she sketches the initial outlines in great detail, never using projection or tracing but often making use of extensive research. Then, despite their classical appearance and historic medium and technique, her paintings can reveal their subversive, contemporary concerns. Von Foerster's tableaux incorporate commentary on such topical issues as deforestation, wildlife protection and extinction caused by human activity. *Ex Mare* (below), for instance, features a Chinese porcelain bowl containing a shark fin, offering commentary on the widely controversial act of 'shark finning' for the Chinese delicacy shark fin soup. At the bottom of the altar, she includes a plastic bottle and a six-pack yoke, both of which have been roundly criticized for harming marine life. Von Foerster's paintings take on the role of contemporary curios, showcasing an array of symbolic objects and items of current and conceptual intrigue.

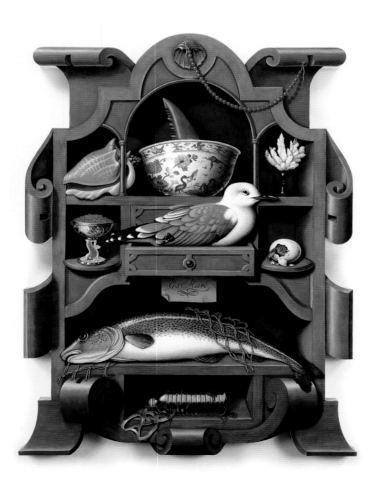

'I wish to convey beauty and meaning with my paintings, and to sacrifice neither to the other. While my paintings utilize classical methods and imagery, they are passionately relevant to the present. They are visual altars to our imperiled natural world.'

Left: *Ex Mare*, 2010, oil and egg tempera on panel, 99 × 76 × 5 cm (39 × 30 × 2 in.)

Opposite: *Invasive Species II*, 2008, oil and egg tempera on panel, 39.5 × 30.5 cm (15½ × 12 in.)

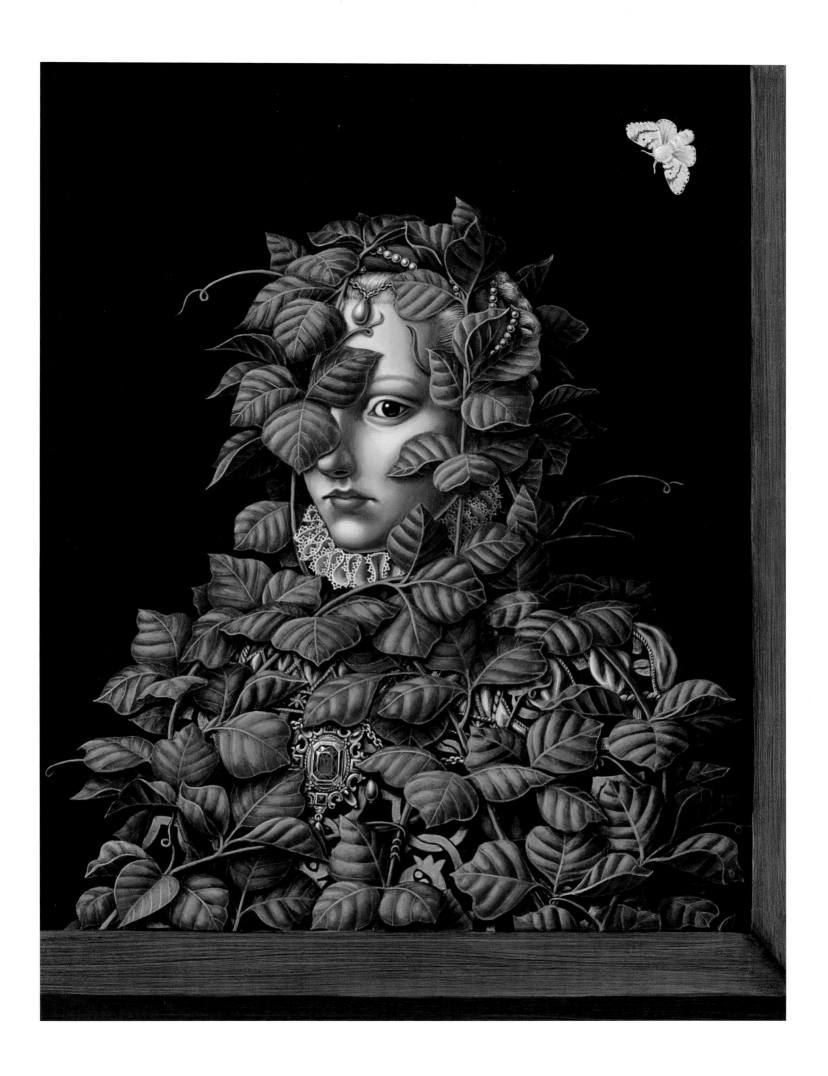

Madeline von Foerster

MARC FREEMAN

b. 1979, Melbourne, Australia
Lives and works in Melbourne

The role of pure abstraction within the vernacular of contemporary painting is a subject that has been known to spark debate. Marc Freeman finds such argument both healthy and informative. He believes painting is relevant because of 'its ability to continually reinvent itself as a visual language'. His large-scale paintings – typically around 2 metres (6½ feet) in height – are layered and energetic, often using mixed media to epitomize the spirit of abstraction and to provide the viewer with a familiar yet distinctive iconography. The works rely on both traditional and new materials, and contrast differing genres of painting in order to form a statement on the function of the abstract. 'To explore the well-worn course of painting's dialogue and struggle with both representation and abstraction, I use multiple materials and surface applications,' states Freeman. 'I encourage the influence of modern technology to be seen and read into the work as a way of keeping the conversation relevant.' Collaging materials and surfaces, and combining technological outputs with the handmade, Freeman seeks to create an alternative visual platform. Although he does not work solely with paint and canvas, he employs an intentionally painterly approach in all aspects of his creative method. It is the immediacy of painting – and the idea of subversive juxtaposition – that allows him to delve into abstraction, playfully joining the most traditional of media with striking elements of contemporaneity.

'The fluidity of paint allows the hand to create faster than the mind can dictate. Making and thinking are so interconnected they can at times be indivisible. When the process is working well, it is unclear which action is leading and which is responding.'

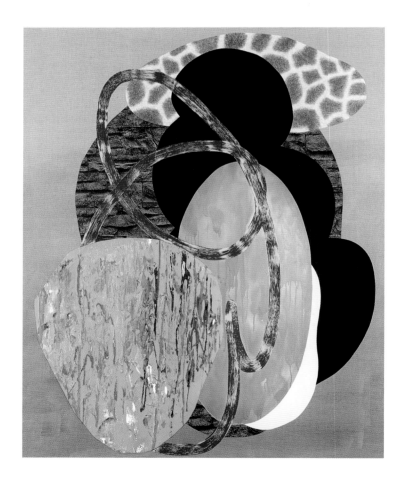

Right: *Composition #2,*
2013, mixed media on linen,
170 × 140 cm (66⅞ × 55⅛ in.)

Opposite: *Composition #4,*
2013, mixed media on linen,
170 × 140 cm (66⅞ × 55⅛ in.)

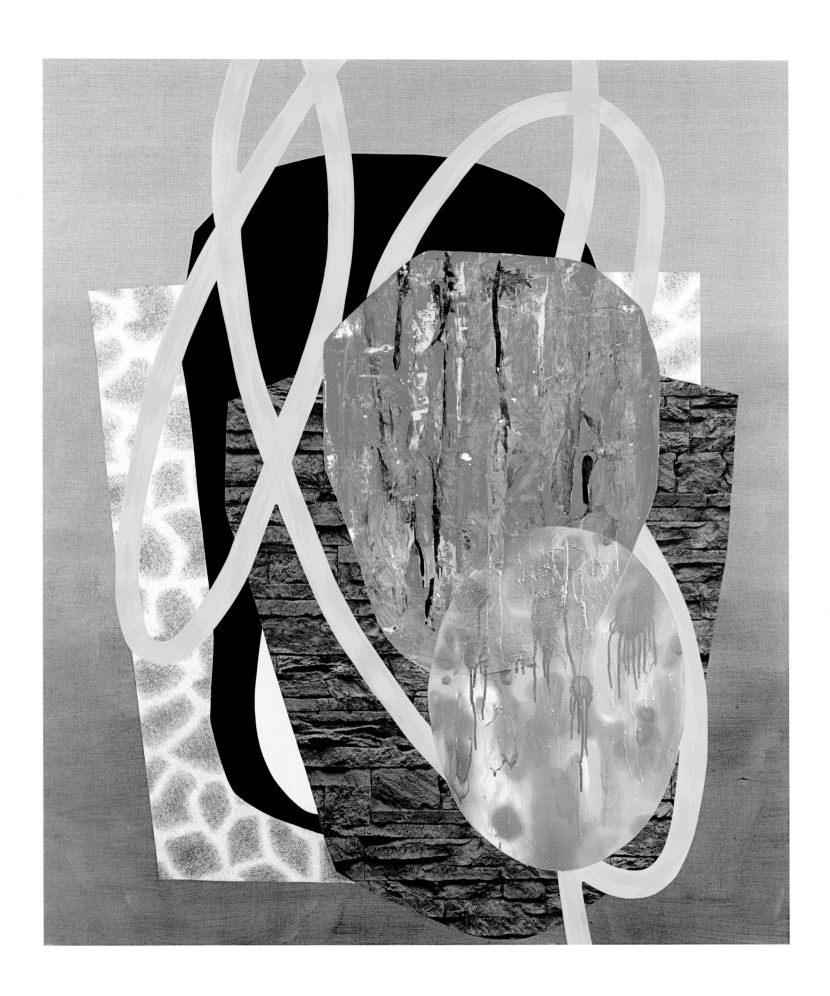

Marc Freeman

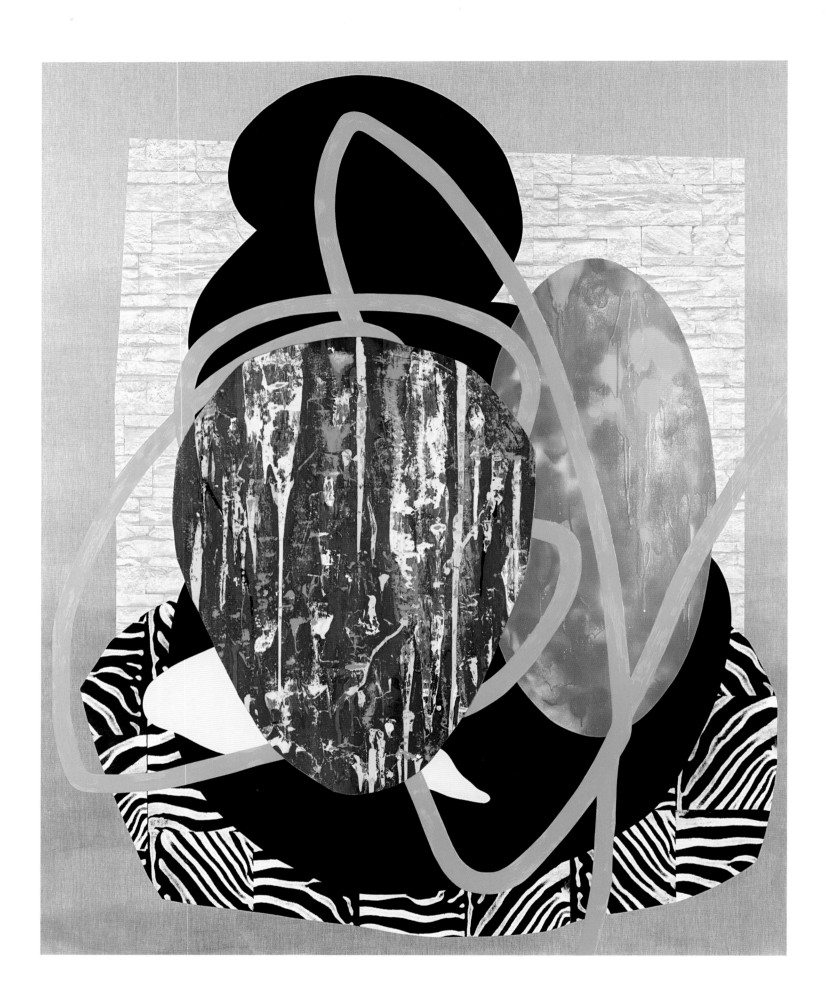

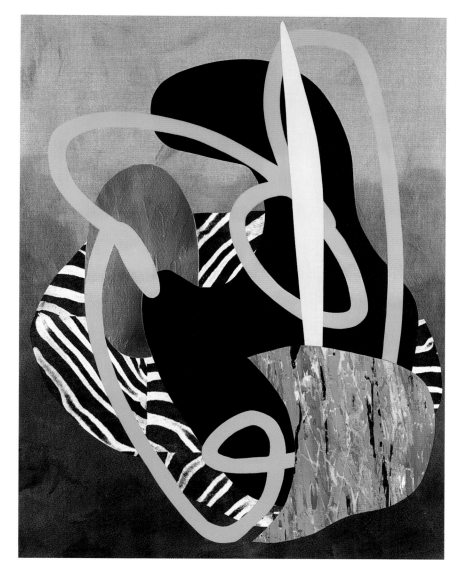

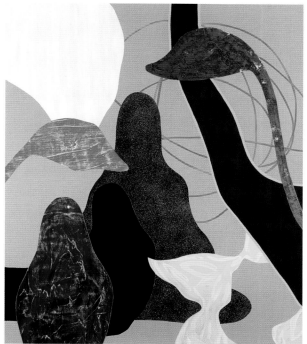

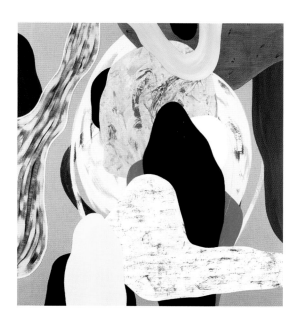

Opposite: *Composition #1*, 2013, mixed media on linen, 235 × 190 cm (92½ × 74⅞ in.)

Above left: *My Kingdom Come*, 2011, mixed media on linen, 200 × 170 cm (78¾ × 66⅞ in.)

Above right: *Untitled #2*, 2013, mixed media on linen, 120 × 90 cm (47¼ × 35⅝ in.)

Left: *Icon for Today's Believer*, 2010, mixed media on canvas, 183 × 168 cm (72 × 66⅛ in.)

Marc Freeman

ROBERT FRY

b. 1980, London, England
Lives and works in London

In a painting entitled *Man with Vesalius Skeleton*, Robert Fry pays homage to 16th-century Dutch anatomist Andreas Vesalius, author of one of the most influential anatomy books ever written. The painting is executed in what has become Fry's trademark style: a flattened perspective in which a human figure is reduced to its bare elements, with scarcely an outline to denote a male figure facing an almost indiscernible skeletal entity. Fry is only concerned with mapping the body in a referential sense; his figures are stripped of any sense of naturalism. A number of mixed-media approaches might be used, including resin, oil-pastel, marker or paint. Typically, the compositions are framed by a thin contour line tracing the outline of the canvas, and they are bathed in deep magentas, purples and violets. Fry also builds tension through the application of layers and textural qualities to the surface of the canvas. In obscuring his figures' heads with Rorschach-style blots or three-dimensional Rubik's cubes, he references a blocking of information and identity to give way to psychological insinuations. These elements serve a greater conceptual mythology, in that the manipulated physical entities suggest a complexity of meaning beyond what is immediately evident. 'I create a relationship between the physicality of materials and psychological terms,' Fry admits. 'I am interested in conveying a slightly brutal picture of the human condition.' In using expressionism and abstraction, he finds a new language of representation.

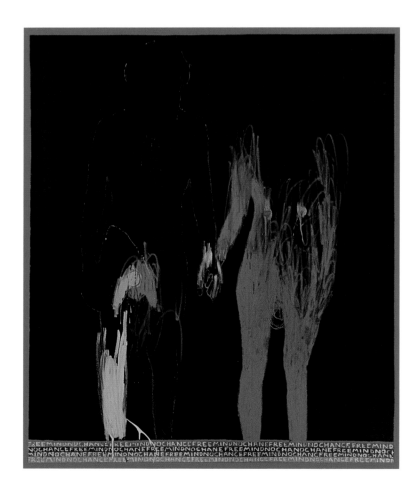

Left: *Purple Study 9*, 2009, acrylic, oil, enamel and gloss paint on canvas, 198 × 163 cm (77⅞ × 64 in.)

Opposite: *Related Study K*, 2013, acrylic, oil, enamel and gloss paint on canvas, 153 × 122 cm (60 × 48 in.)

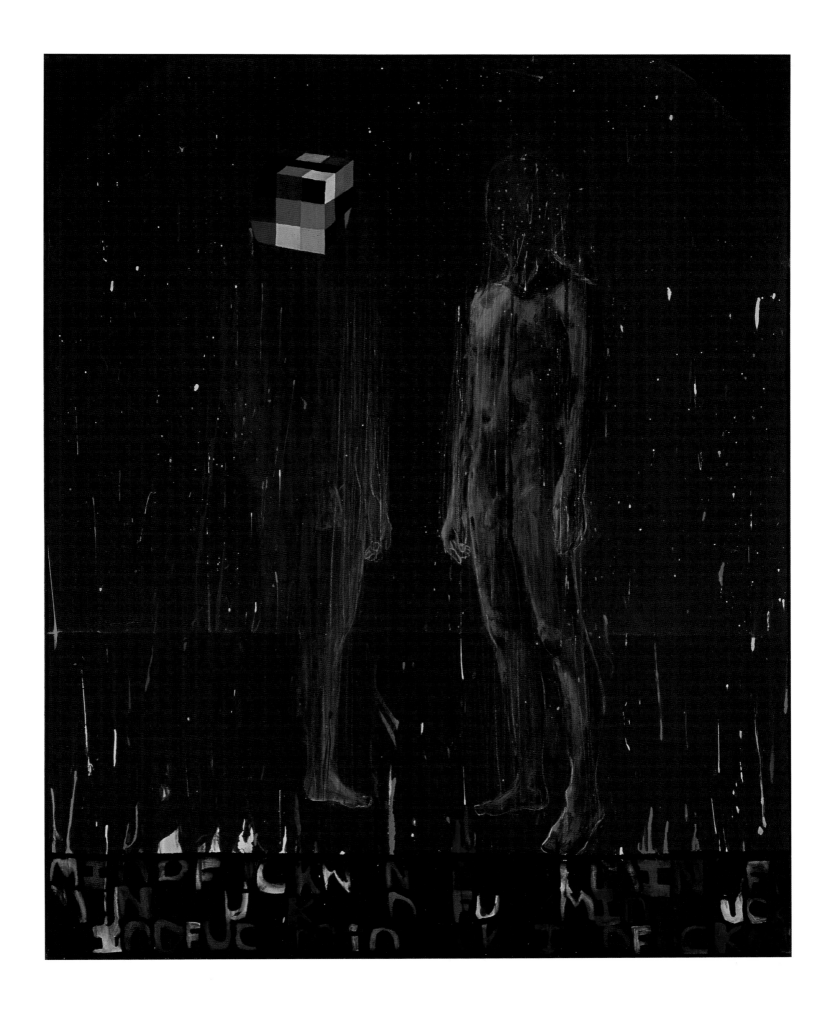

Robert Fry

NUNO GIL

b. 1983, Lisbon, Portugal
Lives and works in Lisbon

Subtly referencing mountains, clouds and foliage, the paintings of Nuno Gil are inspired by organic forms and the natural world. Gil re-interprets his botanical imagery and applies it to the canvas. His process is of tantamount importance to the understanding of his abstracted terrains. Inherent in the fabric of the designs are what appear to be small reflective divots. These are not, however, merely decorative: they are staples used to tack down pieces of painted and illustrated canvas into a greater collage. Form and content are thereby unified as a commentary on proliferation is executed, using a method that favours hundreds of unique accumulating parts. 'Faced with the impossibility of dissolving the limits of shape,' says the artist, 'I have taken the opposite direction: understanding those limits as precise and unambiguous. Repetition follows the same logic: what differentiates one thing from the rest that are identical. The result is excess, but also a kind of inversion that uncovers everything it apparently strives to cover up.' For Gil, painting and collage are organic actions rooted in discovery: intent and execution rarely match up. The worlds he imagines are confronted by the shortcomings of his media and process. In this sense, he views painting as a means of coming to terms with reality and as a metaphor for his own inadequacies. The paintings illustrate the world as a heaving mass, full of disruption, distraction and intricacies that attempt to generate meaning, suggesting the insufficiencies of human society and the sublime power of nature.

'My work is based on the idea that there is something common to all things; a certain logic that does not necessarily have to do with what things are made of. For me, shape has the power to carry "truth", which is in fact nothing more than what is shared by all things.'

Right: *Untitled*, 2013,
china ink, graphite, acrylic
and staples on paper,
76 × 56 cm (29⅞ × 22 in.)

Opposite: *18:16*, 2009/10,
acrylic, enamel and gloss
varnish on canvas, 221 ×
157.5 cm (87 × 62 in.)

Nuno Gil

KATE GOTTGENS

b. 1965, Durban, South Africa
Lives and works in Cape Town, South Africa

Drawing from a pool of found images from her own family albums, Kate Gottgens removes the familiar photographic representation from the terrain of nostalgia and transports it to a place of instability. 'My work is open-ended and ambiguous,' the artist explains. 'I like to build an atmosphere of unease, even dread, that probes the longings, ennui and malaise beneath the surface of everyday life.' Her paintings undulate between withholding and revealing, offering momentary glimpses of clarity that seem to drift in through a haze of memory. Filtered through the subjectivity of painter as omniscient storyteller, the works omit a wealth of descriptive detail in order to focus instead on implication. This is abetted by Gottgens' artistic practice: 'Through strategies like blurring, dripping, sweeping and "pooling" of paint, I abstract forms, flatten the depth of field and accentuate negative shapes in order to shift meaning.' Thus the fine line between reality and fiction is crossed. We might assume that Gottgens incorporates her own personal narrative and social history into her work, but tellingly she is careful to skew her colour palette to evoke emotion in her viewers, exploiting the familiar vernacular of faded photographic printing, the saccharine feeling of a Technicolor film or vintage advert, to dark ends. Suburban scenes, empty interiors, backyards, highways and landscapes are imbued with an ominous atmosphere, as though nostalgic recollections have been tinged with elements of regret, pain, anxiety and even horror.

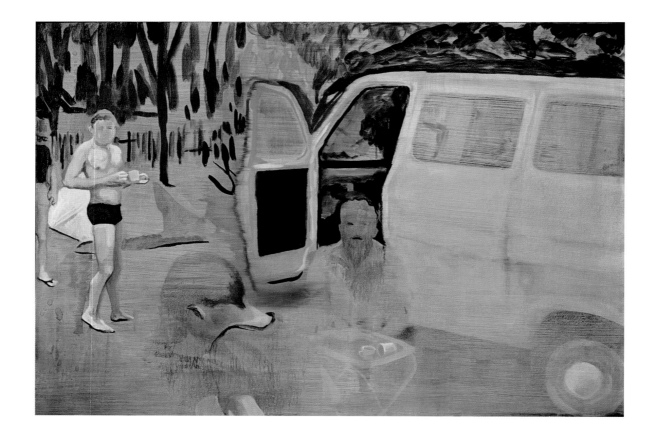

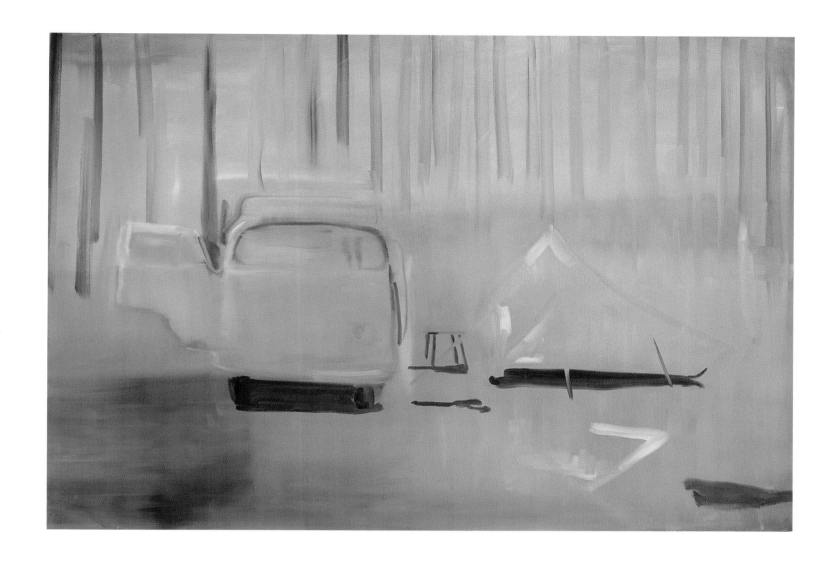

'My aim is to create paintings that
present a world slightly off-kilter,
suddenly menacing and uncertain,
in surreal scenes that express
our fragile attempt at order in the
face of entropy and collapse.'

Opposite: *Bone by
Bone*, 2010, oil on canvas,
61 × 84 cm (24 × 33 in.)

Above: *Camper*, 2013,
oil on canvas, 84 × 120 cm
(33 × 47¼ in.)

Right: *Open Road*, 2013,
oil on canvas, 68 × 90 cm
(26¾ × 35⅜ in.)

Kate Gottgens

Above: *Bulawayo*, 2013,
oil on canvas, 61 × 84 cm
(24 × 33 in.)

Above right: *Red Interior*,
2012, oil on canvas,
69 × 105 cm (27⅛ × 41⅜ in.)

Right: *Harlequin Mother*,
2010, oil on canvas, 92 × 130
cm (36¼ × 51⅛ in.)

Opposite below: *Interior*,
2011, oil on canvas, 61 × 84
cm (24 × 33 in.)

Kate Gottgens

PABLO GRISS

b. 1971, Caracas, Venezuela
Lives and works in Panama City, Panama

Through an approach toward abstraction that incorporates a wide range of styles and media, Pablo Griss constructs poetic interpretations via spatial juxtapositions. 'I am obsessed with space,' he admits. 'My work embodies my need to create atmospheres; not recognizable ones, but rather spaces that reveal themselves in a peculiar, more poetic way.' Uniting an accomplished geometric draftsmanship with a loose and unconventional painterly style, Griss's strongly expressionist work weaves back and forth between angular lines and stream-of-consciousness mark-making. Through such stylistic freedom and a devotion to a layered, palimpsest-like approach, the artist lends a sense of visual depth to his works. He also emphasizes the surreal nature of his backgrounds, both inviting the viewer into their environment while simultaneously reminding the viewer of their pure intangibility. At times, Griss's works seem entirely reliant on geometric abstraction; at other times, as though in a fit of dynamism, these same paintings appear to embody wild organic movement. Perhaps the works find their strongest form of expression when Griss's regimented shapes begin to collapse upon themselves, suggesting so much more than mere patterning. 'As a painter in front of the canvas I explore my weaknesses,' Griss confides. Exploring materiality, including collage, mixed media and gold leaf, he seems eager to establish, and then deconstruct, his own sense of order, both inside and outside the studio space.

Opposite: *Blackonblack.*
Magenta Vestige, 2013,
oil on linen, 175 × 215 × 4.5
cm (68⅞ × 84⅝ × 1¾ in.)

Above: *Yellow 06*, 2013,
oil on linen, 194 × 206 ×
4.5 cm (76⅜ × 81 × 1¾ in.)

'Proposing an abstract dialogue
that goes beyond colours and
elements, objects depart from
geometric shapes and suggested
spaces are reinforced with sharp
lines. The backdrop is rendered
using drippings, transparencies,
layers, gestures and erasures.'

Pablo Griss

ELLEN GRONEMEYER

b. 1979, Fulda, Germany
Lives and works in Berlin, Germany

With their grotesquely distorted features, the cartoon inhabitants of Ellen Gronemeyer's paintings seem like escapees from a bizarre dream, or illustrations for a children's book gone awry. From afar, the paintings take on the appearance of roughly patterned walls, with a stucco-like surface made through extreme impasto. Gronemeyer states: 'The paintings are slowly built up in fine flecks, like many accretions of silt. From a distance, they have the steely sheen of granite, but get up close and speckles of vibrant colour shine through.' On close investigation, absurd details also become apparent. Unidentifiable body parts, comic-book limbs and googly eyes are thrown together to form a jumble of intentional confusion. The word *mish-mash*, which some say originates in the German

language, seems highly appropriate for this Berlin-based painter. But, despite their monstrous surface appearance, her figures are anything but horrific. Whimsy and humour are essential elements of Gronemeyer's works; indeed, these can often be read as fairy tales. She draws her visual stock from pop culture, television and cartoons, but decontextualizes recognizable stylistic tendencies to remove them from the realm of the altogether familiar. Her subjects are consistently generic in appearance, often displaying expressions of ecstatic joy so exaggerated that they become almost agonizing. Though Gronemeyer makes no attempt to create 'pretty' scenes and situations, her frenzied paintings nonetheless hold a somewhat disturbing attraction.

'Comedic sketches on stages: exaggerated, ridiculous, chaotic, noisy characters lead into noisy and chaotic situations. My paintings often have just enough realism not to pass completely into abstraction.'

Right: *'find ich spitze'*, 2012,
oil on canvas, 80 × 60 cm
(31½ × 23⅝ in.)

Opposite: *'was soll's'*, 2012,
oil on canvas, 102 × 80 cm
(40⅛ × 31½ in.)

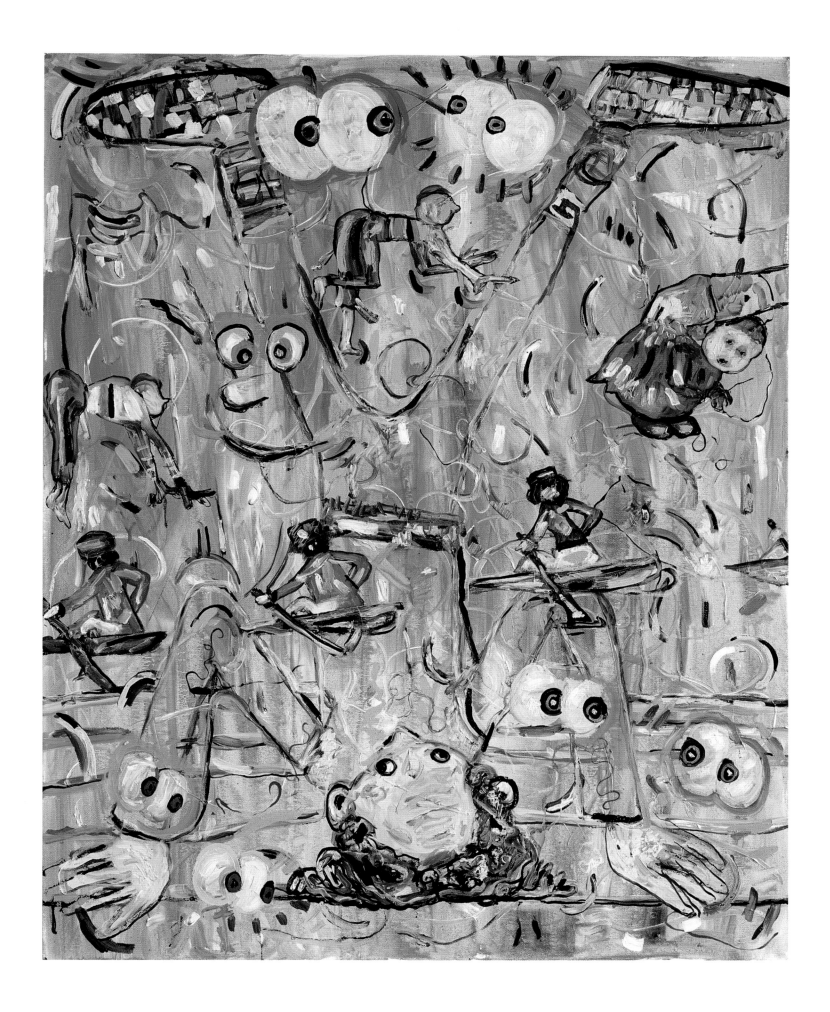

Ellen Gronemeyer

KATE GROOBEY

b. 1979, Leeds, Yorkshire, England
Lives and works in London, England

From the mid-19th century, Edgar Degas began to work on what would develop into a recurrent motif. His nude bathers, alongside his ballet dancers, would become perhaps the most recognizable of his subjects. The works of Kate Groobey seem like tongue-in-cheek references to Degas' beloved nudes. Like crudely re-imagined homages, Groobey's paintings depict lithe, lifeless figures before skewed backgrounds in a variety of sea greens, cool turquoises and sandy browns. A relationship to the Modernists can also be perceived: the works can, for example, appear like studies from Matisse's dancers. While Groobey's recent work discards the figure in favour of plant- or machine-based subject matter, the continuity from the earlier figures is still evident: quickness of brushwork,

broken lines and what appears to be a frantic painting pace. Groobey works from small sketches and watercolours, often relating to personal experiences, which she then transposes onto larger-scale canvases that she paints directly on the floor. 'I work fast, with liquid paint, recreating the immediacy of the initial drawings. I tend to work in series. At a particular time there will be a vocabulary of motifs or images that circulate or get cut up and re-arranged so that the paintings talk to each other. Figures disintegrate into gestures, but each mark has to count, to have a purpose.' Groobey relishes working with intuition and immediacy. 'I like the idea that with painting there's no back button. You can't save a previous version, and that makes it exciting.'

Left: *The Fence*, 2010, oil on canvas, 150 × 130 cm (59 × 51 in.)

Opposite: *The Cutting Mat*, 2010, oil on canvas, 150 × 130 cm (59 × 51 in.)

'Painting is how I process things,
how I think, how I see. My work is sort
of diaristic, so things that happen
to me can end up in paintings via
a motley crew of characters.'

Kate Groobey

ALEXANDER GUTSCHE

b. 1970, Potsdam, Germany
Lives and works in Leipzig, Germany

It seems evident looking at the large-scale works of Alexander Gutsche that he is based in Leipzig, bearing in mind the celebrated New Leipzig School of the 21st century that has produced painters such as Neo Rauch, Tim Eitel, Matthias Weischer and David Schnell. A similar uncanny, magic realist tendency exists in Gutsche's works, but, where many of his predecessors and peers have favoured a fantastical painting style, Gutsche renders his pieces with unnerving hyper-realism. His universe combines 'retention and renaissance', in a wealth of competing systems that are present in various pseudo-scientific, personal and political references, all collated for a heady prioritization of the recalculation of 'the subject'. 'My paintings are meticulous, irritatingly precise, detail-obsessed,' Gutsche

states. Surreal stories are told using 'real' methods, with only slightly skewed perspectives, unnatural occurrences, heightened shadows or hyperbolic details as reminders that what we are viewing is, in fact, fiction. Gutsche works in other media as well – drawing, sculpture and collage – but he particularly relishes the often tedious painting process he imposes on himself. 'The so-called simple process of painting is intriguing. One utilizes the most simple means. One simply applies paint to the canvas using a brush, and, depending on practice, talent and temper, the results differ considerably. The resulting paintings are telling images about their creator, and they retain so much for themselves. It is magic.'

'My aim is to represent figures and objects with perfection; to exhibit them as dematerialized, like cut-outs, detail-obsessed, with heightened lucidity, oversized in dimension, and collage-like'.

Left: *Selbstporträt (Self-portrait)*, 2009, acrylic on canvas, 200 × 160 cm (78¾ × 63 in.)

Opposite: *Monarchie und Alltag (Monarchy and Everyday Life)*, 2012, acrylic on canvas, 240 × 160 cm (94½ × 63 in.)

Alexander Gutsche

SHAHRYAR HATAMI

b. 1983, Tehran, Iran
Lives and works in Tehran

Shahryar Hatami approaches painting with the curiosity and intellect of one enthralled by fantasy, literature, art history, and even dreams. One work (opposite) seems to feature a floating world, as if lifted from the musings of Borges. In another (below), the plane of the painting is transformed into a desolate marshland, with an owl looming overhead and a *pietà*-like scene below, amidst what appears to be the debris of a lost civilization. In another, a figure in a leopard costume mounts a lion, a cobalt-hued peacock barely visible in the corner, yet the setting seems totally familiar, even uncanny: this image recalls Antoine-Jean Gros' *Bonaparte Visiting the Plague-Stricken in Jaffa* (1804), or the sepia colour scheme and macabre Romanticism of the work of Géricault. Hatami's paintings include elements of magic realism, and are informed by history painting as well as the artist's Persian background. A theme of devastation is also central. 'I am inspired by the natural world, but also by the complexity of human social relationships and the grave misfortunes that mankind inflicts upon itself, which could eventually lead to its destruction.' Hatami's works transcend mere representation, adopting a visual language through which deep-seated psychological fears may be discussed. Through the mystique of painting we might also undertake an emotional journey; in this case, one that 'often begins with aesthetic pleasure and ends with feelings of revulsion; or perhaps exhilaration at being exempt from what's going on in the painting'.

'My paintings mainly depict
the subject of death, portraying
it as a combination of one's
deepest childhood memories in
contrast to the enormity and
sublime horrendousness of nature.'

Opposite: *The Child and
his Inner Mother*, 2013, oil
on canvas, 145 × 145 cm
(57 × 57 in.)

Above: *The Weightless
Imagination*, 2013, oil
on canvas, 145 × 145 cm
(57 × 57 in.)

Shahryar Hatami

ANDRÉ HEMER

b. 1981, Queenstown, New Zealand
Lives and works in Sydney, Australia

André Hemer is quick to note the sources that inform his paintings, which have titles such as *Swag*, *Smushing and Nicki Minaj* and *Diamonds and Swimming Pools*. 'Colour gradations, vector scrawls, spray tools, tessellated screensavers, painted gestures and digital glitches are layered, composed, entangled and erased, embracing the possibility, beauty and failure of the slippage between digital and objecthood.' Hemer's works are eminently topical, oozing from a zeitgeist of Photoshop and graffiti, and even a cool sense of Aussie surfboarder aesthetic: loud, bright and uncompromising. His art is explicit in its contemporary context. He does not try to hide his works' 'superficiality', their prioritization of surface, shine and optical stimuli creating a connection between video game,

computer screen and studio floor. However, despite the paintings' neon colour schemes and flattened compositions, they revert to a confidence in communication through a series of familiar visual cues. 'Ultimately they always navigate back to physicality and the materiality of paint,' the artist states. He goes on to comment: 'I have grown up in a generation that had its way of interfacing with the visual world completely altered by the screen and virtualization. Images are flat, back-lit and fast-moving.' Yet his paintings maintain a critical distance, appearing detached from this way of looking, without becoming senselessly graphic. As Hemer asks: 'When else in history could a painting be informed simultaneously by both Cy Twombly and the Apple homepage?'

Right: *Diamonds and Swimming Pools*, 2012, acrylic on canvas, 157 × 137.5 cm (61⅞ × 54⅛ in.)

Opposite: *Auto Tone (inexplicable things that hipsters say)*, 2012, acrylic on canvas, 60.5 × 45.5 cm (24 × 18 in.)

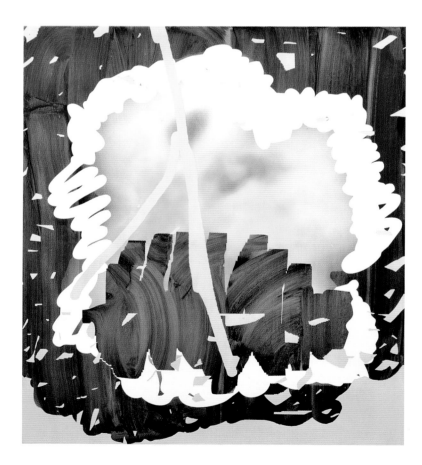

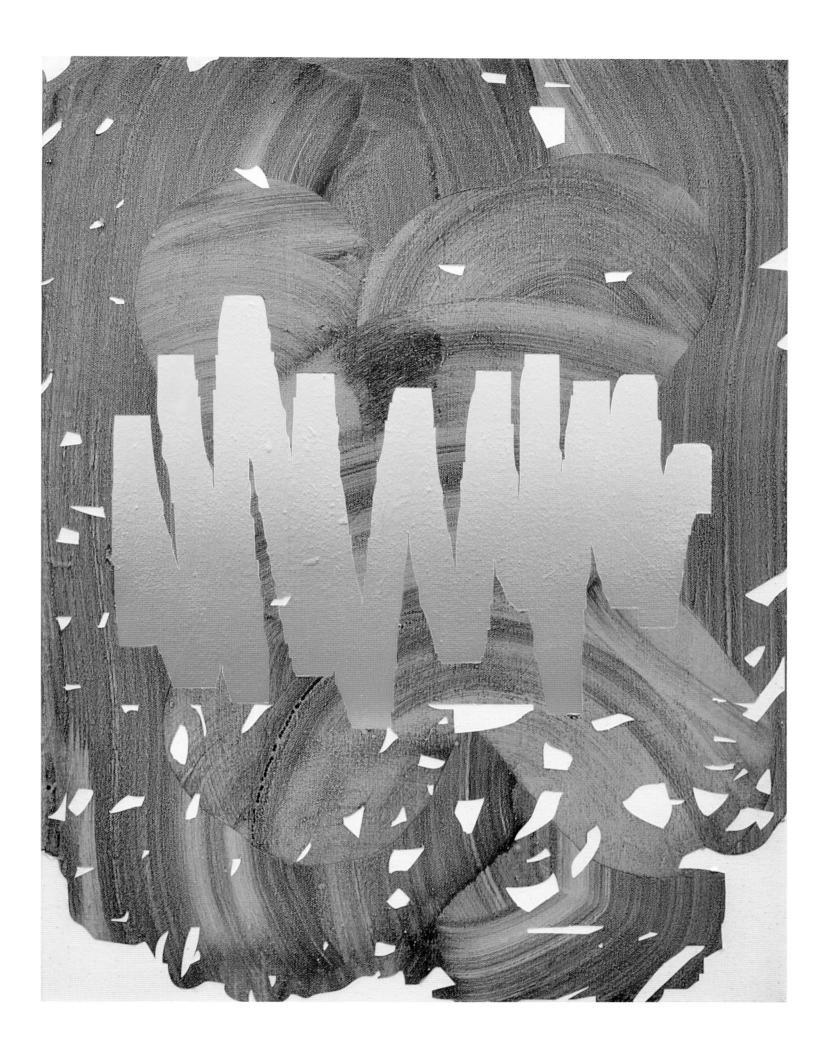

André Hemer

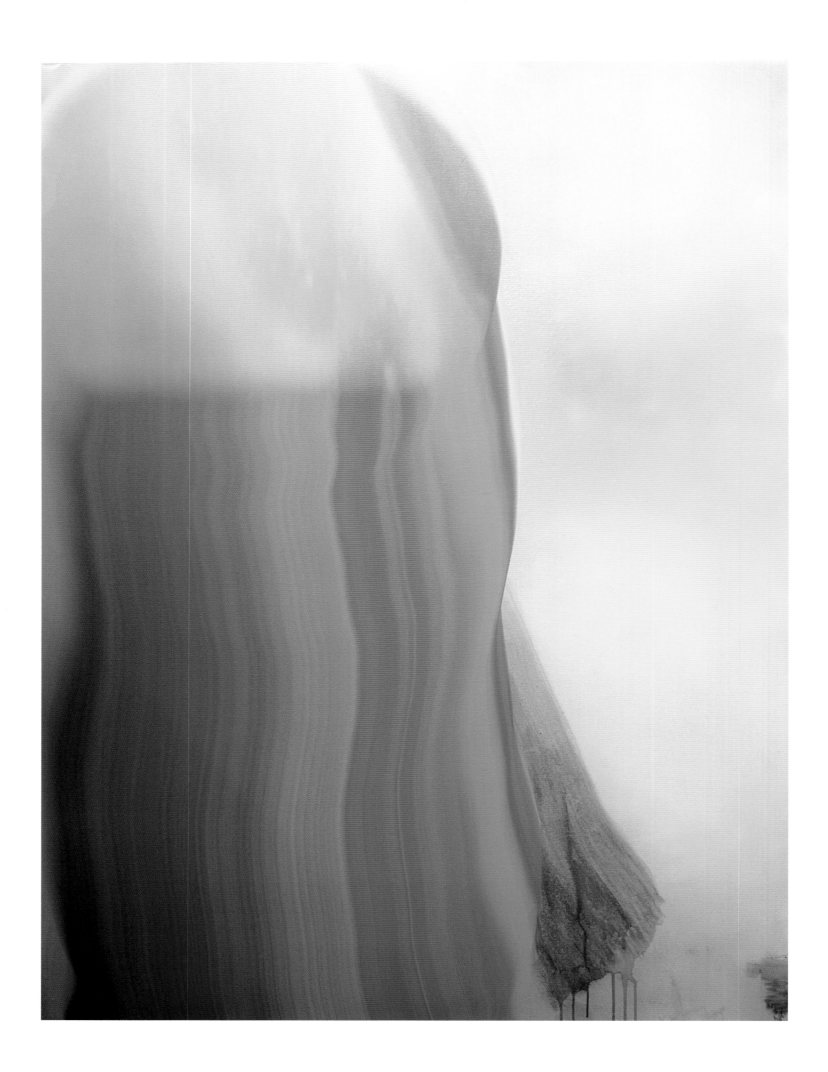

'Each painting can be seen as a
stack of gestures. Sometimes these
stacks are minimal, such as a raw
canvas gesture appearing to cut
through a spray-painted gradient.
Sometimes they are more complex,
interweaving or fragmented.'

Opposite: *New Smart Object
#61*, 2013, acrylic and pigment
on canvas, 183.5 × 137.5 cm
(72 × 54 in.)

Above: *New Smart Object #64*,
2013, acrylic and pigment on
canvas, 35 × 28 cm (14 × 11 in.)

André Hemer

HANNAH HEWETSON

b. 1977, Oxford, England
Lives and works in London, England

For Hannah Hewetson, painting is about tangible, evident reactions that can be seen upon a canvas. She avoids concept, subject matter and theme in favour of purely technical aspects: the tactility of paint, the visual message and the responsive qualities of her own subjective process while painting. 'My work is an investigation into the relevance and possibility of the painted mark, through both an engagement with it and detachment from it,' she states, navigating each work as though it were a series of problems seeking resolutions as the issues present themselves. Often she paints over existing works to create new layers of meaning, the ghostly traces hinting at previous paintings that may have been unresolved. The insinuation of this approach

– painting as palimpsest – dislodges the work from being mere design or composition, suggesting a deeper reading and reinforcing the work's process-driven creation, wherein Hewetson articulates and re-articulates an intuitive vision. Her method owes its playful, organic spontaneity to causality and chance: each gesture informs the next, and each painting leads to its successor. 'One painting is usually a response to the previous one, or to the others around it,' the artist notes. Revelling in her medium, she also comments: 'As a material to work with, paint is surprising, it can be illogical and, more interestingly, it embraces failure. I am interested in the physicality of the painted gesture. I also see painting as a means of igniting thought and the imagination.'

'My paintings are about actions where the balance between restriction and liberation is key. I continually question the value of my painted marks, and there is a ruthlessness and purity in the way I select and delete information.'

Right: *Dancer*, 2011,
oil on linen, 52.6 × 38 cm
(20¾ × 15 in.)

Opposite: *Lights*, 2013,
oil on linen, 60 × 40 cm
(23½ × 15¾ in.)

Hannah Hewetson

AKIRA IKEZOE

b. 1979, Kochi, Japan
Lives and works in Brooklyn, New York, USA

Food, sleep, sex: some of our most fundamental human needs and desires. Though the gloss of civilization has tempered our animalistic urges, they still lie intact within us. In the work of Brooklyn-based Japanese artist Akira Ikezoe, the questionable authority of civilization is constantly challenged. *War at Zoo* (below) or *The Olympics* (opposite above) seem to glorify decadence, violence and humanity's carnal urges. As Ikezoe states: 'Within my practice, I mainly investigate "human instability": the disconnection between mental activity and physical function. Nature exists not only in our surroundings but also within our body. Many activities related to animal instinct make me aware of our connection to nature. Therefore the

existence of our bodies lies in between human and nature.' His paintings, filled to all four corners with an abundance of visual information, depict the human condition with irony and humour, their scenes seemingly situated in a time-lapsed version of reality. In *The Way To and From School* (opposite below), nude figures are dispersed in a naturalistic idyll, with one standing atop an oversized iPhone. Ikezoe points out: 'By exaggerating the human body's construction, such as muscles and joints, I create "human-like" figures that are missing something essential to identify them as human.' For Ikezoe, art is an umbilical cord between the savage forces of nature and our attempts at cultivation. It addresses the ongoing struggle to understand our evolving place in the universe.

Opposite: *War at Zoo*, 2011, oil on canvas, 101 × 137 cm (39¾ × 53⅞ in.)

Above: *The Olympics*, 2012, oil on canvas, 127 × 158 cm (50 × 62¼ in.)

Left: *The Way To and From School* (diptych), 2012, oil on canvas, each 56 × 41 cm (22 × 16 in.)

EWA JUSZKIEWICZ

b. 1984, Gdansk, Poland
Lives and works in Warsaw, Poland

In the history of art, stereotypical representations of women are discouragingly predominant. Ewa Juszkiewicz, who trained at the Academy of Fine Arts in Krakow, is highly sceptical of any such antiquated gender norms. In her recent work, she rejects canonical depictions of beauty that conform to the 'feminine ideal'. Her paintings, while traditional in terms of technique and execution, challenge convention through the use of whimsical or downright disturbing elements to conceal her subjects' faces. She notes, 'I always use reproductions of original works – that means, a borrowed image of an image – to create a deconstructed image based on it.' The conventional appearance of her subjects – mainly women, but also occasionally men – is negated by the inclusion of these obscuring forms. Juszkiewicz views her works as acts of transgression. She takes inspiration from 'extraordinary faces, cabinets of curiosities, tribal masks from different cultures, contemporary and historical fashion, baroque aesthetics, and Renaissance painting in terms of attention to detail'. With the addition of elements of the fantastical or cultural, such as a decontextualized totem-pole mask, her works dance on the edge of parody, poking fun at the expectations of the past. Although Juszkiewicz recognizes that painting is itself a medium rooted in the past, she believes that it lends itself to being easily applicable to issues of contemporary society. Within her work, paint is an effective transmitter of social and political messages.

Left: *Locks*, 2012, acrylic and oil on canvas, 130 × 100 cm (51¼ × 39⅜ in.)

Opposite: *Cardinal*, 2012, oil on canvas, 145 × 90 cm (57 × 35⅜ in.)

Ewa Juszkiewicz

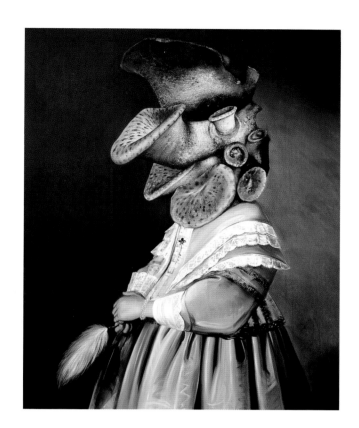

'My work appropriates Old Master portraits. By deconstructing classical images, I take a critical view of the way women have historically been depicted. Replacing faces with other forms changes perceptions of the human figure.'

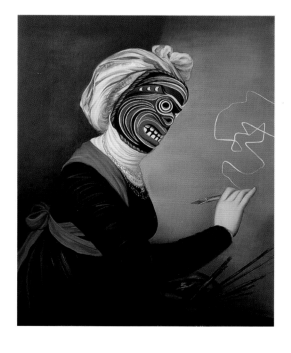

Opposite: *Straw Hat*, 2012, oil on canvas, 170 × 125 cm (66⅞ × 49¼ in.)

Above left: *Maria*, 2013, oil on canvas, 130 × 100 cm (51¼ × 39⅜ in.)

Above right: *Girl in Blue*, 2013, oil on canvas, 200 × 160 cm (78¾ × 63 in.)

Left: *Self-Portrait at the Easel*, 2013, oil on canvas, 80 × 65 cm (31½ × 25⅝ in.)

Ewa Juszkiewicz

TAMARA K.E.

b. 1976, Tbilisi, Georgia
Lives and works in Brooklyn, New York, USA

Tamara K.E.'s works may at first appear to be whimsical, simple, colourful sketches executed with the gestural quality of scribbles. However, further consideration reveals each painting to be anarchic, unfolding and dynamic: 'ex-static', as the artist has stated. Perhaps their scale is telling: with most pieces measuring over 1.5 metres (5 feet) in height and 1 metre (3 feet) in width, they belie their coquettish nature. K.E. denies any conceptual meaning, stating that the works are bereft of the political and beyond the social or linguistic; that they are, rather, a desirous exploration of consciousness. In both treatment and scale the paintings recall the work of Twombly, or perhaps reduced re-

imaginings of Kandinsky, or Sonia and Robert Delaunay; they may even remind us of the graphic quality inherent in Andy Warhol's early drawings. K.E. describes a process of turning colours, events and signifiers into a 'substance of seduction'. Poetically and enigmatically, she is quoted as saying that her art lies 'where vital wind of unlimited desire joins pain and pleasure, deprived word and psalm, dark abyss and transparency of the heights of mountains. Here, within this new world castles are built out of boiling magma and we are knights of desire'. K.E.'s vibrant new worlds – in which she, as artist, is like a nomad, wandering through sultry, dream-like terrains – defy easy comprehension or classification.

Left: *Lolly*, 2012, oil on canvas, 148 × 127 cm (58 × 50 in.)

Opposite: *Shithead*, 2013, oil on canvas, 183 × 142 cm (72 × 56 in.)

Tamara K.E.

ALON KEDEM

b. 1982, Jerusalem, Israel
Lives and works in Jerusalem

'What stories do we tell ourselves? How do we perceive reality?' Alon Kedem, a graduate of Jerusalem's Bezalel Academy of Art, believes these inquiries to be critical to the act of painting. He intends his works to be platforms open to interpretation. As he puts it, he is interested 'in the intermediate space between "inside" and "outside"'. For Kedem, the paintings are defined by suggestion as well as explication, allowing viewers to read reality through their own 'veil of unconscious subjectivity'. Through a system of signs articulated in paint, Kedem is concerned with how we perceive and understand language via the visual, semiological systems that typically surround us in daily life. His paintings, suggesting movement and featuring scenes in transition, offer a nostalgic idea of progress, with assembly lines replacing human presence. In one example, a painterly mass appears to be a depiction of a rubbish heap; in another, this same pile appears more corporeal, like a pyre of detached limbs. The artist credits Philip Guston as a primary influence, citing his coding of personal symbols and indecipherable objects. In Kedem's works, despite their simplified renderings, we sense a deep subjective complexity and point of view. One particular painting (overleaf) articulates the artist's wry, almost macabre perspective. In it, a box sits atop a conveyor belt, but upon closer inspection one may perceive the presence of bodies. All is tempered by Kedem's preferred palette of pastels: a painterly scene navigating through horror, humour, nostalgia and play.

Opposite: *Eventually We Will Find It*, 2013, oil on canvas, 150 × 200 cm (50½ × 79 in.)

Above: *Moonlight Scramble*, 2012, oil on canvas, 160 × 160 cm (63 × 63 in.)

Right: *Mirror Room*, 2012, oil on canvas, 120 × 160 cm (47 × 63 in.)

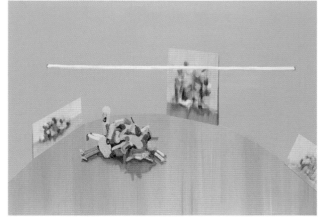

Alon Kedem

Above: *Moving Forward*,
2013, oil on canvas, 170 × 270
cm (67 × 106 in.)

Opposite above: *The New
Place*, 2013, oil on canvas,
130 × 140 cm (51 × 55 in.)

Opposite below: *Cruising*,
2012, oil on canvas, 130 × 160
cm (51 × 63 in.)

'My work deals with questions
of creation and destruction. I am
looking for open situations into which
diverse interpretations can be read.
I try to build interesting "settings"
that viewers can enter, or look at,
and bring their own world.'

Alon Kedem

JENNY KEMP

b. 1979, Sheboygan, Wisconsin, USA
Lives and works in Troy, New York, USA

The human body represents a vast world of unseen interactions. The artist Jenny Kemp is intrigued by that which is hidden and unobserved. Her biologically inspired paintings act as meditations on human relationships to the organic world. Patterns, made with delicately crafted lines, flow over the surface of her works, suggesting a constant state of physical and emotional development and change. But, while Kemp draws on her keen interest in science, she tempers her fact-based sources with her artistic sensibility. 'I am inspired by the interactions of form, colour and sounds in space,' she says, noting that she also creates small stop-motion videos from her paintings in Photoshop, 'which in return feed inventiveness to the painting'. The passing of time is a key influence on her practice. 'Time can be seen through layers of colour and intricate growth patterns.' Kemp views painting as an inherently temporal medium, each brushstroke serving as a document of a specific moment, wherein 'the accumulation of individual marks in a painting acts like a record of history'. She also draws attention to materiality through her freely abstract compositions. Titles such as *Conchodial* and *Decodelia* reference both personal memory and imagination, as well as naturally occurring systems. In some ways, the materiality of paint serves as a metaphor for the cycle of physical and organic relationships throughout the course of human lives; Kemp's highly individual process appears to reference this.

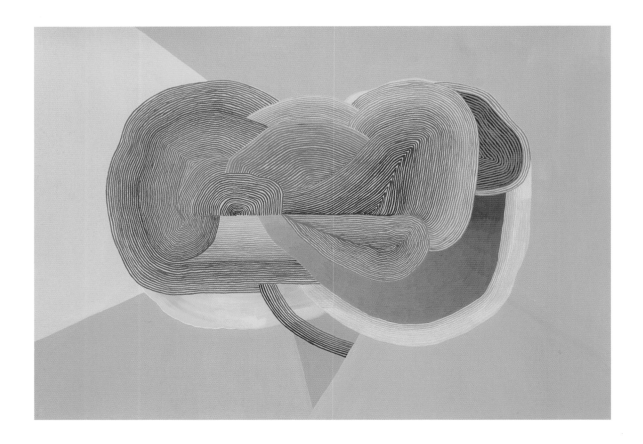

Left: *Conchodial*, 2013, gouache on paper, 46 × 61 cm (18 × 24 in.)

Opposite: *Concentricity 2*, 2012, gouache on paper, 76 × 51 cm (30 × 20 in.)

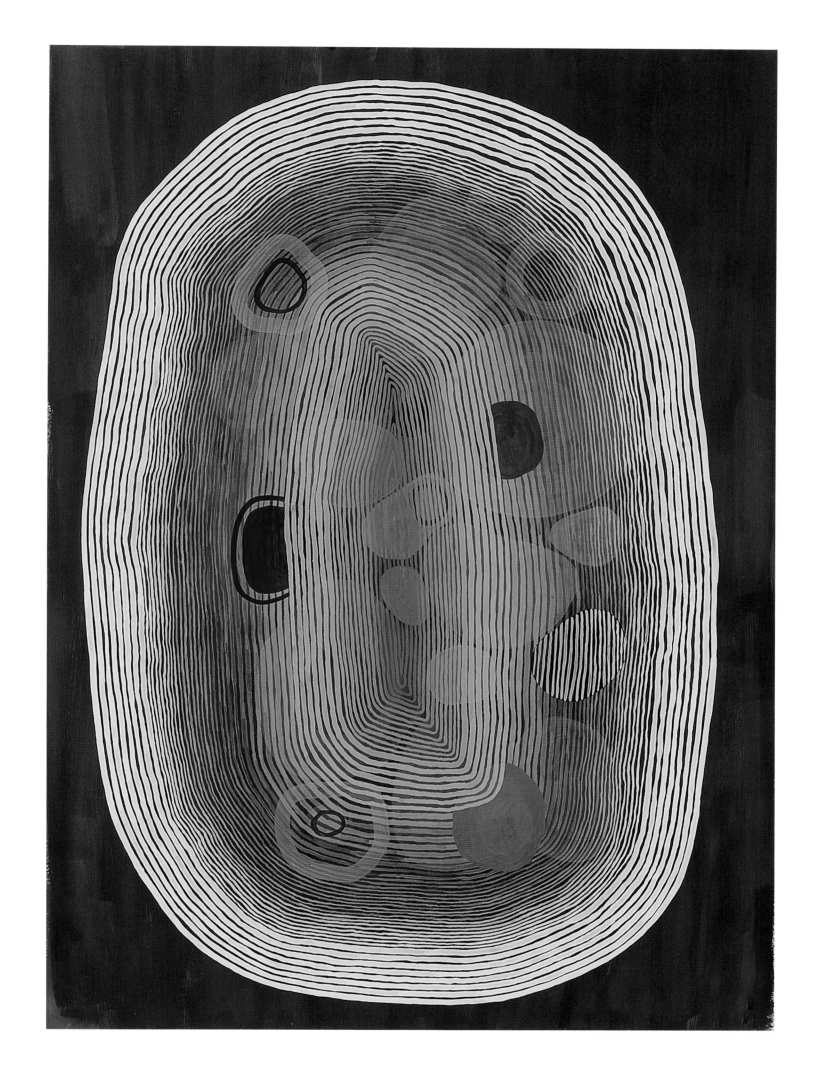

Jenny Kemp

'The subject matter of my work
stems from contemplations of
human beings and our relationship
to organic matter. Biologically
inspired imagery is built through lines
and planes of subtly shifting
hue intensities, generating form
through a slow additive process that
parallels growth in nature.'

Above: *Crevice*, 2012,
gouache on paper, 51 × 76
cm (20 × 30 in.)

Opposite: *Decodelia*, 2013,
gouache on paper, 76 × 51
cm (30 × 20 in.)

Jenny Kemp

JAMES KUDO

b. 1967, Pereira Barreto, Brazil
Lives and works in São Paulo, Brazil

In the early 1990s, the beloved hometown of Brazilian artist James Kudo was devastated by flooding following the construction of a hydroelectric power plant. Overwhelmed by the destruction of the landscape so familiar and dear to him, Kudo turned to art to communicate the complexity of the loss. His paintings are based on the transience of memory and the overarching theme of transformation. Just as the flood inexorably submerged his town, so Kudo maintains that memories are inevitably submerged in the tides of passing time. Given this consideration, it is notable that his paintings often seem to depict architectural debris afloat in space (and time), as though suspended just above the surface of the painting. For Kudo, the act of painting presents an opportunity to recover and make permanent fleeting moments; those overlapping elements which seem to constitute the fragments of memory that can so easily slip through the cracks and become almost intangible or forgotten. 'I am inspired by these submerged memories,' he says, 'by nature, by the artificial and the layers that overlap the imagery.' Indeed, there is always the question of the accuracy of these painted recollections. Subjectivity and fiction play a role in Kudo's work, and he consistently implies the fiction of memory itself. Painting allows him to record, however subjectively, the elusive reminiscences of his childhood. For Kudo, the result has come to represent a reclaimed version of the past, both for himself and for the viewer.

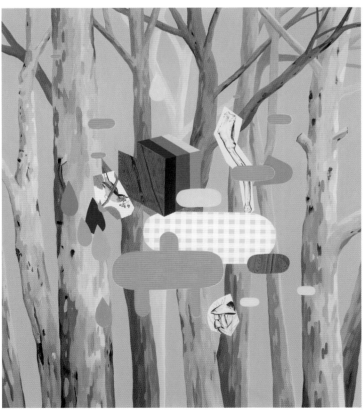

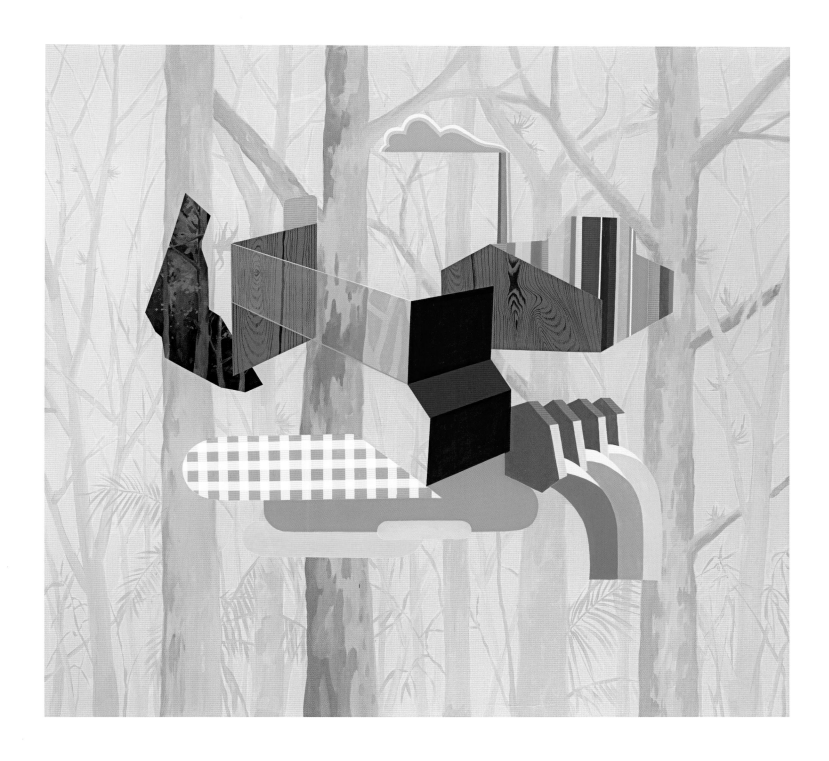

'My work consists of fragments of memory; like single words in a haiku. It is up to the observer to create the link between these clippings of images.'

Opposite left: *When I Left Home*, 2012, acrylic on canvas, 160 × 140 cm (63 × 55⅛ in.)

Opposite right: *Topophilia*, 2012, acrylic on canvas, 160 × 140 cm (63 × 55⅛ in.)

Above: *Hydroelectric Plant*, 2011, acrylic on canvas, 150 × 160 cm (59 × 63 in.)

James Kudo

153

TALA MADANI

b. 1981, Tehran, Iran
Lives and works in Los Angeles, California, USA

Tala Madani, born in Iran and educated at Yale University, is concerned with visualizing the simple ideas that can give rise to major dramatic moments. Dark comedy lends itself effectively to her work, which often features scenes that seem particular to her cultural heritage, even if somewhat obscurely referenced, critical and even obscene. Elements are repeated: legs, stripes, figures, all executed with plain lines and a rudimentary style. Occasionally figures and backgrounds are morphed to create an absurd sense of place and identity, and at times the immediacy of negative space seems almost to overwhelm the subject matter. Themes of identity, anonymity, discomfort and (breached) conformity are prevalent, Madani employing a cast of crudely painted, bald characters – sometimes brown-skinned, like fictional Iranian stereotypes – to engage in scenarios that blend primitive execution with cultural perversion. It is the discomfort of the viewer as much as the awkwardness of the subject matter that produces the works' effective tension. These men are vomiting, shaving, eating, embracing and at play, but Madani's consideration never seems entirely comforting. For her, the materiality of paint references the visceral actions on display, provoking polarizing sensations of repulsion and intimacy. This draws the viewer closer to the strange worlds portrayed, enabling a heightening and questioning of the work's odd display in relation to the West's often vilified, oversimplified understanding of Iran and Greater Asia.

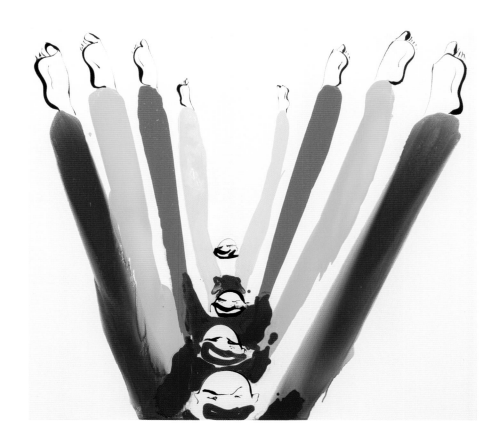

Left: *Morris Men with Brown Stain*, 2013, oil on canvas, 152.4 × 167.6 cm (60 × 66 in.)

Opposite: *Blackout*, 2012, oil on linen, 59.7 × 44.5 cm (23½ × 17½ in.)

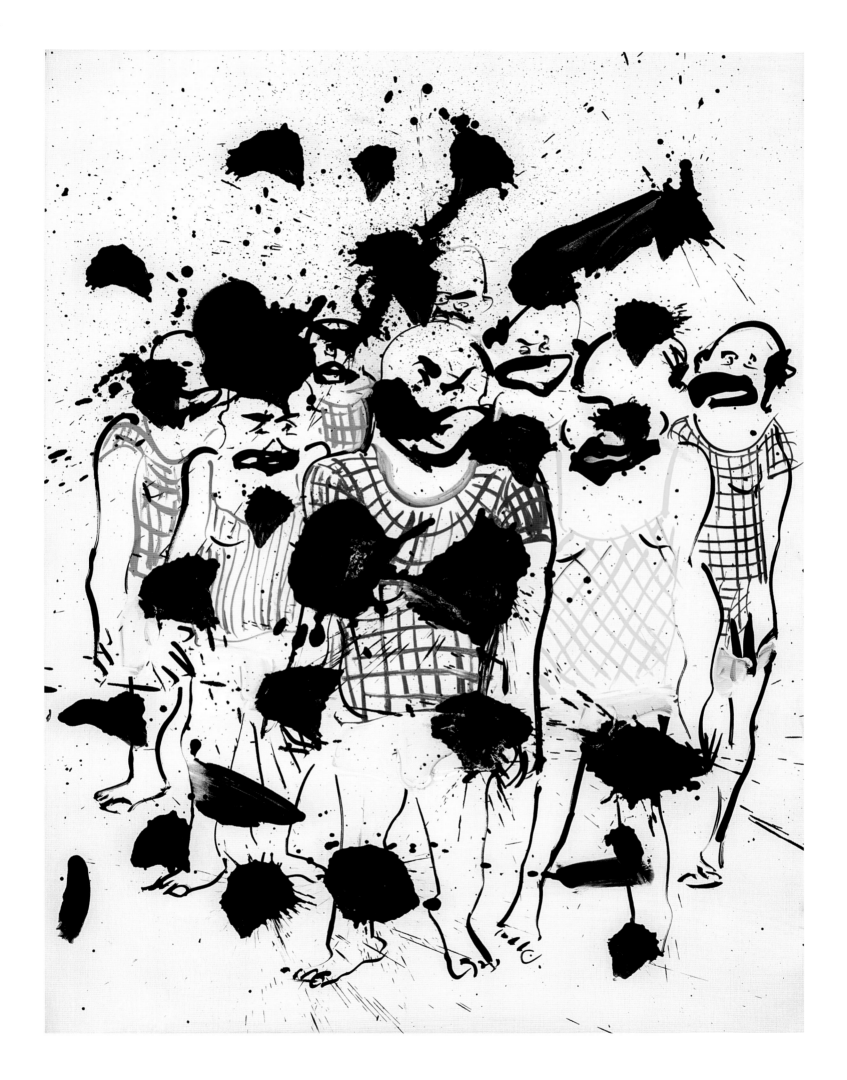

Tala Madani

FRANK MAIER

b. 1966, Stuttgart, Germany
Lives and works in Berlin, Germany

It may seem as if abstraction and realism are opposing genres that cannot be reconciled, but the paintings of German artist Frank Maier beg to differ. Maier considers abstraction to be simply an extension of reality. His paintings are reflections on real-life experiences, and in some ways he views painting itself as a manifestation of authenticity. This may seem like a paradox given the stark, 'design'-like works that he produces, but for Maier his paintings concern a narrative; almost like a constellation that traces memory and emotion. He has pointed out: 'A painting insists on its format, on its rigidity, on its selfhood, and through

this it attains an immense freedom and openness.' Maier exploits these possibilities by establishing a set of modes in each work that seeks to alter the way in which we, as viewers, consider and understand symbols. The elements of line and geometry on his canvases provoke a discourse on the significance that these symbols hold in our lives, both in a literal and metaphorical sense. 'Painting is a cultural construction to debate life,' says Maier. For him, the medium of painting is the only way to explore profound concepts. The physicality and materiality of paint become an allegory for human existence.

'My paintings don't just aim at mere surface or a well-balanced pattern. They are indebted to a physical – an experienced – narrative mode. They are about, and hopefully convey, reality.'

Left: *Re: ... drei Schatten (Re: ... three shadows)*, 2013, acrylic on nettle, enamelled wooden box, frame lath and painted wood, 181 × 78.5 × 11.5 cm (71¼ × 30⅞ × 4½ in.)

Opposite: *Offense/Defense (diptych)*, 2011, acrylic on nettle, enamelled wooden box, frame lath and painted wood, 184.5 × 194.5 × 7 cm (72⅜ × 76½ × 2¾ in.)

Frank Maier

LAEL MARSHALL

b. 1968, Seattle, Washington, USA
Lives and works in Brooklyn, New York, USA

For American artist Lael Marshall, art begins with interaction and manipulation. Her paintings are executed on utilitarian fabrics, such as dishtowels and handkerchiefs, and she enjoys stretching the relationship between paint and pre-existing pattern. She does not simply impose abstraction upon her materials, however; rather, she most commonly finds herself drawing inspiration from her source materials, finding beauty in the textural qualities of cloth and using its unaltered physicality as a base when painting upon it. She enjoys what she calls the 'stubborn' quality of paint, and the often surprising ways in which its application affects her finished

artworks. The natural, unplanned tendency of fabrics to pull and twist in response to paint is something that she both appreciates and embraces.'I love paint,' she acknowledges; 'the body of it; what happens when colours meet.' Even in cases where she does not use paint, she says, 'I sometimes consider a work a painting. It has more to do with my approach to the piece; making decisions and manipulating material in a "painterly" way.' Marshall's process is full of discovery and exploration, and all of her objects, whether painted or not, are crafted and act as tributes to the transformative powers of the artist.

'I am inspired by my materials –
cloth, wood, paint, plaster, soap,
found objects – and their physical
qualities as I find them, and the
ways they can be manipulated,
ordered and arranged.'

Right: *Untitled*, 2013,
ink, rabbit-skin glue and
cotton on wooden support,
35.6 × 25.7 × 2.2 cm
(14 × 10⅛ × ⅞ in.)

Opposite: *L.A. Dishtowel*,
2013, oil, rabbit-skin glue
and cotton on wooden
support, 45.7 × 26.3 × 1.9
cm (18 × 10⅜ × ¾ in.)

TONJE MOE

b. 1978, Trondheim, Norway
Lives and works in Gratangen, Norway

The dichotomies inherent in painting sometimes present a visual or conceptual challenge through which an artist's entire practice can find its purpose. Tonje Moe considers it her mission to strike a balance between order and disorder, harmony and harshness, truth and fabrication. In her paintings, geometric forms are placed within an indefinable space and are thus isolated from a sense of representational authenticity. Her works have a hallucinatory quality that causes the viewer to oscillate between foreground and background, reality and reverie, architecture and nature. The meditative and mindful Moe Pettersen states: 'I make organic paintscapes with references to vegetation, earth, sky and fjords.' Inspired by the transcendent power of the natural world, she incorporates abstracted organic imagery into her work, usually confined within the borders of her geometric objects. This simultaneous appreciation for architectural structure and organic fluidity manifests itself clearly. It is by juxtaposing seemingly opposite visual identities that the work takes on a complex and multilayered meaning. A key influence has been Norwegian artist Inger Sitter, whose abstract expressionism and mastery of gestural painting impress Moe Pettersen with their confidence and powerful energy. Of her own animation of a flat surface, Moe Pettersen says, 'I love to make a painting breathe, to create bits that move in and out, surfaces where something is growing one second and shrinking the next. The painting comes alive.'

'The mystery of nature never ceases to astonish me: the colours, the shades, the depth. I am also, maybe paradoxically, inspired by design: there is a lot of beauty in man-made objects and in architecture. Sometimes my work looks like nature trapped in boxes, or nature morphing into straight lines.'

Left: *Turn up the silence,* 2012, acrylic on canvas, 100 × 80 × 3 cm (39⅜ × 31½ × 1⅛ in.)

Opposite: *Unpredictable periscope,* 2012, acrylic on canvas, 100 × 80 × 3 cm (39⅜ × 31½ × 1⅛ in.)

Tonje Moe

GORKA MOHAMED

b. 1978, Santander, Spain
Lives and works in London, England

Gorka Mohamed, a graduate of London's Goldsmiths College, seems to pick quite arbitrarily from a canon of art history. His sources include the Spanish Baroque, the Surrealists, animation and a tradition of austere historical portrait painting. His own works – simultaneously grotesque and humorous – exhibit a notable tension between tradition and deviation. Their colour palettes, though piqued with vibrant pinks and highlights, remain relatively understated, given the characters that parade within them. *Balanced Spanish Civil Guard* (overleaf) refers as much to the conventions of compositional correctness as it does to the levelling tool perched atop what appears to be a military guard with a phallus-like nose. Mohamed's works, at once political commentaries and art historical mockeries, feature a recurring

cast of militia-types, foolish dandies and perverted aristocrats, all playing the part of the theatrical outsider. Mohamed's handling is equal parts Velázquez and 'Ren & Stimpy'. Indeed, he has said, 'My paintings embrace a polymorphous perversity close to the one that takes place in certain cartoons that inspire me.' *I'm a Painter* (below) sees the artist turning the lens inward, perhaps upon himself or perhaps as a reflection on the set of canonical expectations from which he hails. It might be Mohamed, but it might also be Picasso; it might be a homage, or it might be a lampoon. 'A painting made during a distant period can have a dialogue with a contemporary painting. Moments of self-revelation or self-mockery present themselves to me by chance ... and I am challenged to [re-think] what I was attempting in the first place.'

Gorka Mohamed

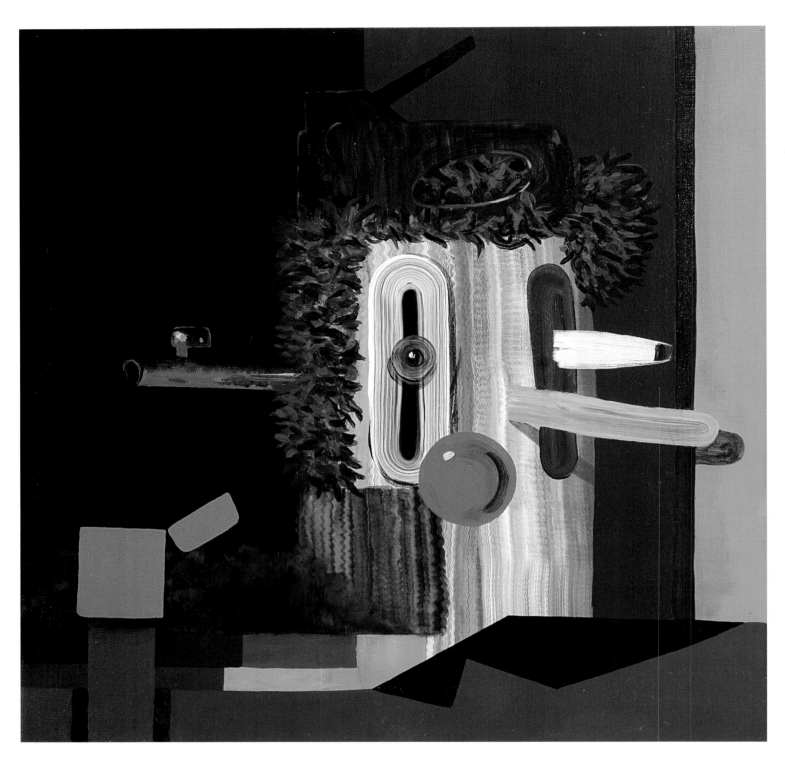

'I am interested in building characters out of an accumulation of shapes, forms and objects. This approach in painting could be compared with the process of constructing sculptures or assemblages. Through my pictorial language there is the intention to reflect on the things that are affecting us psychologically in our socio-cultural reality.'

Opposite above: *Traumatrope*, 2009, acrylic on linen, 50 × 50 cm (19⅝ × 19⅝ in.)

Opposite below: *Quijotismos*, 2008, acrylic on canvas, 60 × 60 cm (23⅝ × 23⅝ in.)

Above: *Balanced Spanish Civil Guard*, 2008, acrylic on canvas, 25.5 × 35.5 cm (10 × 14 in.)

Right: *Unashamedly Erected*, 2011, acrylic on linen, 50 × 50 cm (19⅝ × 19⅝ in.)

GUiLLERMO MORA

b. 1980, Madrid, Spain
Lives and works in Madrid

As a medium, paint might be considered a form of manipulation of the surface to which it is applied. Guillermo Mora appreciates this aspect of the art form. His body of work consists of painted sculptural objects that manipulate the function of painting as we have come to understand it. Removing the medium from its canonical dependence on the framed canvas, Mora cultivates any number of offbeat elements to provide source material for his works: these are paintings that remind us of a rucksack, a rolled carpet, a collapsing ceiling.... Mora is interested in the way we 'tend to gather and contain things' and attempt to compact and compartmentalize our lives. 'We are always trying to adapt and reduce our everyday objects into smaller spaces; to put more and

more information into smaller formats. These forms of storage force the object into a logical/practical system, but what would happen if these systems were applied to the pictorial object?' Mora's sculptural technique, which lends itself to the process of construction/destruction, allows him to reflect on this idea. As layers of paint transform and build up the surface of an object, so the object itself becomes hidden in both literal and metaphorical ways. 'I work through the manipulation of the mechanisms of making a painting,' says Mora. He sees paint as a chance at a second life for his materials – his bits of wood, his metal hinges, his rubber bands – whereby they are transformed and newly positioned in relation to their otherwise decorative or superfluous former lives.

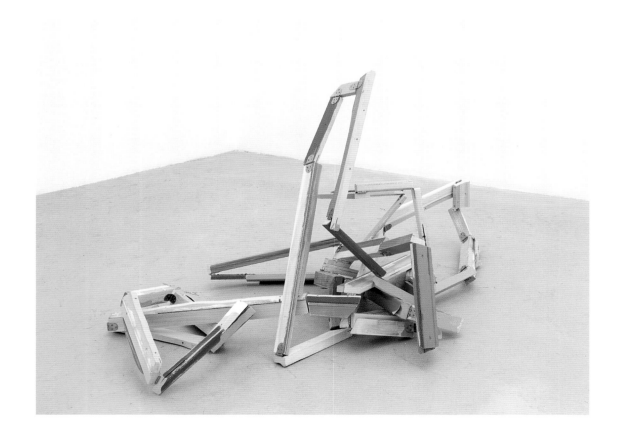

Left: *Signo*, 2007, oil and resin on canvas, wood, 103 × 5 × 23 cm (40½ × 2 × 9 in.)

Opposite above left: *Prototipo* (mobile piece), 2011, mixed media on fragments of stretchers, metal hinges, 100 × 183 × 119 cm (39⅜ × 72 × 46⅞ in.)

Opposite above right: *Uno tras otro/otro tras uno* (mobile pieces), 2011, gouache, acrylic, vinyl, oil, enamel and varnish on wood, variable dimensions

Opposite below: *[She] [If]*, 2011, layers of acrylic paint tied with the fragment of a painting, and acrylic on cotton tied with rubber bands, 17 × 21 × 27.5 cm (6⅝ × 8¼ × 10⅞ in.)

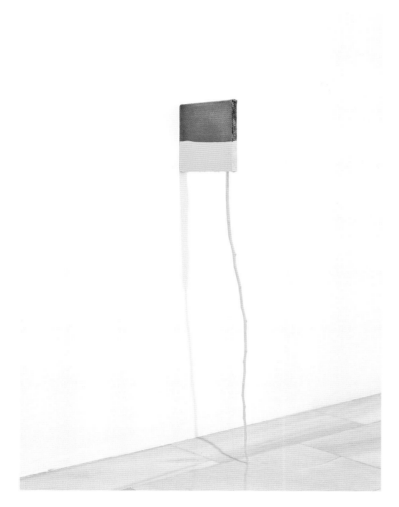

Guillermo Mora

RYAN MOSLEY

b. 1980, Chesterfield, Derbyshire, England
Lives and works in Sheffield, South Yorkshire, England

The works of Ryan Mosley seem to tell tales rooted in fantasy and the macabre. In *Dance of the Nobleman* (opposite above), the viewer is confronted with a painting framed as though it were a stage. A group of onlookers in silhouette line the canvas and witness the curious spectacle of a figure, clothed in black, dancing alongside a skeleton and a series of apparently floating skulls. The entire piece glows from an unearthly neon orange under-painting, typical of Mosley's work, as though the story has evolved from where it first began. In this way Mosley suggests further layers of meaning beneath his chosen vignettes. His is a powerful language – one of recurrent figures, such as lonesome farmers, bearded noblemen and gentlemen in top hats. The setting is performative,

even 'silly', but belied by a sense of claustrophobia and nightmare. Mosley has stated that the stage setting helps free his paintings from the rational and creates a space where ambiguous narratives and anthropomorphic objects can swirl and intoxicate. A sense of sadness is present, too, in the futile pursuits of the often solitary protagonists. 'Painting is uplifting,' says Mosley, 'but it is depressing and tormenting equally.' As viewers, we are privy to this paradox through the limited portals offered to us. Are these works magically realistic? Fantastical? Folkloric? The extent to which Mosley has based his scenarios on reality is ambiguous, but perhaps this is the accomplishment of these works: we as viewers find ourselves pressed to dig further into the worlds he has created.

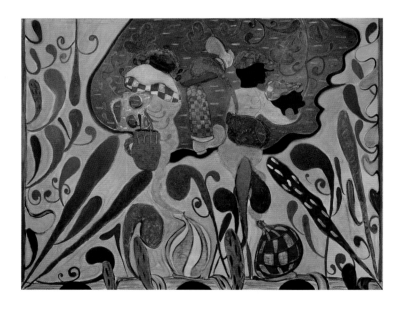

Right: *When the Wall Becomes the Vehicle*, 2012, oil on canvas, 210 × 275 × 3.2 cm (82⅝ × 108¼ × 1¼ in.)

Opposite above: *Dance of the Nobleman*, 2011, 215 × 185 × 3.2 cm (84⅝ × 72⅞ × 1¼ in.)

Opposite below left: *Gardening Victory*, 2013, oil and watercolour on linen, 260 × 183 × 3.2 cm (102⅜ × 72 × 1¼ in.)

Opposite below centre: *Primitive Ancestry XI*, 2011, oil on canvas on board, 120 × 100 × 3.2 cm (47¼ × 39⅜ × 1¼ in.)

Opposite below right: *Nature Boy*, 2010, oil on linen, 215 × 154 × 3.2 cm (84⅝ × 60⅝ × 1¼ in.)

'In my work I attempt to elaborate on a narrative that seems to have no beginning or ending. Painting is a language that evolves so much through its making that, even for the author, it becomes difficult to re-trace the passages painted.'

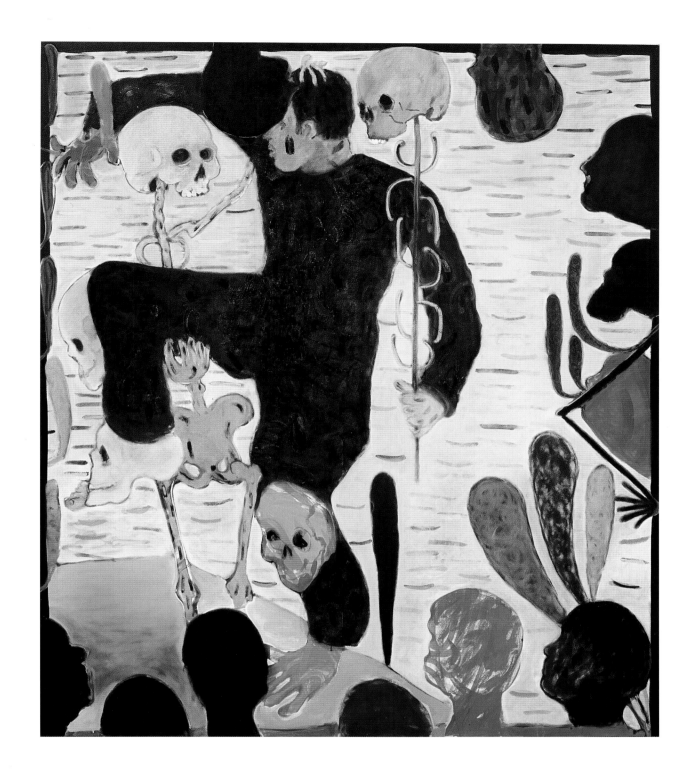

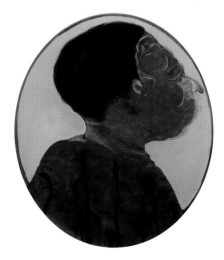

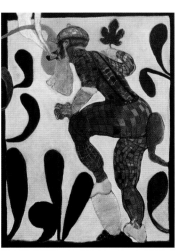

Ryan Mosley

CAROLINE MOUSSEAU

b. 1989, Winnipeg, Manitoba, Canada
Lives and works in Vancouver, British Columbia, Canada

Caroline Mousseau views painting as a negotiation, offering a malleable understanding of how ideas are conveyed and images received. For Mousseau, painting is marked by its predecessors. With slippery meanings and buried histories, it is a medium that spreads itself across material and thought. 'Malleable', 'marked', 'slippery', 'buried': these adjectives, used by Mousseau herself, aptly reference her own practice, which she describes as steeped in 'matte, sullied palettes' and based on imperfect repetitions, wherein systematic structures or unrecognizable landscapes bear the properties of mud but also perform as an allegory for ideas of transition, hybridity, movement and, finally, a confrontation of structural power. One work, *seep slow*, bears an impasto latticework motif that seems to reference the minimalist (and meaningless) pattern-making present in the work of Agnes Martin. *Half-set* (below right) suggests a similar repeating motif, just as it might mimic an aerial photograph of a farmer's field, in a vein similar to Dirk Skreber's 'Flood' paintings. It is perhaps a slightly more didactic but equally anti-characteristic approach to the conventional landscape. As 'abstract paintings', Mousseau's works present themselves without any sense of form, as though she were eager to do away with the hierarchy of imagery. Indeed, she admits that she is 'continuously searching for moments of hybridity'. Her works conjure up emotion by playing on the viewer's relationship to the image and its lack of meaning.

Above left: *float (follow)*, 2013, oil on canvas, 183.5 × 122 cm (72¼ × 48 in.)

Above right: *half-set*, 2012, oil on canvas, 180.3 × 122 cm (71 × 48 in.)

Opposite: *quickfired*, 2013, oil on canvas, 122 × 91.5 cm (48 × 36 in.)

'My paintings embody constant progressions of movement between positions or states of being. I am not looking for a solid footing, but rather a crucial and critical ambiguity. My paintings strive to become hybrid forms.'

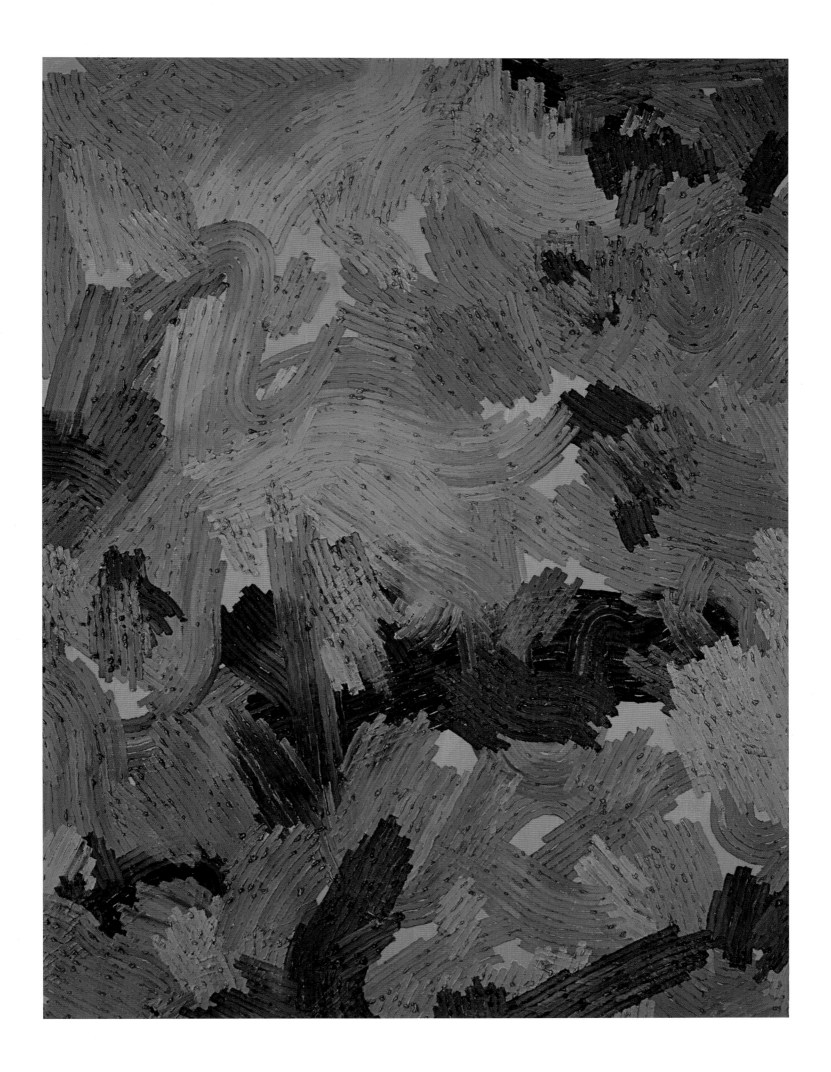

Caroline Mousseau

MARK NADER

b. 1986, Basingstoke, Hampshire, England
Lives and works in London, England

Mark Nader's paintings are like visual assaults. With a plethora of patterning, typically executed in a loud, almost garish palette, they confront the means by which we piece together facts about ourselves and our society. Nader's own mixed heritage (half-British, half-Mexican) originally prompted his interest in personal identity and cultural displacement. 'Within the structure of my paintings,' he says, 'I can form a narrative of sorts between these two cultures.' A rich variety of references and icons – digital images from the internet, representations of Aztec and Nahua deities, mismatched cross-cultural objects, among them – are depicted with a naïve primitivism, whereby crude brushmarks and jarring perspectival shifts create an overwhelming sense of magic realism. Combining the aesthetics of Mexican folk art, the presence of *alebrijes* (imaginary beings with both mystical and anthropomorphic properties) and marked references to styles and themes taken from dreams and the idea of the Lacanian Self and Other, Nader forces a nightmarish collapse of realism. While also exploring the digital world and concepts of virtual reality – 'the creatures and figures are distorted references from my research online' – the artist chooses to ground his work in a wonky re-envisioning of 18th-century domestic genre painting. The works thereby create a tension in what we expect to perceive, conventionality infiltrated by the fantastical and by 21st-century cultural anonymity.

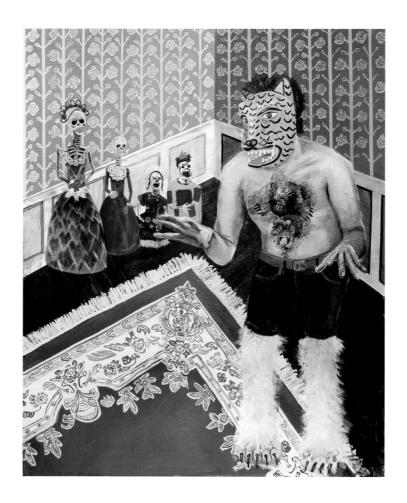

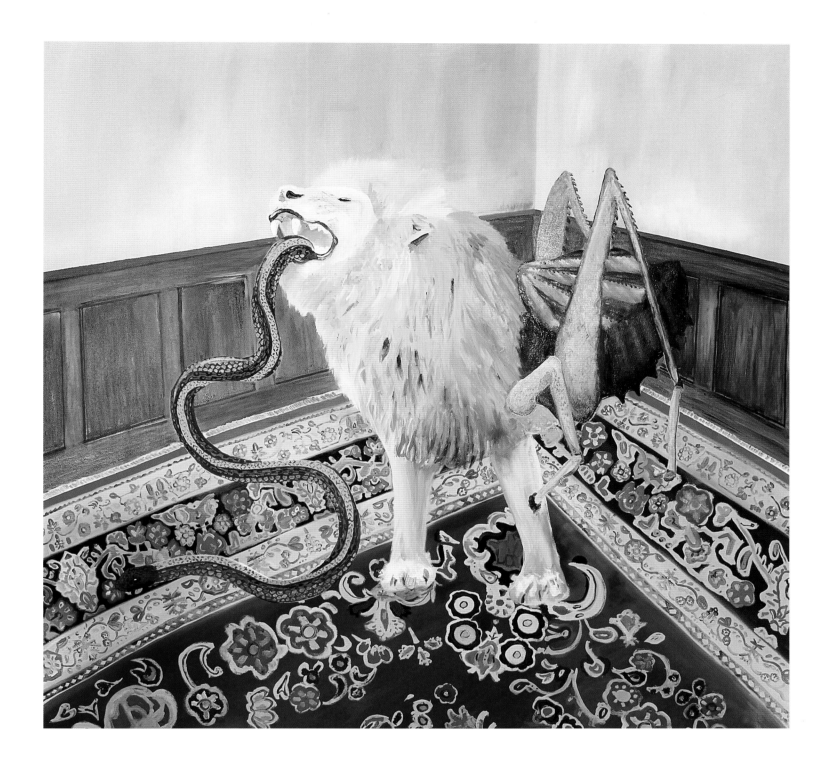

'My work confronts the figurative representation of the clinical, desolate virtual worlds of online games, as well as how we portray ourselves on social media sites. My cross-cultural family background is also of vital significance.'

Opposite: *Dia de los Dead*, 2012, oil on canvas, 130 × 100 cm (51⅛ × 39⅜ in.)

Above: *Google told me wrong*, 2013, oil on canvas, 150 × 160 cm (59 × 63 in.)

Mark Nader

Opposite: *Grasa Dama*, 2013,
oil on canvas, 150 × 150 cm
(59 × 59 in.)

Above: *Perro in a Panda*, 2013,
oil on canvas, 60 × 60 cm
(23⅝ × 23⅝ in.)

Left: *Monkey Correa*, 2013,
oil on canvas, 60 × 60 cm
(23⅝ × 23⅝ in.)

Mark Nader

KiNGA NOWAK

b. 1977, Krakow, Poland
Lives and works in Krakow

Kinga Nowak is a painter for whom the subconscious spirit is the greatest source of inspiration. Forgotten memories from childhood are revisited decades later and inform her work on a subliminal level. It transpires, for example, that recurrent African motifs originate from childhood exposure to a museum of African art – a connection that only occurred to Nowak years later, in adult life. Incorporating elements like these symbolizes the juxtaposition of past and present, a prevalent theme in Nowak's work. Her paintings – a mixture of figurative scenarios, seemingly out of context and set within flattened, almost cartoonish landscapes – aim to express the ambiguity of emotions and relationships, as well as the fragile link between memory and the self. 'I choose

representation,' the artist says, 'but I try to avoid literality or naturalism. Memory joins elements of culture and art with personal experience.' Nowak views paint as a medium through which the thin boundary between what is material, spiritual and intellectual can be crossed. 'Painting lets us grasp something deeper and ethereal,' she notes. 'It is an object and an idea at the same time.' She therefore crafts each of her paintings as a kind of puzzle, attempting to convey a feeling of narrative or metaphor to the viewer on a subconscious level. Only through this methodology does Nowak believe that she is able to reach into the past and solidify her memories and messages for her viewers as something less ephemeral and more substantial.

Above: *Cats*, 2010, oil
on canvas, 130 × 150 cm
(51 × 59 in.)

Opposite: *Trip*, 2013, oil
on canvas, 60 × 40 cm
(23½ × 15¾ in.)

'My paintings constitute a mixture
of associations, apprehensions and
intuition, as in a dream. I want the
reality I create to be symbolic, credible
and impossible all at the same time.'

Kinga Nowak

KAIDO OLE

b. 1963, Tallinn, Estonia
Lives and works in Tallinn

Despite the technical, almost systematic appearance of his paintings, Kaido Ole harbours an appreciation for the unanticipated aspects encountered during the creative process. 'Painting makes a good basis for a well-balanced mix of understandings and creative mistakes,' he states. He chooses to root his own artistic practice in the knowledge that, while a painting can never be perfected, it might come close to offering an augmented reality of that which lies within the mind, despite its reliance on the human hand. This paradox and limitation is a major source of interest for Ole. His often large-scale works seek to emphasize the flaws that remain, despite the mathematical 'visions' that are presented. 'Painting is generally handicraft,' he notes, 'so the result can

never be too good. Despite the effort, a clumsiness always remains, which I consider to be an unavoidable precondition of a great result and mental balance.' In addition, Ole is attracted to painting because it is a familiar form of communication and 'just one more human activity among many others'. As such, he is well aware that his work is open to a wide audience. Taking inspiration from the events of daily life, he removes objects from their original context and reappraises them within the flattened space of his paintings. His artistic output thereby serves to translate personal experience and to communicate his placement within the art historical canon through the medium of paint.

Left: *The First Still Life*, 2011, oil and acrylic on canvas, 160.5 × 160.5 cm (63⅛ × 63⅛ in.)

Opposite: *Still Life with Three Boxes of Ultramarine*, 2011, oil and acrylic on canvas, 200 × 145 cm (78¾ × 57 in.)

Kaido Ole

'My main idea is to find myself and to get approval from society. In other words, I want to present my strange personality to the audience with such confidence that they will have to accept it as normal and self-evident.'

Opposite: *Like-a-Tree Still Life*, 2011, oil and alkyde paint on canvas, 190 × 140 cm (74⅞ × 55⅛ in.)

Above left: *Still Life with Three Colours*, 2011, oil, acrylic and alkyde paint on canvas, 240 × 190 cm (94½ × 74⅞ in.)

Above right: *Still Life with Badly Fitting Objects*, 2011, oil, acrylic and enamel with plastic details on canvas, 150 × 145 cm (59 × 57 in.)

Left: *Still Life with Self-Planted Flowers*, 2011, oil and acrylic on canvas, 220 × 190 cm (86⅝ × 74⅞ in.)

Kaido Ole

181

OLIVER OSBORNE

b. 1985, Edinburgh, Scotland
Lives and works in London, England

Oliver Osborne is captivated by the subliminal. His works can be taken as an apt illustration of an artist who has chosen to indulge in and interpret that which is concealed. He often juxtaposes meticulously rendered realism with ostensibly displaced cartoon drawings, though at times focusing on one or the other in their entirety, seeming to convey a sort of painterly statement regarding the role of images within society. Osborne's *Rubber Plant* has two incarnations: the first, a hyper-real depiction of the titular plant; the second, a depiction with a quick comic scribble added. As viewers, we are left to question the divorce from reality Osborne presents to us. Is the source material even further removed – not a painting of a rubber plant at all, but a painting of an image

of a rubber plant, with another image placed on top? Painting in this mode stems from a long history of artistic exploration, perhaps most deftly exemplified by Magritte with '*Ceci n'est pas une pipe*'. Osborne finds the inevitable historic connotations and commonly understood vernacular of his medium to be both useful and exciting for his own practice. 'I work with both materials and forms that are quite orthodox, but through very careful reshuffling of modes I hope to unseat the paintings a little,' he remarks. Embracing the present status of painting as an (in)effective mode of communication, he says, 'When you try to seek out what orthodoxy might mean, it becomes very illusive, and that opens up a lot of possibilities for something quite unruly and complex.'

'I am interested in the potential for images to harbour and conceal meaning, and the way in which our ability to interpret or respond to pictures is affected and often sabotaged by recognition.'

Right: *Rubber Plant*, 2013, oil on linen, 56 × 40 × 3 cm (22 × 16 × 1 in.)

Opposite: *Rubber Plant (Bar)*, 2013, oil and collage on linen, 45 × 32 × 3 cm (18 × 13 × 1 in.)

Oliver Osborne

SIKELELA OWEN

b. 1984, London, England
Lives and works in London

For Sikelela Owen, the medium of painting presents a unique opportunity to deepen personal relationships. Through the act of painting she challenges herself to obtain a greater understanding of the individuals whose lives have intersected with or impacted on her own, both historically and in the present day. Referencing portraiture of the 19th century, her works have the intimate atmosphere of a quiet conversation with a close friend. Owen embraces this familiarity with her subjects through what she considers to be the immediacy of painting – a characteristic that allows her to close the gap between the painter and the represented subject. 'It is important to me that the figures are specific,' she remarks, 'despite the fact that I don't have a great interest in achieving close likenesses and that my figures are often loosely painted.' While her portraits are largely based on friends and family, they maintain a universal relevance that alludes to issues of race, class and representation. 'While painting black figures is not my main drive, I am aware of the complex histories of the black figure, or its absence on canvas.' Owen goes on to note: 'One of the qualities shared by a number of artists I admire is their ability to conjure out of privacy narratives that are both personal and political, or at least a little ideological.' She herself works with a consideration of the loaded historic connotations associated with painting, and an appreciation for the past that helps to inform the intimate nature of her present portraits.

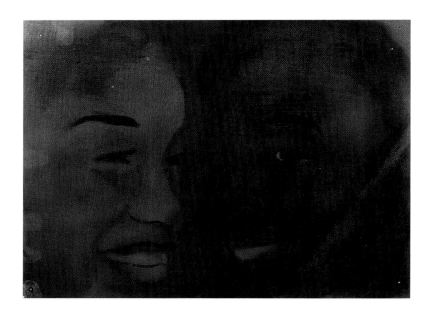

Above: *Me and Jo*, 2013, oil on canvas, paper, 22.9 × 30.6 cm (9 × 12 in.)

Opposite above: *Xabas of Sheffield*, 2012, oil on canvas, paper, 25.2 × 40.8 cm (10 × 16 in.)

Opposite below: *Sleeping Cousin (Mureki)*, 2011, oil on canvas, 100 × 125 cm (39⅜ × 49¼ in.)

'The origins of my work are people, communities and a desire to understand – and to project my understanding into the sphere of painting. Through interpreting and re-interpreting subjects, I can explore parallels between personal and wider experience.'

Sikelela Owen

DJORDJE OZBOLT

b. 1967, Belgrade, former Yugoslavia
Lives and works in London, England

Gentlemen of Ngongo (below) depicts a man in an Elizabethan ruff, his head replaced by an African mask; *Solomon* (opposite above) is a vision of the Guggenheim Museum, the scene littered with post-apocalyptic debris; in *Great Liberator* (opposite below left), a monument to Louis XIV is seen in silhouette, perched precariously upon its head before a bombed-out Roman forum, a vulture waiting nearby; in the foreground of *Run Run as Fast as You Can* (opposite below right), a Titian-esque landscape incorporates a fleeing gingerbread man with a mischievous grin on his face. Such is the narrative *potpourri* enjoyed by Djordje Ozbolt, who finds inspiration in a hugely eclectic variety of sources, ranging from politics, through high and low culture, to art history.

Resulting from seemingly incongruous combinations, his paintings are often macabre, amusing and subversive re-tellings of history and art, and even visions of the future. 'Inspiration and ideas come from unexpected places and situations,' says Ozbolt, 'but it's how you use these to make a painting that is the more interesting part of the process ... and the changes and mistakes that come along.' Using a lexicon entirely his own, Ozbolt employs a multitude of techniques, stylistic approaches and recurring themes, including bloodied animals, tribal masks and what appear to be defaced and defamed icons from a Classical art historical canon. In his paintings, he revels in the creation of a distinct and darkly humorous image of the world.

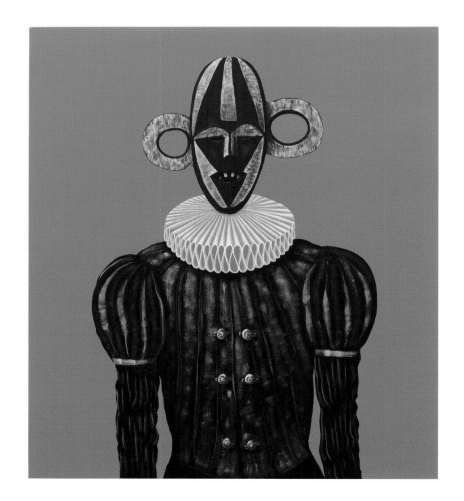

Left: *Gentlemen of Ngongo (3)*, 2012, acrylic on icon board, 80 × 70 × 6 cm (31½ × 27½ × 2⅜ in.)

Opposite above: *Solomon*, 2013, acrylic on canvas, 226 × 235 × 4 cm (89 × 92½ × 1⅝ in.)

Opposite below left: *Great Liberator*, 2011, acrylic on canvas, 165 × 185 cm (65 × 72⅞ in.)

Opposite below right: *Run Run as Fast as You Can*, 2007, acrylic on board, 80 × 60 cm (31½ × 23⅝ in.)

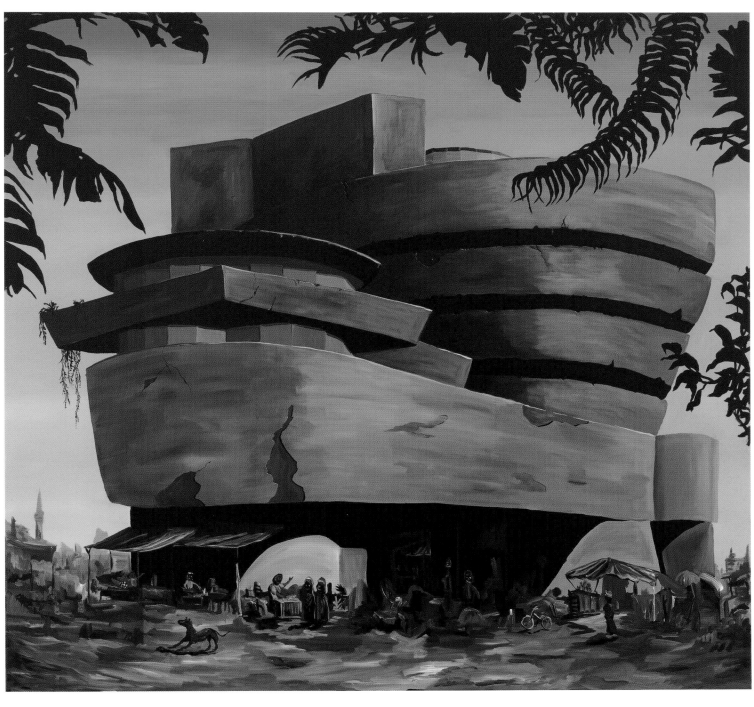

Djordje Ozbolt

187

SELMA PARLOUR

b. 1976, Johannesburg, South Africa
Lives and works in London, England

It is a testament to the authority of the medium that sometimes the most minimal paintings are the most powerful. In the meticulously rendered work of Selma Parlour, simplicity is a critical factor. Listing Frank Stella, Jonathan Lasker and Tomma Abts as influences, Parlour draws upon a rich lineage of minimalist art. One can sense her loyalty to this legacy in her subtle use of colour and shape. 'I use soft films of transparent oil,' she adds. 'Imagery appears *behind* the surface, backlit, and as though drawn or printed.' Her delicate, translucent painting offers a suggestion of a back-story for each work, tantalizing the viewer with withheld information. This notion is crucial for Parlour, who considers illusion and the limitations of painting to be central themes in

her work. 'I use bands of colour to explore conventions contrary to modernist thinking, such as figure/ground relationships, the frame and *trompe l'oeil*.' The simultaneous creation and negation of space are significant in Parlour's work. Through geometry and isolated two-dimensional forms, she crafts stage-like settings that mingle foreground with background and imbue a sense of spatial confusion. Her interest lies in 'painting that questions its historical constraints to re-frame itself through invented vocabulary and abstract space'. However, her artificial spaces hold more than mere aesthetic interest; they are a means through which Parlour can emphasize the greater possibilities of painting as a tool for interrogation and communication.

Opposite left: *A View of Modernism*, 2012, oil on linen, 91 × 76 cm (35¾ × 30 in.)

Opposite right: *Meme*, 2011, oil on linen, 91 × 76 cm (35¾ × 30 in.)

Above: *The Mutability of the Sign*, 2012, oil on linen, 160 × 150 cm (63 × 59 in.)

Selma Parlour

'The questions I ask relate to modernist painting and to minimalism. I hope to convey the possibilities of painting through the creation of artificial spaces. My work is about depicting the limits of painting.'

Above: *Apparatus*, 2013,
oil on linen, 50 × 60.5 cm
(19¾ × 24 in.)

Opposite: *Keystone*, 2012,
oil on linen, 71 × 61 cm
(28 × 24 in.)

Selma Parlour

EMiLY PLATZER

b. 1989, Basingstoke, Hampshire, England
Lives and works in London, England

Painting can often act as a mask, subverting the reality of a situation or object. Emily Platzer draws on this notion to create a painterly metaphor of human insecurities and emotions. 'While recognizable imagery might seem to ground my paintings in the present time, working with the life object and the photographic image disrupts this,' the artist notes. 'These formats are so traditional to us that they are synonymous with memory, [thus] losing their credibility in reality.' Platzer's work, in depicting scenes that are 'neither true to life nor memory', can be said to represent non-existence – one of humanity's fundamental fears, bringing to mind the idea of a struggle to find meaning distinct from any basis in reality. As a result, Platzer's paintings suggest a certain psychoanalytic quality of the unconscious, the repressed, as though the works articulate hidden human terrors and desires, in lieu of any wish to record 'truth'. In *Dog* (opposite), the animal is reduced to a freakish amorphous blob atop a laid-brick floor tilting upward: our reaction to this uncanny spectacle is one of unnerving removal. But Platzer revels in notions of the physical as much as the psychological. 'Glossy raw meat, ripe soft fruit and shaggy dogs: I enjoy replicating the sensations of a subject through the medium of paint. I also paint on finely sanded wooden supports because I enjoy the slippage of paint…. It can become a material you don't recognize.' For Platzer, an exploration in paint allows for a critical means of expressing the subtleties of internal conflict.

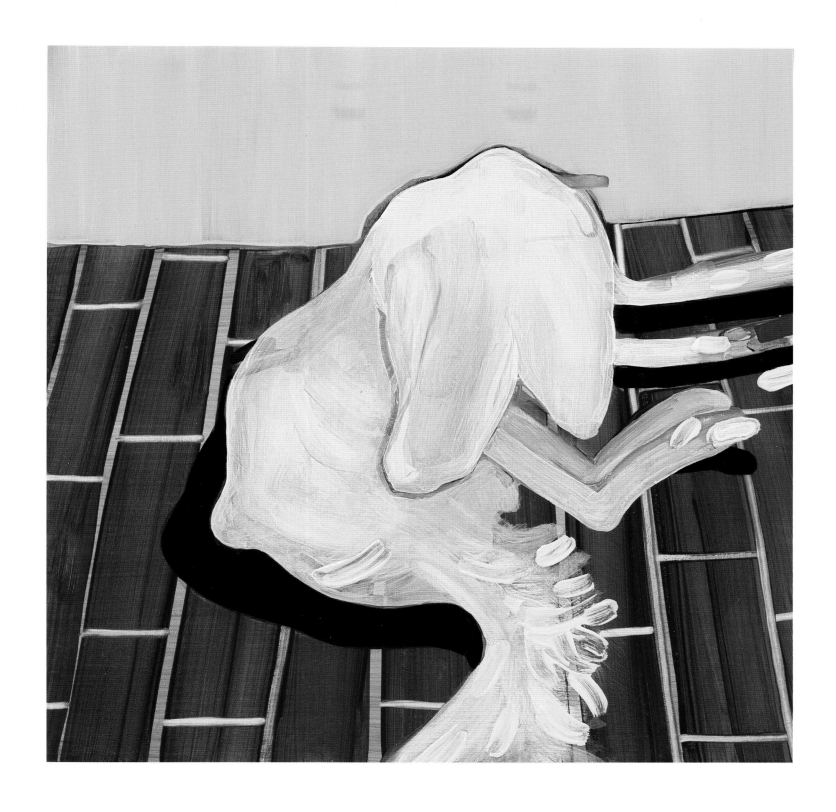

'Paint's ability to move and
transform itself in the present
masks and alters what we perceive
to be real within a painting. I create
strange spaces, neither true to
life nor memory; non-existent.'

Opposite: *Ceramic Animal
Figures*, 2013, gouache on
paper, 14.5 × 21 cm (5¾
× 8¼ in.)

Above: *Dog*, 2012, oil on
board, 40 × 40 × 3.5 cm
(15¾ × 15¾ × 1½ in.)

Emily Platzer

b. 1978, Urals, Russia
Lives and works in Nottingham, England

The palely painted installations of Russian-born artist Yelena Popova are heavily informed by the principles of Russian Constructivism. She draws from the movement in her fascination with technological relationships and mechanical happenings. However, her paintings make an intentional and marked deviation from the aggressive aesthetic of their forebears. As Popova's translucent markings seem to slip away from their substrates, so the work suggests instability and transience – two characteristics that Popova attributes to painting itself. She remarks: 'My work is about the way painting operates as an object. Can a painted image float between an immaterial physical absence and a kind of "digital presence"? Or can a two-dimensional image have three-dimensional qualities? What if an image withdraws from the surface?' She also asks, 'What can be conveyed through the display of paintings?' She chooses not to imbue individual paintings with complete sets of meaning; rather, it is the final installation of the paintings, and the ways in which they interact with one another, that denotes their significance. This notion of parts joining to form a whole is also reminiscent of her Constructivist inspirations. Yet even as she pays homage to previous stylistic movements, Popova carefully amends her works for consumption by a modern audience. Her paintings are at once contemporary and timeless, exploring the role of the painting in the act of constructing or deconstructing an image.

Opposite left: *Untitled (Blue)*,
2012, mixed media on linen,
100 × 75 cm (39⅜ × 29½ in.)

Opposite right: *Untitled (Red)*,
2012, mixed media on linen,
160 × 120 cm (63 × 47¼ in.)

Above: *Untitled*, 2013,
mixed media, painting
arrangement 90 × 65 cm
(35⅛ × 25⅝ in.); circle 27 cm
(10⅝ in.) in diameter; 130
× 95 cm (51⅛ × 37⅜ in.);
75 × 55 cm (29½ × 21⅝ in.)

Yelena Popova

HENRIJS PREISS

b. 1973, Riga, Latvia
Lives and works in London, England

Henrijs Preiss's highly stylized paintings feature starkly coloured, emblem-like designs, typically in a reduced palette that includes cadmium, ochres, black, white and grey. Unsurprisingly, Preiss credits drawings of utopian architecture and the boldness of propaganda posters as informative of his work. 'I draw inspiration from urban architecture,' he notes, 'and from marks left by human intervention in large, monumental landscapes: from the deserts of Utah … to "grid-like" streets of large cities, where everything seems to be connected and organized to keep a system running.' Preiss's process involves delving into the pictorial annals of history to identify and appropriate common elements that have recurred throughout the centuries and in the visual language of apparently unconnected cultures. Once this esoteric visual syntax has been boiled down to its most basic, abstracted form, Preiss recombines it into 'complex, multilayered pieces that aim to tap into an archetypal visual and aesthetic language'. These diagrammatic works often feature a central mandala-like symbol, or sun-like rays spiralling out from a central nucleus. They also incorporate a wide array of obscure hieroglyphic codes that remind the viewer of systems of power, social organizations, religion and government. Perhaps Preiss intends to remind us that history is cyclical, that traditions and geographies are indefinite and blurred, and that our concepts of language and understanding are actually in a state of constant and infinite flux, repetition and meaninglessness.

'I use visually common elements –
motifs, compositions, colour schemes
and symbols – that arise time
and again over the centuries and
throughout seemingly disparate
cultures to tap into a kind of archetypal
visual and aesthetic language.'

Opposite: *No. 343*, 2012,
acrylic on wood, 105 ×
110 cm (41⅜ × 43⅜ in.)

Above: *No. 360*, 2013,
acrylic on wood, 95 × 91
cm (37⅜ × 35⅞ in.)

Henrijs Preiss

HERIBERTO QUESNEL

b. 1971, Mexico City, Mexico
Lives and works in Oaxaca, Mexico

For self-taught artist Heriberto Quesnel, the principles of artistic practice are grounded by the notion of a universal history. 'I grew up reading stories and looking at pictures in my grandfather's 19th-century books, which talked about the Industrial Revolution, the independence of states, the end of one empire, the beginning of another,' Quesnel recalls. 'Later I realized that the story is always the same – like a Shakespeare play, in which only the characters and places change: the reasons and facts are the same from the beginning.' Oscillating between rigid formalism and the playful fragmentation of the comic strips of his childhood, Quesnel's own artistic practice includes conventional oil-on-canvas painting but also found-object collage; one series also involves the alteration

of vintage magazines and books. His imagery, originating as a response to drug-related violence and corruption in his native Mexico, frequently depicts mutilated torsos and decapitated heads. A series of paintings of oversized *LIFE* magazine covers features political leaders whose eyes have been doctored to make the men appear deceased, while stark blackened backgrounds and decontextualized texts offer critical socio-political commentary on contemporary Mexico. While these works, through an apparently historical presentation, at first seem removed from real-life issues, we quickly realize that Quesnel's critiques are in fact topical warnings of a culture in peril and under duress, or else reminders of recent histories that we, as a society, seem all too quickly to forget.

Within the image:

LIFE
EN ESPAÑOL

'TRIUNFO Y TRAGEDIA'

EMPIEZA EN ESTE NUMERO

7 DE DICIEMBRE DE 1953

'My work is based on the history of humanity, inspired by art history. I like to portray moments in contemporary history that interest me as a Mexican, but also the problems that affect us generally as a globalized society.'

Heriberto Quesnel

Opposite: *Verano de violencia (calavera)*, 2013, oil on canvas, coloured pencils and collage on old magazine pages, 158 × 181 cm (62¼ × 71¼ in.)

Above: *Triunfo y tragedia*, 2012, oil and acrylic on *LIFE* magazine cover, 35.5 × 26.5 cm (14 × 10⅜ in.)

ANNA RING

b. 1979, Örebro, Sweden
Lives and works in Oslo, Norway

Anna Ring takes a distinctly unconventional approach to painting. She uses organic materials, such as chocolate, algae and fruit, to paint site-specific forms directly onto the walls and floors of galleries. Preferring to emphasize the materiality of these substances over any overarching conceptual idea, Ring constructs her paintings using reduced, simplistic, geometric shapes. The size and placement of each work is determined entirely by its relationship to the nature of the exhibition space, and Ring's own relationship to her surroundings. At times, she incorporates architectural elements of the room into her installations to further our understanding of medium and space, as though commenting on the transience of the work and our site-specific relationship not only to the work in question but to our temporal, sensory-based comprehension of existence itself. When asked what she hopes to convey through her work, Ring replies, simply: 'Temporality.' The organic nature and thereby short 'shelf life' of her materials means that the works can only be preserved through photographic documentation. Ring, however, embraces this as the inevitable course of the artwork's lifespan. Indeed, the eventual destruction of each work is critical to the underlying conceptual foundation, whereby viewers are alerted to the inescapably fleeting nature of the experience of art and of life itself.

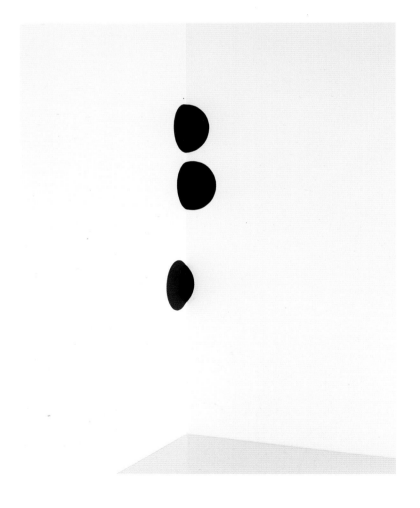

Left: *Corner Circles*, 2013, chocolate on wall, each circle 26 cm (10¼ in.) in diameter

Opposite above left: *24 06 12*, 2011, chocolate on wall/floor, 110 × 5 cm (43¼ × 2 in.)

Opposite above right: *May 2012*, 2013, algae and gum arabic on wall, 245 × 120 cm (96½ × 47 in.)

Opposite below: *02/2013*, 2012, chocolate and algae on wall/floor, 75 × 227 × 152 cm (29½ × 89 × 60 in.)

Anna Ring

OMAR RODRIGUEZ-GRAHAM

b. 1978, Mexico City, Mexico
Lives and works in Mexico City

When one considers painting in the history and culture of civilization, it is tempting to categorize it as simply another form of artistic expression. However, for Omar Rodriguez-Graham, painting is about more than tools and techniques; he considers it to be a pure experience intimately connected to human nature itself, and he predicts that, as long as civilization survives, painting will continue to evolve and hold purpose. In his own practice, he uses still lifes to explore the act of creation and the role of the painter in constructing reality. 'My work creates an ambiguous relationship between abstraction and representation,' he states. 'It is not so much about copying a common reality; it is, rather, concerned with the manner in which experience is reduced to its essential core and economically imposed upon the canvas. It thus creates a reality that is true, not in relation to that which exists beyond it, but to itself as a painting.' Inspired by subtle registers of the act of painting that are left behind as marks on the canvas – the expository lack of opaqueness seen in the works of Euan Uglow, Nicholas de Staël and Giorgio Morandi, among others – Rodriguez-Graham concludes that these traces are evidence of the artist's humanity. 'By depicting objects,' he adds, 'or, more directly, the experience that they incite, I present the language of painting.' As seen in his carefully composed works, this evidence transforms itself into the foundation of our visual culture and defines painting as an act that is both timeless and intrinsically human.

'My work is about the history of mark-making. Marks are constructed with wooden blocks and painted. I compose paintings that depict constructed scenes and objects that borrow from – and are – the language of painting.'

Left: *Composición #47*, 2012, oil on linen laid on wood, 21 × 20 cm (8¼ × 7⅞ in.)

Opposite: *Composición #57*, 2013, oil on linen, 60 × 51 cm (23⅝ × 20 in.)

Omar Rodriguez-Graham

RiCHARD ROTH

b. 1946, Brooklyn, New York, USA
Lives and works in Oilville, Virginia, USA

Although painting is generally perceived as a two-dimensional medium, some artists seek to encourage a re-evaluation of this viewpoint. In the work of Richard Roth, geometric shapes and blocks of colour interact to liberate painting from its traditional limitations. Roth's graphically patterned works toy with popular culture, making reference to product design, elements of advertising, architecture, custom cars and fashion. 'Interested in play, the quotidian and the "retinal", my work taps into the 3D polychrome universe,' says Roth. Taking on the structure of three-dimensional boxes, his paintings embrace notions of geometry and confinement. Roth has stated: 'The paintings' box-like

proportions allow a wide range of issues to enrich my practice, as two dimensions interact with three.' Perhaps ironically, it is through structure that Roth finds the freedom to express his ideas. Confinement of colour, form and medium is imperative. Roth's artistic endeavours originated in conventional forms of painting, but he then ventured into a more conceptual mode of practice, creating collections of contemporary material culture. Nowadays he approaches each artwork with this background in mind, 'fuelled by conceptualism and informed by postmodern attitudes'. The wooden panels on which he creates his work exemplify the simultaneous restriction and freedom that painting allows.

Left: *Still Pairing*, 2013, acrylic paint on birch plywood panel, 30.5 × 20.3 × 10.2 cm (12 × 8 × 4 in.)

Opposite: *Moonlight Saving Time*, 2013, acrylic paint on birch plywood panel, 30.5 × 20.3 × 10.2 cm (12 × 8 × 4 in.)

Richard Roth

JAYANTA ROY

b. 1973, Kolkata, India
Lives and works in Kolkata

Using elements of text, design and references to capitalist society, the paintings of Jayanta Roy form a simultaneous critique of and ode to contemporary culture. 'I like to deal with a variety of subjects,' the artist has stated, 'such as neo-consumer culture, identity in the era of globalization, art and politics.' Roy is particularly inspired by the role of advertising in present-day society, 'with its ubiquity, persuasive power, concealed agendas, and frequent formal and aesthetic brilliance'. He employs both wit and irony in an attempt to deconstruct the familiar second-hand images that make up the basis of the commercial image culture. Painting serves this purpose ideally because of its status as a medium that is fictionalized, translated through the subjectivity

and experiences of the artist by whom it is enacted. Moreover, painting is a peculiarly elastic medium, 'capable of expanding itself to produce simulated versions of other modes of representation'. In Roy's estimation, a painted depiction is always a metaphor for reality, whereby painting becomes 'more an intellectual practice than an instinctive one; where texts and puns have vital roles ... so that the objecthood of the canvas comes alive'. In terms of expressing notions of consumerism and identity, this view of the medium as metaphor and object unto itself is especially effective, the artist deconstructing the Romantic myth of artist-as-genius in favour of a more modern perspective, whereby artist is facilitator and conduit of communicative tools.

'The metaphorical character
of painting complements and
contradicts the properties of most
of my mechanically produced and
reproducible source images. This
enriches the ironies and paradoxes
that are staples of my work.'

Opposite: *A Maze*, 2013, oil
and acrylic on canvas, 91.4 ×
91.4 cm (36 × 36 in.)

Above: *Arthayoga*, 2009, oil
and acrylic on canvas, 198.1 ×
152.4 cm (78 × 60 in.)

Jayanta Roy

JAMES RYAN

b. 1982, Leeds, West Yorkshire, England
Lives and works in London, England

The paintings of James Ryan, a graduate of the Royal College of Art in London, focus on an implied three-dimensional space as transcribed onto an often unconventional two-dimensional surface, such as a simple gingham fabric. In *Blue over Red over Yellow* (opposite below), Ryan creates a jarring juxtaposition between the patterned movement of the stretched fabric and the sharply delineated lines of the geometric forms that sit superficially atop. Originating from line drawings or found imagery, these transparent geometric forms become further divorced from their original source material as they are applied in an experimental process that responds to the painting itself. With reference to his intuitive method, Ryan notes: 'I hope to call into question the viewer's preconceived ideas of geometric abstraction being overly rational and [itself] preconceived.' Ryan admits to an obsession with the history of painting – in particular, modernism and geometric abstraction – and also notes that his work centres around an interest in architecture and the built environment. His finished works suggest a series of memories and codes that might calmly unravel, and invite the viewer to navigate the subtle variations in colour and form. On a purely practical level, his preferred fabric offers a type of Op Art, readymade grid. The suggestion of domesticity inherent in its appearance and its traditional functionality is at odds with the historically masculine practice of fine art painting, further adding meaning to these works.

Opposite: *Untitled*, 2010,
acrylic on checked fabric, 51
× 46 × 2 cm (20 × 18 × 1 in.)

Above: *Untitled*, 2010, acrylic
on printed fabric, 61 × 76 × 2
cm (24 × 30 × 1 in.)

Right: *Blue over Red over
Yellow*, 2009, acrylic on
gingham fabric, 41 × 46
× 2 cm (16 × 18 × 1 in.)

James Ryan

ANDREW SALGADO

b. 1982, Regina, Saskatchewan, Canada
Lives and works in London, England

Andrew Salgado's large-scale gestural paintings explore concepts relating to the destruction and reconstruction of identity. Re-considering the convention of figurative painting, Salgado shies away from the term 'portraitist', feeling it pejorative and one-dimensional, and preferring to situate his work within a context of abstraction. 'I want to create paintings that engage beyond what is immediately visible,' he states, 'consciously and reflexively questioning the nature of painting itself and where my own practice is situated.' A graduate of London's Chelsea College of Art and Design, Salgado draws from a wide array of painterly inspirations: he lists Veronese, Chavannes, Caravaggio and Gauguin as well as Daniel Richter, Bjarne Melgaard and

Francis Bacon. 'I am drawn to the rule-breakers,' he says, 'and I am interested in how my paintings might operate independently from their literal figurative foundation; how they might engage abstractly, pulling the viewer from the sutures of the subject to invite understandings beyond the confines of the painted picture.' His recent works eschew any purely figurative classification, conceptually rooted in notions of identity, masculinity and sexuality, in favour of a practice that allows for a growing sense of technical exploration and conceptual experimentation. 'For me, painting is not an act or a medium. It is the only thing fundamental to who I am as a person. I am a painter first and foremost, and that defines every other aspect of my life.'

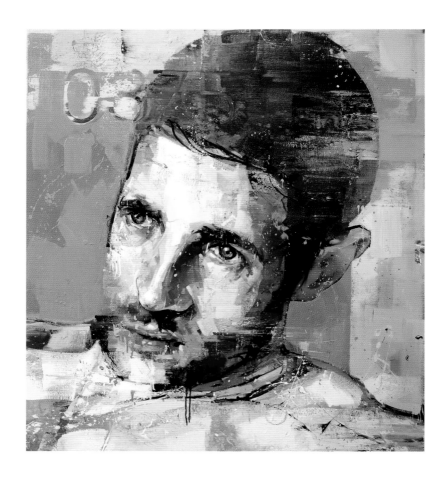

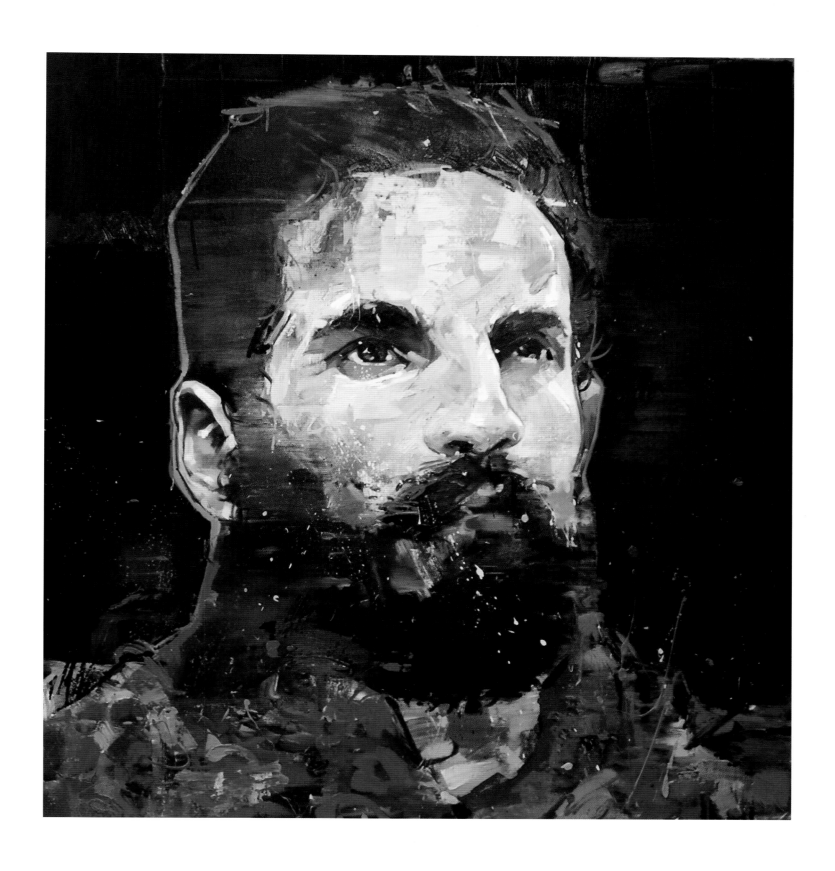

Opposite: *Scheveningen Dark (soft focus)*, 2014, oil on canvas with spray, 140 × 130 cm (55⅛ × 51⅛ in.)

Above: *Ultramarine*, 2014, oil on canvas with spray, 140 × 130 cm (55⅛ × 51⅛ in.)

Andrew Salgado

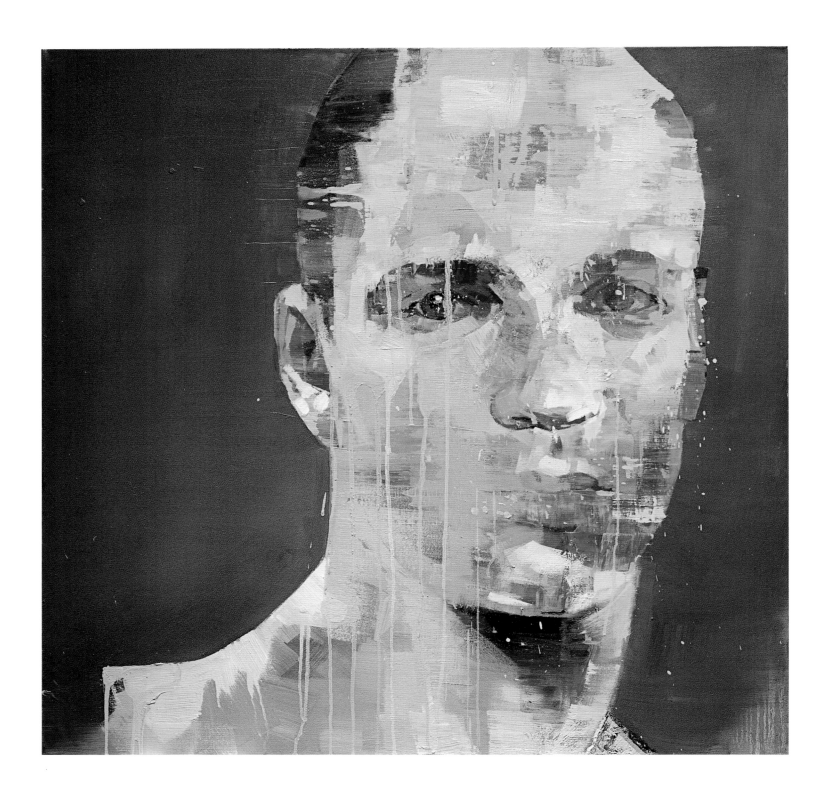

Above: *Waiting*, 2013, oil on
canvas with spray, 100 × 100
cm (39⅜ × 39⅜ in.)

Opposite: *Enjoy the Silence*,
2014, oil on canvas with spray,
125 × 125 cm (49¼ × 49¼ in.)

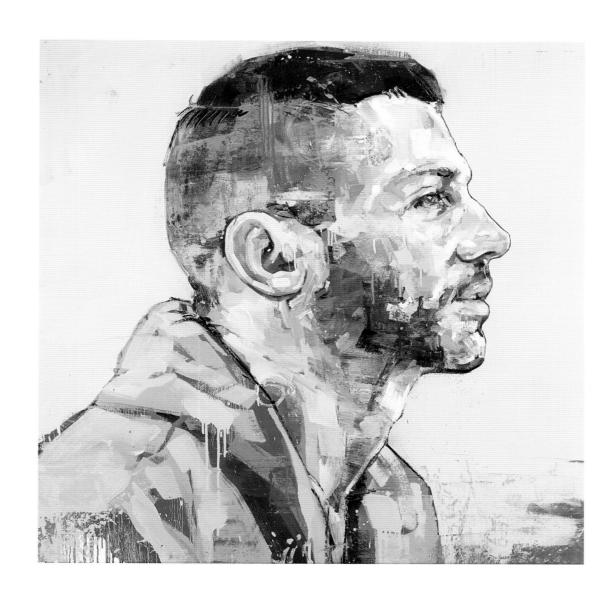

'I no longer view each painting
as an autonomous entity. Instead,
I consider painting as an act,
without beginning or end, and the
articulations that arise along the
way help me understand who I am.
They are a visual record of where
I come from and where I am going.'

ANDREW SENDOR

b. 1977, New York City, New York, USA
Lives and works in Brooklyn, New York, USA

In the mid-19th century, the invention of photography sparked a series of debates as to how the new medium was to function in relation to painting. Andrew Sendor, who holds a fine arts degree from the Pratt Institute in New York, has been driven to add to this discussion. His hyper-realistic oil paintings examine a recent development in the contentious relationship between painting and photography: the advent of the digital age. His works, most often created in a strict monochromatic colour palette (typically black and white), depict installation views of imagined gallery exhibitions. In this way, he utilizes the painting as a photograph, and yet the falsity of the content belies the perceived truthfulness of the photographic medium. Incorporated into the paintings are elements of digital pixelation – a new visual phenomenon that is entirely unique to a contemporary photographic idiom of culture, digitalization and pastiche, also emphasizing both the ubiquity and meaninglessness of the image. Sendor thereby raises questions that are of interest to viewers of all backgrounds. What can a painting do that a photograph cannot? How has the digitalization of photography altered its relationship to painting (a medium that has, in essence, remained technologically unchanged for centuries)? For Sendor, the answers come closer to revealing themselves with each new work.

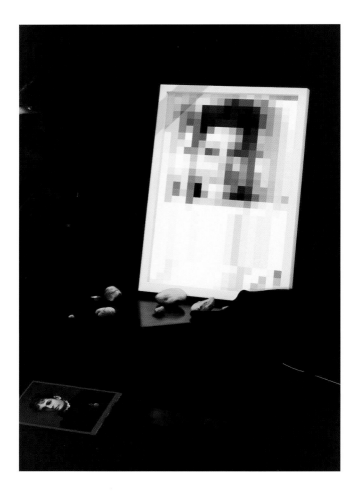

Left: *Installation view: First Grade Class Portrait, Miss Corvette, 1983–2039, various materials, dimensions variable, Living Proof, 2037, Dr. Limonene L. Lafstafvavitz, alien skulls, dimensions variable, Veronique Obscurité Ingres, 1869, found altered photograph,* 2013, oil on panel, 168.9 × 116.8 cm (66½ × 46 in.)

Opposite: *Site Specific Installation with 'Pixelated Portrait of Hugo L. Hugo', Artist unknown, 2031, oil on canvas, 38 × 22 inches,* 2011, oil on linen mounted to panel, 66 × 45.7 cm (26 × 18 in.)

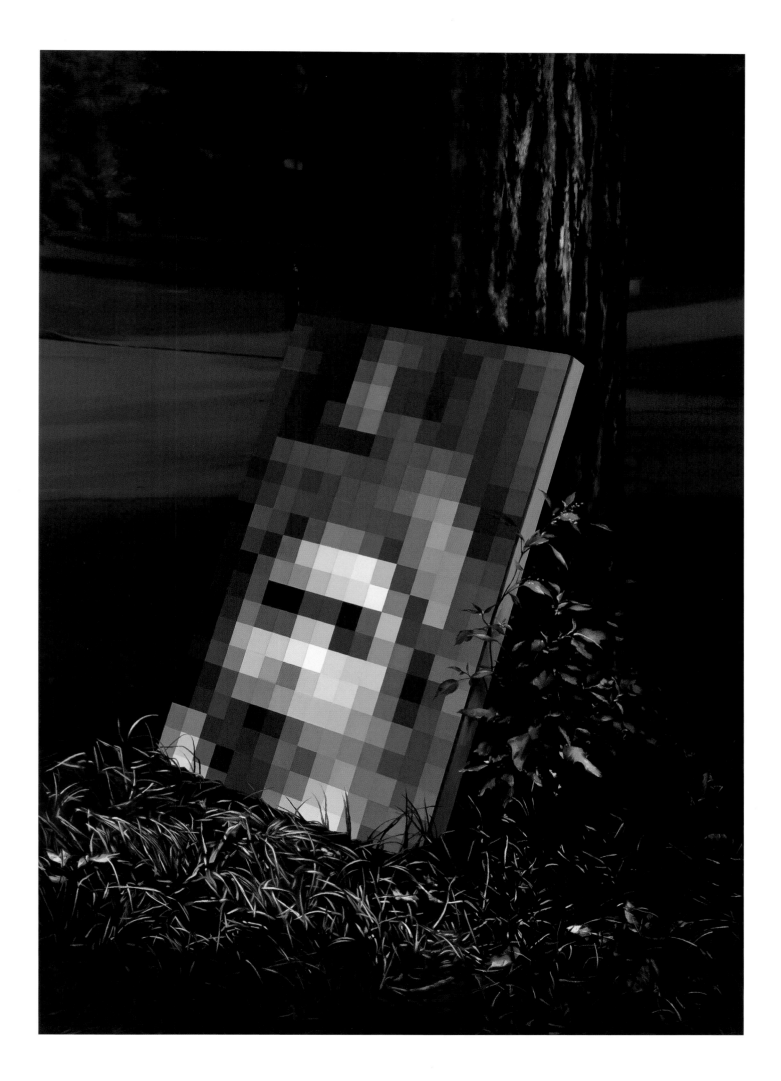

Andrew Sendor

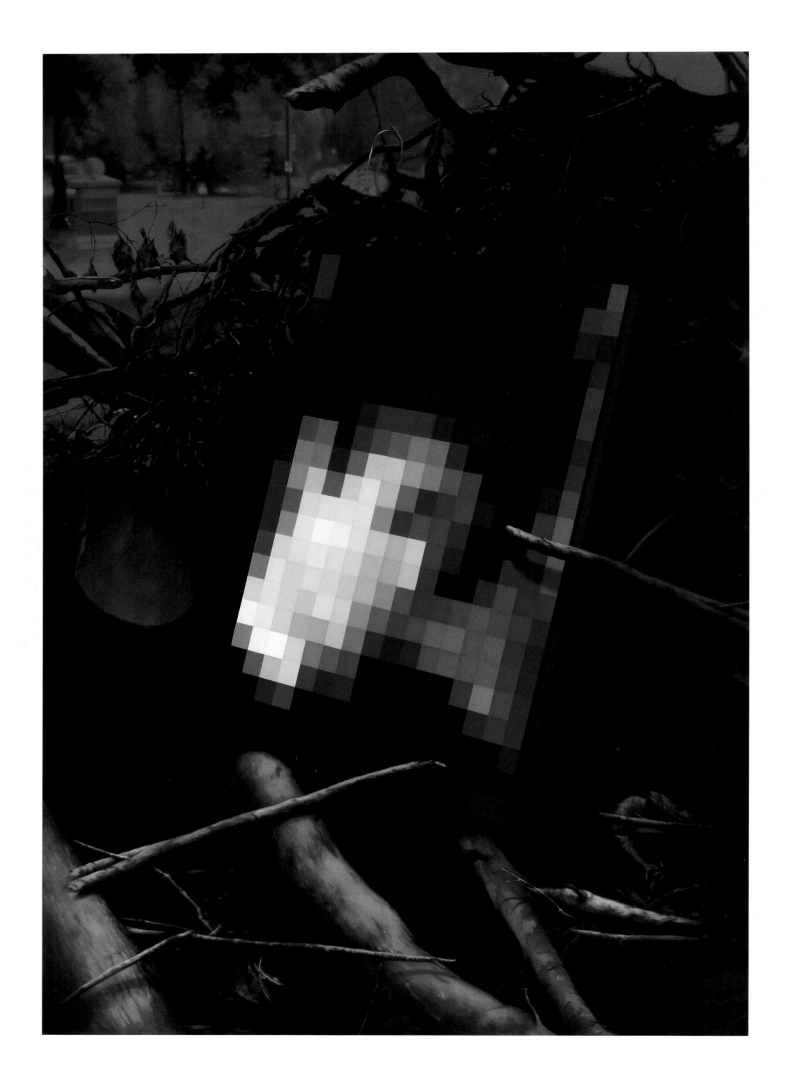

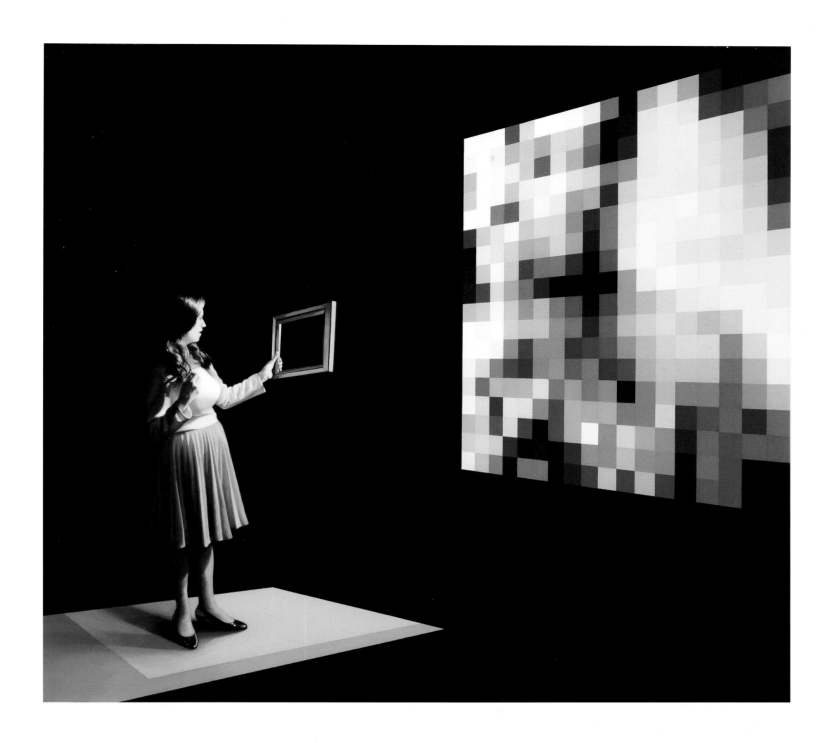

Opposite: *Site Specific
Installation with 'Pixelated
Portrait of The Caravaggio
Victim of 1594', Artist
unknown, 2031, oil on
canvas and mixed media,
dimensions variable,
2012, oil on linen mounted
to panel, 66 × 45.7 cm
(26 × 18 in.)*

Above: *Installation view:
(left) Performance with The
Grand Master Cryptologist;
(right) Onora Afua,
Un-thinkable, 2033, single
channel video projection,
duration 52:55, 2012, oil on
linen mounted to panel,
53.3 × 58.4 cm (21 × 23 in.)*

Andrew Sendor

BENJAMIN SENIOR

b. 1982, Southampton, Hampshire, England
Lives and works in London, England

Benjamin Senior uses painting as an instrument for contrasting the past with the present and for expressing a commentary on the contemporary 'cult of the body'. His paintings examine modern issues through a historical lens and aesthetic. As he says: 'I enjoy placing the otherworldly order of Seurat or Piero Della Francesca in the worldly context of a fitness club.' He also notes that he sees his work 'in relation to the geometricized body in the European art and design of the 1920s and '30s', citing Léger and Malevich, and the costumes and choreography of Oskar Schlemmer and Busby Berkeley. Senior also touches on notable dualities: the natural and the unnatural, the healthy and the unhealthy, the collective and the individual. In his depictions of the human figure, he refers back to the traditions of Modernism and historic views of bodily perfection, but here we see contemporary settings that replace traditional references with a language culled from a cultural sporting zeitgeist of yoga mats, BOSU balls and sports bras. However, the geometric patterns and bold background colours disrupt any sense of Modernist order or perfection. It is as though Senior wishes us to understand that these paintings are at once crucially relevant and crucially satirical. This disruption perhaps serves to alert us to the issues inherent in the quest for perfection, his polyrhythmic figures often compromising amorphous motifs; a disturbing, almost alien vision of a future perfect. Such contradictions abound and add layers of interest to Senior's work.

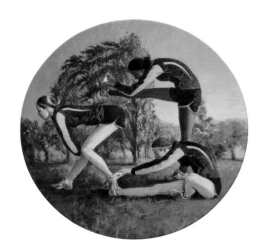

'I have chosen exercise as the setting for an exploration of geometry, pattern and rhythm. Part of the narrative of the pictures is the narrative of colours and shapes. The figures are bound up with the language of painting.'

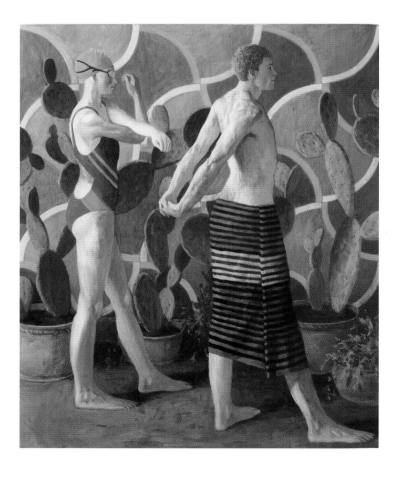

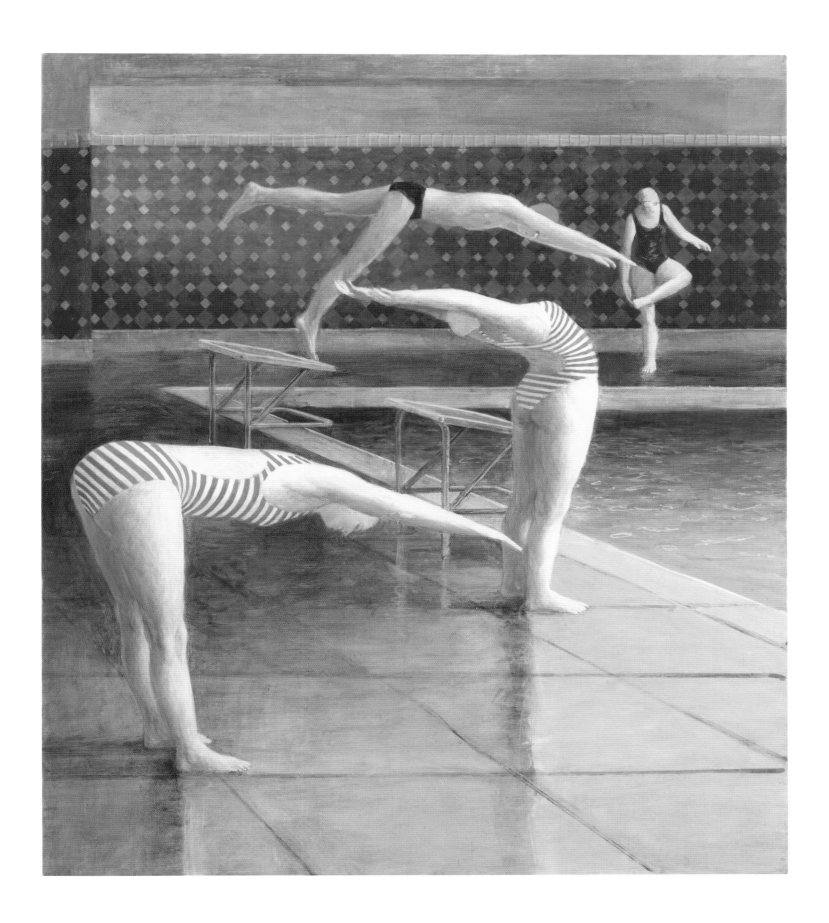

Opposite left: *Birth of Spring (Tondo)*, 2013, egg tempera on cotton on aluminium, 60 cm (23⅝ in.) in diameter

Opposite right: *Two Bathers*, 2013, egg tempera on cotton on aluminium, 60 × 50 cm (23⅝ × 19⅝ in.)

Above: *Forward Approach*, 2011, egg tempera on cotton on aluminium, 40 × 35 cm (15¾ × 13¾ in.)

Benjamin Senior

ALICE SHINTANI

b. 1971, São Paulo, Brazil
Lives and works in São Paulo

Inundated with images as we are in modern times, it sometimes seems as if we have developed an impatience when looking at art. Alice Shintani wishes to circumvent this artistic ambivalence. Her practice consists of working on entire rooms and spaces in order to immerse viewers fully in her painting. In fact, it is difficult for one simply to view her work; more accurately, one experiences it. Her use of a pastel palette – what she calls 'almost' colours, hand-mixed and airy – allows participants to float through the space while considering their own interactions with the ideas and implications of painting. With an aesthetic reminiscent of painter Gary Hume's and an emphasis on spatial manipulation that recalls Japanese artist Yayoi Kusama, Shintani is rapidly making a name

for herself among the stars of conceptual painting. However, she is also interested in the democratization of the medium. Herself of Japanese heritage, she notes: 'There is an old Japanese concept about a "between place", a certain state of suspension they used to call "Ma-space". It is a non-affirmative, non-assertive space, where pre-judgments and certainties can be suspended to favour a conscious perceptual experience.' By removing artwork from the traditional confines of the frame, Shintani aims to make it more accessible to a broad audience. Uninterested in providing 'high culture', she sees the potential of art as 'an instance of resistance to the status quo'. Her painted spaces question the role of painting within society and offer a fresh interpretation of a historic medium.

'I intend an experience of active "pause" through painting. I propose another sense of time and space. This is all about presence, the here and now, and it is democratic: artistic, multi-perceptual access for all.'

Above: *Bakemono 3*, 2011, acrylic resin on canvas, 130 × 400 cm (51⅛ × 157½ in.)

Opposite above: *Chimera*, 2007, acrylic resin on walls and floor, 400 × 750 × 1800 cm (157½ × 295¼ × 708⅝ in.)

Opposite below: *Ether*, 2009, bricks, cement and acrylic resin on walls, floor and ceiling, 400 × 750 × 1800 cm (157½ × 295¼ × 708⅝ in.)

Alice Shintani

PAWEŁ ŚLIWIŃSKI

b. 1984, Chełm, Poland
Lives and works in Warsaw, Poland

Paweł Śliwiński believes that painting should not transcend utilitarian function or purpose. He seeks to uphold what he calls the 'traditions of painting'. Influenced by 20th-century German painters of the New Objectivity movement, he draws on the precedent of Otto Dix, George Grosz and others, and, in keeping with the conventions of New Objectivity, his paintings embrace a raw, almost satirical view of humanity and continually reference deep-seated psychological concerns. Here we see a view of society that is completely responsive to its surroundings, both historically and contemporarily, yet at the same time strangely divorced from reality. *Great Bread Eaters* (below) seems to owe a debt to the 18th-century etchings of Hogarth as much as it is

a fantastical satire, incorporating elements of analytical Cubism, the hard lines and sorrowful themes of German Expressionism, and even elements from the contemporary subculture of grotesque or comic illustration. What we take from these paintings is an understanding of Śliwiński's diverse repertoire of images. As he notes: 'I refer to the traditions of painting in their own contextual realm, but sometimes I reach for an image to quote and co-opt. A completed painting is the culmination of this and of creating a situation that allows my work to contain logical and aesthetic contradictions of a surreal persuasion. I strive to create art objects that are tangible and readable, so that any intricate commentary becomes needless.'

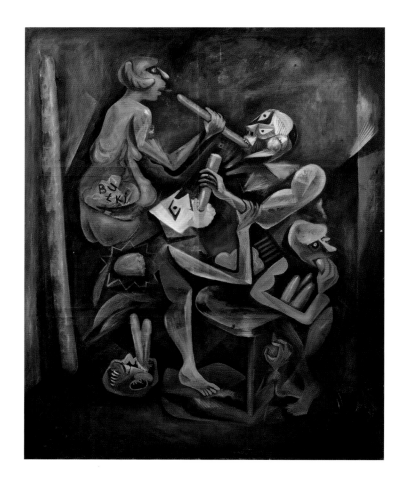

Left: *Great Bread Eaters*, 2011,
oil on canvas, 200 × 160 cm
(78¾ × 63 in.)

Opposite: *Untitled*, 2012,
oil on canvas, 120 × 100 cm
(47¼ × 39¾ in.)

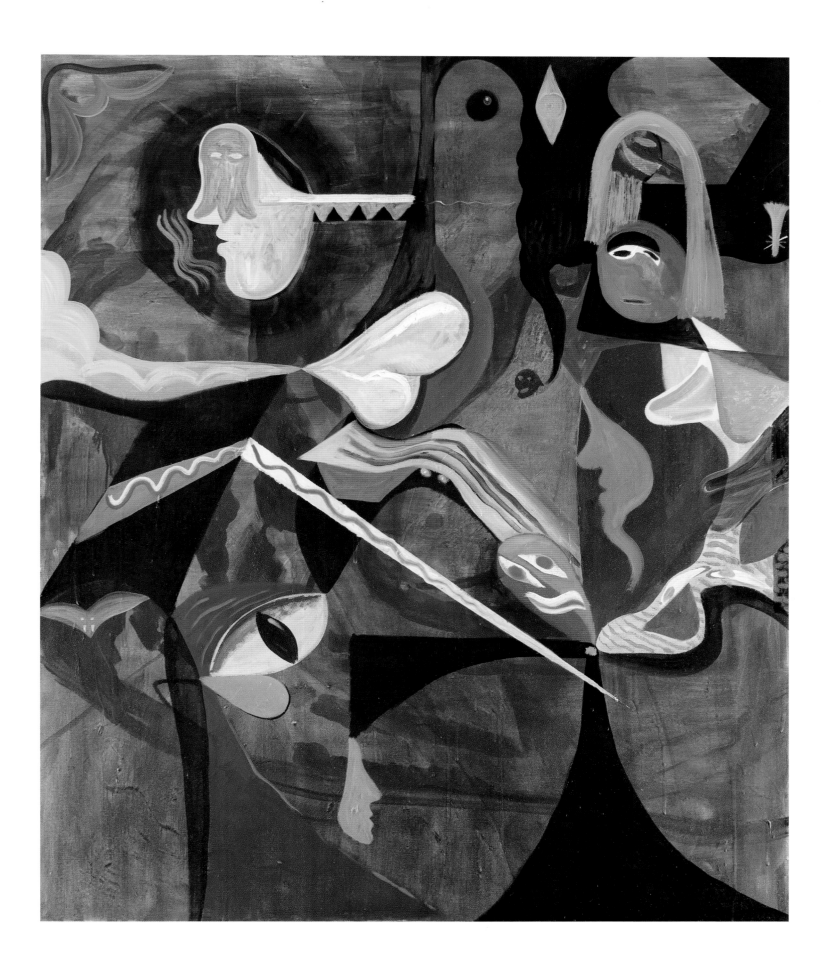

Paweł Śliwiński

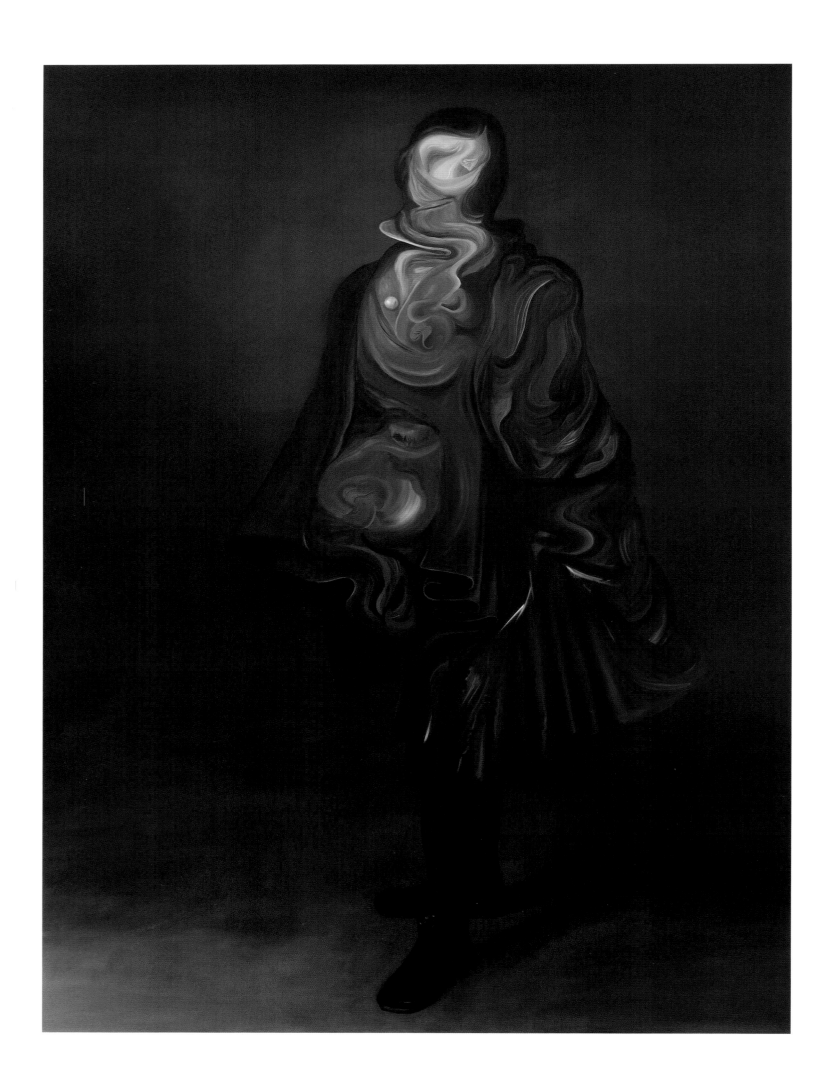

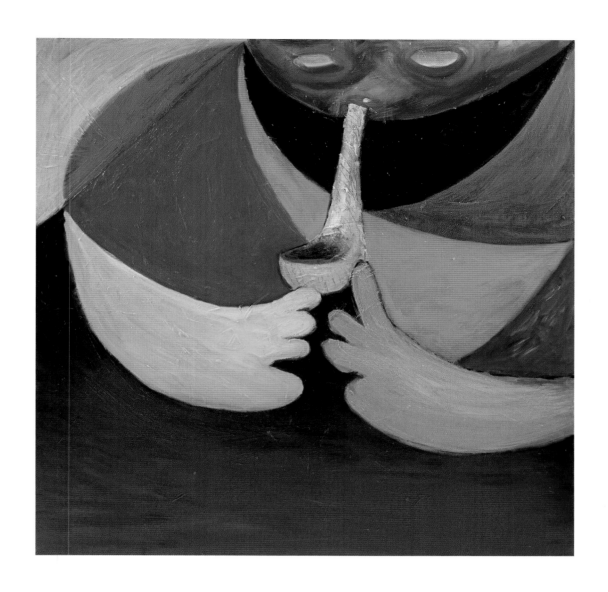

Opposite: *Seravilo*, 2010, oil on canvas, 195 × 146 cm (76¾ × 57½ in.)

Above: *Salvia*, 2013, oil on canvas, 90 × 90 cm (35⅜ × 35⅜ in.)

Left: *Untitled*, 2011, oil on canvas, 100 × 70 cm (39⅜ × 27½ in.)

Paweł Śliwiński

ANJ SMITH

b. 1978, Pembury, Kent, England
Lives and works in London, England

In the case of painter Anj Smith, it is certainly true that dexterity lies in the details. Her exquisitely crafted works are dependent on the proximity of the viewer, their small scale seemingly counter-intuitive to the obsessive, almost overwhelming amount of detail that is packed into the canvas. In *The Revision of Systema Naturae* (below), one must take a close look truly to appreciate the abundance of flora and fauna, the spectacle, the elements of grotesque, even the tiny single pearl earring lost amidst the natural detritus. Smith's subtle minutiae often come alive within a wild painterly technique that creates a terrain of textural richness upon the surface of the painting, not unlike the forest scenes they so frequently depict. The artist notes: 'Time, places and psychologies

overlap, with jewel-toned colour-banks existing alongside crude impasto slabs, scratched passive areas or zones of pornographic intensity.' Her compelling portraits, solidly based in contemporary culture, raise questions about gender, femininity and conventional ideas of beauty, and seek to confront the viewer with the meaning of representation itself. Like a subversive disciple of Bosch or Dadd, Smith seems to be influenced by art historical tradition but then to depart from it with a thoughtful cultural commentary. 'Ideas connected to a certain sense of fragility are at play,' confirms Smith, 'be it the precariousness of constructing identities, the mechanics of language and its ambition to quantify experience, or the impossibility of true communication.'

'There is no literal or singular narrative in any of the paintings, but multiple "narratives" existing simultaneously. Located between portrait, landscape and still-life painting, they encompass or reject elements of all genres. Collapsing and re-configuring of phenomena is intrinsic to these works, where narratives are as complex and layered as the application of paint.'

Left: *The Revision of Systema Naturae*, 2012, oil on linen, 37.1 × 29.2 cm (14⅝ × 11½ in.)

Opposite: *Youth With Matinée Necklace*, 2013, oil on linen, 38.2 × 30.6 cm (15 × 12 in.)

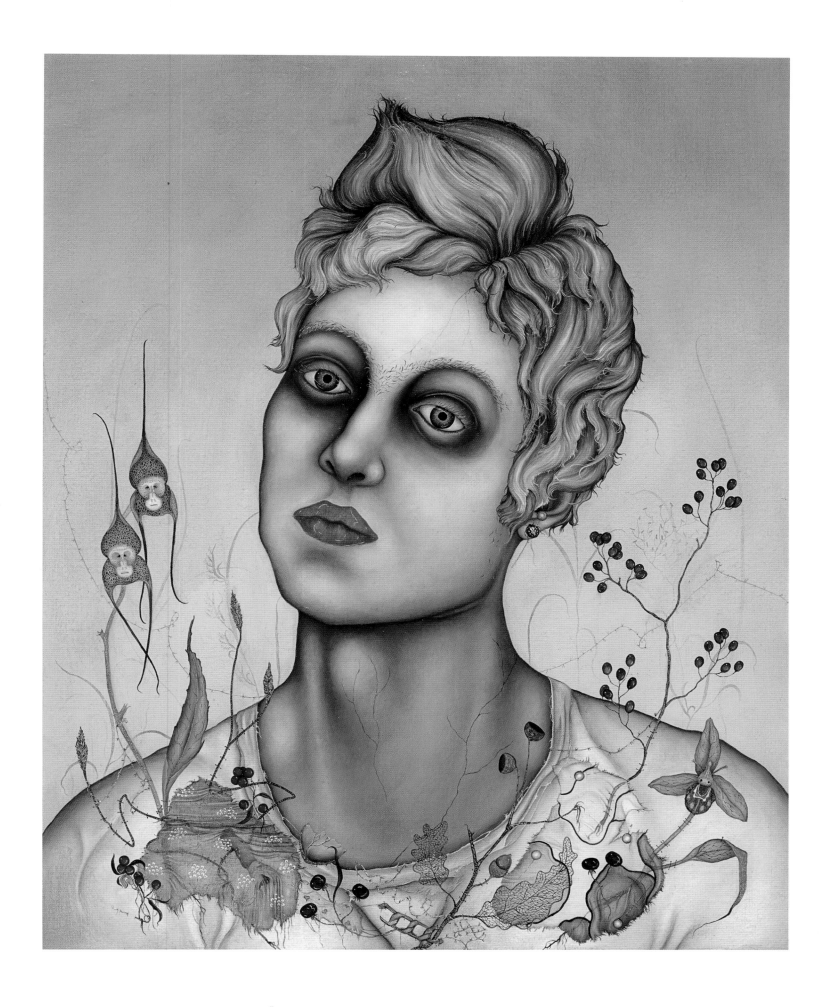

Anj Smith

Opposite: *Attempts at Conversation*, 2011, oil on linen, 39 × 50.7 cm (15⅜ × 20 in.)

Above: *Threshold*, 2011, oil on linen, 15.1 × 20.2 cm (6 × 8 in.)

Left: *Lost Patteran*, 2010, oil on linen, 18 × 24.8 cm (7⅛ × 9¾ in.)

Anj Smith

DAVID BRIAN SMITH

b. 1981, Wolverhampton, West Midlands, England
Lives and works in London, England

Growing up in the English countryside during what he calls 'a period of rural decline', David Brian Smith became concerned with issues of heritage, abandoned tradition and loss of agricultural land to development. These concerns have manifested themselves in his paintings, in which he appropriates both personal and found imagery. He recalls: 'My mother found an image in an old newspaper of a shepherd bowing his head and I was instantly drawn to it. Over the last few years I have repeatedly painted this image of a shepherd among a flock of sheep. A shepherd is an important figure to me, as my father looked after the sheep on our farm up until his death.' The resulting appearance is at the same time a vision of a rural idyll, saturated through a lens of

magic realism, or even near-psychedelia. A patchwork or quilted appearance further embellishes this phantasmagoric appearance or sense of personal memory. 'Essentially,' says Smith, 'I want a painting to educate and entertain. Dream-like invention, folkloric subjects and a spiritual quality combine for an enjoyable journey.' Inspired by rural landscapes and autobiographical incidents and memories, and drawing on poems and aphorisms from his sketchbooks, Smith challenges himself to make 'a piece of art that deserves to exist'. By adding layered washes of oil paint to herringbone linen, he creates a medley of real and imagined history, social narrative and fantasy. The resulting paintings are part of his own personal journey.

'My landscapes are inspired by personal and found imagery. However, while the figures and representational areas help to root the paintings in the real world, paint always has the freedom to take over, as I look for new ways to use colour, apply paint and unify a surface.'

Right: *Great Expectations – A short history*, 2012, oil and silver leaf on herringbone linen, 180 × 150 cm (70 × 59 in.)

Opposite: *I'm In A Dancing Mood*, 2012, oil on herringbone linen, 180 × 150 cm (70 × 59 in.)

David Brian Smith

NICOLA STÄGLICH

b. 1970, Oldenburg, Germany
Lives and works in Berlin, Germany

In *Cup* (below centre), a circular wall object expands into the third dimension, curving upon itself like the tip of a spiral. For Nicola Stäglich, a graduate of London's Chelsea College of Art and Design, this relationship of forms – complete with light and cast shadow as active parts of the composition – encompasses the complex physical method of experiencing the power of colour. 'My reliefs and objects develop from the surface into the space in front of them,' states Stäglich. 'Wood or rigid foam plates are painted, cut into pieces and then curved, layered and mounted into organic or geometric colour formations. This coexistence of the painterly and sculptural creates a colour space that extends into, and combines with, real space.' Noting that her primary language is colour – 'its

space-generating quality, its physical, emotional and associative potential' – Stäglich uses her wall-based works, as well as her sculptural objects that stand, curve and lean about the exhibition space, to play on the theme in a restrained fashion. 'The spectator plays an active role in assembling the multiple perspectives into a new entirety,' notes Stäglich. 'I hope to enable a complex three-dimensional "seeing", as well as to convey new experiences of the potential of colour.' Promoting an aesthetic interest that includes the moments between the wall and the space in front, Stäglich's works confound simplified readings. What delineates the confines of a work of art?' her pieces seem to ask. 'Where does a work end and the exhibition space begin? Ultimately, does this even matter?'

Left: Installation view: *Fold in Space (Body Height) #1*, 2012, acrylic and oil on MDF, 167 × 115 × 110 cm (65¾ × 45⅜ × 43⅜ in.); *Cup*, 2012, acrylic on rigid foam, 195 × 195 × 60 cm (76⅞ × 76⅞ × 23⅝ in.); *Sequences of Light and Shade #1*, 2012, acrylic on MDF, 167 × 115 × 7 cm (65¾ × 45⅜ × 2⅞ in.)

Opposite: *Body Height (Fluorescent Yellow Black)*, 2013, acrylic and oil on MDF, 167 × 90 × 90 cm (65¾ × 35⅜ × 35⅜ in.)

Nicola Stäglich

ŁUKASZ STOKŁOSA

b. 1986, Kalwaria Zebrzydowska, Poland
Lives and works in Krakow, Poland

Łukasz Stokłosa is compelled by a desire to communicate a melancholic vision, articulated through an appearance that resonates with Classical themes, decadence and antiquity. In fact, his paintings are informed as much by pop culture as they are by a Baroque sensibility. As a result, a sense of timeless immobility prevails. One painting is entitled *Interview with the Vampire* (below), after the sensational Anne Rice novel that defined a 1990s subculture. Another work, *Sanssouci*, depicting a lone Rococo sofa beneath a series of blackened frames (opposite), takes its name from Frederick the Great's former summer palace in Potsdam, inspired by Versailles. In a sense, Stokłosa's paintings act like Russian dolls – copies buried within copies – to create

hybrid melodramas that transcend forms and years. 'Great inspirations for my art include biographies of, for example, Marie Antoinette, especially [elements] between private and public; stories, passions, love, fears,' confides Stokłosa. 'Some of my paintings are inspired by pornography – again, private and public. Also soap operas and series, such as *Dynasty*.' Old Master influences include Caspar David Friedrich, Caravaggio, Watteau, Van Dyck, Reynolds and Velázquez, while contemporary references include Wolfgang Tillmans, Tom of Finland, Elizabeth Peyton and Marlene Dumas. 'I try to show that there was a revolution,' says Stokłosa, 'but we don't yet know what it brought. We are still in between, but we don't know between what. It is an impression of suspension.'

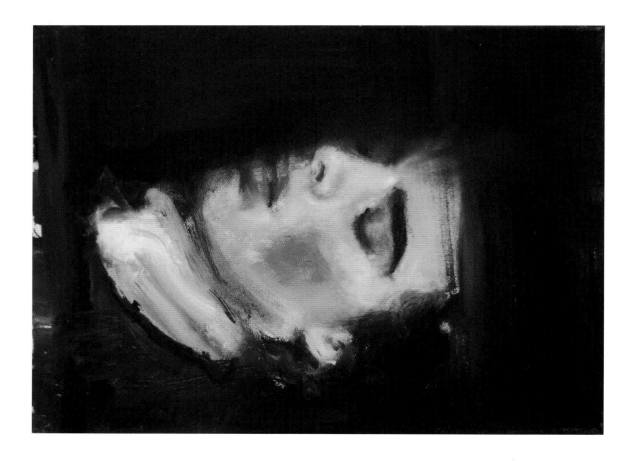

Left: *Interview with the Vampire*, 2012, oil on canvas, 30 × 40 cm (11⅞ × 15¾ in.)

Opposite above: *Sanssouci*, 2012, oil on canvas, 40 × 50 cm (15¾ × 19⅝ in.)

Opposite below: *Ludwig*, 2013, oil on canvas, 50 × 60 cm (19⅝ × 23⅝ in.)

'My paintings are inspired by movies, old palace interiors, pop culture, pornography. The paintings oscillate between erotic passion and death. It is a romantic and melancholic vision of vanishing. Beautiful places and tragic stories.'

Łukasz Stokłosa

EVREN SUNGUR

b. 1980, Istanbul, Turkey
Lives and works in Istanbul

Evren Sungur approaches painting from an aesthetic point of view that celebrates austerity and severity. Aggressive colour schemes predominate, in canvases that often measure over 2 metres (6½ feet) in height. In some works, angular, rigidly posed, unsympathetic figures shock the viewer with their graphically sexual positions. Sungur calls this the 'aesthetics of his generation', a jarring sensory overload that initially startles, then compels the viewer irresistibly to return to the depicted scene. The paintings have their conceptual basis in ideas about human nature and male/female relationships, but these are articulated through a palette and appearance mostly reminiscent of Chinese propaganda art of the early 20th century. Sungur refers to his work as being reflective of humanity's

most honest state. 'I'm painting to search for the origins and motivations of my being; my persona socially, psychologically, historically and politically. I'd like viewers to see themselves in my work and to be shocked by themselves, then after a while to accept their reality and come to a new self-realization.' Sungur believes that painting is a therapeutic act, and he considers each work to be beseeching him to discover something new about himself, his process or his surroundings. 'Painting is a form of self-exploration,' he says. 'Daily news, politics, personal relationships; anything that gives me a hint of our social/personal behaviour inspires me. The duality of a person's instincts and mind takes all my interest.'

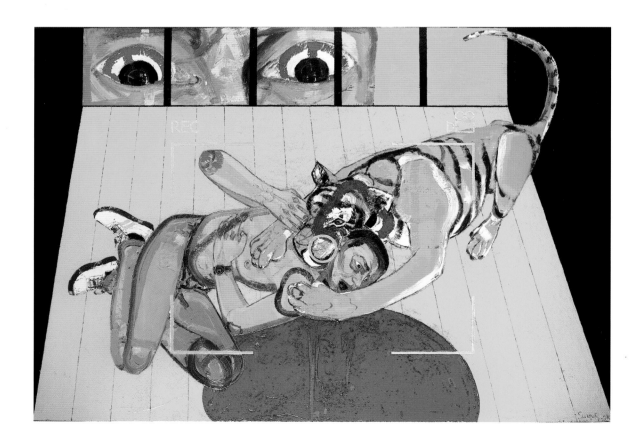

Left: *Tiger Attacking His Caretaker (A Youtube Video)*, 2010, oil on canvas, 170 × 245 cm (67 × 96½ in.)

Opposite: *Politicians*, 2012, oil on canvas, 250 × 200 cm (98½ × 78¾ in.)

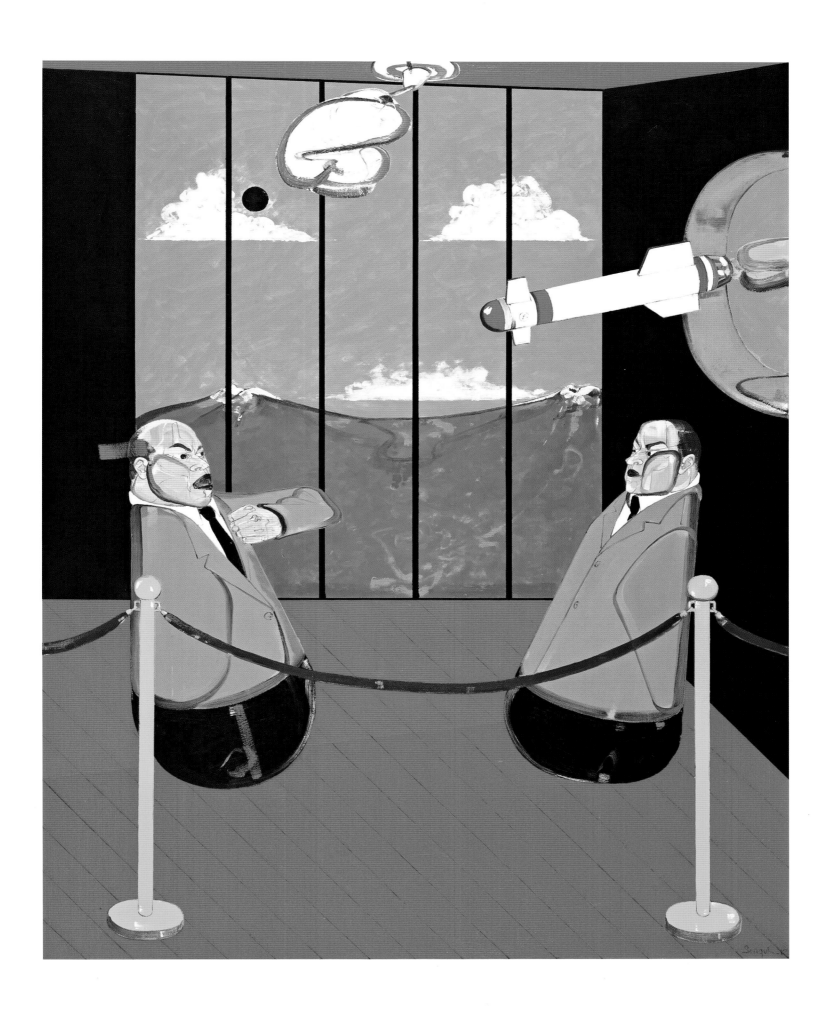

Evren Sungur

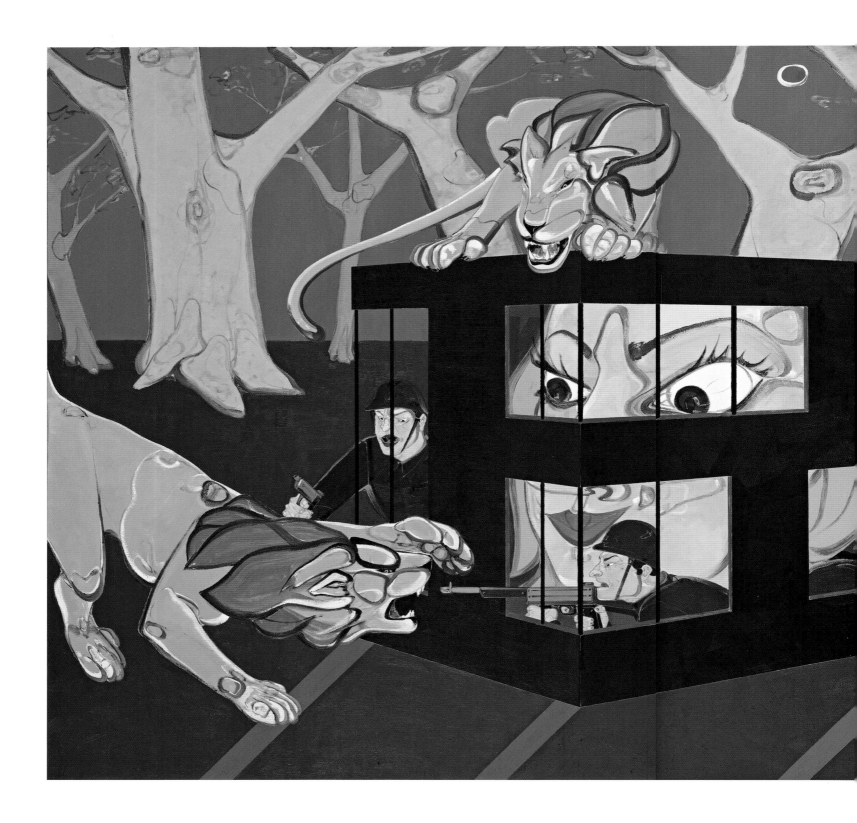

Above: *The Birth of Civilization*
(diptych), 2012, oil on canvas,
250 × 400 cm (98½ × 157½ in.)

Opposite: *Untitled*, 2012,
oil on canvas, 250 × 200 cm
(98½ × 78¾ in.)

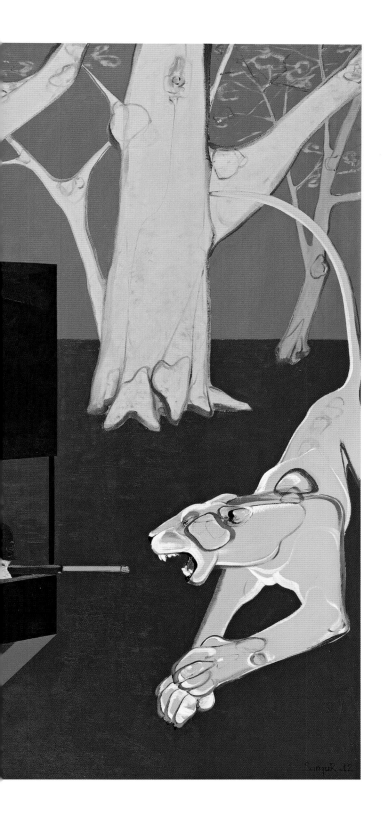

'My work is about human
nature, basic human instincts
and behaviour, including my own.
Usually I paint about myself.
I hope to paint humanity as it is,
in its most honest state. I'd like
viewers to see themselves in the
work and to be shocked.'

Evren Sungur

239

SHAAN SYED

b. 1975, Toronto, Ontario, Canada
Lives and works in London, England

A seminal experience as a teenager at a rock concert became a metaphor for Shaan Syed's artistic practice. 'I was so close to the raised dais of the stage that I couldn't see the show. At first I was horribly disappointed that my vision was cancelled out by my vantage point, but I quickly realized that it didn't matter. I was at the centre of "it"; somewhere between seeing and experiencing. I find this has a lot of parallels to how we look at and make paintings.' This graduate of London's Goldsmiths College notes of his practice: 'My work is about finding a place for absence: the empty concert stage, the curtain, the platform, the barricade, the invisible landscape, the missing portrait and the cartoonist's flat black hole drawn as a last resort for a make-believe protagonist's instant mode of escape.' Syed cites these recurring themes in his work as a way of exploring 'the idea of finding something through looking to where "want" may exist'. This practice is informed as much by a Foucaultian relationship to space, vision and absence as it is by child-like imagery, challenging established systems of looking through a playful engagement with the viewer. In place of intense theoretical jargon, Syed finds his locus in humour, simplicity and a syntax that has been reduced to its most rudimentary level. The artist notes: 'It is inevitable that, as humans, we attempt to draw conclusions and assumptions. I find painting is a way to remind ourselves that actually things are a lot more complicated, or perhaps a lot more simple.'

Left: *Untitled*, 2012,
gouache on paper, 60.5
× 43 cm (24 × 17 in.)

Opposite: *Untitled*, 2012,
gouache on paper, 60.5
× 43 cm (24 × 17 in.)

SYED SHAAN
HASSAN-SYED
SHAAN SYED
SHAAN TARIQ HASSAN-SYED
SHAAN SYED SHAAN
SHAAN TARIQ HASSAN
HASSAN TARIQ SYED SHAAN
SHAAN SYED SHAAN TARIQ
SHAAN TARIQ SYED HASSAN
SHAAN SYED SHAAN SYED
SYED SHAAN TARIQ SYED
TARIQ SHAAN HASSAN

STHS
2012

EMMA TALBOT

b. 1969, Old Swinford, West Midlands, England
Lives and works in London, England

'I use deliberately simple, direct language to articulate the immediate and constant nature of thoughts and memories,' says Emma Talbot. Her works, which are made directly on raw sealed canvas and cannot be erased or altered, embrace their communicative powers, often making reference to painterly and literary traditions, but also to social issues and gender politics. 'In *The Good Terrorists* [below] I illustrated a house with separate rooms to show a number of independent political acts that could be read both as individual actions or as a mass organization.' Often, her works incorporate texts from famous poets, such as Sylvia Plath or Walt Whitman, but they also relate personal experiences and ideas to become widely significant to

a contemporary audience. The paintings present themselves as windows into private worlds, in which characters (sometimes autobiographical) play out scenes of psychological significance. For Talbot, painting is a critical tool that offers the freedom to form thoughts and ideas into images. She intertwines figurative scenes, abstractions and text, and imbues each component with equal meaning and importance. Complex and layered though the paintings are, at their core they are about the translation of innermost thoughts into a vocabulary of imagery. 'I try to make apparent the complex interweave of everyday personal experiences and psychological inner worlds as honestly as possible, [like] a verbal language translated into the realm of the visual.'

'My paintings are composites of disparate yet interconnected images and words, describing experiences, memories and ideas that make up an inner life. Different times exist simultaneously, one person can be in two places at once, and dreams and realities hold equal status.'

Right: *The Good Terrorists*, 2012, acrylic on canvas, 165 × 115 × 4 cm (64 × 45 × 1½ in.)

Opposite: *Times Are Changing*, 2012, acrylic on canvas, 214 × 153 × 4 cm (82 × 61 × 1½ in.)

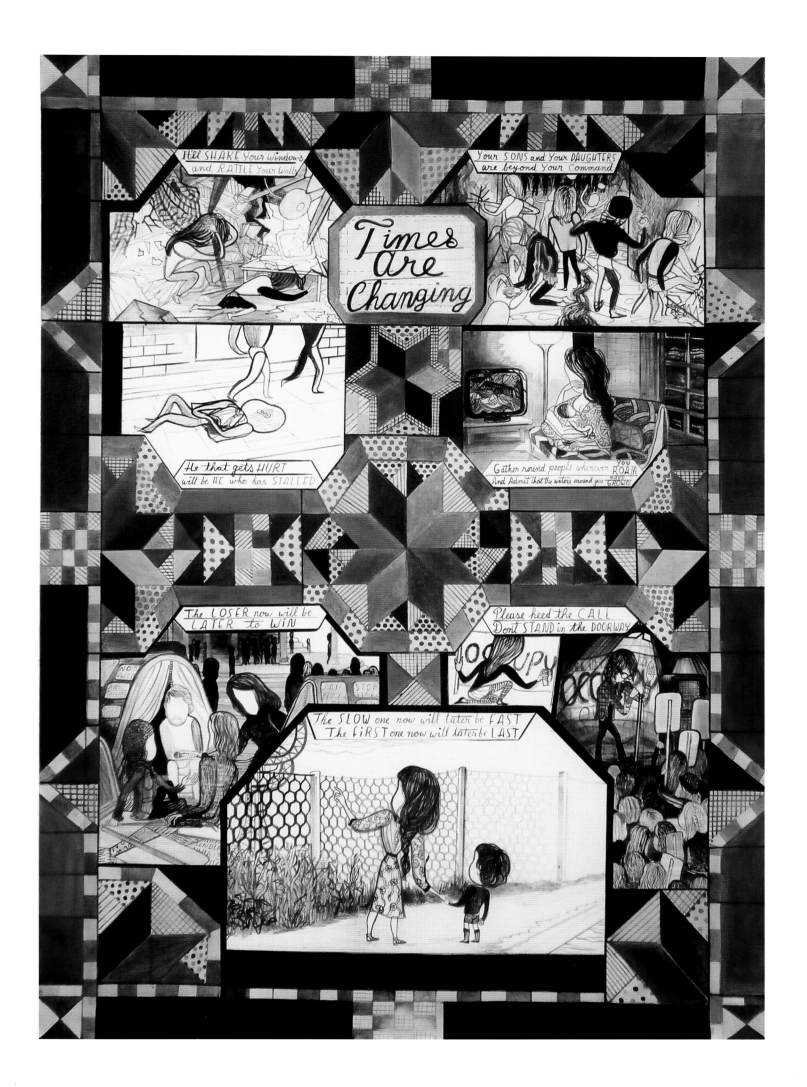

Emma Talbot

JiRAPAT TATSANASOMBOON

b. 1971, Samut Prakarn, Thailand
Lives and works in Bangkok, Thailand

In the modern age of communication, the intersection of Eastern and Western traditions has resulted in a fusion of cultural practices. Thai artist Jirapat Tatsanasomboon has made it his artistic mission to deconstruct this cultural synthesis. His paintings refer to Eastern mythical figures from the Ramayana/Ramakien epic, but these are contrasted by his inclusion of Western superheroes and pop culture objects, Warhol, Indiana and Lichtenstein being just a few of those whose work and titles he has appropriated. Drawing aesthetic parallels with the elegance of Thai mural painting, Tatsanasomboon deviates from tradition with a bold commentary, interjecting the history of mythological and religious iconography with a politics of consumerism, modern technology or simple

pastiche. In *The Guardian of Siam* (below left) the artist calls attention to upheaval in Thailand caused by ruralist and nationalist parties, known as the Red Shirts and Yellow Shirts, depicted here – along with multicoloured shirts – as Keith Haring silhouette figures. As viewers, we are compelled to ponder the political, historical and personal interplay on offer. By juxtaposing the tradition and history of the East with the forward-looking commercialism of the West, Tatsanasomboon introduces a discourse on the cultural significance of painting, adding a critical weight to widely represented iconography in reminding us that our knowledge base and the method by which we read and understand imagery is greatly dependent on our personal and cultural heritage.

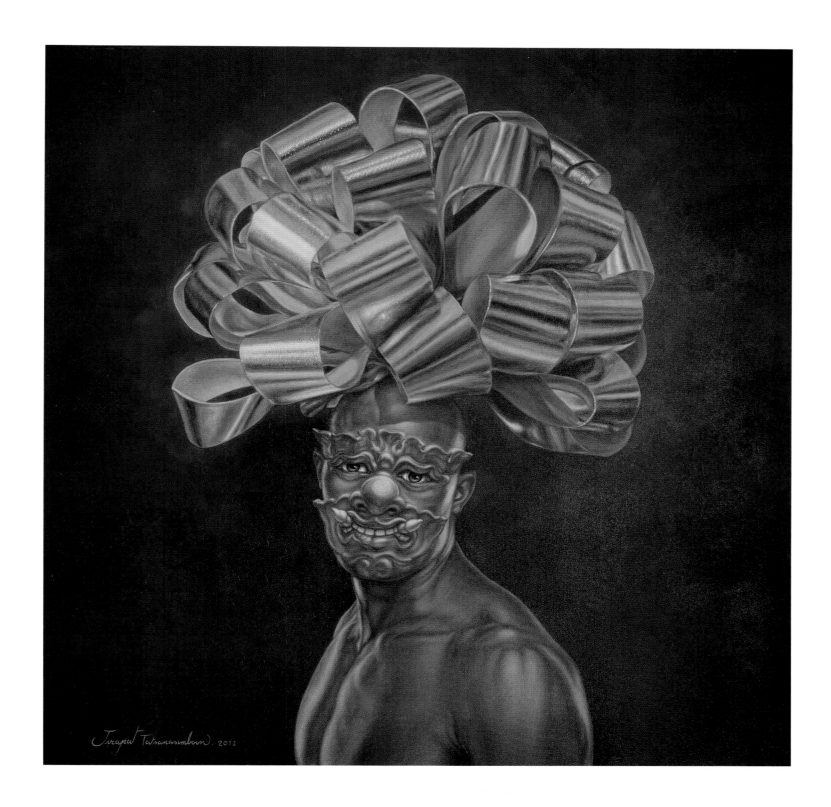

Opposite left: *The Guardian of Siam (after K. Haring)*, 2010, acrylic on canvas, 130 × 100 cm (51⅛ × 39⅜ in.)

Opposite right: *I will Survive! (after F. Botero)*, 2011, acrylic on canvas, 130 × 100 cm (51⅛ × 39⅜ in.)

Above: *Take Me, Please!*, 2012, acrylic on canvas, 129 × 129 cm (50¾ × 50¾ in.)

'My work addresses the differences and contradictions in cultural beliefs and traditions of the East and West through Eastern mythical figures from the Ramayana/ Ramakien epic and through popular Western superheroes.'

VIKTOR TIMOFEEV

b. 1984, Riga, Latvia
Lives and works in London, England

Latvian-born, London-based artist Viktor Timofeev is interested in conveying the exploits of his imagination through the process of art-making. Inspired by so-called 'low-brow' cultural forms such as fanzines, blogs, sci-fi illustration and architectural fantasy, he brings his own unearthly realms to vivid life. He has stated that a key element of his work is 'chasing your mind', as well as 'improvisation', which is evidenced through his embrace of online and new media cultural references. Sometimes he embraces a wild relationship to mixed media: in one piece, *Verything is Working*, he utilizes oil, acrylic, oil stick, felt-tip marker and glitter to depict a pyre-like structure adrift within a pyramidal shape,

with various hexagonal formations and platforms floating above what could be a bottomless abyss. In other works he uses black ink on paper to create fantastic, futuristic, post-apocalyptic landscapes, cityscapes and alien structures, graphic with patterning, grids and bold lines. Timofeev prefers to call his practice 'world-making', or 'world-building', rather than painting. With an 'ultimate dream-goal [of] communication and participation in some kind of affective exchange', he improvises to arrive at his stark utopian/dystopian dioramas – with titles such as 'Lalalalair', 'Totem99' and 'Residual Dividual' – which draw viewers in and open up our own minds.

Left: *iwannaflyrightupto thesky*, 2012, ink on paper, 55 × 35 cm (21¾ × 13⅞ in.)

Opposite: *Once It Was One*, 2012, ink on paper, 55 × 35 cm (21¾ × 13⅞ in.)

Viktor Timofeev

ALEKSANDAR TODOROVIC

b. 1982, Belgrade, former Yugoslavia
Lives and works in Belgrade

The artistic practice of Serbian painter Aleksandar Todorovic is much like his work: chaotic, diverse, defined by difference and influenced by a countless number of theories, political movements and historical figures. Todorovic explains his thematic approach as one stemming from polarities: good/evil, body/soul, power/obedience, messiah/follower. His goal is to create a visual metaphor for a global existence in crisis and flux. Ultimately, he says, 'My works are a kind of warning; a plea for sanity and compassion.' Borrowing from both Byzantine art and contemporary advertising, they comment on societal issues, whether the Holocaust or corporate globalization. They feature a microscopic, almost headache-inducing attention to detail, like a contemporary

re-imagining of Bosch's *Garden of Earthly Delights*, in which virtually every vice seems under attack – gluttony, lust, greed and wrath, to name only a few of the recurrent issues. The ongoing series depicted here adopts the form of the iconostasis (a wall of religious paintings in the Christian church). Using the series title 'Iconostasis of Isms', Todorovic takes aim at Communism, capitalism and Nazism, and adds 'criticism' of modern-day Serbia. The form of the religious iconostasis is integral to the reading: each of these systems strives to assert its ideology as the only true and 'right' one, and comes replete with prophets, messiahs and followers – all of whom Todorovic seems eager to illustrate in excruciating detail, cleverly mocking their false authority.

'The central theme I explore in my art is evil in its many forms. It is represented in the form of an archetype. The politician – selfish, despotic, ruthless, greedy, manipulative and unforgiving – is the most prevalent character in my paintings.'

Left: *Iconostasis of Communism*, 2008, watercolour, acrylic and ink on paper, 90 × 70 cm (27½ × 35⅛ in.)

Opposite: *Iconostasis of Capitalism*, 2008, watercolour, acrylic and ink on paper, 90 × 70 cm (27½ × 35⅛ in.)

Aleksandar Todorovic

LEILA TSCHOPP

b. 1978, Buenos Aires, Argentina
Lives and works in Buenos Aires

'Language', 'symbols', 'choreography', 'performance': these are the words that Leila Tschopp uses to describe her artwork and the experience it delivers. Working in the field of installation, she often features paintings on movable structures along with temporary wall paintings. 'The concept of montage is essential,' she says in relation to the navigation of her works, their coordinates often seemingly distorted. She pulls from art history, urban architecture, the natural landscape and even theatrical stage design to configure arrangements that compel the viewer to consider the nature and illusion of space, the relationship of isolated individual to ensemble, and the image within the three-dimensional realm. Having broken free from the confines of the two-dimensional support, Tschopp approaches painting as if it were a dance or narrative through a pictorial language. 'I see painting as a conceptual operation rather than a material gesture,' she confirms. 'Painting is performance, idea, experience and language in constant change. It is movement: two ears, two eyes, two hands and two feet that explore, apprehend and interpret the context. Painting has been declared dead, [but] it has hybridized, expanded.' Tschopp's own inspirations are diverse and include the Concrete movement in South America, Bauhaus, the Russian avant-garde, the works of Sol LeWitt and minimalism. 'With painting, we have to "be there",' she says. 'We have to spend time to experience it. This is both its shortfall and its incredible gain.'

'My installations allow for an interplay of images while proposing a fragmented narrative that privileges juxtaposition and superposition. Each image is an integral part of the choreography.'

Above: *Big Wall*, 2012, acrylic on canvas, 150 × 200 cm (59 × 78¾ in.)

Opposite above and below: *Ideal Models*, 2011, acrylic on canvas, wall and MDF panel, wood structures, two rooms of 4 × 6 × 5 m (13 × 19½ × 16½ ft) each

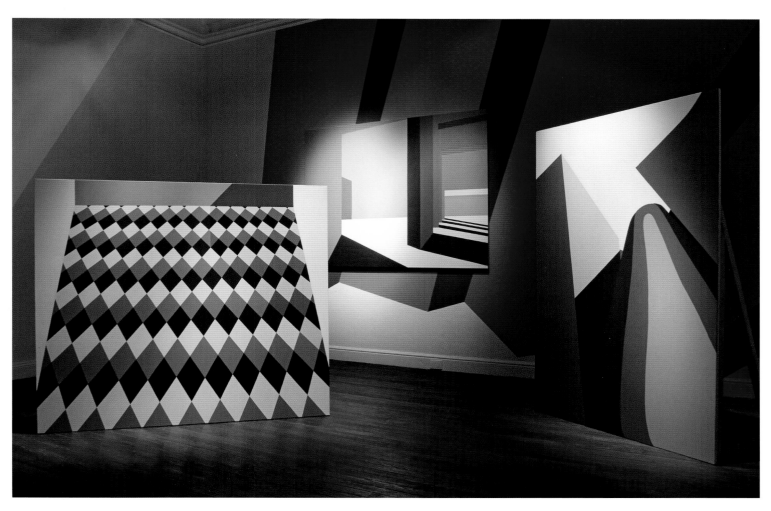

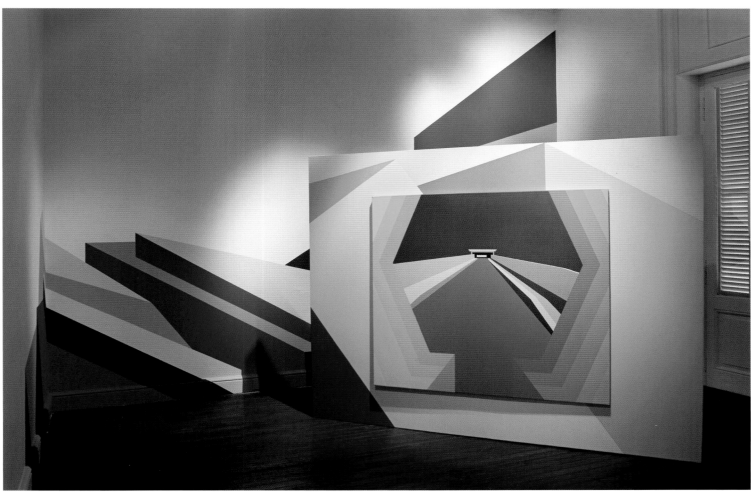

Leila Tschopp

iVANA DE ViVANCO

b. 1989, Lisbon, Portugal
Lives and works in Leipzig, Germany

A graduate of the University of Chile in Santiago, Ivana de Vivanco found herself so inspired by the New Leipzig school of artists such as Neo Rauch, Bernhard Heisig and Arno Rink that she relocated to the city to immerse herself in a generation that had so clearly defined their genre. Her own paintings, in a similar way to the approaches of the New Leipzig movement, tend to focus on problematic narratives, with mythical characters, who, according to the artist, 'violate the intimacy of the private domain'. Her domestic scenarios seem populated by uncanny, dream-like, even nightmarish curiosities. De Vivanco credits *Imagines*, the 2nd-century book attributed to a grandfather and grandson both named Philostratus, as a primary source of inspiration. In its two

volumes, the Ancient Greek sophists describe 64 works of art from Naples, offered as a pedagogical and allegorical presentation to a ten-year-old boy. In reconstructing the descriptions, de Vivanco's handling of her media showcases a striking naïve and primitive quality, the scenes composed with equal amounts trepidation, imagination and omniscience. 'To build my paintings I use images that I have stolen and do not intend to return: film stills, family photos, images from the internet or old snapshots purchased at markets,' states de Vivanco, adding, 'with a piece of canvas, a little bit of oil and pigment everything seems to be possible, [enabling] the painter to invent fantastic and infinite numbers of scenarios ... and new possibilities of thought and experience.'

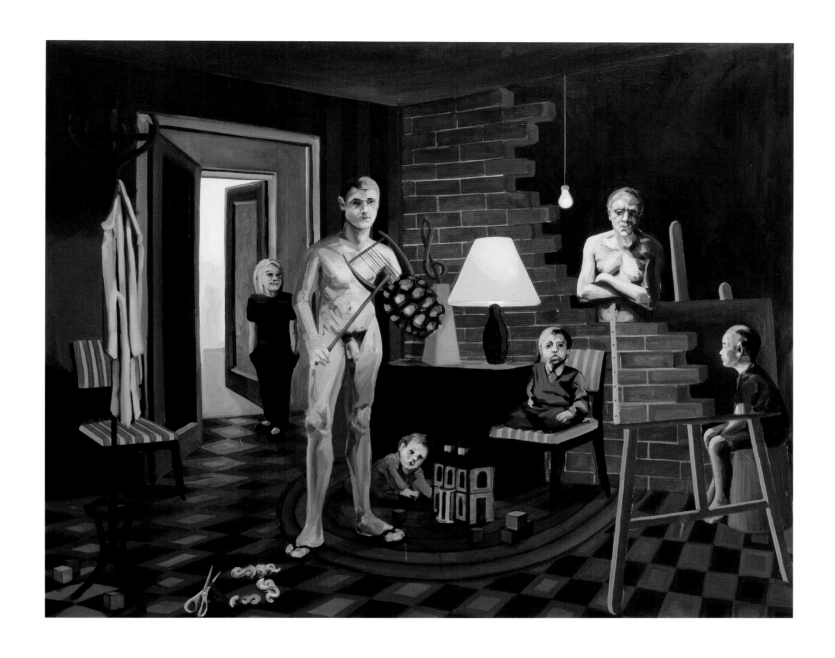

'What happens to painting when it comes into contact with other media? By reconstructing literary descriptions of immaterial pictures, my goal is to re-think, [through] contemporary painting, old narrative and scenic art problems, stressing articulations between image and word.'

Opposite: *Ariadne*, 2012, oil on canvas, 190 × 275 cm (74⅞ × 108¼ in.)

Above: *Amphion*, 2012, oil on canvas, 160 × 210 cm (63 × 82⅝ in.)

JULIA WACHTEL

b. 1956, New York City, New York, USA
Lives and works in London, England

Julia Wachtel, an American based in London, is fascinated by the visual language of mass culture. Cartoons, newspaper clippings, internet pictures and other imagery are incorporated into a visual game, wherein the appropriated vernacular is, as the artist puts it, 'illustrated, simulated, replicated, altered and parodied'. As if in response to the Pop movement, her paintings continue a tradition of using 'readymade', decontextualized, popular imagery. Of her influences, Wachtel remarks, 'Visually I am inspired by the landscape of suburban sprawl. Structurally I am inspired by music and its underlying strategies of construction, for example sampling or mash-ups.' She chooses to further confound our understanding of her barrages of imagery by juxtaposing her elements against planes of solid colour. Her work has also included what Wachtel refers to as a 'focal panel that expounds particular notions of the representational "everyman"'. Perhaps she is asking the viewer to draw connections between her images, or perhaps simply to receive passively the seemingly arbitrary messages on offer. As she has noted: 'Paintings provide a moment to stop, think, feel and not just automatically consume the onslaught of imagery we are exposed to constantly.' In appropriating particularly from the internet, Wachtel's commentary is presented as a colloquial form of communication that is intended to be universally understood. Her work is a means of questioning contemporary image culture, and the roles that these images take on within our lives.

Left: *Double*, 2012, oil on canvas, 114.3 × 195.6 cm (45 × 77 in.)

Opposite above: *Energy*, 2011, oil on canvas, 102 × 211 cm (40 × 83 in.)

Opposite below: *The Ideology of Love*, 2013, oil on canvas, 101.5 × 249 cm (40 × 98 in.)

'My paintings respond to the question, "What does it look like to be everywhere in the world all the time?" How does one process the reality that we live in every time zone, every climate, every political moment all the time, yet not at all? My pictures are small slices of this emotional dislocation'.

Julia Wachtel

MATHEW WEIR

b. 1977, Ipswich, Suffolk, England
Lives and works in London, England

Man of Sorrows (opposite) is a painting depicting a little black porcelain figurine, whose coy smile curves hauntingly upwards and whose eyes are downcast. Small in scale, the painting cannot be much larger than the precious doll it depicts. Despite the glossy illusion on the surface of the subject matter, the paint is dry and flat, with a quality similar to a matte photograph. It is a bizarre and subversive piece, and one that aptly represents the greater realm of British artist Mathew Weir's practice. 'Utilizing fragments of pre-existing imagery, the paintings draw on a specific tradition of 18th- and 19th-century decorative art,' Weir notes. Ceramic figurines are ever-prevalent, and so are skeletons, wilting flowers worthy of a Dutch still life, and other culturally loaded objects,

presented with a sense of didactic, albeit enigmatic narrative. The paintings are hyper-real, even though their technique is one of complete abstraction, for Weir's handling is laborious and evokes an unearthly stillness; an appearance reminiscent of the surface of rippling water. Weir is concerned with context and 'how interpretations and meanings shift and/or change through time'. In his work, 'the focus of interpretation moves between violence and exploitation, cruelty and tenderness, death and innocence' – often all within the same painting. His prowess enables him to slow these issues to a static moment, existing distinct from cultural signifiers and time, and re-energized with a sensation that the works are something we have never quite seen before.

Left: *A Fool's Life*, 2010, oil on canvas mounted on board, 54 × 40.5 cm (21¼ × 16 in.)

Opposite: *Man of Sorrows*, 2010, oil on canvas mounted on board, 29 × 20.5 cm (11⅜ × 8⅛ in.)

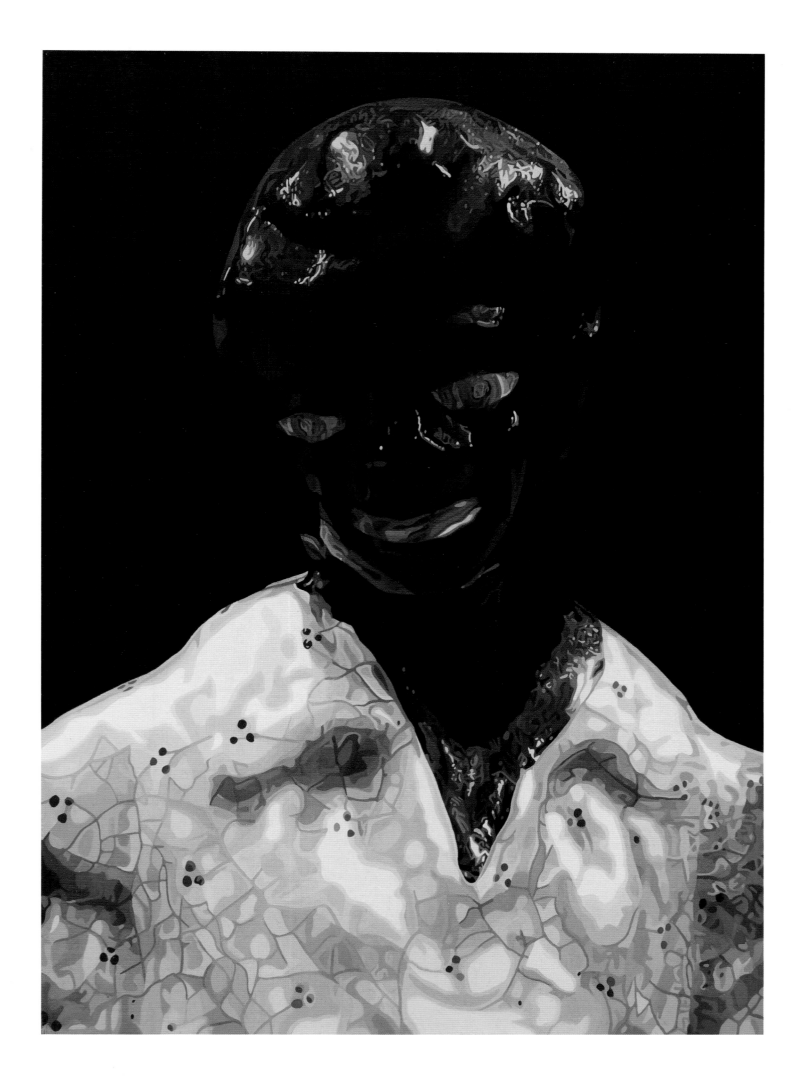

Mathew Weir

Opposite: *Gathering Evidence*, 2012, oil on canvas mounted on board, 60.5 × 45.5 cm (23⅞ × 17⅞ in.)

Above left: *Jar*, 2011, oil on canvas mounted on board, 51 × 37 cm (20 × 14⅝ in.)

Left: *Glory, Hallelujah*, 2013, oil on canvas mounted on board, 55 × 41 cm (21⅝ × 16⅛ in.)

Mathew Weir

WONG XIANG Yi

b. 1987, Malaysia
Lives and works in Hong Kong

The ancient Chinese art of *gongbi* dates back nearly 2,000 years, finding its origins in the Han Dynasty and describing a detailed realism typified by careful brushstrokes, use of high colour and depiction of figural or narrative subjects. Although the technique is steeped in history and tradition, contemporary painter Wong Xiang Yi has adapted it to suit a modern study of gender and sexuality. Inspired by the homoeroticism of *yaoi*, a subculture of Japanese manga comics that is in fact most widely consumed by girls, Wong's meticulous ink-on-silk paintings offer an invitation to the viewer to witness the intimate negotiations on display. Rather than seeming voyeuristic, the paintings feature an element of knowingness, making viewers feel as though they have been granted quiet entry into a world of personal relationships from behind the safety of a shoji screen. 'I chose *gongbi* to present an atmosphere of peace, sweetness and comfort in my paintings,' says the artist. The use of the ancient technique offers an intriguing contrast to the modern perceptions of sexuality and play underpinning the conceptual basis of the work. In *Borrowed Heaven* (below), Wong depicts a modern, titillating, orgiastic scene; in *You Know* (opposite), a mild suggestion of bondage or S&M permeates the scene. For Wong, 'Chinese painting' can break free from its traditional connotations, harmonizing historic *gongbi* with contemporary *yaoi* to present a new appearance and a new way of looking at gender and sexuality in the modern age.

'My work is about "Boy's Love",
a subculture extended from yaoi Japanese
manga. I am trying to combine this new
subculture with the tactile materiality of
traditional Chinese painting'.

Above: *Borrowed Heaven I*, 2012, ink on silk, each 68 × 122 cm (20½ × 36½ in.)

Opposite: *You Know*, 2012, ink on silk, 122 × 76 cm (36½ × 22¾ in.)

Wong Xiang Yi

CAITLIN YARDLEY

b. 1984, Ballarat, Australia
Lives and works in London, England

Caitlin Yardley views her work as a response to her surroundings; a process that intertwines sources but is never fully responsible to them in the re-telling of a story. In placing her works in a wider context, she insinuates a life beyond the painted image. A recurring quilt motif becomes doubly referenced in *Tragic Painting (Center Diamond Variation)* (below). 'It became necessary to include the physically aged quilt to help identify and place my use of geometric patterning in the paintings,' states Yardley. Well aware of working in a historically male-dominated canon, she found an avenue to communicate through the patterning of the 1920s Amish quilt – 'a specific community of women at quite a remove from the art world'. This allowed her to find a distance

from painting; a way to work within it, while remaining outside it. 'I am interested in using painting to work with history, as not only retrospective but as built within and affecting a current situation,' says Yardley. Her installation technique causes us to search for linkages between her findings and her painted creations. In one work, she places concrete paving stones beside a painting with a similarly porous surface, suggesting an attempt for one to communicate the other. But her methods are not always immediately perceptible and specific information is not always available. Each installation is a circular body of ideas that work together to describe or relate a series of connections between a contemporary and historical experience.

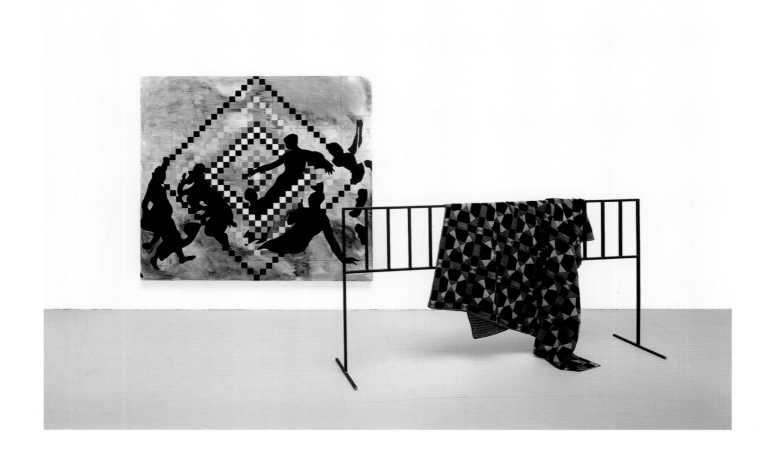

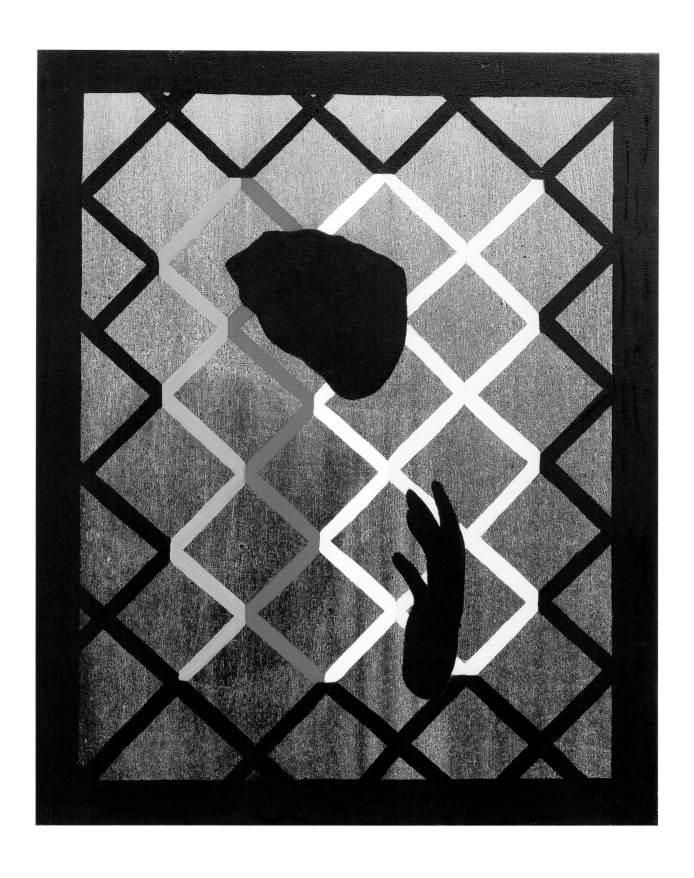

'I am interested in manipulating
relationships between things as
a means of revealing something not
generally visible or accessible. I pull
content from history until an overlap
is found. My work aims to consider
and communicate this overlap.'

Opposite: *Tragic Painting
(Center Diamond Variation)*,
2012, oil on canvas, 187 ×
204.5 cm (73½ × 80½ in.);
steel; Amish quilt, 110 × 222 ×
40 cm (43⅜ × 87⅜ × 15¾ in.)

Above: *Tragic Painting
(Lattice)*, 2012, oil on canvas,
68 × 53 cm (26¾ × 21 in.)

Caitlin Yardley

263

ZHANG FAN

b. 1973, Guangdong Province, China
Lives and works in Wuhan, China

The intentionally discomfiting paintings of Chinese artist Zhang Fan force viewers to reflect on their unease. Zhang's works employ a cast of characters who struggle simply to exist in their claustrophobic environments. With green skin, missing noses and tortured expressions, the figures seem otherworldly and out of place. Yet their bizarre appearance belies an approach based in metaphor, for they are in fact representatives of the reality of contemporary Chinese society. Zhang uses his work as a politicized criticism of his own culture and an empathetic look at the individuals who have to exist within it. 'These days there are a lot of problems,' he notes. 'The air exudes a kind of "make-me-feel-uncomfortable" atmosphere. The situation is too complex, the reality is too cruel, people in the queue, fighting, burning themselves, struggling to swim to the other side.' In his paintings, the stresses and agonies of everyday life are portrayed as traumatic moments, and the people involved are accordingly disfigured. But even as he inflicts pain upon his characters, Zhang explores the nature of reality with a combination of wit and seriousness. While the perverse alternate worlds of his paintings portray humanoid monsters caught in straightjackets and shrouded in sickening smog, their eyes can often be seen to be raised skyward, as if in hope of help or in search of some kind of meaning. Zhang concludes, 'Flesh proves nothingness and existence. Everyone will go to another place.'

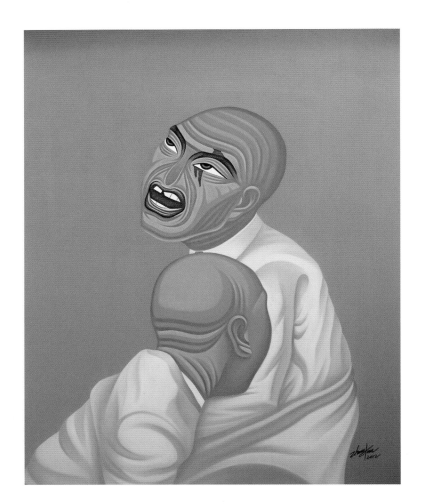

Left: *These days-brawl*, 2012, oil on canvas, 100 × 80 cm (39⅜ × 31½ in.)

Opposite above: *These days-the other side*, 2010, oil on canvas, 120 × 80 cm (47¼ × 31½ in.)

Opposite below: *These days-huge crowds of people*, 2011, oil on canvas, 130 × 97 cm (51⅛ × 38⅛ in.)

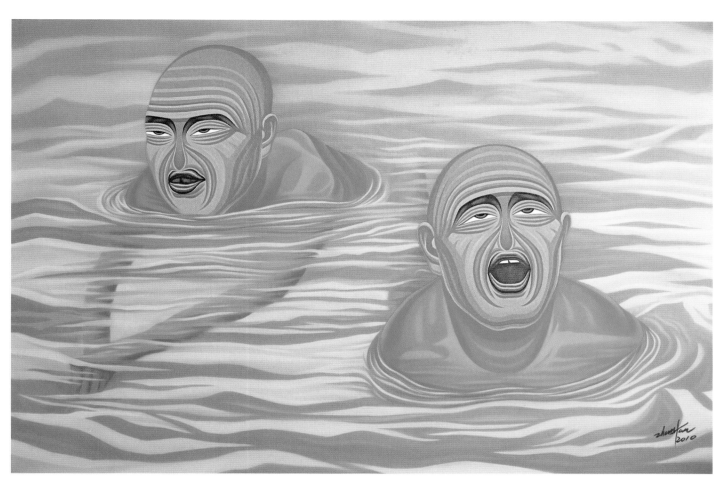

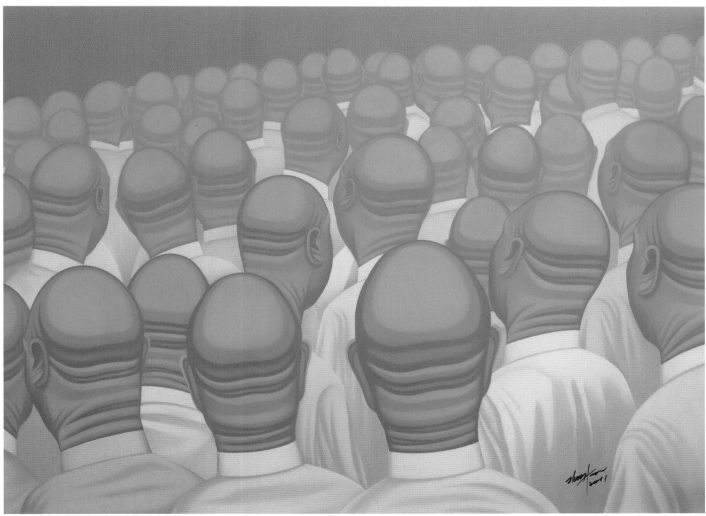

Zhang Fan

JAKUB JULIAN ZIOLKOWSKI

b. 1980, Zamość, Poland
Lives and works in Krakow and Zamość, Poland

In many of his graphic and disturbing works, made in a studio that is 'cut off from the world by means of blinded windows', Jakub Julian Ziolkowski seems to be telling tales through depictions of monstrosity, filth, shame and excess. The decadence and fecundity of human nature are reflexively reiterated through paintings that mirror a sardonic view of life. A prominent preoccupation is the human body – flesh, eyes, hair, bones, intestines – which, with luscious colour and gleaming highlights, he makes both compelling and repellent. In the fifteen-part *Story of King Bananus*, Ziolkowski has created a sort of decadent 'passion play' for the titular banana. The works are of various sizes and incorporate religious iconography, bits of viscera, sexual organs, and even three-dimensional artifacts housed in a box-frame. References to Robert Crumb, Philip Guston and James Ensor are as abundant and marked as the sensory overload depicted in the paintings. According to the artist, his visions are 'doomed to constant accumulation'. Paintings are made one after another, rapaciously, until they themselves swarm within other paintings. Characters, inventions and obsessions repeatedly spring up in what Ziolkowski describes as a 'painterly biography', or scenarios that project a sense of conviction and verisimilitude despite their departure from reality. The artist says, 'This is a part of the process, with the end being not just one painting, but all my works constituting one spread-out statement on why, for whom, what, who and where I am.'

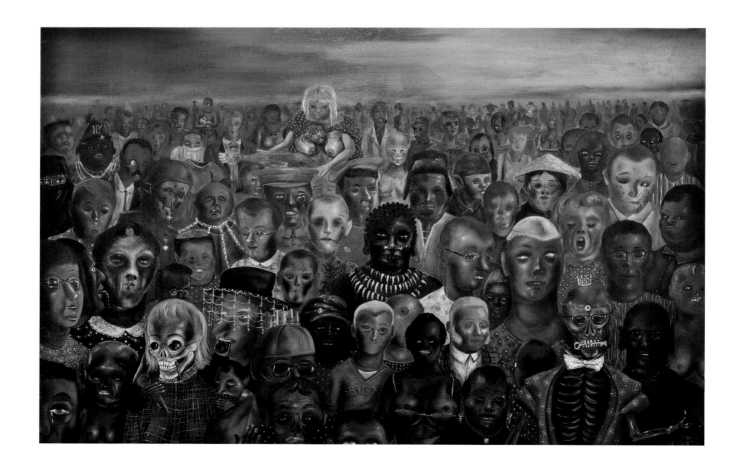

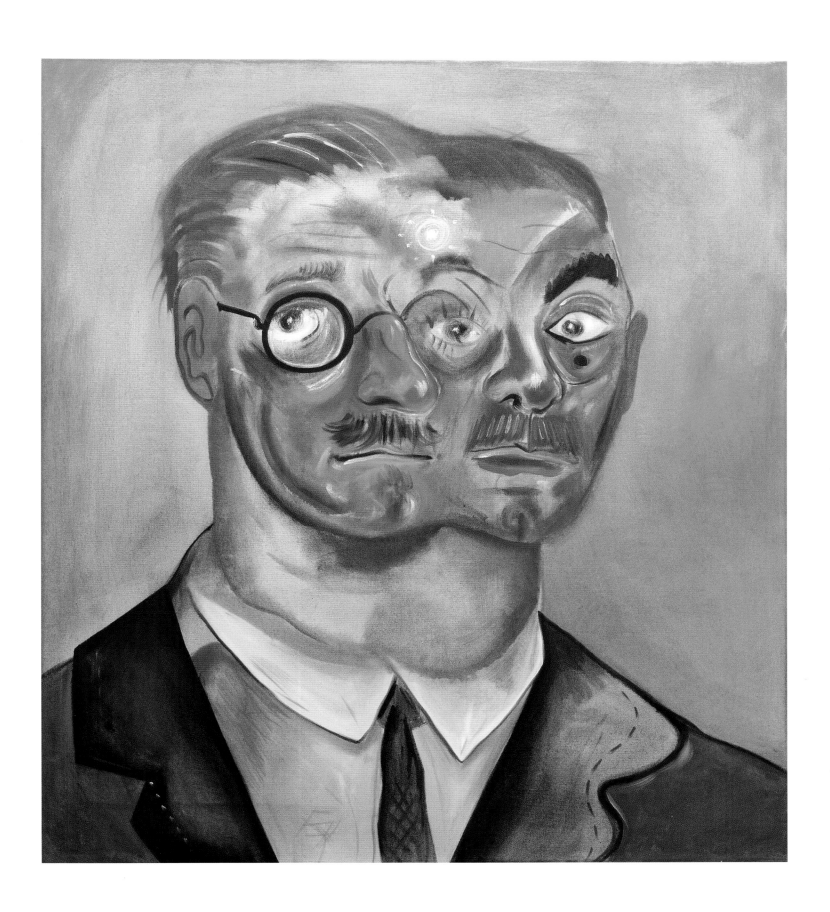

Opposite: *Fears*, 2013, oil on panel, 64.5 × 99.5 cm (25⅜ × 39⅛ in.)

Above: *Joycemann*, 2012, oil on canvas, 90 × 80 cm (35⅜ × 31½ in.)

Jakub Julian Ziolkowski

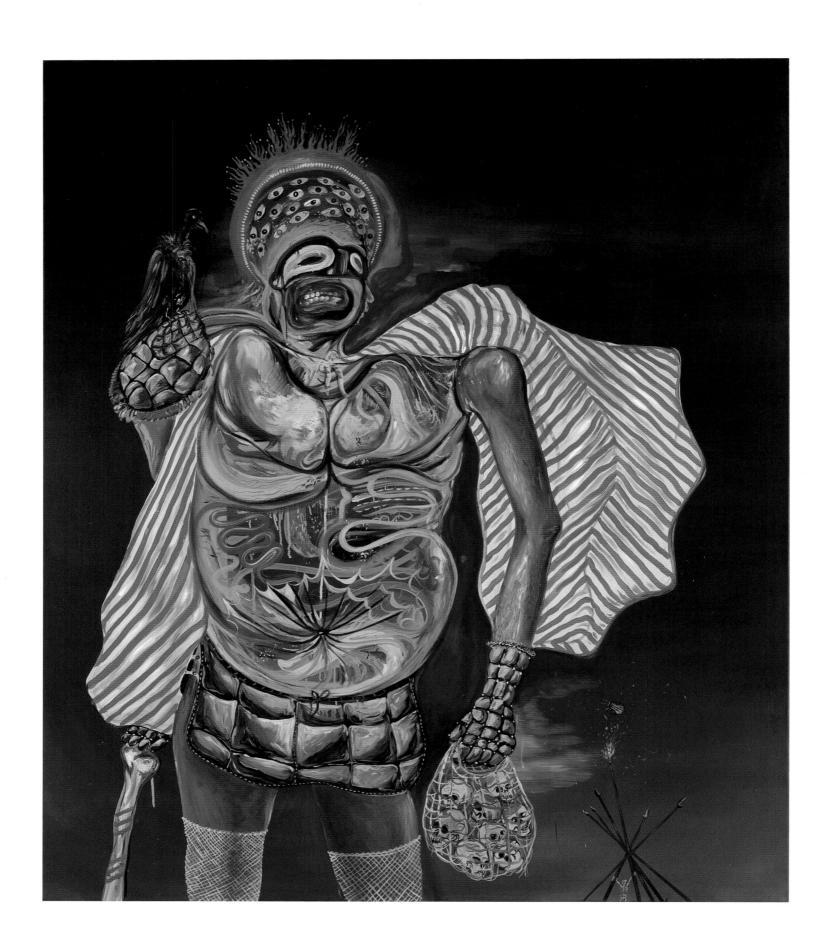

'Everything is a process, everything
has got its end, yet not everything
has got its clearly defined beginning.
I cannot distinguish my life from my
working process anymore.'

Opposite: *Gladiator*, 2009,
oil on canvas, 154 × 132 cm
(60⅝ × 52 in.)

Above: *Untitled (Montana)*,
2010, gouache and ink on
paper, 87.8 × 70.4 cm (34⅝
× 27¼ in.)

Jakub Julian Ziolkowski

JURORS' PICK

Each member of the *100 Painters of Tomorrow* jury was invited to nominate a select number of artists who have been making a significant contribution to the painting scene today. This specially curated resource is, together with the Further Reading list, intended to provide suggestions for further exploration and study.

FIONA ACKERMAN
b. 1978, Montreal, Quebec, Canada
Lives and works in Vancouver,
British Columbia, Canada
Studied at Concordia University, Montreal; Emily Carr Institute of Art and Design, Vancouver • Work exhibited at Art Toronto (Toronto International Art Fair). Received an honourable mention for the Kingston Prize for Canadian Portraiture in 2009. Collected by Bankhaus Bauer HT, Stuttgart, Germany; BMO – Bank of Montreal • Represented by Diane Ferris Gallery, Vancouver, Canada; Gallery Claus Steinrötter, Münster, Germany; Herringer Kiss Gallery, Calgary, Canada; Oeno Gallery, Bloomfield, Canada; White Brush Gallery, Düsseldorf, Germany; Winsor Gallery, Vancouver, Canada.

ELISE ADIBI
b. 1965, Boston, Massachusetts, USA
Lives and works in New York City, New York, USA
Studied at University of Pennsylvania, USA; Columbia University, New York, USA • Work exhibited at The Andy Warhol Museum, Pittsburgh, Pennsylvania; The Armory Show Focus 2013, New York. Recipient of the 2013–14 Radcliffe Institute Fellowship Program, Harvard University, Cambridge, Massachusetts; twice awarded grants from the Pollock-Krasner Foundation, New York; awarded a fellowship by the Terra Foundation for American Art in Giverny, France • Represented by Churner and Churner, New York, USA.

JIA AILI
b. 1979, Liaoning, China
Lives and works in Beijing, China
Studied at Lu Xun Academy of Fine Art, Shenyang, China • Work exhibited at Academy of Fine Art, Shenyang, China; China National Museum, Beijing, China; Minsheng Center for Contemporary Art, Shanghai, China; Shanghai Art Museum, China. Collected by The Franks-Suss Collection • Represented by Platform China Contemporary Art Institute, Beijing, China.

JUMALDI ALFI
b. 1972, Lintau, West Sumatra, Indonesia
Lives and works in Yogyakarta, Indonesia
Studied at the Indonesian Institute of the Arts, Yogyakarta • Work exhibited at Esa Sampoerna Art Museum, Surabaya, Indonesia; The National Gallery of Indonesia, Jakarta; Hong Kong International Art Fair; Shanghai Art Fair, China. Co-founded the artist collective OFFICE For Contemporary Art (OFCA) International, Yogyakarta • Represented by Arndt Gallery, Berlin, Germany; Gajah Gallery, Singapore; Singapore Tyler Print Institute, Singapore.

MATTHEW ALLEN
b. 1981, Auckland, New Zealand
Lives and works in Sydney, Australia
Studied at Sydney College of the Arts, University of Sydney • Work exhibited at Factory 49, Sydney; MOP Gallery, Sydney; TIGHT Space, Sydney. Finalist for the Wilson Art Award, Trinity College, Lismore, New South Wales, Australia, and for the Kogarah Art Prize, Sydney, Australia. Collected by Artbank (collection of the Australian government); James Wallace Arts Trust, Auckland, New Zealand; and private collections throughout Australia • Represented by Sullivan+Strumpf, Sydney, Australia.

SONIA ALMEIDA
b. 1978, Lisbon, Portugal
Lives and works in Boston, Massachusetts, USA
Studied at Universidade de Lisboa, Portugal; Slade School of Fine Art, University College London, England • Work exhibited at Centrum Sztuki Współczesnej Zamek Ujazdowski, Warsaw, Poland; MIT List Visual Arts Center, Cambridge, Massachusetts, USA; Muzeul National de Arta Cluj-Napoca, Romania; Frieze Art Fair, London, England; Prague Biennale 5, Czech Republic. Recipient of a UK Art and Humanities Research Council grant and the Slade Prize in Fine Art • Represented by Simone Subal Gallery, New York, USA.

AHMED ALSOUDANI
b. 1975, Baghdad, Iraq
Lives and works in New York City, New York, USA
Studied at Yale School of Art, New Haven, Connecticut, USA; Skowhegan School of Painting and Sculpture, Maine, USA • Work exhibited at Gwangju Museum of Art, South Korea; Phoenix Art Museum, Arizona, USA; Portland Museum of Art, Maine, USA; Venice Biennale, Italy. Collected by Pinault Foundation, Paris, France; Saatchi Gallery, London, England • Represented by Edge of Arabia, London, England; Gladstone Gallery, New York, USA; L&M Arts, Los Angeles, USA.

ELLEN ALTFEST
b. 1970, New York City, New York, USA
Lives and works in New York
Studied at Yale University School of Art, New Haven, Connecticut, USA; Skowhegan School of Painting and Sculpture, Maine, USA • Work exhibited at Chinati Foundation, Marfa, Texas, USA; Contemporary Art Museum, Houston, Texas; New Museum, New York, USA; Royal Academy of Arts, London, England; Venice Biennale, Italy. Recipient of the Richard and Hinda Rosenthal Award, Academy of Arts and Letters, New York, USA • Represented by Bellwether Gallery, New York, USA; Brand New Gallery, Milan, Italy; White Cube, London, England.

AMTK (ANDREW MAZOROL & TYNAN KERR)
Andrew Mazorol, b. Edina, Minnesota, USA; lives and works in Minneapolis, Minnesota
Studied at University of Minnesota, Minneapolis, Minnesota, USA; Minneapolis Community and Technical College, Minnesota, USA
Tynan Kerr, b. St Paul, Minnesota, USA; lives and works in Minneapolis, Minnesota
Studied at Minneapolis College of Art and Design, Minnesota, USA
• Work as AMTK exhibited at Midway Contemporary Art, Minneapolis, Minnesota. Recipients of the 2009–10 Jerome Foundation Fellowship for Emerging Artists, Minneapolis College of Art and Design, Minnesota • Represented by Unspeakable Projects, San Francisco, California, USA.

HURVIN ANDERSON
b. 1965, Birmingham, England
Lives and works in London, England
Studied at Wimbledon School of Art, London; Royal College of Art, London • Work exhibited at Ikon Gallery, Birmingham, England; Museum of Contemporary Art, Chicago, USA; Saatchi Gallery, London, England; Studio Museum Harlem, New York, USA; Tate Modern, London, England. Artist-in-residence at Headlands Centre for the Arts, Sausalito, California, USA and Dulwich Picture Gallery, London, England • Represented by Durham Press, Pennsylvania, USA; Michael Werner Gallery, New York, USA; Thomas Dane Gallery, London, England.

IAIN ANDREWS
b. 1974, Sutton Coldfield, Birmingham, England
Lives and works in Manchester, England
Studied at University College of Wales,
Aberystwyth; Sheffield University, England
• Work exhibited at Aberystwyth Arts Centre,
Wales; Contemporary Art Society, London,
England; Derby City Art Gallery, England; Mall
Galleries, London, England; Tate Liverpool,
England; Williamsburg Art Centre, New York, USA.
Shortlisted for the Jerwood Drawing Prize and
the Jerwood Painting Fellowship, London, England
• Represented by Man&Eve, London, England.

AU HOI LAM
b. 1978, Hong Kong
Lives and works in Fo Tan, Hong Kong
Studied at École Supérieure des Beaux-arts du
Mans, France; The Chinese University of Hong
Kong, Sha Tin • Work exhibited at Hong Kong
Arts Centre; Hong Kong Central Library and
Experimental Gallery; Museum of Contemporary
Art Shanghai, China; Hong Kong Art Biennial
• Represented by Osage Gallery, Kwun Tong,
Hong Kong; VA Gallery, Sheng Wan, Hong Kong.

TAUBA AUERBACH
b. 1981, San Francisco, California, USA
Lives and works in New York City, New York, USA
Studied at Stanford University, Palo Alto,
California, USA • Work exhibited at Bergen
Kunsthall, Norway; Castello di Rivoli Museum of
Contemporary Art, Turin, Italy; Contemporary Arts
Museum, Houston, Texas, USA; Malmö Konsthall,
Sweden; Museum of Contemporary Art, Los
Angeles, USA; Museum of Modern Art, New York,
USA; Tate St Ives, England; Wattis Institute for
Contemporary Art, San Francisco, California, USA;
Whitechapel Gallery, London, England. Recipient
of an Artist Research Fellowship from the
Smithsonian Institution, Washington, DC, and the
San Francisco Museum of Modern Art's Society for
the Encouragement of Contemporary Art award
• Represented by Paula Cooper Gallery, New York,
USA; Standard (Oslo), Norway.

ANDISHEH AVINI
b. 1974, New York City, New York, USA
Lives and works in New York
Studied at Hunter College, New York • Work
exhibited at Fundación/Colección Jumex, Mexico
City, Mexico; Kunstmuseum Bern, Switzerland;
PS 1 Contemporary Art Center, New York, USA;
Tisch Gallery, Tufts University, Somerville,
Massachusetts, USA; The Armory Show, New York,
USA; FIAC, Paris, France • Represented by Alberto
Peola, Turin, Italy; Feinkost, Berlin, Germany;
Marianne Boesky Gallery, New York, USA.

EMI AVORA
b. 1979, Athens, Greece
Lives and works in London, England
Studied at Ruskin School of Fine Art, Oxford,
England; Royal Academy Schools, London,
England • Work exhibited at Le Musée de
Marrakech, Morocco; National Museum of
Contemporary Art, Athens, Greece; Pallant House
Gallery, Chichester, England; Whitechapel Gallery,
London, England. Collected by Ernst & Young
Collection, London, England; The Hiscox Collection,
UK; The Slade Collection, UK; The Wonderful Fund
Collection, UK • Represented by The Apartment,
Athens, Greece; Van Doren Waxter, New York, USA.

VASILIS AVRAMIDIS
b. 1981, Kilkis, Greece
Lives and works in Thessaloniki, Greece,
and London, England
Studied at Aristotle University, Thessaloniki, Greece;
Central Saint Martins College of Art and Design,
London, England • Work exhibited at Ministry of
Culture of Slovakia, Bratislava; Art Athina, Athens,
Greece; London Art Fair, England. Shortlisted
for the 2011 Salon Art Prize, Matt Roberts Arts,
London, England. Collected by University of the
Arts London and private collections in the UK,
USA, Greece and Japan • Represented by The
Contemporary London, England; Opus Fine Art,
Stow on the Wold, Gloucestershire, England.

MOHAMAD SAID BAALBAKI (BAAL)
b. 1974, Beirut, Lebanon
Lives and works in Berlin, Germany
Studied at the Institut des Beaux-Arts, Beirut,
Lebanon; University of the Arts, Berlin, Germany
• Work exhibited at Goethe-Institut, Beirut,
Lebanon; Mathaf: Arab Museum of Modern Art,
Doha, Qatar; Werkbundarchiv – Museum der
Dinge (Museum of Things), Berlin, Germany
• Represented by Anima Gallery, Doha, Qatar;
Rose Issa Projects, London, England; Wilde Gallery,
Berlin, Germany.

MONIKA BAER
b. 1964, Freiburg im Breisgau, Germany
Lives and works in Berlin, Germany
Studied at Kunstakademie Düsseldorf, Germany
• Work exhibited at the Art Institute of Chicago,
USA; Bonner Kunstverein, Switzerland; Kunsthalle
Münster, Germany; Museo Nacional Centro de
Arte Reina Sofia, Madrid, Spain; Museum of
Contemporary Art, Los Angeles, USA; Pinakothek
der Moderne, Munich, Germany; Williams College
Museum of Art, Williamstown, Massachusetts,
USA; Documenta 12, Kassel, Germany. Collected
by the Booth School of Business, Chicago, USA;
Burger Collection, Berlin, Germany; Museum of
Modern Art, New York, USA • Represented by
Galerie Barbara Weiss, Berlin, Germany; Kerstin
Engholm Gallery, Vienna, Austria; Richard Telles
Fine Art, Los Angeles, USA.

TOM BARNETT
b. 1984, London, England
Lives and works in London
Studied at University of the West of England,
Bristol; Chelsea College of Art and Design, London
• Work exhibited at Mall Galleries, London; Victoria
& Albert Museum, London; Art Brussels, Belgium;
Venice Biennale, Italy • Represented by Hannah
Barry Gallery, London, England; Marcelle Joseph
Projects, Berkshire, England.

RANA BEGUM
b. 1977, Sylhet, Bangladesh
Lives and works in London, England
Studied at Chelsea College of Art and Design,
London; Slade School of Fine Art, University
College London • Work exhibited at Art Museum
of Western Virginia, USA; The City Gallery,
Leicester, England; Royal Academy of Arts,
London, England; ABC Art Fair, Berlin, Germany;
The Armory Show, New York, USA. Collected
by Art Museum of Western Virginia, USA;
Coimbatore Centre for Contemporary Arts,
Rajshree Pathy Collection, Tamil Nadu, India;
Ernst & Young Collection, London, England
• Represented by Bischoff/Weiss, London,
England; Galerie Christian Lethert, Cologne,
Germany; Jane Deering Gallery, Santa Barbara,
California, USA; The Third Line, Dubai, United
Arab Emirates.

RADU BELCIN
b. 1978, Brașov, Romania
Lives and works in Brașov
Studied at Bucharest National University of
Arts, Romania • Work exhibited at Art Factory,
Dromonero, Crete, Greece; The Art Museum,
Brașov, Romania; Brukenthal National Museum,
Sibiu, Transylvania, Romania; SKC Cultural
Centre, Belgrade, Serbia; Liverpool Biennial,
England • Represented by Nasui Collection and
Gallery, Bucharest, Romania.

CÉLINE BERGER
b. 1973, Saint-Martin-d'Hères, France
Lives and works in Moscow, Russia
Studied at Academy of Media Arts Cologne,
Germany • Work exhibited at Beursschouwburg,
Brussels, Belgium; Bundeskunsthalle, Bonn,
Germany; Künstlerhaus, Vienna, Austria;
Worcester City Art Gallery, England; UCLA
New Wight Biennial 2012, Los Angeles, USA;
Rijksakademie OPEN, Rijksakademie van
beeldende kunsten, Amsterdam, Netherlands.
Recipient of the Nam June Paik Newcomer Award
2012, Kunststiftung North Rhine-Westphalia,
Germany. Awarded the 2012–13 residency at the
Dutch Ministry of Education, Culture and Science,
The Hague, Netherlands • Represented by Iragui
Gallery, Moscow, Russia and Paris, France.

ANNA BETBEZE
b. 1980, Mobile, Alabama, USA
Lives and works in New York City, New York, USA
Studied at Lamar Dodd School of Art, University
of Georgia, USA; Yale School of Art, New
Haven, Connecticut, USA • Work exhibited at
Herbert F. Johnson Museum of Art – Cornell
University, New York, USA; Massachusetts
Museum of Contemporary Art, USA; MoMA
PS1, New York, USA; Musée d'Art Moderne de la
Ville de Paris, France; Philadelphia Institute of
Contemporary Art, Pennsylvania, USA. Awarded
the 2013–14 Harold M. English/Jacob H. Lazarus
– Metropolitan Museum of Art Rome Prize •
Represented by Brand New Gallery, Milan, Italy;
Lüttgenmeijer, Berlin, Germany; Kate Werble
Gallery, New York, USA.

ANNA BJERGER
b. 1973, Skallsjo, Sweden
Lives and works in Småland, Sweden
Studied at Central Saint Martins College of Art
and Design, London, England; Royal College of
Art, London, England • Work exhibited at Centre
Culturel Suédois, Paris, France; La chapelle de
l'École des beaux-arts de Paris, France; Museo
de la Ciudad de Querétaro, Mexico; Pump House
Gallery, London, England; Växjö Konsthall,
Sweden; Dublin Contemporary 2011, Ireland.
Collected by the Zabludowicz Collection, London,
England • Represented by David Risley Gallery,
Copenhagen, Denmark; Galerie Gabriel Rolt,
Amsterdam, Netherlands; Paradise Row,
London, England.

MAYA BLOCH
b. 1978, Be'er Sheva, Israel
Lives and works in Tel Aviv, Israel
Studied at Tel Aviv University • Work exhibited
at Haifa Museum of Art, Israel; Petach Tikva
Museum of Art, Israel; SanGallo Art Station,
Florence, Italy; The 4th Drawing Biennial, Artists'
House, Jerusalem, Israel; NADA Art Fair, Miami,
Florida, USA • Represented by Thierry Goldberg
Gallery, New York, USA.

ZANDER BLOM
b. 1982, Pretoria, South Africa
Lives and works in Johannesburg, South Africa
Studied at University of Pretoria • Work exhibited
at Palazzo delle Papesse, Siena, Italy; Sandton
Civic Gallery, Johannesburg, South Africa;
Savannah College of Art and Design, Savannah
and Atlanta, Georgia, USA; Tshwane University of
Technology, Pretoria, South Africa; ZKM Center for
Art and Media Karlsruhe, Germany • Represented
by Christian Ferreira, London, England; Rooke
Gallery, Johannesburg, South Africa; Stevenson,
Capetown and Johannesburg, South Africa.

ZSOLT BODONI
b. 1975, Élesd, Romania
Lives and works in Budapest, Hungary
Studied at Hungarian Academy of Fine Arts,
Budapest • Work exhibited at Hungarian Cultural
Institute, Brussels, Belgium; MODEM Centre
for Modern and Contemporary Arts, Debrecen,
Hungary; 2011 Armory Show, New York, USA;
Prague Biennale 5, Czech Republic. Collected
by The Blake Byrne Collection, Los Angeles, USA;
The Mallin Collection, New York, USA; Salsali
Private Museum, Dubai, United Arab Emirates;
Whitespace: The Mordes Collection, West Palm
Beach, Florida, USA • Represented by Ana
Cristea Gallery, New York, USA; Brand New
Gallery, Milan, Italy; Green Art Gallery, Dubai,
United Arab Emirates.

ARMIN BOEHM
b. 1972, Aachen, Germany
Lives and works in Berlin, Germany
Studied at Kunstakademie Düsseldorf • Work
exhibited at City Gallery Kiel, Germany;
Goethe-Institut Johannesburg, South Africa;

Kunsthistorisches Institut, University of Bonn,
Germany; Schirn Kunsthalle, Frankfurt, Germany;
Städtische Galerie Delmenhorst, Germany;
Zeppelin Museum Friedrichshafen, Germany
• Represented by Francesca Minini, Milan, Italy;
Galerie Peter Kilchmann, Zurich, Switzerland;
Meyer Riegger, Berlin and Frankfurt, Germany.

GABRIELLA BOYD
b. 1988, Glasgow, Scotland
Lives and works in London, England
Studied at Glasgow School of Art • Work exhibited
at Barbican Art Gallery, London, England; Pratt
Institute, New York, USA; Royal Academy of
Arts, London, England; Beijing International Art
Biennale 2012, National Art Museum of China,
Beijing, China. Named a Saatchi New Sensation
in 2011, Saatchi Gallery and Channel 4, UK, and
shortlisted for the 2012 Catlin Prize, UK. Collected
by Creative Cities Collection, Barbican, London,
England; Saatchi Gallery, London, England
• Represented by High House Gallery, Clanfield,
Oxfordshire, England.

JOE BRADLEY
b. 1975, Kittery, Maine, USA
Lives and works in New York City, New York, USA
Studied at Rhode Island School of Design,
Providence, USA • Work exhibited at Le
Consortium, Dijon, France; Midway Contemporary
Art, Minneapolis, Minnesota, USA; MoMA PS1,
New York, USA; Museum of Contemporary Art of
Rome (MACRO), Italy; National Museum, Berlin,
Germany; the 2008 Whitney Biennial, Whitney
Museum of American Art, New York, USA
• Represented by Almine Rech Gallery, Paris,
France, and Brussels, Belgium; Canada Gallery,
New York, USA; Gavin Brown's Enterprise,
New York, USA; Jonathan Viner Gallery, London,
England; Peres Projects, Berlin, Germany.

KERSTIN BRÄTSCH
b. 1969, Hamburg, Germany
Lives and works in Berlin, Germany,
and New York City, New York, USA
Studied at Columbia University, New York, USA
• Work exhibited at Art Institute of Chicago,
USA; Kölnischer Kunstverein, Cologne, Germany;
Kunsthalle Zürich, Switzerland; MoMA PS1, New
York, USA; Swiss Institute, New York, USA; Venice
Biennale, Italy; Gwangju Biennale, South Korea.
Recipient of the Agnes Martin Fellowship Award,
New York, USA, and the Prix du Quartier des Bains,
Geneva, Switzerland; nominated for the National
Gallery Prize for Young Art 2013, Hamburger
Bahnhof, Germany. Collected by Museum of
Modern Art, New York, USA; Syz Collection,
Geneva, Switzerland • Represented by Galerie
Balice Hertling, Paris, France; Gavin Brown's
Enterprise, New York, USA.

ORLANDA BROOM
b. 1974, Lisbon, Portugal
Lives and works in London, England
Studied at Cheltenham School of Art, England;
Winchester School of Art – Elisava, Barcelona,

Spain • Work exhibited at Royal Academy of
Arts, London, England; National Open Art
Competition, Chichester, England. Nominated
for the Threadneedle Prize, London, England, and
BEEP Wales International Contemporary Painting
Prize, Swansea, Wales • Represented by Art in
the Yard, Franschhoek, South Africa; Five Senses
Art Consultancy, San Francisco, California, USA;
Stephanie Hoppen Gallery, London, England.

MATTHEW BROWN
b. Birmingham, England
Lives and works in Toronto, Canada
Studied at University of Victoria, Canada;
Concordia University, Montreal, Canada • Work
exhibited at Emily Carr Institute, Vancouver,
Canada; Midway Contemporary Art, Minneapolis,
Minnesota, USA; Museum of Contemporary
Canadian Art, Toronto, Canada; Vancouver Art
Gallery, Canada. Recipient of project and travel
grants from Canada Council for the Arts.

RYAN BROWNING
b. 1981, Houston, Texas, USA
Lives and works in Doha, Qatar
Studied at Brigham Young University, Provo,
Utah, USA; Mount Royal School of Art, Maryland
Institute College of Art, Baltimore, USA
• Work exhibited at Central Utah Art Center,
Salt Lake City, USA; Creative Alliance, Baltimore,
Maryland, USA; Curious Matter, Jersey City,
New Jersey, USA; Delicious Spectacle, Washington,
DC, USA; Salisbury University, Maryland, USA;
Silber Art Gallery, Goucher College, Baltimore,
Maryland, USA. Selected for inclusion in New
America Paintings (2011 and 2013), Boston,
Massachussetts, USA.

TOM BUTLER
b. 1979, London, England
Lives and works in Portland, Maine, USA
Studied at Winchester School of Art, Southampton
University, England; Chelsea College of Art and
Design, London, England; Slade School of Fine
Art, University College London, England • Work
exhibited at Centre for Maine Contemporary Art,
Rockport, USA; The Flavel Arts Centre, Dartmouth,
England; Salisbury Art Centre, England; Victoria
House London, England; Worcester Art Gallery and
Museum, England; Paris Photo, Grand Palais, Paris,
France. Collected by The SØR Rusche Collection,
Oelde and Berlin, Germany; University of Maine
Museum of Art, Bangor, Maine, USA • Represented
by Aucocisco Galleries, Portland, Maine, USA;
Gallery51, Antwerp, Belgium.

MIRIAM CAHN
b. 1949, Basel, Switzerland
Lives and works in Basel and Bergell, Switzerland
Studied at Allgemeine Gewerbeschule, Basel
• Work exhibited at Musée la Chaux-de-Fonds,
Switzerland; Museum of Modern Art, New York,
USA; Venice Biennale, Italy. Saint-Moritz Art
Master Prize • Represented by Elizabeth Dee
Gallery, New York, USA; Galerie Jocelyn Wolff,
Paris, France; Meyer Riegger, Berlin, Germany.

DARREN COFFIELD
b. 1969, London, England
Lives and works in London
Studied at Slade School of Fine Art, London; Camberwell School of Art, London; Goldsmiths College, London • Work exhibited at the Courtauld Institute, London; National Portrait Gallery, London; Voloshin Museum, Crimea. National Portrait Gallery BP Portrait Award • Represented by Chart Gallery, London; Herrick Gallery, London; Paul Stolper, London; Pertwee, Anderson & Gold, London, England.

MATT CONNORS
b. 1973, Chicago, Illinois, USA
Lives and works in Los Angeles, California, USA
Studied at Bennington College, Vermont, USA; Yale University School of Art, New Haven, USA • Work exhibited at Dallas Museum of Art, Texas, USA; Kunsthalle Düsseldorf, Germany; MoMA PS1, New York, USA • Represented by Canada Gallery, New York, USA; Cherry and Martin, Los Angeles, USA.

CALEB CONSIDINE
b. 1982, Los Angeles, California, USA
Lives and works in New York City, New York, USA
Studied at Columbia University, New York, USA; Yale University School of Art, New Haven, USA • Work exhibited at Fisher Landau Center for Art, New York, USA; MoMA PS1, New York, USA • Represented by Essex Street, New York, USA.

SARAH CROWNER
b. 1974, Philadelphia, Pennsylvania, USA
Lives and works in Brooklyn, New York, USA
Studied at University of California, Santa Cruz, USA; Hunter College City University of New York, USA • Work exhibited at Museum of Contemporary Art, Detroit, USA; Museum of Modern Art, New York, USA; Zacheta National Museum of Art, Warsaw, Poland; Whitney Biennial, New York, USA • Represented by Galerie Nordenhake, Stockholm, Sweden; Nicelle Beauchene Gallery, New York, USA.

ZHU CUNWEI
b. 1972, Xuzhou, Jiangsu Province, China
Lives and works in Nanjing, Jiangsu, China
Studied at Nanjing Normal University • Work exhibited at Center for Contemporary Art, Shandong, China; Qinghe Contemporary Art Museum, Nanjing, China; Sanchuan Modern Art Museum, Nanjing, China.

JAMES DEAN
b. 1986, Adelaide, Australia
Lives and works in Adelaide
Studied at University of South Australia, Adelaide • Work exhibited at SpringART, Loreto College, Adelaide. University of South Australia Illustration Award • Represented by Espionage Gallery, Adelaide Australia.

FRANCESCA DIMATTIO
b. 1981, New York City, New York, USA
Lives and works in New York

Studied at Cooper Union, New York; Columbia University, New York • Work exhibited at Cluj Museum, Romania; Institute of Contemporary Art, Boston, USA; Prague Biennial, Czech Republic. Collected by The Miami Art Museum, Florida, USA; Saatchi Gallery, London, England • Represented by Pippy Houldsworth Gallery, London, England; Salon 94, New York, USA.

MICHAELA EICHWALD
b. 1967, Cologne, Germany
Lives and works in Cologne
Work exhibited at CAPC Musée d'Art Contemporain, Bordeaux, France; Institute of Contemporary Art, Philadelphia, USA • Represented by Deborah Schamoni, Munich, Germany; Dépendance, Brussels, Belgium; Pro Choice, Vienna, Austria; Reena Spaulings Fine Art, New York, USA; Vilma Gold, London, England.

IDA EKBLAD
b. 1980, Oslo, Norway
Lives and works in Oslo
Studied at Central Saint Martins College of Art, London, England; The National Academy of Art, Oslo, Norway; The Mountain School of Arts, Los Angeles, USA • Work exhibited at Astrup Fearnley Museum of Modern Art, Oslo; Museum of Contemporary Art, Miami, USA; Museum of Contemporary Art, Oslo; Prague Biennale, Czech Republic; Venice Biennale, Italy • Represented by Green Naftali, New York, USA; Karma International, Zurich, Switzerland.

JEFF ELROD
b. 1966, Dallas, Texas, USA
Lives and works in Marfa, Texas, and Brooklyn, New York, USA
Studied at University of Texas, Denton, USA; Rijksakademie Van Beeldende Kunsten, Amsterdam, Netherlands • Work exhibited at Contemporary Arts Museum, Houston, Texas, USA; MoMA PS1, New York, USA; Whitney Museum of American Art, New York, USA. Collected by the Museum of Modern Art, New York, USA • Represented by Luhring Augustine, New York, USA; Peres Projects, Berlin, Germany; Simon Lee Gallery, London, England; Talley Dunn Gallery, Dallas, Texas, USA.

SCOTT EVERINGHAM
b. 1978, Toronto, Ontario, Canada
Lives and works in Toronto
Studied at Fanshawe College Fine Art, Ontario, Canada; Nova Scotia College of Art and Design University, Halifax, Canada; University of Waterloo, Ontario, Canada • Work exhibited at Musée d'Art Contemporain de Montréal, Canada; National Gallery of Canada, Ottawa. Finalist in the RBC Canadian Painting Competition; Toronto Arts Council Emerging Artist Grant. Collected by the Canada Council Art Bank; Royal Bank of Canada • Represented by Galerie Trois Points, Montreal, Canada; General Hardware Contemporary, Toronto, Canada; Patrick Mikhail Gallery, Ottawa, Canada.

AMIR H. FALLAH
b. 1979, Tehran, Iran
Lives and works in Los Angeles, California, USA
Studied at Maryland Institute College of Art, Baltimore, USA; University of California, Los Angeles, USA • Work exhibited at Lancaster Museum of Art and History, California, USA; Weatherspoon Art Museum, Greensboro, North Carolina, USA; LA Weekly Annual Biennial, California, USA. Awarded the Jacob Javits Fellowship • Represented by Gallery Wendi Norris, San Francisco, USA; The Third Line, Dubai, United Arab Emirates.

ANNA FASSHAUER
b. 1975 Cologne, Germany
Lives and works in Berlin, Germany
Studied at De Montfort University, Leicester, England; Chelsea School of Art and Design, London, England • Work exhibited at International Triennial of Contemporary Art, Izmir, Turkey; Liverpool Biennale. First Prize, Prix des Arts, Strasbourg, France • Represented by Galerie Andreas Höhne, Munich, Germany.

EMANUEL FAYTCHEVITZ
b. 1971, Hulon, Israel
Lives and works in Tel Aviv, Israel
Studied at Bezalel Academy of Arts and Design, Jerusalem, Israel • Work exhibited at Haifa Museum of Art, Israel; Herzliya Museum of Contemporary Art, Israel. Isracard and Tel Aviv Museum of Art Prize • Represented by Tal Esther Gallery, Tel Aviv, Israel.

PAMELA FRASER
b. 1965, Smyrna, Tennessee, USA
Lives and works in Charlotte, Vermont, USA
Studied at Skowhegan School of Painting and Sculpture, Maine, USA; Skidmore College, Saratoga Springs, USA; School of Visual Arts, New York, USA; University of California, Los Angeles, USA • Work exhibited at Albright-Knox Art Gallery, Buffalo, USA; Museum of Modern Art, Ibaraki, Japan. Louis Comfort Tiffany Award; The Pollock-Krasner Foundation Grant • Represented by Casey Kaplan Galley, New York, USA; Galerie Schmidt Maczollek, Cologne, Germany.

LEO GABIN
Collaborative project of Lieven Deconinck, Gaëtan Begerem and Robin De Vooght.
Founded 2000, Ghent, Belgium
Live and work in Ghent
Studied at Royal Academy of Fine Arts, Ghent • Work exhibited at Foto Museum, Antwerp, Belgium; The Ileana Tounta Contemporary Art Center, Athens, Greece • Represented by Elizabeth Dee Gallery, New York, USA.

MAUREEN GALLACE
b. 1960 Stamford, Connecticut, USA
Lives and works in New York City, New York, USA
Studied at University of Hartford, Connecticut, USA; Rutgers University, New Jersey, USA

• Work exhibited at The Art Institute of Chicago Museum, USA; Whitney Biennial, New York, USA. Collected by The Art Institute of Chicago, USA; Dallas Museum of Art, Texas, USA • Represented by 303 Gallery, New York, USA; Gallery Side 2, Tokyo, Japan; Kerlin Gallery, Dublin, Ireland.

MICHAL GEVA
b. 1980, Kibutz Ein Shemer, Israel
Lives and works in Tel Aviv, Israel
Studied at Gerrit Rietveld Academy, Amsterdam, Netherlands; Hamidrasha School of Visual Art, Beit Berl College, Israel • Work exhibited at Hamidrasha School of Visual Art, Beit Berl College, Israel. America-Israel Cultural Foundation Scholarship; Rabinovich Foundation Grant. Collected by Bank Hapoalim Art Collection; Bank Leumi Art Collection.

NICK GOSS
b. 1981, Bristol, England
Lives and works in London, England
Studied at Slade School of Fine Art, London; Royal Academy Schools, London • Work exhibited at Hong Kong International Art Fair, China; Saatchi Gallery, London, England. Painters' Company Gordon Luton Award. Collected by The Franks-Suss Collection, London, England • Represented by Josh Lilley, London, England.

GONZALO GOYTISOLO GIL
b. 1966, Barcelona, Spain
Lives and works in Barcelona
Work exhibited at Museu d'Art Modern, Barcelona, Spain; National Portrait Gallery, London, England. National Portrait Gallery BP Portrait Award. Collected by Museum of Contemporary Art, Madrid, Spain • Represented by Sala Parés, Barcelona, Spain; Trama Gallery, Barcelona, Spain.

AURELIA GRATZER
b. 1979, Hartberg, Austria
Lives and works in Vienna, Austria
Studied at University of Vienna; Academy of Fine Arts, Vienna • Work exhibited at Tyrolean State Museum, Innsbruck, Austria. Strabag International Art Award, Vienna, Austria. Collected by Austrian State Collection, Vienna; West Collection, Philadelphia, USA • Represented by Bechter Kastowsky Galerie, Vienna, Austria; Brunnhofer Gallery, Linz, Austria; Galerie Bugdahn und Kaimer, Düsseldorf, Germany; Galerie Suppan Contemporary, Vienna, Austria.

JOANNE GREENBAUM
b. 1953, New York City, New York, USA
Lives and works in New York
Studied at Bard College, Annandale-on-Hudson, New York, USA • Work exhibited at Brooklyn Museum, New York, USA; MoMA PS1, New York, USA; Museum of Contemporary Art, Chicago, USA. John Simon Guggenheim Memorial Foundation Grant; The Pollock-Krasner Foundation Grant • Represented by greengrassi, London, England; Nicolas Krupp Contemporary Art, Basel, Switzerland; Shane Cambell Gallery, Chicago, USA.

WANG GUANGLE
b. 1976 Fujian, China
Lives and works in Beijing, China
Studied at Central Academy of Fine Arts, Beijing • Work exhibited at Minsheng Art Museum, Shanghai, China; Singer Laren Museum, Netherlands; The Ullens Center for Contemporary Art, Beijing China; Zhejiang Art Museum, Hangzhou, China • Represented by Beijing Commune, China; White Rabbit, Chippendale, Australia.

WADE GUYTON
b. 1972, Hammond, Indiana, USA
Lives and works in New York City, New York, USA
Studied at University of Tennessee, Knoxville, USA; Hunter College City University of New York, USA • Work exhibited at MoMA PS1, New York, USA; Whitney Museum of American Art, New York, USA; Lyon Biennale, France; Venice Biennale, Italy. Collected by Museum of Contemporary Art, Los Angeles, USA; Museum of Modern Art, New York, USA; Tate Museum, London, England • Represented by Petzel Gallery, New York, USA.

CONOR HARRINGTON
b. 1980, Cork, Ireland
Lives and works in London, England
Studied at Limerick School of Art and Design, Ireland • Work exhibited at Daelim Museum of Contemporary Art, Seoul, South Korea; National Gallery of Zimbabwe, Harare • Represented by Lazarides Gallery, London, England.

NEIL HARRISON
b. 1981, Winnipeg, Canada
Lives and works in Toronto, Canada
Studied at University of Victoria, Canada; York University, Toronto, Canada • Work exhibited at Art Gallery of Mississauga, Ontario, Canada; National Gallery of Canada, Ottawa. Honorable Mention, RBC Canadian Painting Competition. Collected by Royal Bank of Canada • Represented by Beers Contemporary, London, England; Central Art Garage, Ontario, Canada.

GABRIEL HARTLEY
b. 1981, London, England
Lives and works in London
Studied at Chelsea College of Art and Design, London; Royal Academy Schools, London • Work exhibited at Royal Academy of Arts, London; Saatchi Gallery, London. John Moores Painting Prize, Walker Art Gallery, Liverpool, England • Represented by Brand New Gallery, Milan, Italy; Foxy Production, New York, USA; Praz-Delavallade, Paris, France.

EBERHARD HAVEKOST
b. 1967, Dresden, Germany
Lives and works in Dresden and Berlin, Germany
Studied at Hochschule für Bildende Künste, Dresden, Germany • Work exhibited at Phoenix Art Museum, Arizona, USA; Stedelijk Museum, Amsterdam, Netherlands; Prague Biennale,

Czech Republic. Collected by Museum of Modern Art, New York, USA; Tate Gallery, London, England • Represented by Anton Kern Gallery, New York, USA; Galerie Gebr. Lehmann, Berlin, Germany; Roberts & Tilton, Culver City, California, USA; White Cube Gallery, London, England.

IRIT HEMMO
b. 1961, Jerusalem, Israel
Lives and works in Tel Aviv, Israel
Studied at Indianapolis University, Indiana, USA; School of Art Teaching, Ramat Hasharon, Israel • Work exhibited at Albright Knox Gallery, Buffalo, USA; Haifa Museum, Israel; Herzelia Museum, Israel. Jerusalem Drawing Biennial, Israel; Israel Museum Prize for Israeli Artists • Represented by Inga Gallery of Contemporary Art, Tel Aviv, Israel.

FEDERICO HERRERO
b. 1978, San Jose, Costa Rica
Lives and works in San Jose
Studied at Pratt Institute, New York, USA • Work exhibited at Museum of Fine Arts, Taiwan; Watari Museum of Contemporary Art, Japan; Seville Biennial, Spain; Venice Biennale, Italy. Golden Lion Award for Best Young Artist, Venice Biennale • Represented by Bridgette Mayer Gallery, Philadelphia, USA; Galeria Juana de Aizpuru, Madrid, Spain; Galeria Luisa Strina, São Paulo, Brazil; Gallery Koyanagi, Tokyo, Japan; Sies & Hoeke, Düsseldorf, Germany.

SARAH HOLLARS
b. 1983, Lakeview, Oregon, USA
Lives and works in Brooklyn, New York, USA
Studied at University of Washington, Seattle, USA; University of Oregon, Eugene, USA; Universität der Künste Berlin, Germany; Hunter College City University of New York, USA • Work exhibited at LaVern Krause Gallery, University of Oregon, Eugene, USA. Honorable Mention, C12 Emerging Artist Grant; Gladys and Forrest Cooper Fund; Richard Martin Kaye Award.

AARON HOLZ
b. 1972, Minneapolis, Minnesota, USA
Lives and works in Lincoln, Nebraska, USA
Studied at Moorhead State University, Nebraska; University at Albany, State University of New York, USA • Work exhibited at Rourke Art Museum, Minnesota, USA; Sheldon Museum of Art, Nebraska, USA. Collected by The Sheldon Memorial Art Gallery, Nebraska, USA • Represented by RARE Gallery, New York, USA.

HAI-HSIN HUANG
b. 1984, Taipei, Taiwan
Lives and works in Brooklyn, New York, USA
Studied at National Taipei University of Education, Taiwan; School of Visual Arts, New York, USA • Work exhibited at Herzliya Museum of Contemporary Art, Israel; Museum of Contemporary Art, Taipei, Taiwan. Honorable Mention, Taipei Arts Award; Taoyuan Creation Award.

ZHANG HUI
b. 1969, Yinchuan Province, China
Lives and works in Beijing, China
Studied at Sichuan Academy of Fine Arts, China
• Work exhibited at Museum of Contemporary
Art, Shanghai, China; Yuandong Museum,
Changchun, China • Represented by Willem
Kerseboom Gallery, Bergen, Netherlands.

JACQUELINE HUMPHRIES
b. 1960, New Orleans, Louisiana, USA
Lives and works in New York City, New York, USA
Studied at Parsons School of Design, New York
• Work exhibited at Museum of Contemporary
Art, Cleveland, Ohio, USA; Museum Ludwig,
Cologne, Germany. The Pollock-Krasner
Foundation Grant. Collected by Museum of
Modern Art, New York, USA; Whitney Museum
of American Art, New York, USA • Represented
by Green Naftali Gallery, New York, USA.

NATHAN HYLDEN
b. 1978, Fergus Falls, Minnesota, USA
Lives and works in Los Angeles, California, USA
Studied at Minnesota State University, USA;
Staatliche Hochschule fur Bildende Kunste
Staedelschule, Frankfurt, Germany; Art
Center College of Design, California, USA
• Work exhibited at Museum of Contemporary
Art Detroit, Michigan, USA; Museum Van
Boijmans Beuningen, Rotterdam, Netherlands;
Schildbürger Biennale, Austria • Represented
by Galerie Art: Concept, Paris, France; Johann
Koenig, Berlin, Germany; Misako & Rosen,
Tokyo, Japan.

PIOTR JANAS
b. 1970, Warsaw, Poland
Lives and works in Warsaw
Work exhibited at Institute of Contemporary
Arts, London, England; Kunsthalle Basel,
Switzerland; National Gallery of Art, Warsaw,
Poland; Venice Biennale, Italy. EXIT Art Magazine
National Painting Contest Prize. Collected by
Tate Modern, London, England • Represented
by Bortolami Gallery, New York, USA.

ROBERT JANITZ
b. 1962, Alsfield, Germany
Lives and works in New York City, New York, USA
Work exhibited at Art Basel Miami Beach,
Florida, USA; Art Basel, Switzerland; Art
Brussels, Belgium; Cooper Union School of Art,
New York • Represented by Team Gallery, New
York, USA.

BENJAMIN JENNER
b. 1981, Dover, Kent, England
Lives and works in London, England
Studied at University of the Arts, London;
Slade School of Fine Art, London • Work
exhibited at The Centre for Recent Drawing,
London; Royal Academy of Art, London;
Drawing Biennial, London. The Red Mansion
Art Prize, Beijing, China.

SERGEJ JENSEN
b. 1973, Maglegaard, Denmark
Lives and works in Berlin, Germany
Studied at Städelschule, Hochschule für Bildende
Künste, Frankfurt, Germany • Work exhibited
at MoMA PS1, New York, USA; Museum of
Contemporary Art, Chicago, USA; Museum of
Modern Art, San Francisco, USA; Biennale São
Paulo, Brazil; Whitney Biennial, New York, USA.
Carnegie Art Award; Fred Thieler Prize
• Represented by Anton Kern Gallery, New York,
USA; Dépendance, Brussels, Belgium; Galerie Neu,
Berlin, Germany; Regen Projects, Los Angeles,
USA; White Cube Gallery, London, England.

CUI JIE
b. 1983, Shanghai, China
Lives and works in Beijing, China
Studied at China Academy of Art, Hangzhou,
China • Work exhibited at Central Academy of Fine
Arts, Beijing; Iberia Center for Contemporary Art,
Beijing; Minsheng Art Museum, Shanghai, China;
Prague Biennial, Czech Republic • Represented
by Leo Xu Projects, Shanghai, China.

JITISH KALLAT
b. 1974, Mumbai, India
Lives and works in Mumbai
Studied at Sir Jamsetjee Jeejebhoy School of
Art, Mumbai • Work exhibited at The Art Institute
of Chicago, USA; Musée d'Art Contemporain
de Lyon, France; Tate Modern, London, England.
Collected by The Art Institute of Chicago, USA;
National Gallery of Modern Art, New Delhi, India
• Represented by ARNDT Berlin, Germany; Galerie
Daniel Templon, Paris, France.

JACOB KASSAY
b. 1984, Lewiston, New York, USA
Lives and works in Los Angeles, California, USA
Studied at State University of New York, Buffalo,
USA • Work exhibited at MoMA PS1, New York,
USA; Museo di Arte Moderna e Contemporanea,
Rovereto, Italy; Museum of Fine Arts, Boston, USA;
North Carolina Museum of Art, Raleigh, USA;
Prague Biennale, Czech Republic • Represented
by 303 Gallery, New York, USA; Art: Concept, Paris,
France; Xavier Hufkens, Brussels, Belgium.

JOSEPHINE KING
b. 1965, London, England
Lives and works in London
Studied at Gerrit Rietveld Academie, Amsterdam,
Netherlands; École Nationale Supérieure des
Arts Décoratifs, Paris, France • Work exhibited at
Dutch Tile Museum, Otterlo, Netherlands; Museu
Do Azulejo, Lisbon, Portugal; Zoological Museum,
Amsterdam, Netherlands • Represented by
Riflemaker, London, England.

JOHN KISSICK
b. 1962, Montreal, Canada.
Lives and works in Ontario, Canada
Studied at Queen's University at Kingston,
Ontario, Canada; Cornell University, Ithaca,

New York, USA • Work exhibited at Museum of
Contemporary Canadian Art, Toronto; Palmer
Museum of Art, Pennsylvania, USA. Penn State
College of Arts and Architecture Award for
Outstanding Teaching, Philadelphia, USA. Collected
by Kitchener Waterloo Art Gallery, Ontario,
Canada • Represented by Galerie Bigué Art
Contemporain, Montreal, Canada; Kaztman-Kamen
Gallery, Toronto, Canada; Michael Gibson Gallery,
Ontario, Canada.

KENTARO KOBUKE
b. 1975, Hiroshima, Japan
Lives and works in London, England
Studied at Kuwasawa Design Institute, Tokyo, Japan;
Chelsea College of Art and Design, London, England
• Work exhibited at Mori Art Museum, Tokyo, Japan;
Saatchi Gallery, London, England. Collected by The
Franks-Suss Collection • Represented by Identity Art
Gallery, Hong Kong, China; SCAI The Bathhouse,
Tokyo, Japan; Witham Gallery, London, England.

JUTTA KOETHER
b. 1958, Cologne, Germany
Lives and works in New York City, New York, USA
Studied at University of Cologne, Germany
• Work exhibited at Lentos Art Museum, Linz, Austria;
Museum of Contemporary Art, Antwerp, Belgium;
Whitney Biennial, New York, USA. Collected by
Museum of Contemporary Art, Los Angeles, USA
• Represented by Bortolami Gallery, New York, USA;
Campoli Presti, London, England; Reena Spaulings
Fine Art, New York, USA; Susanne Vielmetter Los
Angeles Projects, California, USA.

ELLA KRUGLYANSKAYA
b. 1978, Riga, Latvia
Lives and works in New York City, New York, USA
Studied at Cooper Union, New York, USA; Yale
University School of Art, New Haven, USA • Work
exhibited at Abrons Art Center, New York, USA.
Collected by Barneys New York, USA • Represented
by Gavin Brown's Enterprise, New York, USA; Kendall
Koppe, Glasgow, Scotland.

OLAF KUHNEMANN
b. 1972, Basel, Switzerland
Lives and works in Tel Aviv, Israel,
and Berlin, Germany
Studied at New York Studio School, USA; Parsons
School of Design, New York, USA • Work exhibited
at The Israel Museum, Jerusalem; Tel Aviv Museum
of Art, Israel; Herzliya Biennial, Israel. Excellence
in Painting Award, National Arts Club, New York,
USA; Isracard Award, Tel Aviv Museum of Art, Israel
• Represented by Feinberg Projects Gallery,
Tel Aviv, Israel.

ANNIE KURKDJIAN
b. 1972, Beirut, Lebanon
Lives and works in Beirut
Studied at Lebanese University, Beirut • Work
exhibited at Royal Academy of Art, London, England;
Biennale Arts Hors Normes, Lyon, France. Johayna
Baddoura Prize. Collected by Musée de Tessé, Le

Mans, France; The University of Balamad, Beirut, Lebanon • Represented by Albareh Art Gallery, Adliya, Bahrain; Art Circle Gallery, Beirut, Lebanon.

EMILY NOELLE LAMBERT
b. 1975, Pittsburg, USA
Lives and works in New York City, New York, USA
Studied at Antioch College, Ohio, USA; Hunter College City University of New York, USA • Work exhibited at Brooklyn Museum, New York, USA; Noyes Museum of Art, New Jersey, USA; Torrance Museum of Art, Los Angeles, USA. Edward F. Albee Foundation Residency, Montauk, USA • Represented by Lu Magnus Gallery, New York, USA.

HEEJOON LEE
b. 1988, Seoul, South Korea
Lives and works in Glasgow, Scotland
Studied at College of Fine Arts, Hongik University, Seoul, South Korea; Glasgow School of Art, Scotland • Work exhibited at The Independent Artist Fair, London, England; Mackintosh Museum, Glasgow, Scotland.

SIMON LING
b. 1968, UK
Lives and works in London, England
Studied at Chelsea College of Art and Design, London; Slade School of Fine Art, University College London • Work exhibited at Camden Arts Centre, London; CAPC Bordeaux, France; Tate Britain, London. Collected by Tate Collection, UK; National Collection, UK • Represented by Greengrassi, London, England.

ANDREW LITTEN
b. 1970, Aylesbury, Buckinghamshire, England
Lives and works in Fowey, Cornwall, England
Studied at Amersham College of Art, Buckinghamshire • Work exhibited at Milwaukee Art Museum, Wisconsin, USA; Tate Modern, London, England; Venice Biennale, Italy.

GEORGE LITTLE
b. 1988, London, England
Lives and works in London
Studied at Kingston University, Surrey, England; University of Brighton, England; Royal College of Art, London, England • Work exhibited at Institute of Contemporary Arts, London, England; Los Angeles Contemporary Art Fair, California, USA; Saatchi Gallery, London, England; Liverpool Biennial, England. Collected by The Saatchi Collection, London, England • Represented by The Art Cabin, London, England.

DORA LONGO BAHIA
b. 1961, São Paulo, Brazil
Lives and works in São Paulo
Studied at Fundação Armando Alvares Penteado, São Paulo; Universidade de São Paulo • Work exhibited at Museum of Modern Art, São Paulo; Museum of Art, Tijuana, Mexico; Monterrey

FEMSA Biennial, Mexico; São Paulo International Biennial, Brazil; Havana Biennial, Cuba • Represented by Vermelho, São Paulo, Brazil.

NATE LOWMAN
b. 1979, Las Vegas, Nevada, USA
Lives and works in New York City, New York, USA
Studied at New York University • Work exhibited at Astrup Fearnley Museum of Modern Art, Oslo, Norway; Solomon R. Guggenheim Museum, New York, USA; Moscow Biennial of Contemporary Art, Russia; Prague Biennial, Czech Republic • Represented by Maccarone, New York, USA.

CASSANDRA MacLEOD
Lives and works in New York City, New York, USA
Studied at Rhode Island School of Design, USA; Brown University, Rhode Island, USA • Work exhibited at Foundation for Contemporary Arts Benefit, New York, USA.

DEIRDRE McADAMS
b. 1977, Oakville, Ontario, Canada
Lives and works in Vancouver, British Columbia, Canada
Studied at Victoria College of Art, Canada; Emily Carr University of Art and Design, Vancouver, Canada • Work exhibited at The Art Gallery of Alberta, Canada; The Art Gallery of Hamilton, Canada. Honorable Mention, RBC Painting Competition; Runner-up, Canadian Art Writing Prize, Canada Art Magazine. Collected by the Royal Bank of Canada Collection.

PATRICK McELNEA
b. 1981, New York City, New York, USA
Lives and works in Brooklyn, New York, USA
Studied at Cooper Union, New York, USA; Yale University School of Art, New Haven, USA • Work exhibited at Cooper Union, New York, USA. Foundation for Contemporary Arts Grant, New York, USA. Collected by The Rubell Family Collection, Miami, USA • Represented by Yael Rosenblut Gallery, Santiago, Chile.

LUCY McKENZIE
b. 1977, Glasgow, Scotland
Lives and works in Brussels, Belgium
Studied at Duncan of Jordanstone College of Art and Design, Dundee, Scotland; Karlsruhe Kunstakademie, Germany • Work exhibited at Kunsthalle Basel, Switzerland; Museum of Modern Art, New York, USA; Tate Britain, London, England; Venice Biennale, Ital • Represented by Cabinet, London, England; Galerie Buchholz, Berlin, Germany; Galerie Micheline Szwajcer, Antwerp, Belgium.

VICTOR MAN
b. 1974, Transylvania, Romania
Lives and works in Berlin, Germany, and Cluj, Romania
Studied at Jerusalem Studio School, Israel • Work exhibited at San Francisco Museum

of Modern Art, California, USA; International Biennial of Contemporary Art, Jerusalem, Israel; Prague Biennial, Czech Republic; Venice Biennale, Italy. Deutsche Bank Artist of the Year • Represented by Blum & Poe, Los Angeles, USA; Galeria Plan B, Berlin, Germany; Galleria Zero, Milan, Italy; Gladstone Gallery, New York, USA.

MARGHERITA MANZELLI
b. 1968, Ravenna, Italy
Lives and works in Ravenna
Work exhibited at The Armand Hammer Museum of Art and Culture Center, Los Angeles, USA; Art Institute of Chicago, USA; Irish Museum of Modern Art, Dublin; Biennial of Saõ Paulo, Brazil; Venice Biennale, Italy. Collected by Museum of Modern Art, New York, USA • Represented by greengrassi, London, England; Kimmerich, New York, USA.

JASON MARTIN
b. 1970, Jersey, Channel Islands
Lives and works in London, England
Studied at Chelsea School of Art, London; Goldsmiths, London • Work exhibited at Mönchehaus Museum, Goslar, Germany; Museum of Modern Art, Oxford, England; Liverpool Biennial of Contemporary Art, England. Jerwood Painting Prize, London. Collected by The Museum of Contemporary Art, Salzburg, Austria • Represented by Galerie Thaddaeus Ropac, Paris, France; L.A. Louver, Los Angeles, USA; Lisson Gallery, London, England; Pearl Lam Galleries, Shanghai, China.

MELVIN MARTINEZ
b. 1976, San Juan, Puerto Rico
Lives and works in San Juan
Studied at School of Fine Arts, San Juan • Work exhibited at Museum of Contemporary Art, San Juan; National Gallery of Art, Puerto Rico. International Association of Art Critics Prize for Outstanding Representation of Puerto Rico. Collected by The Irish Museum of Modern Art, Dublin • Represented by David Castillo Gallery, Miami, USA.

NICK MAUSS
b. 1980, New York City, New York, USA
Lives and works in New York and Berlin, Germany
Studied at Cooper Union, New York • Work exhibited at Institute of Contemporary Art, Philadelphia, USA; MoMA PS1, New York; Museum of Modern Art, New York; Whitney Biennial, New York. Collected by Museum of Contemporary Art, Los Angeles, USA • Represented by 303 Gallery, New York, USA; Campoli Presti, London, England; Galerie Neu, Berlin, Germany.

DAMIEN MEAD
b. 1969, Limerick, Ireland
Lives and works in London, England
Studied at Dublin Institute of Technology, Ireland; Chelsea College of Art, London, England • Work exhibited at Walker Art Gallery, Liverpool, England. Irish Arts Council Artist Bursary;

Irish Arts Council Travel Award. Collected by The Saatchi Gallery, London, England • Represented by Daniel Weinberg, Los Angeles, USA; Scheublein + Bak, Zurich, Switzerland.

BJARNE MELGAARD
b. 1967, Sydney, Australia
Lives and works in New York City, New York, USA
Studied at Norwegian National Academy of Fine Arts; Rijksakademie, Amsterdam, Netherlands; Jan van Eyck Academy, Maastricht, Netherlands • Work exhibited at Astrup Fearnley Museum of Modern Art, Oslo, Norway; Kunstmuseum, Bergen, Norway; European Biennale of Contemporary Art, Luxembourg • Represented by Galerie Guido W. Baudach, Berlin, Germany; Gavin Brown's Enterprise, New York, USA; Lars Bohman Gallery, Stockholm, Sweden; Patricia Low Contemporary, Gstaad, Switzerland.

XIE MOLIN
b. 1979, Zhejiang, China
Lives and works in Beijing, China
Studied at Central Academy of Fine Arts, Beijing, China; Edinburgh College of Art, Scotland • Work exhibited at Royal Scottish Academy, Edinburgh. Hope Scottish Trust Award for Outstanding Postgraduate Student Work; Seawhite Material Prize, Edinburgh. Collected by The White Rabbit Collection • Represented by Beijing Commune, China.

DIANNA MOLZAN
b. 1972, Tacoma, Washington, USA
Lives and works in Los Angeles, California, USA
Studied at School of the Art Institute of Chicago, USA; Universität der Kunste, Berlin, Germany; University of Southern California, USA • Work exhibited at Armand Hammer Museum of Art and Culture Center, Los Angeles, USA; Whitney Museum of American Art, New York, USA; LA Weekly Annual Biennial, Los Angeles, USA • Represented by Overduin and Kite, Los Angeles, USA.

REBECCA MORRIS
b. 1969, Honolulu, Hawaii, USA
Lives and works in Los Angeles, California, USA
Studied at Smith College, Massachusetts, USA; School of the Art Institute of Chicago, USA • Work exhibited at Santa Monica Museum of Art, California, USA; Whitney Biennial, New York, USA. Illinois Arts Council Award; Solomon R. Guggenheim Fellowship. Collected by the Museum of Contemporary Art, Chicago, USA • Represented by Corbett vs. Dempsey, Chicago, USA; Galerie Barbara Weiss, Berlin, Germany.

COBI MOULES
b. 1980, Oakdale, California, USA
Lives and works in Boston, Massachusetts, USA
Studied at San Jose State University, California, USA; School of the Museum of Fine Arts, Boston, USA • Work exhibited at Leslie-Lohman Museum of Gay and Lesbian Art, New York, USA; Museum

of Fine Arts, Boston, USA. Ruth and Harold Chenven Foundation Award. Collected by RISD Museum, Rhode Island, USA • Represented by Carroll and Sons Art Gallery, Boston, USA; Lyons Wier Gallery, New York, USA.

OTHMAN MOUSSA
b. 1974, Zabadani, Syria
Lives and works in Damascus, Syria
Studied at Adham Ismail Centre for Plastic Arts, Damascus; Walid Izzat Institute for Sculpture, Syria • Work exhibited at Ayyam Gallery, Dubai, United Arab Emirates. Shabab Ayyam Competition for Emerging Artists • Represented by Ayyam Gallery, Dubai, United Arab Emirates.

OSCAR MURILLO
b. 1986, La Paila, Colombia
Lives and works in London, England
Studied at University of Westminster, London; Royal College of Art, London • Work exhibited at Rhine Center for Contemporary Art, Alsace, France; The Rubell Family Collection, Miami, USA; Slade School of Art Research Center, London • Represented by Carlos/Ishikawa, London, England; David Zwirner, New York, USA.

ADAM MYSOCK
b. Cincinnati, Ohio, USA, 1983
Lives and works in New Orleans, Louisiana, USA
Studied at Tulane University, New Orleans, USA; Southern Illinois University, Carbondale, USA • Work exhibited at Contemporary Arts Center, New Orleans, USA; Dishman Art Museum, Texas, USA; Mississippi Museum of Art, Jackson, USA; The Ogden Museum of Southern Art, New Orleans, USA. Mary L.S. Neill Prize in the Visual Arts • Represented by Jonathan Ferrara Gallery, New Orleans, USA.

SOPHY NAESS
b. 1982, Chicago, Illinois, USA
Lives and works in Gothenburg, Sweden
Studied at Slade School of Fine Art, London, England; Cooper Union, New York, USA • Work exhibited at The Lower Manhattan Cultural Council, New York, USA. Frank Caldiero Humanities Award; Pietro and Alfrieda Montana Prize for Excellence in Drawing and Sculpture. Collected by The Cartier Foundation, Paris, France; The National Public Art Council of Sweden.

ELIZABETH NEEL
b. 1975, Stowe, Vermont, USA
Lives and works in New York City, New York, USA
Studied at Brown University, Rhode Island, USA; School of the Museum of Fine Arts, Boston, USA; Columbia University, New York, USA • Work exhibited at The Neuberger Museum, Purchase College, New York, USA; Saatchi Gallery, London, England; Prague Biennial, Czech Republic • Represented by Deitch Projects, New York, USA; Galleria Monica de Cardenas, Milan, Italy; Pilar Corrias Gallery, London, England; Sikkema Jenkins Co., New York, USA; Susanne Vielmetter Los Angeles Projects, California, USA.

ANNE NEUKAMP
b. 1976, Düsseldorf, Germany
Lives and works in Berlin, Germany
Studied at Hochschule für Bildende Künste Dresden, Germany • Work exhibited at Art Basel Miami, Florida, USA; Wilhelm Hack Museum, Ludwigshafen, Germany; Prague Biennale, Czech Republic • Represented by Galerie Chez Valentin, Paris, France; Galerija Gregor Podnar, Berlin, Germany.

REGINA NIEKE
b. 1979, Germany
Lives and works in Berlin, Germany
Studied at University of the Arts • Work exhibited at International Contemporary Art Fair, Lithuania; Santander International Fair of Contemporary Art, Spain. Rudolf-Schweitzer-Cumpana Foundation Studio Scholarship • Represented by Beers Contemporary, London, England; Collectiva Gallery, Berlin, Germany; Galerie Anke Zeisler, Berlin, Germany; Galerie Hans Tepe, Damme, Belgium; Junge Kunst Berlin, Germany.

THOMAS NOZKOWSKI
b. 1944, Teaneck, New Jersey, USA
Lives and works in New York City, New York, USA
Studied at Cooper Union, New York, USA • Work exhibited at Ludwig Museum, Koblenz, Germany; The National Gallery of Canada, Ontario; Venice Biennale, Italy. American Academy Medal of Merit in Painting. Collected by the Metropolitan Museum of Art, New York, USA; Museum of Modern Art, New York, USA • Represented by Pace Gallery, New York, USA.

ALEX NUNEZ
b. 1984, Miami, Florida, USA
Lives and works in New York City, New York, USA
Studied at Loyola University, New Orleans, USA; School of the Arts and Cultural Development, Florence, Italy; Metafora School of the Arts, Barcelona, Spain; Tufts University, Boston, USA; Hunter College City University of New York, USA • Work exhibited at Contemporary Arts Center, New Orleans, USA; School of the Museum of Fine Arts, Boston, USA; La Bienal, El Museo del Barrio, New York, USA. C12 Fellowship Award, Hunter College City University of New York, USA

PAULINA OLOWSKA
b. 1976, Gdansk, Poland
Lives and works in Mszana Dolna, Poland
Studied at School of the Art Institute of Chicago, USA; Academy of Fine Arts, Gdansk, Poland; Rijksakademie, Amsterdam, Netherlands • Work exhibited at Kunsthalle Basel, Switzerland; Museum of Modern Art, New York, USA; The National Museum, Krakow, Poland; Berlin Biennial for Contemporary Art, Germany; Venice Biennale, Italy. Fine Art Award, Cultural Foundation, Warsaw, Poland • Represented by Metro Pictures, New York, USA; Simon Lee Gallery, London, England.

ALEX OLSON
b. 1978, Boston, Massachusetts, USA
Lives and works in Los Angeles, California, USA

Studied at Harvard University, Cambridge, USA; California Institute of the Arts, Valencia, USA • Work exhibited at Museum of Contemporary Art, Chicago, USA. The Hollywood Biennale, Los Angeles, USA. Nancy Graves Foundation Grant. Collected by The Armand Hammer Museum of Art and Culture Center, Los Angeles, USA • Represented by Laura Bartlett Gallery, London, England; Lisa Cooley, New York, USA; Shane Campbell Gallery, Chicago, USA.

JULIE OPPERMANN
b. 1982, San Francisco, California, USA
Lives and works in Brooklyn, New York, USA, and Berlin, Germany
Studied at Cooper Union, New York, USA; University of California, Berkeley, USA; Hunter College City University of New York • Work exhibited at Universität der Künste, Berlin, Germany. The Elsie Seringhaus Award, Hunter College City University of New York, USA. Collected by Museum of Contemporary Arts, San Diego, USA; Museum of Fine Arts, Houston, USA • Represented by Galerie Stefan Röpke, Cologne, Germany; Mark Moor Gallery, Los Angeles, USA.

TOM ORMOND
b. 1974, Derbyshire, England
Lives and works in London, England
Studied at Loughborough College of Art and Design, England; Goldsmiths Collge, London • Work exhibited at Art Basel, Miami Beach, USA. Boise Travel Scholarship, Idaho, USA. Collected by Deutsche Bank; Soho House, London, England.

DAVID OSTROWSKI
b. 1981, Cologne, Germany
Lives and works in Cologne
Studied at Kunstakademie, Düsseldorf, Germany • Work exhibited at Art Basel, Hong Kong, China; Art Basel, Miami Beach, USA. Atelierstipendium, Kölnischer Kunstverein, und Imhoff-Stiftung Award • Represented by Peres Projects, Berlin, Germany; Simon Lee Gallery, London, England.

BAKER OVERSTREET
b. 1981, Augusta, Georgia, USA
Lives and works in Brooklyn, New York, USA
Studied at Center for Arts and Culture, Aix-en-Provence, France; Maryland Institute College of Art, Baltimore, USA; Yale University School of Art, New Haven, USA • Work exhibited at The Armory Show, New York, USA; Saatchi Gallery, London, England; VOLTA, Basel, Switzerland. Collected by The Saatchi Gallery, London • Represented by Fredericks & Freiser, New York, USA; Kai Heinze, Berlin, Germany.

STUART PEARSON WRIGHT
b. 1975, Northampton, England
Lives and works in London, England
Studied at Slade School of Fine Art, London • Work exhibited at the British Museum, London; Museum of London; National Portrait Gallery, London. National Gallery BP Portrait Award.

Collected by Jerwood Foundation, London; The J.K. Rowling Collection, Edinburgh, Scotland • Represented by Riflemaker, London, England.

NATAN PERNICK
b. 1980, Kfar Mordechai, Israel
Lives and works in Jerusalem, Israel
Studied at Bezalel Art Academy, Jerusalem • Work exhibited at Ashdod Art Museum, Israel; National Portrait Gallery, London, England; Royal Academy of Art, London. Finalist, The Art Sprinter International Art Competition • Represented by Dan Gallery, Tel Aviv, Israel.

SETH PICK
b. 1985, Reading, Berkshire, England
Lives and works in Frankfurt, Germany
Studied at Goldsmiths College, London, England; Städelschule Hochschule für Bildende Kunst, Frankfurt, Germany • Work exhibited at Contemporary Art Society, London, England; Museum of Modern Art, Frankfurt, Germany • Represented by Neue Alte Brücke Galerie, Frankfurt, Germany.

MAGNUS PLESSEN
b. 1967, Hamburg, Germany
Lives and works in Berlin, Germany
Work exhibited at The Art Institute of Chicago, USA; MoMA PS1, New York, USA; Museu Serralves, Portugal; Venice Biennale, Italy. Collected by the Museum of Modern Art, New York, USA • Represented by Gladstone Gallery, New York, USA; White Cube Gallery, London, England.

FRANCESCO POLENGHI
b. 1936, Milan, Italy
Lives and works in Milan
Studied at New York University, USA • Represented by Art Cube Gallery, Laguna Beach, USA; Ten Art Gallery, Milan, Italy.

DEBORAH POYNTON
b. 1970, Durban, South Africa
Lives and works in Cape Town, South Africa
Studied at Rhode Island School of Design, Providence, USA • Work exhibited at Irma Stern Museum, Cape Town, South Africa; Johannesburg Art Gallery, South Africa; Savannah College of Art and Design, Georgia, USA. Finalist, Tatham Art Gallery National Portrait Competition • Represented by Stevenson Gallery, Cape Town, South Africa.

NATHLIE PROVOSTY
b. 1981, Cincinnati, Ohio, USA
Lives and works in New York City, New York, USA
Studied at Maryland Institute College of Art, Baltimore, USA; University of Pennsylvania, Philadelphia, USA • Work exhibited at American Academy of Arts and Letters, New York, USA; Inside Out Museum, Beijing, China. American Academy of Arts and Letters Purchase Prize; Fulbright Grant for Painting, India.

R.H. QUAYTMAN
b. 1961, Boston, Massachusetts, USA
Lives and works in New York City, New York, USA
Studied at Bard College, Annandale-on-Hudson, USA; National College of Art & Design, Dublin, Ireland; Institut des Hautes Études en Arts Plastiques, Paris, France • Work exhibited at the Museum of Modern Art, Warsaw, Poland; Solomon R. Guggenheim Museum, New York, USA; Venice Biennale, Italy; Whitney Biennial, New York. Collected by The Saatchi Gallery, London, England; Tate Modern, London, England • Represented by Gladstone Gallery, New York, USA; Miguel Abreu Gallery, New York, USA.

GED QUINN
b. 1963, Liverpool, England
Lives and works in Cornwall, England
Studied at Rijksakademie Amsterdam, Netherlands; Kunstakademie Düsseldorf, Germany; Slade School of Fine Art, London, England; Ruskin School of Drawing, Oxford, England • Work exhibited at State Hermitage Museum, St Petersburg, Russia; Tate Britain, London, England; Biennale of Southern Italy, Puglia. Collected by The Saatchi Gallery, London, England; Victoria & Albert Museum, London, England • Represented by Stephen Friedman Gallery, London, England.

BERND RIBBECK
b. 1974, Cologne, Germany
Lives and works in Berlin, Germany
Studied at University of Cologne, Germany; University of the Arts, Berlin, Germany; Academy of Fine Arts, Munich, Germany; Kunstakademie Düsseldorf, Germany • Work exhibited at Georg-Kolbe Museum, Berlin, Germany; Institute for Contemporary Art, Berlin, Germany; Kunstmuseum, Wolfsburg, Germany • Represented by Galerie Kamm, Berlin, Germany; Galerie Peter Kilchmann, Zurich, Switzerland.

LOU ROS
b. 1984, France
Lives and works in Paris, France
Work exhibited at Art Basel, Miami Beach, USA; Moscow Museum of Modern Art, Russia • Represented by The Christopher Moller Art Gallery, Cape Town, South Africa; Rofaïda Zaïd Gallery, Paris, France; Tache Gallery, New York, USA.

NANO RUBIO
b. 1983, California, USA
Lives and works in Los Angeles, California, USA
Studied at California State University, Bakersfield, USA; Claremont Graduate University, California, USA • Work exhibited at Museum X of Contemporary Art Pomona, California, USA; Torrance Art Museum, California, USA. Joan Mitchell Foundation Grant Nominee; Moore Family Foundation Grant.

MAJA RUZNIC
b. 1983, Bosnia-Herzegovina
Lives and works in San Francisco, California, USA

Studied at University of California, Berkeley, USA; California College of Arts, San Francisco, USA • Work exhibited at California College of the Arts, San Francisco, USA • Represented by Jack Fischer Gallery, San Francisco, USA.

MARWAN SAHMARANI
b. 1970, Beirut, Lebanon
Lives and works in Beirut
Studied at École Supérieure d'Art Graphique, Paris, France • Work exhibited at Museum of Art and Design, New York, USA; Museum of Modern Art, Doha, Qatar; Thessaloniki Biennial of Contemporary Art, Greece. Abraaj Capital Art Prize, Dubai, United Arab Emirates • Represented by Kashya Hildebrand, Zurich, Switzerland; Lawrie Shabibi, Dubai, United Arab Emirates.

NICOLA SAMORI
b. 1977, Forlì, Italy
Lives and works in Bagnacavallo, Italy
Studied at Accademia di Belle Arti, Bologna, Italy • Work exhibited at Museum of Contemporary Art, Gibellina, Italy; Royal Palace, Milan, Italy; Venice Biennale, Italy. Giorgio Morandi Engraving Prize, Morandi Museum, Bologna, Italy • Represented by Ana Cristea Gallery, New York, USA; Art.Lab Arte Contemporanea, Grosseto, Italy; Christian Ehrentraut, Berlin, Germany; LARMgalleri, Copenhagen, Denmark; Rosenfeld Porcini Gallery, London, England.

WILL SCHNEIDER-WHITE
b. 1988, Ojai, California, USA
Lives and works in Washington, DC, and Richmond, Virginia, USA
Studied at Cooper Union, New York, USA; Pacific Northwest College of Art, Oregon, USA; Slade School of Art, London, England • Work exhibited at Slade School of Art, London, England. Steer Prize for Painting, London, England; VCU Fountainhead Arts Fellowship in Painting and Printmaking, Virginia, USA • Represented by Hamiltonian Gallery, Washington, DC, USA.

SEBASTIAN SCHRADER
b. 1978, Berlin, Germany
Lives and works in Berlin
Studied at Kunsthochschule, Berlin-Weissensee, Germany • Work exhibited at Alta Fine Art Galerie, Istanbul, Turkey; Berlin Art Projects, Germany.

HUGH SCOTT-DOUGLAS
b. 1988, Cambridge, England
Lives and works in New York City, New York, USA
Studied at Ontario College of Art & Design, Toronto, Canada; Pratt Institute, New York, USA • Work exhibited at Art Basel, Switzerland; Museum of Contemporary Canadian Art, Toronto. Collected by Dallas Museum of Art, Texas, USA; Depart Foundatino, Rome, Italy • Represented by Blum & Poe, Los Angeles, USA; Croy Nielsen, Berlin, Germany; Jessica Silverman Gallery, San Francisco, USA.

IVAN SEAL
b. 1973, Stockport, England
Lives and works in Berlin, Germany
Studied at Sheffield Hallam University, England • Work exhibited at Contemporary Art Society, London, England; Nationalmuseum, Berlin, Germany; University of Berkeley Museum, California, USA • Represented by Carl Freedman Gallery, London, England; RaebervonStenglin, Zurich, Switzerland.

BEN SEAMONS
Lives and works in Knoxville, Tennessee, USA
Studied at School of the Art Institute of Chicago, USA; University of Tennessee, Knoxville, USA • Work exhibited at DePaul University Museum of Art, Chicago, USA; Ewing Gallery, University of Tennessee, Knoxville, USA.

LI SHURUI
b. 1981, Chongqing, China
Lives and works in Beijing, China
Studied at Sichuan Fine Arts Institute, Chongqing, China • Work exhibited at the Louisiana Museum of Modern Art, Humlebœk, Denmark; Shanghai Gallery of Art, China; Today Art Museum, Beijing, China; Singapore Biennial • Represented by 82 Republic, Hong Kong, China; Connoisseur Contemporary, Hong Kong, China; Goedhuis Contemporary, New York, USA.

AVERY K. SINGER
b. 1987, New York City, New York, USA
Lives and works in New York
Studied at Cooper Union, New York, USA; Skowhegan School of Painting and Sculpture, Maine, USA • Work exhibited at Cooper Union, New York, USA; Glasgow International Festival of Art, Scotland • Represented by Kraupa-Tuskany Zeidler, Berlin, Germany.

JOSH SMITH
b. 1976, Knoxville, Tennessee, USA
Lives and works in New York City, New York, USA
Studied at Miami University, Ohio, USA; University of Tennessee, Knoxville, USA • Work exhibited at Museum of Contemporary Art, Los Angeles, USA; Museum of Modern Art, New York, USA; Lyon Biennial, France; Venice Biennale, Italy. Collected by Museum of Modern Art, New York, USA; Whitney Museum of American Art, New York, USA • Represented by Luhring Augustine Gallery, New York, USA.

ELIEZER SONNENSCHEIN
b. 1967, Haifa, Israel
Lives and works in Rosh Pina, Israel
Studied at Bezalel Academy of Art, Jerusalem, Israel • Work exhibited at Herzliya Museum of Contemporary Art, Israel; The Israel Museum, Jerusalem; Tel Aviv Museum of Art, Israel; Venice Biennale, Italy. Israeli Ministry of Culture Prize • Represented by Sommer Contemporary Art, Tel Aviv, Israel.

JOHN STARK
b. 1979, London, England
Lives and works in London
Studied at University of the West of England, Bristol, England; Royal Academy Schools, London, England • Work exhibited at Royal Academy, London; Somerset House, London; Torrance Art Museum, California, USA. The Victoria Levin Fund Premiums Award. Collected by The Mark Clannachan Collection, Linchmere, England • Represented by Charlie Smith, London, England.

MARLENE STEYN
b. 1989, Cape Town, South Africa
Lives and works in London, England
Studied at Stellenbosch University, South Africa; Royal College of Art, London, England • Work exhibited at Institute of Contemporary Arts, London, England • Represented by Mirus Gallery, San Francisco, USA.

VLADIMIR STOJANOVIC
b. 1980, Belgrade, Serbia
Lives and works in Belgrade
Studied at Faculty of Fine Arts, Belgrade, Serbia.

CATHERINE STORY
b. 1968, London, England
Lives and works in London
Studied at Royal Academy Schools, London • Work exhibited at Finnish Academy of Fine Arts, Helsinki; Liste 15, Basel, Switzerland; Tate Britain, London • Represented by Carl Freedman Gallery, London, England.

RYAN SULLIVAN
b. 1983, New York City, New York, USA
Lives and works in New York
Studied at Rhode Island School of Design, Providence, USA • Work exhibited at MoMA PS1, New York, USA; Robert Rauschenberg Foundation, New York, USA; The Rubell Family Collection, Miami, USA; Kings County Biennial, Brooklyn, USA • Represented by Maccarone, New York, USA; Sadie Coles HQ, London, England.

KYUNG SUNGHYUN
b. 1978, Korea
Lives and works in Seoul, South Korea
Studied at Hongik University, Seoul • Work exhibited at Hangaram Art Museum, Seoul; Ilmin Museum of Art, Seoul • Represented by Arario Gallery, Seoul, South Korea.

MIKA TAJIMA
b. 1975, Los Angeles, California, USA
Lives and works in New York City, New York, USA
Studied at Bryn Mawr College, Pennsylvania; USA; Columbia University, New York, USA • Work exhibited at Aspen Art Museum, Colorado, USA; MoMA PS1, New York, USA; Mori Art Museum, Tokyo, Japan; Museo Nacional Centro de Arte Reina Sofia, Madrid, Spain; San Francisco Museum of Modern Art, California, USA; Whitney Biennial, New York, USA.

Jurors' Pick

DOLLY THOMPSETT
b. 1969, London, England
Lives and works in London
Studied at Manchester Metropolitan University, England; Byam Shaw School of Art, London, England; Goldsmiths College, London • Work exhibited at City Museum and Art Gallery Prague, Czech Republic; London Metropolitan University Gallery, England; Museo di Republica Di San Marino, Italy. Finalist, Jerwood Drawing Prize. Collected by The Zabludowitz Collection • Represented by All Visual Arts, London, England.

JANAINA TSCHÄPE
b. 1973, Munich, Germany
Lives and works in New York City, New York, USA
Studied at Hochschule fur Bildende Künste, Hamburg, Germany; School of Visual Arts, New York, USA • Work exhibited at Irish Museum of Modern Art, Dublin; Museo Nacional Centro de Arte Reina Sofia, Madrid, Spain. Collected by National Gallery of Art, Washington, DC, USA; Solomon R. Guggenheim Museum, New York, USA • Represented by Carlier Gebauer, Berlin, Germany; Catherine Bastide, Brussels, Belgium; Edouard Malingue Gallery, Hong Kong, China; Galeria Fortes Vilaca, São Paulo, Brazil; Galerie Xippas, Paris, France; Nichido Contemporary Art, Tokyo, Japan; Tierney Gardarin, New York, USA.

PHOEBE UNWIN
b. 1979, Cambridge, England
Lives and works in London, England
Studied at Newcastle University, England; Slade School of Fine Art, London, England • Work exhibited at Saatchi Gallery, London, England; Slade School of Fine Art, London. Philip Leverhulme Prize, The Leverhulme Trust. Collected by Museum Boijmans, Rotterdam, Netherlands; The Tate Gallery, London • Represented by Honor Fraser, Los Angeles, USA; Wilkinson Gallery, London, England.

ELIF URAS
b. 1972, Ankara, Turkey
Lives and works in New York City, New York, USA, and Istanbul, Turkey
Studied at Brown University, Providence, USA; Columbia University, New York, USA; School of Visual Arts, New York, USA • Work exhibited at Corcoran Gallery of Art, Washington, DC, USA; MoMA PS1, New York, USA; Museum of Contemporary Art, Istanbul, Turkey; Shanghai Biennial, China • Represented by Smith-Stewart, New York, USA.

NATEE UTARIT
b. 1970, Bangkok, Thailand
Lives and works in Bangkok
Studied at Silpakorn University, Bangkok; College of Fine Art, Bangkok • Work exhibited at Fine Art Museum of Ho Chi Minh City, Hanoi, Vietnam; Museum of Modern Art, Tokyo, Japan; Taipei Fine Art Museum, Taiwan. International Print Exhibition Biennial, Taipei, Taiwan • Represented by Numthong Gallery, Bangkok, Thailand.

FREDRIK VAERSLEV
b. 1979, Moss, Norway
Lives and works in Drøbak and Vestfossen, Norway
Studied at Einar Granum School of Art, Oslo, Norway; NISS, Fine Art Department, Oslo, Norway; Staatliche Hochschule fur Bildende Kunste, Stadelschule, Frankfurt, Germany; Malmö Art Academy, Sweden • Work exhibited at Malmö Art Academy, Sweden; Moderna Museet, Malmö, Sweden. Office for Contemporary Art International Support Grant, Norway. Collected by Astrup Fearnley Museum of Modern Art, Oslo, Norway • Represented by Johan Berggren Gallery, Malmö, Sweden; Standard Gallery, Oslo, Norway.

LILY VAN DER STOKKER
b. 1954, Den Bosch, Netherlands
Lives and works in Amsterdam, Netherlands, and New York City, New York, USA
Work exhibited at Museum of Contemporary Art, Chicago, USA; Museum Ludwig, Cologne, Germany; Worcester Art Museum, Massachusetts, USA. Collected by Stedelijk Museum, Amsterdam, Netherlands • Represented by Air de Paris, France; Cabinet, London, England; Galerie van Gelder, Amsterdam, Netherlands; Kaufmann Repetto, Milan, Italy; Koenig & Clinton, New York, USA.

LESLEY VANCE
b. 1977, Milwaukee, Wisconsin, USA
Lives and works in Los Angeles, California, USA
Studied at University of Wisconsin, Madison, USA; California Institute of the Arts, Valencia, USA • Work exhibited at Aspen Art Museum, Colorado, USA; Dallas Museum of Art, Texas, USA; Huntington Library Art Collections, California, USA; Whitney Biennial, New York, USA • Represented by David Kordansky Gallery, Los Angeles, USA; Xavier Hufkens, Brussels, Belgium.

RAFAEL VEGA
b. 1979, Yabucoa, Puerto Rico
Lives and works in New York City, New York, USA, and Puerto Rico
Studied at Universidad de Puerto Rico; School of the Art Institute of Chicago, USA • Work exhibited at Institute of Puerto Rican Culture, San Juan; International Art Fair of Puerto Rico, San Juan. Collected by the Museum of Contemporary Art Detroit, Michigan, USA • Represented by Walter Otero Contemporary Art, San Juan, Puerto Rico.

NED VENA
b. 1982, Boston, Massachusetts, USA
Lives and works in Brooklyn, New York, USA
Studied at AICAD New York Studio Program, USA; School of the Museum of Fine Arts, Tufts University, Boston, USA • Work exhibited at The Art Complex Museum, Massachusetts, USA; Midway Contemporary Art, Minneapolis, USA; The Zabludowicz Collection, London, England • Represented by Société Berlin, Germany; White Flag Projects, St Louis, Missouri, USA.

CHARLINE VON HEYL
b. 1960, Mainz, Germany
Lives and works in New York City, New York, USA
Studied at Kunstakademie Düsseldorf, Germany • Work exhibited at Museum of Contemporary Art, Chicago, USA; Museum of Contemporary Art, Miami, USA; Museum of Modern Art, New York, USA; Finalist, Hugo Boss Prize. Collected by the Museum of Modern Art, New York, USA; Tate Gallery, London, England • Represented by 1301PE Gallery, Los Angeles, USA; Galerie Gisela Capitain, Cologne, Germany; Petzel Gallery, New York, USA.

AMELIE VON WULFFEN
b. 1966, Breitenbrunn, Germany
Lives and works in Berlin, Germany
Studied at Academy of Fine Arts, Munich, Germany • Work exhibited at Kunstmuseum Basel, Switzerland; National Gallery of Iceland, Reykjavík; Berlin Biennial for Contemporary Art, Germany; Venice Biennale, Italy. Collected by Museum of Modern Art, New York • Represented by Galerie Meyer Kainer, Vienna, Austria.

DARREN WARDLE
b. 1969, Melbourne, Australia
Lives and works in Melbourne
Studied at Royal Melbourne Institute of Technology, Australia • Work exhibited at Chelsea Art Museum, New York, USA; National Gallery of Victoria, Melbourne, Australia. City of Whyalla Art Prize, Australia. Collected by National Australia Bank • Represented by Fehily Contemporary, Mebourne, Australia; Stephan Stoyanov Gallery, New York, USA.

ALLY WHITE
b. 1991, Georgia, USA
Lives and works in Atlanta, Georgia, USA
Studied at University of Georgia, Athens, USA • Work exhibited at Athens Institute for Contemporary Art, Georgia, USA; Lamar Dodd School of Art, Athens, Georgia, USA. Collected by Jimenez-Colon Collection, Puerto Rico.

LISA WILLIAMSON
b. 1977, Chicago, Illinois, USA
Lives and works in Los Angeles, California, USA
Studied at Richmond University, London, England; Arizona State University, Tempe, USA; University of Southern California, Los Angeles, USA • Work exhibited at The Armand Hammer Museum of Art and Culture Center, Los Angeles, USA; Orange County Museum of Art, California, USA; California Biennial, Los Angeles, USA • Represented by The BOX Gallery, Los Angeles, USA; Light & Wire Gallery, Los Angeles, USA; Shane Campbell Gallery, Chicago, USA.

JONAS WOOD
b. 1977, Boston, Massachusetts, USA
Lives and works in Los Angeles, California, USA
Studied at Hobart and William Smith Colleges, Geneva, New York, USA; University

of Washington, Seattle, USA • Work exhibited at The Armand Hammer Museum of Art and Culture Center, Los Angeles, USA; Saatchi Gallery, London, England. Collected by the Museum of Modern Art, New York; San Francisco Museum of Modern Art, California, USA • Represented by Anton Kern Gallery, New York, USA; David Kordansky Gallery, Los Angeles, USA; Shane Campbell Gallery, Chicago, USA.

LISA WRIGHT
b. 1965, Kent, England
Lives and works in Cornwall, England
Studied at Maidstone College of Art, Kent, England; Royal Academy Schools, London, England • Work exhibited at Royal Academy, London, England; Tate Gallery St Ives, Cornwall, England. Arts Council of England Award; The Threadneedle Art Prize, London, England. Collected by The Jerwood Foundation, London, England • Represented by Beardsmore Gallery, London, England.

ROSE WYLIE
b. 1934, Kent, England
Lives and works in Kent
Studied at Folkestone and Dover School of Art, England; Royal College of Art, London, England • Work exhibited at Cheltenham Art Gallery & Museum, England; Jerwood Gallery, Hastings, England. Collected by National Museum of Women in the Arts, Washington, DC, USA; Tate Britain, London, England • Represented by Galerie Michael Janssen, Berlin, Germany; Regina Gallery, Moscow, Russia; Union Gallery, London, England.

QIU XIAOFEI
b. 1977, Haerbin, Heilongjiang Province, China
Lives and works in Beijing, China
Studied at Central Academy of Fine Arts, China • Work exhibited at Art Museum of the Central Academy of Fine Arts, Beijing, China; Groninger Museum, Netherlands; Minsheng Art Museum, Shanghai, China; Zhejiang Art Museum, Hangzhou, China. Collected by the White Rabbit Collection, Sydney, Australia.

LU XINJIAN
b. 1977, Jiangsu, China
Lives and works in Shanghai, China
Studied at Nanjing Arts Institute, China; Design Academy Eindhoven, Netherlands; Frank Mohr Institute, Hanze University, Netherlands • Work exhibited at Moscow International Biennial for Young Art, Russia. Chaumont Studio Prize, International Poster Festival, France • Represented by Art Labor Gallery, Shanghai, China; Fabien Fryns Fine Art, London, England; Gallery Jones, Vancouver, Canada.

XU BACHENG
b. 1983, Wuxi, Jiangsu Province, China
Studied at China Academy of Art, Zhejiang, China • Work exhibited at Art Museum of China,

Beijing, China; Jiangsu Provincial Art Museum, Nanjing, China; Liu Haisu Art Museum, Shanghai, China; Shenzhen Art Museum, China; Art Tokyo, Japan; Asian Students and Young Artists Art Festival (ASYAAF), Seoul, South Korea; Shanghai Art Fair, China. Collected by the Modern Chinese Art Foundation, Beijing, China; Liu Haisu Museum, Shanghai, China; Shenzhen Art Museum, China • Represented by L-Art Gallery, Chengdu, China.

YANG XUN
b. 1981, Chongquing, China
Lives and works in Beijing, China
Studied at Sichuan Fine Arts Institute, China • Work exhibited at Shenzhen Art Museum, China; Wuhan Art Museum, China; Yan Huang Art Museum, Beijing, China; Chengdu Biennial, China; Youth Art Biennial, Chongqing, China. Collected by Shanghai Art Museum, China • Represented by Art Seasons, Singapore; Fang Gallery, Jakarta, Indonesia.

ZHAO YAO
b. 1981, Luzhou, Sichuan Province, China
Lives and works in Beijing, China
Studied at Sichuan Fine Arts Institute, China • Work exhibited at Eli and Edythe Broad Art Museum, Michigan, USA; Tate Modern, London, England • Represented by Beijing Commune, China; Pace Gallery, New York, USA.

LIU YE
b. 1964, Beijing, China
Lives and works in Beijing
Studied at Beijing Central Academy of Fine Arts, China; Fine Arts University, Berlin, Germany • Work exhibited at Irish Museum of Modern Art, Dublin; Museum of Contemporary Art, Taipei, Taiwan; Chinese Oil Painting Biennale, National Art Museum of China; Shanghai Biennale, China. Collected by Today Art Museum, Beijing, China • Represented by Art Scene Warehouse, Shanghai, China; Schoeni Art Gallery, Hong Kong, China; Sperone Westwater, New York, USA.

LYNETTE YIADOM-BOAKYE
b. 1977, London, England
Lives and works in London
Studied at Central Saint Martins School of Art and Design, London, England; Falmouth College of Art, Cornwall, England; Royal Academy Schools, London, England • Work exhibited at Birmingham Museum and Art Gallery, England; New Museum, New York, USA; Saatchi Gallery, London, England; Lyon Biennial of Contemporary Art, France; Seville Biennial, Spain; Venice Biennale, Italy. Nominated for the Turner Prize • Represented by Corvi-Mora, London, England; Jack Shainman Gallery, New York, USA.

GUAN YONG
b. 1975, Heze, Shadong Province, China
Lives and works in Beijing, China
Studied at Tianjin Academy of Fine Arts, China

• Work exhibited at Museum of China, Beijing; Museum of Contemporary Art Jackson, Florida, USA; Shanghai Duolun Museum of Modern Art, China. First Prize, New Star Shenzhen Fine Arts Academy, China • Represented by Wellington Gallery, Hong Kong, China.

SONG YONGHONG
b. 1966, Hebei Province, China
Lives and works in Beijing, China
Studied at Zhejiang Academy of Fine Arts, China • Work exhibited at Barcelona Museum of Contemporary Art, Spain; Hong Kong Cultural Museum, China; Shanghai Duolun Art Museum, China; Ullens Center for Contemporary Art, China • Represented by Soobin Art International, Singapore; Tao Water Art Gallery, Provincetown, Massachusetts, USA.

JWAN YOSEF
b. 1984, Stockholm, Sweden
Lives and works in London, England
Studied at Konstfack University College of Arts, Stockholm, Sweden; Central Saint Martins College of Art, London, England • Work exhibited at Central Saint Martins College of Art, London; Beers Contemporary Award for Emerging Art; Threadneedle Art Prize, London, England • Represented by Galleri Anna Thulin, Stockholm, Sweden.

CHOI JI YOUNG
b. 1982, South Korea
Lives and works in South Korea
Studied at Hongik University, Seoul, South Korea • Work exhibited at Hangaram Museum of Art, Seoul; Shanghai Doulun Museum of Modern Art, China. Kumho Museum of Art Young Artist Prize • Represented by Art Seasons, Singapore.

ETIENNE ZACK
b. 1976, Montreal, Quebec, Canada
Lives and works in Los Angeles, California, USA
Studied at Emily Carr Institute of Art and Design, Vancouver, Canada; Concordia University, Montreal, Canada; College Saint-Laurent, Montreal, Canada • Work exhibited at Museum of Contemporary Canadian Art, Toronto; National Gallery of Canada, Ottawa. First Prize, Royal Bank of Canada Painting Competition. Collected by The Zabludowicz Collection, London, England • Represented by Equinox Gallery, Vancouver, British Columbia, Canada.

XIAO ZHELUO
b. 1983, Chengdu, Sichuan Province, China
Lives and works in China
Studied at Chengdu Academy of Fine Arts, China • Work exhibited at Fine Arts Museum of Capital Norman University, Beijing, China; Shanghai Duolun Museum of Modern Art, China; Contemporary Art Biennial, Shanghai, China • Represented by 9 Art Space, Beijing, China.

JURORS' BIOGRAPHIES

KURT BEERS
Kurt Beers, initiator of *100 Painters of Tomorrow*, is the founder of Beers Contemporary gallery in London. In his capacity as director, he works with both emerging and established artists and has initiated several multidisciplinary projects, including the Award for Emerging Art, the annual open group exhibition 'Contemporary Visions', and various international collaborations with universities and other galleries. Beers previously worked as the executive assistant to a former Canadian prime minister and as legislative assistant to the Minister of Public Works and Government Services. He holds a Bachelor's Degree from Carleton University in Ottawa, Canada, and a Master's Degree from City University in London, England.

CECILY BROWN
Born in London in 1969, Cecily Brown is one of the leading artists of her generation and has been instrumental in the resurgence of interest in painting since the 1990s. She studied at the Slade School of Art, London, before moving to the US, and first showed with Gagosian Gallery in 2000. She has had solo exhibitions at the Hirshhorn Museum in Washington, DC, Modern Art Oxford, Museum of Fine Arts in Boston, and Museo Reina Sofia in Madrid, and has also participated in group exhibitions around the world.

TONY GODFREY
Tony Godfrey works as a curator and writer in South-East Asia. He is currently Director of Exhibitions at Equator Art Projects in Singapore. He previously worked at Sotheby's Institute of Art (1989–2012), latterly as its Director of Research. Since 2006 he has also been a Professor of Fine Art at Plymouth University. He has published a number of books on contemporary art, including *The New Image: Painting in the Eighties*, *Conceptual Art*, *Painting Today* and *Marcel Duchamp in South-East Asia*. He is currently researching a book on contemporary art in South-East Asia and a book on contemporary painting in Indonesia.

YUKO HASEGAWA
Yuko Hasegawa is Chief Curator of the Museum of Contemporary Art in Tokyo and a professor of the Department of Art Science at Tama Art University in Tokyo. She was the founding artistic director (1999–2006) of the 21st Century Museum of Contemporary Art in Kanazawa. Hasegawa has curated and co-curated several major exhibitions, including the Istanbul, Shanghai and São Paulo biennials, and has been a member of the Asian Art Council at the Solomon R. Guggenheim Museum since 2008. She recently curated the 2013 Sharjah Biennial.

SUZANNE HUDSON
Suzanne Hudson is Assistant Professor of Art History and Fine Arts at the University of Southern California. A specialist in modern and contemporary art, she received her PhD from Princeton University. Hudson previously taught at the University of Illinois and Parsons The New School for Design. She is co-founder of the Contemporary Art Think Tank and President Emerita and Chair of the Executive Committee of the Society of Contemporary Art Historians. Her writing has appeared in publications such as *Parkett*, *Flash Art*, *Art Journal* and *October*, and she is a regular contributor to *Artforum*. Her book, *Robert Ryman: Used Paint*, was published in 2009, and *Contemporary Art: 1989–Present* in 2013; *Painting Now* is forthcoming from Thames & Hudson.

JACKY KLEIN
Formerly a commissioning editor at Thames & Hudson, exhibitions curator at London's Hayward Gallery and assistant curator at Tate Modern, Jacky Klein is an editor and writer. She is the author of a monograph on Turner Prize-winning artist Grayson Perry and co-author, with Suzy Klein, of *What is Contemporary Art? A Children's Guide*, both published by Thames & Hudson.

GREGOR MUIR
Gregor Muir is Executive Director of the Institute of Contemporary Arts in London. He worked previously as the Kramlich Curator of Contemporary Art at Tate and, from 2004 to 2011, as Director of Hauser & Wirth, London, organizing and curating exhibitions in London, Zurich and New York. He is the author of the book *Lucky Kunst*, documenting the London art scene during the 1990s.

VALERIA NAPOLEONE
Valeria Napoleone is a philanthropist and collector of contemporary art. Her collection focuses on female contemporary artists working internationally. She received a BA from New York University's journalism school and an MA in Art Gallery Administration at the Fashion Institute of Technology, New York. She is the Chair of the Development Committee at Studio Voltaire and a benefactor and supporter of the South London Gallery, Chisenhale Gallery, Nottingham Contemporary, Camden Arts Centre, Whitechapel Gallery and Milton Keynes Gallery. Her book, *Valeria Napoleone's Catalogue of Exquisite Recipes*, was published by Koenig Books in 2012.

BARRY SCHWABSKY
Barry Schwabsky is art critic of *The Nation* and co-editor of international reviews for *Artforum*. His books include *The Widening Circle: Consequences of Modernism in Contemporary Art* and *Words for Art: Criticism, History, Theory, Practice*. He has taught at the Pratt Institute and the School of Visual Arts in New York, at New York University, Yale University, Goldsmiths College, London, and the School of the Art Institute of Chicago.

PHILIP TINARI
Philip Tinari is Director of the Ullens Center for Contemporary Art, an independent museum in Beijing's 798 Art District. At UCCA he has curated exhibitions and projects with artists including Gu Dexin, Yung Ho Chang, Wang Xingwei, Xu Zhen, Tehching Hsieh, Tino Sehgal and Taryn Simon. Founding editor of the art magazine *LEAP* and contributing editor to *Artforum*, he has also taught at the Central Academy of Fine Arts. He co-edited the books *The Future Will Be … China* (with Hans Ulrich Obrist) and *Ai Weiwei: Dropping the Urn*. Having lived in Beijing for much of the past decade, he has written and lectured widely on contemporary art in China. In 2014 he curated the 'Focus: China' section of the Armory Show in New York.

LIST OF ART SCHOOLS

The following 112 art schools were invited to participate in the *100 Painters of Tomorrow* project. Entries were welcomed from both present and former students.

- Academy of Fine Arts, Prague, Czech Republic
- Academy of Fine Arts, Vienna, Austria
- Academy of Fine Arts in Warsaw, Poland
- Academy of Visual Arts, Leipzig, Germany
- Accademia di Belle Arti di Bologna, Italy
- Alexandria University, Faculty of Fine Arts, Egypt
- American Academy in Rome, Italy
- Art Center College of Design, Pasadena, California, USA
- Art Institute of Indonesia, Yogyakarta
- Art Institute of Vancouver, Canada
- Arts and Skills Institute, Riyadh, Saudi Arabia
- Arts University Bournemouth, Dorset, England
- Autonomous University of Madrid, Spain
- Bauhaus-Universität Weimar, Germany
- Beit Berl College, Hamidrasha School of Art, Israel
- Bezalel Academy of Arts and Design, Jerusalem, Israel
- British School at Rome, Italy
- Brown University, Providence, Rhode Island, USA
- California College of the Arts, Oakland, USA
- California Institute of the Arts, Valencia, USA
- Camberwell College of Arts, London, England
- Carnegie Mellon University, Pittsburgh, Pennsylvania, USA
- Central Saint Martins, London, England
- Chelsea College of Arts, London, England
- Chiang Mai University, Thailand
- China Academy of Art, Hangzhou
- China Central Academy of Fine Arts, Beijing
- College of Fine Arts, University of the Philippines, Quezon City
- Columbia University, New York City, New York, USA
- Concordia University, Montreal, Canada
- Cooper Union School of Art, New York City, New York, USA
- Corcoran College of Art and Design, Washington, DC, USA
- Cranbrook Academy of Art, Bloomfield Hills, Michigan, USA
- Dartmouth College, Hanover, New Hampshire, USA
- École Nationale Supérieure d'Art de Bourges, France
- École Nationale Supérieure d'Art de Dijon, France
- École Nationale Supérieure des Beaux-Arts, Paris, France
- École Supérieure d'Art de Grenoble, France
- École Supérieure des Beaux-Arts d'Alger, Algeria
- École Supérieure des Beaux-Art d'Angers, France
- École Supérieure des Beaux-Arts de Casablanca, Morocco
- École Supérieure des Beaux-Arts de Tours, France
- Edinburgh College of Art, Scotland
- Emily Carr University of Art and Design, Vancouver, Canada
- Falmouth University, School of Art, Cornwall, England
- Freie Akademie Köln, Cologne, Germany
- Gazi University, Ankara, Turkey
- Glasgow School of Art, Scotland
- Glassell School of Art, The Museum of Fine Arts, Houston, Texas, USA
- Goldsmiths College, London, England
- Guangxi Arts Institute, Nanning, China
- Herron School of Art and Design, Indianapolis, Indiana, USA
- Hochschule für Bildende Künste, Hamburg, Germany
- Hungarian Academy of Fine Arts, Budapest, Hungary
- Ilya Repin St Petersburg State Academic Institute of Fine Arts, Sculpture and Architecture, Russia
- Institut Teknologi Bandung, Indonesia
- Kunstakademie Düsseldorf, Germany
- Kyung Hee University, College of Fine Arts, Seoul, South Korea
- LaSalle College of the Arts, Singapore
- Libera Accademia di Belle Arti, Florence and Rimini, Italy
- Maryland Institute College of Art, Baltimore, USA
- Michaelis School of Fine Art, University of Cape Town, South Africa
- Milton Avery Graduate School of the Arts, Bard College, Annandale-on-Hudson, New York, USA
- Moscow State University, Russia
- Nanyang Academy of Fine Arts, Singapore
- National School of the Arts, Johannesburg, South Africa
- Norwich University of the Arts, Norfolk, England
- Nova Scotia College of Art and Design, Halifax, Canada
- Ontario College of Art and Design, Toronto, Canada
- Oslo National Academy of the Arts, Norway
- Otis College of Art and Design, Los Angeles, California, USA
- Parsons The New School for Design, New York City, New York, USA
- Pennsylvania Academy of the Fine Arts, Philadelphia, USA
- Plymouth College of Art, Devon, England
- Portland State University, Oregon, USA
- Pratt Institute, New York City, New York, USA
- Princeton University, New Jersey, USA
- Rhode Island School of Design, Providence, USA
- Ringling College of Art and Design, Sarasota, Florida, USA
- Royal College of Art, London, England
- Ruskin School of Drawing and Fine Art, Oxford, England
- Savannah College of Art and Design, Georgia, USA
- School of the Museum of Fine Arts, Boston, Massachussets, USA
- School of Visual Arts, New York City, New York, USA
- Sharjah Art Institute, United Arab Emirates
- Sichuan Fine Arts Institute, Chongqing, China
- Slade School of Fine Art, London, England
- Sorbonne University, Paris, France
- Staatliche Akademie der Bildenden Künste, Karlsruhe and Stuttgart, Germany
- School of Art and Design, State University of New York, Purchase College, New York, USA
- Sydney College of the Arts, Australia
- Technological University of the Philippines, Manila
- The Chinese University of Hong Kong
- The Florence Academy of Art, Italy
- The Naggar School of Photography, Media and New Music, Jerusalem, Israel
- The School of the Art Institute of Chicago, Illinois, USA
- The University of British Columbia, Vancouver, Canada
- Tokyo University of the Arts, Japan
- UCLA, Los Angeles, California, USA
- Universidad Complutense de Madrid, Spain
- Universitat de Barcelona, Spain
- Universität der Künste Berlin, Germany
- University of Applied Arts Vienna, Austria
- University of Art and Design Helsinki, Finland
- University of Belgrade, Serbia
- University of Pretoria, South Africa
- University of Victoria, Canada
- USC Roski School of Fine Arts, Los Angeles, California, USA
- V. Surikov Moscow State Academy Art Institute, Russia
- Victorian College of the Arts, University of Melbourne, Australia
- Wimbledon College of Art, London, England
- Yale University School of Art, New Haven, Connecticut, USA

FURTHER READING

BOOKS

• Julian Bell, *What is Painting? Representation and Modern Art*, London and New York: Thames & Hudson, 1999

• Lauren Cornell, Massimiliano Gioni and Laura Hoptman (eds), *Younger than Jesus: Artist Directory*, London: Phaidon and New York: New Museum, 2009

• Margherita Dessanay and Marc Valli, *A Brush with the Real: Figurative Painting Today*, London: Laurence King, 2014

• Tony Godfrey, *Painting Today*, London: Phaidon, 2009

• Kelly Grovier, *100 Works of Art That Will Define Our Age*, London and New York: Thames & Hudson, 2013

• Hans Werner Holzwarth (ed.), *Art Now: Volume 4*, Cologne: Taschen, 2013

• Charlotte Mullins, *Painting People: The State of the Art*, London and New York: Thames & Hudson, 2008

• Terry R. Myers (ed.), *Painting (Documents of Contemporary Art)*, London: Whitechapel Gallery, 2011

• Barry Schwabsky, *Vitamin P: New Perspectives in Painting*, London: Phaidon, 2004

• ———, *Vitamin P2: New Perspectives in Painting*, London: Phaidon, 2011

MONOGRAPHIC CATALOGUES

LESLIE BAUM
• *Divergent Discourse: Leslie Baum & Mark Booth*, Elgin, Illnois: Elgin Community College, 2009

SZE YANG BOO
• *Boo Sze Yang: The New Cathedral*, with an essay by Bridget Tracy Tan, Singapore: Sze Yang Boo, 2012

G L BRIERLEY
• *G L Brierley: New Works*, with an essay by Martin Herbert, London: Carslaw St* Lukes, 2012; www.glbrierley.com/reviews/Martin Herbert.html

HEMAN CHONG
• *Of Indeterminate Time Or Occurrence*, Singapore: FOST Gallery, 2014

TOMORY DODGE
• *SubUrban*, Knoxville, Tennessee: Knoxville Museum of Art, 2006
• *Works on Paper*, New York: CRG Gallery and Los Angeles: ACME, 2009
• *Tomory Dodge*, New York: CRG Gallery and Los Angeles: ACME, 2011

TIM ELLIS
• *We Belong Together*, Hong Kong: Identity Contemporary, 2013

STELIOS FAITAKIS
• Stelios Faitakis, *Hell on Earth: Stelios Faitakis* (artist monograph), with texts by Nadia Argyropoulou and Katerina Gregos, Berlin: Gestalten, 2011

ROBERT FRY
• *Robert Fry*, with an introduction by Mamuka Bliadze and essays by Anthony Fry and Jane Neal, Berlin: Galerie Kornfeld and UK: Anomie Publishing, 2013

TAMARA K.E.
• Gia Edzgveradze (ed.) and Keti Chukhrov, *Tamara K.E.: None of Us and Somewhere Else*, Berlin and Heidelberg: Kehrer, 2007

TALA MADANI
• Julia Bjornberg (ed.), Andreas Nilsson (ed.), Daniel Birnbaum, John Peter Nilsson and Hans-Ulrich Obrist, *Tala Madani: Rip Image*, Berlin: Walther Koenig, 2013
• Alex Farquharson (ed.), Abi Spinks (ed.), Negar Azimi, Kathy Noble and Chris Wiley, *Tala Madani: Rear Projection*, Nottingham: Nottingham Contemporary, 2014

GUILLERMO MORA
• *Viaje largo con un extraño*, with an essay by Luisa Fuentes Guaza, 'Mutable Fragments', São Paulo: Casa Triângulo Gallery, 2011; www.guillermomora.com/ENG/bibliography_files/FUENTES%20GUAZA_Luisa_FRAGMENTOS%20MUTABLES_%5Benglish%5D.pdf
• *Quizás mañana haya desaparecido*, with an essay by Teresa Macrì, 'Guillermo Mora: No Fixed Form', Rome: Extraspazio Gallery, 2011; www.guillermomora.com/ENG/bibliography_files/MACRI_Teresa_Guillermo_Mora_NO_FIXED_FORM.pdf

RYAN MOSLEY
• Anthony Byrt, *Ryan Mosley*, London: Alison Jacques Gallery, 2011

KAIDO OLE
• John Smith, *Marko und Kaido* (50th Venice Biennale: Estonian Pavilion), Tallinn: Center for Contemporary Arts, 2003
• *Gorilla says: Fuck!*, Tallinn: Tuntud Gorillad, 2006
• *Kaido Ole*, Tallinn: Estonian Academy of Arts, 2007
• *Kaido Ole 2007–2012*, Tallinn: Temnikova & Kasela, 2012

DJORDJE OZBOLT
• Time Nye, Djordje Ozbolt and David Rimanelli, *Djordje Ozbolt* (artist monograph), New York: Nyehaus/Foundation 20 21, 2008

OMAR RODRIGUEZ-GRAHAM
• Tobias Ostrander (ed.), Erick Castillo and Daniela Pérez, *Omar Rodriguez-Graham*, Mexico City: Arróniz Arte Contemporáneo, 2012

RICHARD ROTH
• *Richard Roth – Under the Influence: New Paintings and Early Work*, Richmond, Virginia: Reynolds Gallery, 2013

ANDREW SALGADO
• *Paint Your Black Heart Red*, Oslo: Galerei Atopia, 2010
• *Andrew Salgado: The Misanthrope*, London: Beers.Lambert Contemporary, 2012
• *The Acquaintance*, Regina, Saskatchewan: Art Gallery of Regina, 2013
• *Enjoy the Silence*, Cape Town: Christopher Møller Art Gallery, 2014

PAWEŁ ŚLIWIŃSKI
• *Paweł Śliwiński: Unknown Master from Kasilan*, Zielona Góra: BWA Zielona Góra, 2012

ANJ SMITH
• Galerie Isa, *Anj Smith: Woods Without Pathways*, Mumbai: Prodon, 2012
• Alison Gingeras and Caoimhín Mac Giolla Léith, *Anj Smith: Paintings*, London: MACK, 2013

NICOLA STÄGLICH
• *Transparencies*, with an essay by Michael Stoeber, Munich: Galerie Wittenbrink, 2005
• *Nicola Stäglich: Time Stills*, with an essay by John C. Welchman, Los Angeles: Main Field Projects, 2007
• Tanja Dückers, *Slit*, Munich: Galerie Wittenbrink, 2009
• *Neon, Dux & Comes*, with an essay by Ingo Arend, Duisburg: Kunstverein Duisburg, 2013

SHAAN SYED
• *Fade Away*, with an essay by Barry Schwabsky, London: Transition Gallery, 2010; www.transitiongallery.co.uk/htmlpages/Fade_Away/text.html

JIRAPAT TATSANASOMBOON
• Steven Pettifor, *Love and Lust*, Bangkok: Thavibu Gallery, 2008; www.thavibu.com/thailand/jirapat_tatsanasomboon/thavibu_jirapat_tatsanasomboon.pdf
• Steven Pettifor, *Camouflage*, Bangkok: Thavibu Gallery, 2010; www.thavibu.com/thailand/jirapat_tatsanasomboon/thavibu_camouflage.pdf
• Rathsaran Sireekan, *The Desires Of Nonthok*, Bangkok: Thavibu Gallery, 2013; www.thavibu.com/thailand/jirapat_tatsanasomboon/thavibu_the_desires_of_nonthok.pdf

JULIA WACHTEL
• Thomas Fredrickson (ed.), *Julia Wachtel*, Chicago, Illinois: Museum of Contemporary Art, 1991

CAITLIN YARDLEY
• Christopher Crouch, *An Intimate Distance*, Perth: Venn Gallery, 2011

JAKUB JULIAN ZIOLKOWSKI
• Centre d'Art Contemporain Genève, *Jakub Julian Ziolkowski*, Zurich: JRP Ringier, 2009
• Hanna Wróblewska, *Jakub Julian Ziolkowski: Hokaina*, Warsaw: Zacheta National Gallery of Art, 2010
• Ziba Ardalan, *Jakub Julian Ziolkowski: In Utero*, Berlin: Walther Koenig, 2011

WEBSITES, MAGAZINES AND BLOGS

• A/Art: www.blogaart.blogspot.co.uk

• Art Daily: www.artdaily.org

• Art Sy: www.artsy.net

• Beautiful/Decay: www.beautifuldecay.com

• BLOUIN ARTINFO: www.blouinartinfo.com

• BOOOOOOOM!: www.booooooom.com

• Colossal: www.thisiscolossal.com

• Contemporary Art Daily: www.contemporaryartdaily.com

• (fundamental) PAINTING: www.fundamentalpainting.blogspot.co.uk

• Modern Painters: blogs.artinfo.com/modernpaintersdaily

• New American Paintings: www.newamericanpaintings.com/blog

• Painters' Table: www.painters-table.com

• Saatchi Art: www.saatchiart.com

• Turps Banana: www.turpsbanana.com

• Two Coats of Paint: www.twocoatsofpaint.com

LiST OF iLLUSTRATiONS

a = above, b = below, c = centre, l = left, r = right

p.2 Courtesy the artist and Pilar Corrias, London

p.9 Private Collection. Courtesy Sperone Westwater

p.10a Cover image by Wilhelm Sasnal. © *Artforum*, November 2004 • p.10b Rubell Family Collection, Miami. Courtesy the artist, David Zwirner, New York/London and Carlos/Ishikawa, London • p.12a Museum of Modern Art, New York. © Gerhard Richter, 2014 • p.12b Collection Famille Lens. © ADAGP, Paris and DACS, London 2014 • p.13a Musées Royaux des Beaux-Arts de Belgique, Brussels. © DACS 2014 • p.13b Museo Nacional del Prado, Madrid • p.14a © Estate of Martin Kippenberger, Galerie Gisela Capitain, Cologne • p.14b Courtesy the artist and Luhring Augustine, New York • p.15a Photo Hugo Glendinning • p.15b Courtesy the Estate of Gordon Matta-Clark and David Zwirner, New York/London. © 2014 Estate of Gordon Matta-Clark /Artists Rights Society (ARS), New York, DACS London • p.16a Courtesy Atelier Hermann Nitsch • p.16b Courtesy the artist and Hauser & Wirth. © Paul McCarthy • p.17a Courtesy Peres Projects, Berlin; Simon Lee Gallery; Almine Rech Gallery. Photo Hans-Georg Gaul, Berlin • p.17b Courtesy the artist and Luhring Augustine, New York

HENNY ACLOQUE • pp.20 & 21 All images courtesy the artist and Ceri Hand Gallery, London. Photos Anna Arca

DALE ADCOCK • pp.22 & 23 Courtesy the artist

JULIETA AGUINACO • pp.24 & 25 Courtesy the artist and Altiplano Galería, Mexico City

CHECHU ÁLAVA • pp.26, 27, 28 & 29 Courtesy the artist. Photos André Morin

KRISTINA ALIŠAUSKAITĖ • pp.30 & 31 Courtesy the artist and The Rooster Gallery, Vilnius

MICHAEL ARMITAGE • pp.32, 33, 34 & 35 Courtesy the artist

CORNELIA BALTES • p.36l Courtesy the artist and Private Collection, London • p.36r Courtesy the artist, Limoncello, London and DREI, Cologne • p.37 Courtesy the artist and Private Collection, Frankfurt

AGLAÉ BASSENS • pp.38, 39, 40 & 41 Courtesy the artist

LESLIE BAUM • pp.42 & 43 Courtesy of Leslie Baum and devening projects + editions

EMMA BENNETT • pp.44 & 45 Courtesy the artist and Charlie Smith London. Photos Peter Abrahams

SZE YANG BOO • pp.46 & 47 Courtesy the artist

NINA BOVASSO • pp.48 & 49 Courtesy the artist. Photos Jean Vong

DAN BRAULT • pp.50, 51, 52 & 53 Courtesy the artist

SASCHA BRAUNIG • p.54l Collection of Ping and Robert Thomson. Courtesy the artist and Foxy Production, New York • p.54c Private Collection. Courtesy the artist and Foxy Production, New York • p.54r Collection of Carol Simon Dorsky. Courtesy the artist and Foxy Production, New York • p.55 Collection of Niva Grill Angel. Courtesy the artist and Foxy Production, New York

BENJAMIN BRETT • pp.56 & 57 Courtesy the artist and Victor Staaf (photographer) London

G L BRIERLEY • p.58 Courtesy the artist and the Reydan Weiss collection • pp.59 & 60 Courtesy the artist • p.61 Courtesy the artist and the Henri Swagemakers Collection

ANDREW BRISCHLER • pp.62 & 63 Courtesy the artist and Gavlak Gallery, Palm Beach

PETER LINDE BUSK • pp.64 & 65 Private Collection. Photos Def Image, Berlin

JANE BUSTIN • pp.66 & 67 Courtesy the artist

CARLA BUSUTTIL • pp.68 & 69 Courtesy the artist and Josh Lilley, London • p.70 Courtesy the artist and Goodman Gallery, Johannesburg • p.71a Courtesy the artist and Josh Lilley, London • p.71b Courtesy the artist and Goodman Gallery, Johannesburg

JORGE CASTELLANOS • p.72l Courtesy the artist • p.72r Courtesy the artist and Wigel Collection, Munich • p.73 Courtesy the artist

CHOKRA • p.74 Courtesy the artist, Domus and The Watermill Center, New York. Photo Ramak Fazel • p.75a & b Courtesy the artist, Queer New York International Arts Festival & Abrons Arts Center, New York. Photos Loren Wohl

HEMAN CHONG • p.76 Courtesy the artist and Vitamin Creative Space, Beijing • p.77al Courtesy

the artist and STPI, Singapore • p.77ar Courtesy the artist and Rossi & Rossi, Hong Kong • p.77bl Courtesy the artist and Wilkinson Gallery, London • p.77br Courtesy the artist and FOST, Singapore

BLAKE DANIELS • pp.78 & 79 Courtesy the artist and Beers Contemporary, London

WILLIAM DANIELS • pp.80 & 81 Courtesy the artist and Vilma Gold, London

PETER DAVIES • pp.82 & 83 Courtesy the artist and The Approach, London

ADAM DIX • pp.84 & 85 Courtesy the artist

TOMORY DODGE • p.86 Courtesy the artist and ACME, Los Angeles • pp.87 & 88–89 Courtesy the artist and CRG Gallery, New York

FREYA DOUGLAS-MORRIS • pp.90 & 91 Courtesy the artist, London

MILENA DRAGICEVIC • pp.92, 93, 94 & 95 Courtesy the artist and Galerie Martin Janda, Vienna

DEJAN DUKIC • p.96 Courtesy the artist • p.97 Courtesy Mayer and Mayer

TIM ELLIS • pp.98 & 99 Courtesy the artist

MATILDA ENEGREN • pp.100 & 101 Courtesy the artist

STELIOS FAITAKIS • p.102 Private Collection, Athens. Courtesy The Breeder, Athens • p.103 Courtesy The Breeder, Athens

MICHAEL FANTA • pp.104 & 105 Courtesy the artist

MADELINE VON FOERSTER • pp.106 & 107 Courtesy the artist

MARC FREEMAN • pp.108, 109, 110 & 111 Courtesy the artist and Nellie Castan Projects, Melbourne. Photos Andrew Wuttke

ROBERT FRY • p.112 Private Collection • p.113 Private Collection. Courtesy Galerie Kornfeld, Berlin

NUNO GIL • pp.114 & 115 Courtesy the artist and Módulo, Lisbon

KATE GOTTGENS • p.116 Courtesy the artist and Private Collection • pp.117a, 117b, 118a, 118–19 & 119b Courtesy the artist and SMAC Gallery, Cape Town • p.118b Courtesy the artist and Private Collection

ACKNOWLEDGMENTS

100 Painters of Tomorrow originated as an idea incited by a passion for art and a desire to acknowledge those emerging artists (in particular, painters) who are so often responsible for establishing trends at a grassroots level, and who are so often overlooked in favour of more established artists. That initial spark was followed by years of pre-production and planning, and has now culminated in the book you hold in your hands. My hope is that this ambitious project will prove to be part of an important legacy in surveying the current shape of painting.

The book is the result of the efforts of a number of people, to whom I am extremely grateful, as without them it simply would not exist. While there is no way to thank personally everyone who contributed to *100 Painters of Tomorrow*, I would like particularly to acknowledge commissioning editor Jacky Klein for her belief in the book in its early stages, and for authorizing and overseeing the project as a whole. The book owes so many of its determining elements to her guidance and judgment.

Thanks are also due to the entire team at Beers Contemporary for their hard work and dedication, but particularly to Assistant Director Beca Laliberte and Amy Monaghan, who rose above their duties and contributed so much to the publication at every stage, and who exhibited such faith and conviction in the project.

A very special thank you also to the jury members for their time, talents and expertise. Through their wisdom and hours of critiquing and adjudication, this book began to take form. A particular acknowledgment is due to Gregor Muir for writing the introduction.

Finally, and perhaps most importantly, thank you to each and every artist who applied to *100 Painters of Tomorrow*. We received an overwhelming response – over 4,300 submissions from 105 different countries; in other words, well over half the world. It is because of this response, and the passion which clearly lies behind it, that this book lives.